History of Concepts

History of Concepts
Comparative Perspectives

EDITED BY
IAIN HAMPSHER-MONK
KARIN TILMANS
FRANK VAN VREE

AMSTERDAM UNIVERSITY PRESS

The publisher and editors gratefully acknowledge the assistance of the Huizinga Instituut, the Dr. Hendrik Muller's Vaderlandsch Fonds and the M.A.O.C. Gravin van Bylandt-stichting.

Cover illustration (front): Edwaert Collier, *Vanitas still life*. Stedelijk Museum 'de Lakenhal', Leiden. Cover illustration (back): Rembrandt van Rijn, *Self-portrait with a dead bittern* (1639). Gemäldegalerie, Dresden.

Cover design: Jaak Crasborn Bno, Valkenburg a/d Geul
Lay-out: Fontline, Nijmegen

ISBN: 90 5356 306 7

Contents

Acknowledgements

This book would never have been written but for the existence of the Netherlands Institute of Advanced Studies in Wassenaar, for it was in NIAS in 1994-1995 that an international research group on conceptual history was formed which took the initiative for the present study. What started out then as a discussion group on the methodological problems of comparative conceptual history later continued as the editorial board which has guided this present volume, and infinite thanks are owed to Hans Bödeker, Pim den Boer, Martin van Gelderen and Wyger Velema for their invaluable and stimulating contributions and editorial support. The editorial meetings were made financially possible through a generous grant from the Huizinga Institute, which also subsidized the translation into English of the chapter by Pim den Boer. We would like to thank the board of the Huizinga Institute most sincerely for their help. We also gratefully acknowledge the support of the Dr. Hendrik Muller's Vaderlandsch Fonds and the M.A.O.C. Gravin van Bylandtstichting, both of which generously helped to subsidize the publication of this volume. Special thanks are due here to Niek van Sas, who made sure that the production work could finally be started. Also, we would like to thank Amsterdam University Press for having confidence in this international enterprise and for their continuous and enthusiastic encouragement during the final stages of the project. Without their efforts this book would never have seen the light of day, and would certainly not have turned out so handsomely.

Iain Hampsher-Monk
Karin Tilmans
Frank van Vree

Amsterdam/Exeter Spring 1998

A Comparative Perspective on Conceptual History – An Introduction

IAIN HAMPSHER-MONK, KARIN TILMANS AND FRANK VAN VREE

In recent decades the growing recognition of the importance of language in understanding reality has dramatically changed both the focus and methods of the humanities and social sciences. A major feature of this has been the development of histories of concepts, of political languages and discourse. However, the orientation and methodological approach within this movement varies considerably from one country to another, depending on different linguistic and scholarly traditions in the humanities. This volume displays the diversity of areas in which conceptual history is currently being deployed, as well as the range of traditions which seek, in their different ways, to deploy one or another form of it.

In Germany a longstanding interest in the history of concepts, reaching back as far as Hegel, resulted in a particularly ambitious and monumental project, led by Reinhart Koselleck, Otto Brunner and Werner Conze. Its aim was to investigate fundamental concepts in history, *Geschichtliche Grundbegriffe*,[*] with regard to their functioning as 'both a factor in, and an indicator of historical processes'. The project resulted in two massive series: *Geschichtliche Grundbegriffe. Historisches Lexicon zur politisch-sozialen Sprache in Deutschland*, seven volumes of which were published between 1972 and 1992, dealing with socio-political language in Germany, and the *Handbuch politisch-sozialer Grundbegriffe in Frankreich*, fifteen volumes of which have been published since 1985, edited by Rolf Reichardt and Eberhard Schmitt.

Both works focus on concepts that are considered to be crucial to the 'sprachliche Erfassung der moderne Welt' – the linguistic constitution of modern world – in law, politics, science, social and economic life and ideology, concepts on which various segments of society and parties relied to express their experiences, expectations, and actions.[1] A good example is the concept of 'Herrschaft' (dominion, domination, lordship, rule, command), the entry of which in the *Geschichtliche Grundbegriffe* is extensively discussed by Melvin Richter in his recent book *The History of Political and Social Concepts*.[2] These concepts were studied over a time-scale which in many cases went back to Antiquity. However, the key period for analysis was that period that following the Enlightenment, a period identified as

[*] NOTE Unless it is clear from the context, the term *Begriffsgeschichte* which has a wider meaning in German will be used in this volume explicitly to denote the work and approaches associated with the *Geschichtliche Grundbegriffe* project and its successors.

constituting a watershed or *Sattelzeit* – Sattel, literally a saddle, here evoking the image of a pass across a mountain range linking two valleys. The transition denoted by the term *Sattelzeit* is the historical transition to modernity. For Koselleck – who may be considered to be the *auctor intellectualis* of the German project – modernity was characterised by four processes which affected societies and their self-awareness: *Verzeitlichung* (the location within a temporal and historical development), *Demokratisierung* (democratization), *Ideologiesierbarkeit* (the increasing susceptibility of concepts to abstraction from their concrete social and historical referent) and *Politisierung* (politicization).

At the heart of the method of the *Begriffsgeschichte* were several technical analytical concepts, drawn mostly from linguistics. The founder of this discipline, the Swiss scholar Ferdinand de Saussure (1857-1913) had already drawn attention to the distinction between the diachronic and synchronic aspects of a language – language changes across time and yet has a definite structure at any one point in time. *Begriffsgeschichte* focuses upon both, alternating analysis of key concepts within a given semantic field at any one point in history, with a diachronic perspective which draws out shifts or changes in the meaning of concepts.

The founders of the *Begriffsgeschichte* project sought to overcome the limitations of historical philology and lexicography. This required their not identifying the concept with any single word. Three analytical linguistic devices were vital in enabling them to do this. The idea of a semantic field held out the prospect of defining a concept not in lexical terms, but in terms of ranges of characteristic synonyms, antonyms, associated terms, forming a more or less unified part of a vocabulary at a given time. So the concept of 'Herrschaft' should be studied within the same semantic field as 'Macht' (power), 'Gewalt' (force, violence), 'Autorität' (authority), 'Staat' (state) or other related concepts. At the same time, the distinction between concept and word or term was marked by the distinction between onomasiology – the study of the different terms available for designating the same or similar thing or concept – and semasiology which seeks to discover all the different meanings of a given term. An onomasiological analysis of the concept of 'liberty' would therefore seek out all the terms and expressions that could be used to designate it. By contrast, a semiological analysis of the word 'liberty' seeks to identify the variety of meanings it may bear.

The *Begriffsgeschichte* project was a massive scholarly enterprise with a very distinctive methodology. However, it was not only in Germany, but also in France and the English-speaking world that scholars were turning away from earlier approaches to intellectual history and the history of political ideas. J.G.A. Pocock and Quentin Skinner, for example, redefined the object of the history of political thought in terms of a diachronic and synchronic study of language. In their view, the task of the historian was to identify and reconstruct the languages in which political moves were made. Other scholars took a similar position, moving away from the 'masterpieces' of political thought to a history of conceptual change, political language and discourse.

Paradoxally, these shifts in historiography, closely interwoven with linguistic and specific scholarly traditions, have taken place contemporaneously but relatively independently. This volume not only aims to present an account of recent developments in the history of

concepts, but also reflects critically on the results and, in particular, compares the methods and basic assumptions of different approaches within these fields of research.

Resulting from an initiative by Dutch historians, this volume, and even more the project which it represents and spearheads, can even be said to find its *raison d'être* in a confrontation of research traditions. Although impressed by the voluminous *Geschichtliche Grundbegriffe*, Dutch scholars, considering the possibility of a project on the history of concepts in the Netherlands, felt that they had to develop an approach that would be tailored to the historical peculiarities of the Low Countries.[3] As the editors of the *Handbuch politisch-sozialer Grundbegriffe in Frankreich* had already experienced, some of the main features of German *Begriffsgeschichte* seemed to bear less relevance to the history of concepts in other languages, e.g. the one-sided emphasis on the eighteenth century as the *Sattelzeit*, the epoch of 'conceptual modernisation'. On the other hand, it was clear, too, that the *Geschichtliche Grundbegriffe* fails to address images, or, to be more specific, the problem of the relationship between verbal and visual representation. It can be argued that a history of socio-political thought cannot be written properly without an in-depth analysis of visual language.

Since some of the Dutch scholars were also familiar with developments in the English-speaking world, the idea of a confrontation of different traditions easily arose. Such an exploration of methods and approaches was thought to be helpful in establishing a solid and practical basis for Dutch conceptual history. From 1990 on, there were a number of lectures and conferences, initially in Amsterdam and later at the *Netherlands Institute of Advanced Study* (NIAS) in Wassenaar. These meetings were attended not only by Dutch scholars, but also by protagonists of different approaches from Germany, France, Great Britain, Italy and the United States. This volume contains selected papers and lectures from those delivered at the NIAS conferences, as well as some contributions especially written for this publication.

As an endeavour to correlate, explain and reconsider different approaches to the history of social and political thought, with a view to assimilating the results of this exploration into a national research program, this volume constitutes an example of a very distinctive characteristic of the history of the Netherlands. From late medieval times, the Low Countries have functioned as an international market place, not only for the trading of money and commodities but for the exchange of ideas and cultural goods as well. Initially this market profited from the dominant commercial and political position of the Dutch Republic, the absence of an autocratic and centralist regime and the prevailing economic and religious freedom. Later, the country took advantage of its central geographical position, surrounded by the rising powers of Western Europe. The initial results of the Dutch concepts project show that with regard to the development of concepts and discourse too, the Dutch have played an important role in the history of European thought.

Even today, policy makers, scholars, artists and theorists of national identity consider this role as a broker to be at the heart of Dutch national politics and culture. Therefore, the need for cross-national comparison and confrontation of methods and disciplines, felt from the outset by the initiators of the Dutch project, was in a sense 'natural'.

The volume consists of thirteen contributions, divided into three sections, the first of which introduces and discusses the methodological issues involved in *Begriffsgeschichte* and the related intellectual pursuits in Anglophone and Francophone academic life.

In the opening chapter, Pim den Boer describes in detail the institutional origins, aspirations and conduct of the *Geschichtliche Grundbegriffe* project, its place in the German historiographical tradition, and the contributions of the individual editors, as well as its successor the *Handbuch politisch-sozialer Grundbegriffe in Frankreich 1680-1820*. He then introduces the case of Holland and what might be expected from a Dutch enterprise of a similar kind: what it might tell us about the extraordinary case of early modern Dutch society where a very different *Sattelzeit* could be expected, what comparative light it might reflect on other such studies and the societies studied, and what light Dutch, as a linguistically 'open' site, can shed on the peculiar problem of conceptual transfer and appropriation between different natural languages that is addressed in this book by Frijhoff and Lüsebrink.

The contribution of Reinhart Koselleck, a founder and the foremost practitioner of *Begriffsgeschichte*, deals with a number of key issues picked up elsewhere in this volume. Koselleck emphasises that the claim of *Begriffsgeschichte* is more than just another historical specialism, as though one could have a history of concepts in the way that one might have a history of dress, or a history of naval warfare. 'Society and language', Koselleck argues, 'are part of the metahistorical givens without which history (*Geschichte, Historie*) is inconceivable'. Any specialist in history must therefore come under the purview of social history and conceptual history – and it is to the creative tension between these two that he wishes to direct our attention. For 'what actually happens is clearly more than the linguistic articulation that produced or intepreted it'.

Acknowledging the linguistic filter through which we (and historical subjects) invariably articulate our experience, does not, claims Koselleck, mean that all history can be reduced to the history of language. But neither does it mean that long run demographical social statistics can be deployed in complete innocence of the conceptual categories available to the historical agents concerned. Moreover, social history and the history of concepts each display both a diachronic and a synchronic dimension. That means each subject matter comprises, at any one time a stable structure which gives meaning and identity to individual instances or actions, and over time each structure displays change. The structure can be conceived of as a *langue* within which the agent is enabled to perform his or her *parole*. We can conceive of an abstract concept like marriage having a persistent and meaningful referent over a long period of time, just as we can conceive of it having particular specifications at different times. Similarly, we can see each ceremony as a *parole* – a speech act – embodying and made possible by the language of marriage. Sensitized by this historical knowledge, we can construct long-term indices of the incidence of marriage – synchronically in terms of their distribution amongst different social classes say, and diachronically in terms of the rise and fall of marriage contracts. Social and conceptual history, it is claimed, are thus intertwined, not only in the sense that their results are complimentary, but in the much more

fundamental sense that neither can be practised successfully without the insights provided by the other.

Iain Hampsher-Monk outlines three models for practising the history of political ideas revealed in language use, that based on the idea of distinct political languages pursued by John Pocock, Quentin Skinner's focus on the 'speech act' analysis of Austin and Searle, and conceptual history. He sets out to emphasise the distinctive character of each, whilst ultimately finding a mutually supportive relationship between the first two. His comparative remarks stress the originally different foci of the Anglophone and *Begriffsgeschichte* enterprise, the Anglophone nervousness about 'concepts' which are not yet words, and the apparent incompatibility between the Anglophone stress on the need for a wide synchronic linguistic context to be able to identify the concept and the German aspiration to extract individual concepts from this for diachronic treatment. His final remarks advert to the emphasis on agency in the Anglophone history as opposed to the sense of process discovered in *Begriffsgeschichte*.

In his critical appraisal of *Begriffsgeschichte*, Hans Bödeker singles out four representative problems connected with this distinctively German genre. Firstly, the problems of identifying and selecting the various relevant fundamental *Begriffe* for investigation. Second there is the problem that arises because meaning, construed, as Wittgenstein enjoined us to, as 'meaning in use', refers epistemological issues to unstable empirical questions about typical users and uses, problems exacerbated by the late-eighteenth-century explosion of reading matter and the diversification of the reading public. A third issue – already focussed on by Koselleck and by a number of other writers – is the relationship of concepts to a 'concrete setting'. *Begriffsgeschichte* is firmly rooted in, and conceived of as a contribution to, social history; it arose at least in part as a reaction to an older history of ideas in which the idea was a transhistorical (and therefore not socio-historically specific) unit. As Koselleck made clear in the second chapter, *Begriffsgeschichte*, in common with French and Anglophone approaches to the history of mentalities and languages, insists on recovering the socio-historically embedded meaning of the concept. Yet for German *Begriffsgeschichte*, that socio-political reality is susceptible to an epistemological approach which is relatively independent of the awareness and concepts through which historical agents experienced it.

Bödeker traces this dichotomy not only to the lack of interdisciplinary exchange between linguistics and history in the Germany of the early Sixties, but also to the survival – evident in many of the contributors to the project – of a predominantly philosophical tradition dating back to the nineteenth century. Inasmuch as the concept of the *Begriffe* fails to emancipate itself from its philosophical origins, it remains distinct and therefore externally related to an historical reality. For the Anglophone and even more the French a more fundamentally synthetic practice emerged in which language *was* political event, social structure, etc. The resistence to the reception of French interest in the every-day mental world as unconceptual, and of French structuralism as unhistorical, long prevented recognition of the real convergence between the two. Yet as this very collection shows, variants of conceptual history have now started to focus on everyday texts, popular symbolism, language, socio-historical semantics and political discourse. Bödeker sees a real international

synthesis emerging whereby different methods can be applied to different questions and areas of evidence on the basis of what is appropriate.

The second section of the book presents a number of exemplary studies in the history of concepts more widely conceived. These take a number of forms which can be thought of as ranging between two foci – the treatment of a particular individual concept and the treatment of a particular conception of the history of concepts.

In a study which implicitly owes more to Anglophone than German methodology, Maurizio Viroli considers the early history of a new locution in sixteenth century Italy: *ragione di stato* (reason of state), a locution which in his view ushered in 'a new language' which supported a transformed understanding of the practice and end of politics. Viroli identifes the sixteenth century writer Giovanni Botero performing a speech act by which the positive connotations of both 'reason' and 'politics', previously attached to a specific kind of rule – limited, law-governed and obtaining in republics – was appropriated by absolute Princes (and eventually by amoral republics too) and attached to whatever practices sustained their power. Although this exemplifies the Skinnerian programme analysed by Hampsher-Monk in Chapter 3, there are interesting points of contact in terms of both method and the findings of *Begriffsgeschichte*. In spite of what we might call his preference for the language of 'languages', Viroli, like the practitioners of *Begriffsgeschichte*, establishes the scope of a concept by referring to its perceived opposites, charting conceptual change partly through reference to changing synonyms and antonyms. As do they, Viroli explicates 'reason of state' by referring to a wider conceptual field, and like them, if less explicitly, he holds in tension the semasiological and onomasiological elements of analysis which enables us to imagine the concept traversing a range of lexical possibilities.

In other studies in this section the focus shifts to the method itself, and examples become secondary. Both Bernhard Scholz and Terence Ball argue for the idea of a discipline-specific *Begriffsgeschichte* or conceptual history. The domain of such a restricted conceptual history approaches Pocock's conception of language, and it might range from the highly formalised – such as physics – to the more open, contested and opportunistic domain – such as politics. Scholz's conscious separation of the subject matter of conceptual history from the 'life-world' is only one of a number of important respects in which his characterisation of it differs from that given by Koselleck. He illustrates his claim from the language of literary criticism which contains both ordinary-language and technical concepts. The project of such a specialized conceptual history is exemplified in the *Reallexikon der Deutschen Literaturwissenschaft*, from which the changes in the connotations of 'emblem' are chosen. Terence Ball, one of the few Anglophone writers to actually practise conceptual history under that name, discusses how an awareness of conceptual history (both German and Anglophone) – which he traces to a common awareness of the 'linguistic turn' taken by philosophy in the twentieth century – impinges on the study of the history of political thought. Yet Ball's conception of 'critical conceptual history' still leans towards the Anglophone school. Although he is untroubled by a history of a concept predating any lexical signifier, he strongly identifies the history of political concepts with the history of 'the political conflicts in which they figured'. His general conception of the role to be per-

formed by conceptual history is not a totalising one, even within the history of political thought. It is ultimately that of sensitizing us to the issues and assumptions, overtones and prejudices – even deceits and misrepresentations – present in the language of the historical actors whose texts we study.

Willem Frijhoff critically discusses the concept 'Cosmopolite' as presented in the *Handbuch*, in relation to changing conceptions of the disciplines within which it might be placed – conceptual history, cultural history and a social history which has increasingly yielded its positivism to a recognition of the 'constructed' character of social reality. Hans-Jurgen Lüsebrink studies the transfer (and transformation) of the conceptual field surrounding 'Nation' as it passed from Revolutionary France into Germany. In doing so he both reveals and extends the methods of classic *Begriffsgeschichte*. Lüsebrink's study, fascinating in its own right, exemplifies, how, for true *Begriffsgeschichte*, a concept is [a position within] a semantic field and not a lexical item. Although the content of this vocabulary picked up peculiarly German connotations in the course of transfer, Lüsebrink shows that the Revolutionary French structure of the discourse in which it was deployed was maintained – using distinctive oral styles of address, adopting political catechisms and songs. Moreover, he observes the irony that it was this very cultural transfer that created, in the nineteenth century, the language of nationalism which increasingly denied the desirability or even the fact of intercultural influence.

The third, and in many ways most speculative section of the book discusses the connections and affinities between words and images as possible media of conceptual histories. A number of the contributions allude to the emblem book of Andreas Alciatus (1492-1550), *Emblematum libellus*, which provides an interesting historical licence for this.[4] Alciatus, a celebrated philologist, also contributed to the emerging genre of books of epigrams, quotations and topoi associated with the spread of humanism to a wider and less educated audience. In his case, as Bernhard Scholz explains, the epigrams were illustrated with woodblocks and the term 'emblem' acquired the connotation of a device which linked text and image.

This attempt to pursue the filiations of text and image is particularly appropriate for a programme of Dutch conceptual history, given the Netherlands' long, rich, and socially pervasive engagement with the graphic arts. But how, exactly, might language and image be related? Three possibilites are explored, one from the high 'official' art of Raphael, one from bourgeois art of the Dutch seventeenth century and one from a demotic revolutionary art-form – the playing cards of the French Revolution.

Bram Kempers discusses the history of interpretation of Raphael's famous frescoes in the *Stanza della Segnatura* in the Vatican Palace, showing how conceptual confusion resulted from successive failures to locate the work in its appropriate intellectual context. 'Context' in this case involves a consummate union of conceptual, architectural and functional space. The rooms containing the frescoes where the Pope held his audiences linked his religious, political and scholarly *personae*, both in the sense that it was there that he discharged his role as political and religious leader using the forms of contemporary humanism, but also in the sense that the rooms formed an architectural space linking the Pope's political secretariat, his private and public devotional space, and his considerable humanist library. With

secular and sacred, political and ecclesiastical, humanist and religious coordinates all intersecting there, the Stanza was a location of potentially devastating cultural turbulence, and Kempers makes clear both how the frescoes drew on the existing conceptual milieux to achieve a momentary calm, as well as how the breakdown of that milieux led to successive misinterpretations.

Kempers' shows Raphael's frescoes to be a focus of extraordinary conceptual intensity on which is brought to bear the entire cultural resources of a particular society at a moment in history. Eddy de Jongh, by contrast, explores the more domestic world of Dutch genre painting. He presses the case for an iconographic reading of these paintings, stressing both the *taligheid* – literally the 'linguistic-ness' – of art and the complementary, pictorialist, character of poetry. In the absence of contemporary theoretical treatises of genre-painting, De Jongh points to the widespread currency of renaissance *topoi* likening poetry to art, and of the popularity of emblem books, iconologies and illustrated collections of proverbs functioning almost as word-image dictionaries. He instances the reliance of numerous pictures on some well-known phrase, proverb or poem. Whilst this is not yet conceptual history, it provides the necessary groundwork for the creation of what might, given the overwhelming importance and presence of art in early modern Dutch culture, turn out to be a significant and distinctive Dutch development of it, linking conceptual iconography and *Begriffsgeschichte*.

The importance of emblem-books going back to Alciato's famous *Emblematum Libellus* (translated into French in 1558) and popular pictures as 'spoken writing' is also one of the starting points for Rolf Reichardt's discussion of French revolutionary card games. These were a deliberate adaptation of the didactic picture books used by the Catholic Church in controlling and mobilising the semi-literate societies of post-Reformation Europe. The importance of the card game is that it reveals the possibility, not simply of identifying images and text, as De Jongh does in the case of popular art, but of going further and recovering a structure of intended relationships and associations between key terms – a genuine semantic field – which it was the task of the games to convey to semi-literate players. This field has both an historical dimension, the representation of a version of French History, and a socio-linguistic one, the establishment – in the player's mind – of appropriate connections, associations and oppositions between key concepts. Rather as in snakes and ladders, landing on certain fields moves one up or down; unsurprisingly landing on 'Bastille' sends you back to the start. However, the moves go well beyond merely imprinting a manicheeistic dichotomy of progress and reaction, important as that was. Landing on 'Varennes' sends you back to a field marked 'Law'; Landing on Montesquieu allows three more advances, on to legislative, judiciary and executive! Moreover, Reichardt uncovers yet another layer of conceptual connections identified not with the movement of players in the game, but with its iconography, which draws together three discrete, bipolar semantic fields 'Bastille', 'Francia' and 'Rights of Man', each comprising a number of concepts or events.

Martin van Gelderen's epilogue reviews some of our major themes. A Dutch-educated historian of ideas who is an author from the Cambridge stable, has taught in Berlin, and now holds a chair in Sussex, he perhaps knows more than most of the contributors to this volume what it is to be situated 'between Cambridge and Heidelberg'. Pursuing the

polarities of text and image, *Begriffsgeschichte* and the history of political languages, involves, he suggests, coming to recognise not only their methodological exclusivity, but their logical interdependence within any plausible historical hermeneutics – a point anticipated by Terence Ball's chapter. Moreover, as he more than hints, for practising historians there are pragmatic considerations: as well as the methodological clarity of the 'Cambridge' prescriptions, its publications are undoubtedly 'a success'.

This concern with practical outcomes may well be a final 'peculiarity of the Dutch' which we should acknowledge here. For in addition to their role as cultural brokers, and in addition to the intimacy they have fostered between text and image, the Dutch are inclined to be practical, and even in an area as abstract as the history of concepts seem unlikely to be inhibited by unresolved tensions between the methodological recipes adopted by their neighbours. Whether such a pudding will be proved in the eating must await the publication of the exciting substantive volumes on individual Dutch concepts which are now in preparation, and to which this volume serves as a prologue and introduction.[5]

PART I

Theoretical and Comparative Frameworks

CHAPTER 1

The Historiography of German Begriffsgeschichte and the Dutch Project of Conceptual History

PIM DEN BOER

It is no coincidence that the study of basic historical concepts first developed in Germany.[1] In the nineteenth century, after all, German philosophers were already interested in the history of philosophical terms. In theological faculties, the practioners of *Dogmengeschichte* – the history of dogma – devoted attention to the history of words and concepts.[2] The thorough studies by F.C. Baur and his students in Tübingen on the use of such theological concepts, such as *religio* and *gnosis* exemplifies this approach. At the end of the nineteenth century, pretentious theories were even contrived in which conceptual history was granted a central position and mathematical figures demonstrated the complex and ambivalent relations between the concepts with seeming precision.

In the tradition of the *Geisteswissenschaften* propagated by Dilthey, a great deal of attention has been devoted to the history of the formation of philosophical and literary concepts. As one member of this venerable family, the first volume of *Archiv für Begriffsgeschichte* was printed in 1955; a series published by cultural philosopher Erich Rothacker with the aim of providing material for a European *Geistesgeschichte*.

Even though the pre-war emphasis on what was 'typically German' had been replaced by an approach in which common elements occupy a central position in the various national traditions, the work of Rothacker *et al.*, with his emphasis on the congruity of the history of ideas was in keeping with the tradition of philosophical idealism. His point of departure was the question of the extent to which the vocabulary and the problems of European and American philosophy had maintained continuity with Greek and Hellenistic thinking. This entailed an understanding of the impact of translating the Greek corpus into Latin, of Christian and Muslim thought, of modern physics and natural law, of the Reformation and Counter-Reformation, as well as their incorporation into modern national cultures.[3] Rothacker was convinced of the need to study *kulturphilosophische Grundbegriffe* and recommended that thorough research be conducted into the application of concepts from one branch of science into another, and the related changes in meaning; a theme to which traditional philosophical dictionaries failed to devote any attention.

In Germany, prior to the publication of the *Geschichtliche Grundbegriffe*, there was consequently a rich tradition of conceptual history. Research was not confined to the history of

philosophical concepts, it also addressed the fields of theology, science, literature, politics, art and culture.

The Role of Koselleck

Attention has been drawn to the continuity which characterizes the *Geschichtliche Grundbegriffe*. This is exemplified by the fact that each of the seven volumes is adorned with the names of the three founding editors, Otto Brunner, Werner Conze and Reinhardt Koselleck. Koselleck especially must have devoted an incredible amount of time and energy to the lexicon. After the death of the other two, he was left with the job of completing the project.

Koselleck's most important achievement, however, pertains to the contents. From a historiographic point of view, his work constitutes a link between the hermeneutic historical tradition in the humanities and modern social history. It was of fundamental significance for the conception of the *Geschichtliche Grundbegriffe* that Koselleck was able to make Brunner's idea of a *Sattelzeit* operational by formulating four fundamental working hypotheses to serve as guidelines.

Koselleck, born in 1923 and thus twenty-five years younger than Brunner and thirteen years younger than Conze, studied history, philosophy and constitutional law at Heidelberg. In 1968, he was appointed professor at Heidelberg, and in 1971 at the new campus university in Bielefeld, which came to be eponymously linked to modern German social history. The *Geschichtliche Grundbegriffe* was published when Koselleck was at Bielefeld, but his interest in conceptual history dates back to his Heidelberg period.

In his dissertation, *Preussen zwischen Reform und Revolution. Allgemeines Landrecht, Verwaltung und soziale Bewegung von 1791 bis 1848* (1965), Koselleck was already trying to link political and social history. In this study, with Conze as supervisor, Prussian property law was viewed as the embodiment of a social theory. After 1791 citizenship was redefined and property ownership and group membership were replaced by individual rights. As a result, at the beginning of the nineteenth century Prussia had extremely modern legislation and an extremely modern administration. This reform was terminated in 1848, after which point a reaction ensued. For his study, Koselleck consulted a wide variety of legal and official documents, thus maintaining an objective distance from the traditional history of political ideas as was practised by the great historian Friedrich Meinecke, who in his opinion had removed himself too far from historical reality.

In his years at Heidelberg, Koselleck was less inspired by historians than by philosophers such as Gadamar, whose renowned seminars were also regularly attended by Heidegger.[4] His views on time and the conception of time were to exert a decisive influence on Koselleck's ideas about the fundamental change in the consciousness of time, in the 'historicization' of the world view, and the accompanying focus on the future by modern society. These insights were to be at the foundation of one of the working hypotheses of the *Geschichtliche Grundbegriffe*.

In the field of political science, Koselleck was influenced by Carl Schmitt. The work of this political theoretician, appointed professor in Berlin in 1933 and dishonourably dis-

missed in 1945, controversial as critic of Versailles, the Weimar Republic and the League of Nations, reviled as admirer of the National Socialist state and defender of the 'Kampf der deutsche Rechtswissenschaft wider den jüdischen Geist',[5] exerted a direct influence on the conceptual history put into practice in the *Geschichtliche Grundbegriffe*.

In his historical works, or so Koselleck held, Schmitt sought the meaning of words by locating them in their proper historical context. Koselleck referred in this connection to Schmitt's book on the concept of dictatorship.[6] The formulation was a neutral one. After all, in Schmitt's view such political concepts as 'Staat', 'Republik', 'Gesellschaft' or 'Klasse' have a fundamentally polemic meaning. They are ultimately *Freund-Feind-Gruppierungen* that are granted meaning in times of war or revolution, and then become empty, ghost-like abstractions as soon as the situation changes.[7] The concept of 'Staat' should similarly be viewed as a modern, nineteenth-century propagandistic concept that can not be applied to earlier times. Nor, Schmitt held, can terms like 'Souveränität', 'Rechtsstaat', 'Absolutismus', 'Diktatur', 'Plan', and 'neutraler oder totaler Staat' be comprehended if one does not concretely know who is being combated, overlooked or refuted with the word.

Schmitt should be viewed as one of the spiritual fathers of the *Geschichtliche Grundbegriffe*, at any rate according to Koselleck, who emphasized in this connection the work of his co-editor Brunner, in which Schmitt was indeed awarded a prominent role.[8] In particular, Schmitt's *Verfassungslehre* (1928) which can be viewed as an historical reaction to the usual formalistic political and legal studies, was of great significance to the development of political and social conceptual history.[9]

Koselleck made multifarious contributions to the *Geschichtliche Grundbegriffe*. He wrote the introduction, published four of the seven volumes, and was the author or co-author of numerous entries.[10] More important perhaps than these concrete contributions were the working hypotheses Koselleck formulated, which were at the foundation of his political and social conception. It was these hypotheses, all four of which pertained to the effects of the societal changes that took place in the period from 1750 to 1850 on the political and social vocabulary, that enabled the *Geschichte Grundbegriffe* to clearly distinguish itself from older specimens of conceptual history.

Koselleck's working hypotheses, designed to influence the direction of the research, can be summarized by four terms: *Politisierung, Demokratisierung, Ideologisierbarkeit* and *Verzeitlichung*. The terms politicization and democratization refer to the increasingly political meaning and the growing social scope of concepts. 'Ideologisability' pertains to the degree to which concepts become part of a philosophical and social system of concepts. The last term, *Verzeitlichung*, refers to a changing conception of time. Concepts that traditionally expressed a static situation are used more and more to describe processes. They are attributed with a retrospective and a prospective dimension, a past and a future. The suffix 'isation' – liberalisation, democratisation – gives many words a new, dynamic dimension.

'Staat' is a good example. According to Koselleck, it was in the *Sattelzeit* that this concept first came to exhibit a dynamic nature. Not only was the notion taken into account that the state was the driving force and the embodiment of progress, the concept also became an inextricable component of sometimes contradictory views of society. Lastly, the

process of politicisation and democratisation also played a role in the development of the concept.

Despite Koselleck's antagonistic stance *vis à vis* the traditional German *Geistesgeschichte*, his contributions to the *Geschichtliche Grundbegriffe* unmistakably revealed the inspiration of historicism. How revealing it was when he said he had re-read Meinecke's celebrated work, *Die Idee der Staatsräson*, without finding anything useful in it for his entry on 'Staat' in the *Geschichtliche Grundbegriffe*.

Koselleck's writing style is abstract and sometimes even cryptic. He speaks of words as entities that have a 'life-span' and 'vital properties' and are equipped with a 'temporal internal structure'. The article about the development of the term 'Krise' is illustrative in this connection. Originally a scholarly concept, at the end of the eighteenth century, according to Koselleck, it came to have a religious, apocalyptic connotation. The term was then applied to revolutionary events and was linked to history. 'Aufgrund seiner metaphorischen Vieldeutigkeit und Dehnbarkeit beginnt der Begriff zu schillern. Er dringt in die Alltagssprache ein und wird zum Schlagwort'.[11] Around 1780, again according to Koselleck, a new perception of time emerged. The concept of 'Krise' became a factor and an indicator of the transition to the new epoch and, judging from its growing use, it must have reinforced itself. But the expression remained 'vielschichtig und unklar wie die Emotionen die sich an ihn hangen'. Lastly, the term 'Krise' was described as 'anschlussfahig' and 'anschlussbedürftig', ambivalent in specifying meaning and seeking meaning alike, relatively vague and interchangeable with unrest, conflict and revolution. Thus the use of a word can in itself be viewed as a symptom of a historical crisis with no precise purpose. 'Die alte Kraft des Begriffs',[12] which provided an unrepeatable, firm and non-interchangeable meaning has vanished into the obscurity of desired alternatives. That is impressively formulated, but words thus seem to have become entities that lead a life of their own.

Conze's Diligence

With his more practical interest in social history, Werner Conze was an ideal complement to Koselleck's focus on philosophical history. Conze's name is linked to the introduction of the social history of the industrialized world to Germany. He was one of the founders of the *Arbeitskreis für moderne Sozialgeschichte*, which scheduled and financed the large-scale project 'begriffs- und wortgeschichtlicher Untersuchungen' in 1958.[13] In an organizational sense Conze, a Heidelberg professor since 1957, was an empire builder. It was especially in this capacity that he was the driving force behind the *Geschichtliche Grundbegriffe*. He was the engine behind the project, edited three of the seven volumes and wrote many of the entries himself; particularly those dealing with the social political concepts in modern and contemporary history.[14] Conze viewed concepts as indicators of social groups, of the stratification of society, and of political conduct. To him, conceptual history was primarily *social* history.

Conze's important role in writing and editing the *Geschichtliche Grundbegriffe* should be viewed as a logical outcome of his interest in industrialized society. In an impressive obitu-

ary entitled 'Tradition and Innovation', Koselleck tried to give an impression of what Conze meant intellectually to the practice of social history.[15] Conze, who was born in 1910 and died in 1986, studied at Königsberg, the German outpost in eastern Prussia, with Hans Rothfels (b. 1891), a student of Meinecke's, and with sociologist and demographer Gunther Ipsen (1899). Since he was Jewish, Rothfels had to resign in 1934.[16] Conze took his Ph.D. that same year with a sociographic analysis of a linguistic island of German-speaking peasants that had developed in the Baltic region in the eighteenth century.[17] In 1940, also under Ipsen's supervision, but this time in Vienna, he submitted his professorial dissertation entitled *Agrarverfassung und Bevölkerung in Litauen und Weissrussland*. Despite the predominant political climate, neither Conze's Ph.D. nor his professorial dissertation exhibited any nationalistic or racist tendencies, or so Koselleck holds; and anyone familiar with the historiography of the day can not help but express 'Hochachtung' for his methodological sobriety.[18]

Conze's interest was primarily in the *Strukturgeschichte des technisch-industriellen Zeitalters*, a form of historiography that in the first instance seemed to bear a marked resemblance to that of the *Annales* in France. However, according to Koselleck, there was one difference: Conze's structural history focused on the present, while the French historians screened themselves off from the political situation of their day and confined their research field to the period before the Revolution. 'Conze was not open to nostalgia', Koselleck wrote, suggestively drawing a distinction between Braudel's reaction to the French *Scheitern 1940* and Conze's reaction to the *Deutsche Katastrophe 1945*.[19] Perhaps there is a connection between the personal and scientific positions. Braudel experienced the fall of France encamped along the Maginot Line and wrote *La Méditerranée* as a German prisoner of war, while Conze took part in the Russian campaign, fought until the bitter end, and returned, wounded, escaped as a Russian prisoner of war. Academically speaking, Conze and Braudel worked within totally different traditions. Without wishing to detract from Conze's work and his significance regarding the practice of social history in Germany, it should be noted that the historiographic impact of *La Méditerranée* is of quite a different magnitude.[20]

Brunner's Influence

On various occasions, Conze and Koselleck both acknowledged their intellectual indebtedness to Otto Brunner, their older fellow editor who was born in 1898 and studied with the renowned Viennese mediaevalist Alfons Dopsch (1868-1953).[21] According to Conze, who considered it to be a classic prelude to his own lexicographical work, Brunner had made clear how absolutely necessary conceptual history was to historical analysis in his *Land und Herrschaft* (1939/1959). Brunner took a firm stance against the notions of men like Georg von Below, Otto von Gierke and Otto Hintze who, in his opinion, adhered to a modern (anachronistic) conception of the state in the study of medieval history.[22] Koselleck, in turn, alluded to the importance of Brunner's work in connection with the introduction of conceptual history as a methodological instrument to distinguish the threshold between old and modern legal history around 1800.[23]

Unlike Conze's work, Brunner's clearly bore the stamp of the era in which it was written. While the post-war editions of *Land und Herrschaft* had as sub-title *Grundfragen der territorialen Verfassungsgeschichte Österreichs im Mittelalter*, the first (1939) and second edition (1942) referred to *Grundfragen der territorialen Verfassungsgeschichte Südostdeutschlands im Mittelalter* and were interspersed with Great-Germanic phrases and National Socialist references. Brunner concluded his volume by expressing the hope that his study, limited as it was in time and space, might be attributed with some special meaning in connection with 'die politischen Grundbegriffe des Dritten Reichs, Führung und Volksgemein-schaft [die] letztlich nur aus germanischen Grundlagen zu verstehen [sind]'.[24]

Brunner, promoted in 1941 from a professor with a specially named chair, to an ordinary professor at the University of Vienna, and dismissed in the *Entnazifizierung*, was appointed again in 1954, but now in Hamburg.[25] A new edition of *Land und Herrschaft* was published five years later; all the traces of 'politische Bedingtheit' had been removed, as Koselleck commented. After world war two, Brunner also followed Conze's example in using the term *Strukturgeschichte* instead of *Volksgeschichte*.[26]

Brunner already bore witness to this altered mentality in *Adeliges Landleben und Europäischer Geist*, a 1949 study of the life and work of a seventeenth-century Austrian nobleman who wrote poetry and works on farming. The orientation was no longer Great-Germanic but pan-European, although the purport of his work was consistent with earlier studies. The Europe of yore, the world as it was prior to the Enlightenment and the Revolution, could not be analysed with nineteenth-century concepts, or so Brunner felt. The battle between *Feudalismus* and the *Bourgeoisie* was over.[27] The notion of 'feudalism' as a 'system of oppression and exploitation' had been introduced by officials of the absolutist state and adopted by scientists and journalists alike in the nineteenth century, but was clearly due for revision.

In later publications, Brunner and his students continued to stress the gap separating us from the Europe of the Ancien Régime and the meaning of the social and conceptual upheaval between 1750 and 1850.[28] He felt it was erroneous to assume medieval and early modern history could be interpreted in terms of the nineteenth and twentieth-century *Staatslehre* or political theories. It would be an illusion to believe, however, that the historian can do his job without using modern concepts of this kind. The historian ought however to realize what he is doing when he uses modern concepts, and should ask himself whether they are appropriate for describing and interpreting the sources.[29]

In the end, Brunner was to write only one entry in the *Geschichtliche Grundbegriffe*; the one on 'Feudalismus'.[30] Still, his intellectual influence should not be underestimated. He was the one, after all, who convincingly demonstrated the inadequacy of modern political terminology for historical analysis and conceived the idea of a *Sattelzeit* as fundamental dividing line.

A Conceptual History Handbuch for France

In the Eighties, even before the *Geschichtliche Grundbegriffe* was completed, one of Koselleck's students, Rolf Reichardt, launched a comparable conceptual history project for

France. The series, fifteen volumes of which were published from 1985 to 1993, is entitled *Handbuch politisch-sozialer Grundbegriffe in Frankreich 1680-1820*. Here again, the notion of a *Sattelzeit* plays a central role. However, in France its start was dated around 1680, about three quarters of a century earlier than in Germany.

This is not the only difference. The entries in the *Handbuch* cover a shorter period than the ones in the *Geschichtliche Grundbegriffe*, which go back to classical times. Another difference is the serial approach, in which the influence can be detected of the French quantitative mentality history such as that of Michel Vovelle who bases his work on comparably extensive serial sources. The *Handbuch* also devotes more attention to the societal range and social function of concepts. Habermas' influence can be distinguished in the attention devoted to communicative dimensions and the problems of public life and public opinion.

Although the *Handbuch* may well have been set up along the same lines as the *Geschichtliche Grundbegriffe*, the atmosphere it evokes is quite different. The *Geschichtliche Grundbegriffe* is visibly rooted in German historiographic and philosophical traditions which are perceived as enigmatic and provoke reflection and contemplation. This is not only expressed in passages on the influence of National Socialism on the development of various concepts, but at other points as well. In his ruminations on early periods, there was evidence that Koselleck, for example, was well aware of the horrendous absurdity of modern history. A certain desire to construct a political pathology in order to come to terms with the political afflictions they themselves had experienced can be discerned in the *Geschichtliche Grundbegriffe*.

The *Handbuch* is clearly the work of members of a younger generation with a professional, chronologically limited sphere of interest. In the work of Reichardt (b.1942) et al. who did not consciously experience the Third Reich, the traumas of the older generation are no longer felt. There are no links to modern social and political vocabulary, let alone interest in the political pathology of the twentieth century. Reichardt and his post-war colleagues focus on the media and communication, though the *Handbuch* does not contain figures on circulations, distribution, or user frequency.

With all the difference in style, approach and sources inevitable in a collective work of these dimensions, one can not but conclude that a large number of the entries in the *Handbuch* barely comply, if at all, with the social historical programme Reichardt formulates in the Introduction to the series. Reichardt begged to differ from the older notions in the history of ideas he felt were being adhered to in the *Geschichtliche Grundbegriffe*. Lengthy quotes from well-known authors were strung together, he noted, disregarding the question how representative they were of society.[31] The criticism was to the point, but it also pertained to many of the entries in his own *Handbuch*.

In other respects too, the comparison between the *Handbuch* and the *Geschichtliche Grundbegriffe* does not solely favour the *Handbuch*. Although more systematic in design, the pieces in the *Handbuch* generally have less philosophical depth. Very little of the writing in the *Handbuch* is of the quality of Koselleck's articles in the *Geschichtliche Grundbegriffe* which are thorough and meaningful in a social historical sense and serve as an incentive for further research.

The difference in orientation also manifests itself in how the selection of the basic concepts to be included was accounted for. Koselleck based the selection of a hundred and twenty-five concepts upon research in dictionaries, but acknowledged the fact that to a degree, the selection was subjective. The distinction between basic and ordinary concepts was a gradual one, or so Koselleck held, and not based upon linguistic criteria, but on a 'pragmatic differentiation in time' and on differences in complexity.[32] Reichardt similarly based the selection of a hundred and fifty-eight concepts for the *Handbuch* on prior lexicographic research in dictionaries and encyclopedias.[33] In his effort to defend this selection as objective, the somewhat naive positivist tendency that was so characteristic of the innovative, quantitatively oriented historiography of the Seventies is evident.

The desire to provide an objective basis for the selection and status of the basic concepts was why the *Handbuch* articulated at greater length than the *Geschichtliche Grundbegriffe* the utilization of source material and the methods deployed. The treatment of the concept 'philosophe' is illustrative here. This entry briefly outlines why it is a fundamental concept, after which the Enlightenment is described in the form of a reconstruction of the history of the concepts 'philosophe' and 'philosophie' from the emergence of the self-image 'philosophe' as an acting subject in a context that was still feudal, where the court set the tone, to a professional role for the philosopher in bourgeois society, for which the Empire constituted the institutional basis.[34]

A comparison of these two standard works also reflects other recent changes in historiography. Starting with the first volume, the *Handbuch* focused more interest on the concepts of cultural history, whereas the *Geschichtliche Grundbegriffe* showed no acknowledgement of such shifts in interest until the list of desiderata, formulated by Koselleck in the last volume, which was published in 1992. This list not only includes concepts such as 'Dienst', 'Glück', 'Pflicht', 'Ordnung', 'Treue' and 'Tugend', it also features names of groups, names of institutions, and social fields.[35] In addition to older terms from the field of theology and anthropology, such as 'Glaube', 'Heil', 'Hoffnung', 'Liebe', 'Held', 'Opfer', 'Leben', 'Tod', 'Erinnerung' and 'Jenzeits', the list also includes contemporary key words such as 'Information' and 'Kommunikation' and terms from the field of ecology. The list can be expanded, according to Koselleck, but remains limited, since the basic concepts that have been coined and have come to represent a body of experiences are finite.[36]

A Dutch Project

There are various conditions that can make a study of the emergence of basic concepts in the Dutch language interesting: the early economic development, the high degree of urbanisation, the increasingly bourgeois social structure, the religious diversity, the lack of a dominant court culture and the distinctive federal political system. The rise of the Republic of the Seven United Netherlands was observed in Europe with awe and envy. In the seventeenth century, for some time the Republic played a leading role in Europe politically and militarily, as well as economically and culturally.

In a wide range of fields, such as trade, ship-building and banking as well as in scientific practice and technological advances, the Dutch language played a major role. It is true that a great deal was still written in Latin, and that French was in fashion, but it would be wrong to underestimate the importance people attached to the Dutch language at that time. As was the case in other countries in Western Europe, starting in the mid-sixteenth century, numerous authors emphasized the value of the national language. There was a whole movement that pursued the advancement and purification of the Dutch language, with the introduction of new words and the recoining of old terms.[37] A good exemple of this movement was Simon Stevin. In his *Vita Politica – Het Burgherlijk Leven* ('Vita Politica – Civil Life'), a striking work conceived in a kind of Cartesian style *avant la lettre*, Stevin propagated the use of Dutch concepts in politics and science, alluding to the misunderstandings resulting from the use of terms like 'monarchy'. He introduced several new Dutch terms to refer to science and political life in the Low Lands.[38] Several of these neologisms became common expressions in Dutch, as was noted in a late seventeenth-century reprint of Stevin's work.[39]

When a study is involved with the origins and development of concepts, the historian could not wish for a better point of departure than debates of this kind. Caution is, however, called for in precisely this point. In conceptual history, there is an almost inevitable tendency to attach a great deal of value to statements by contemporaries on the use of words, the introduction of new terms, or shifts in meaning. However, it is not always clear what value should be attributed to these individual statements, no matter how apt they might be, in assessing day-to-day language usage. And how, except for a series of sources that can easily be traced, can the effect be determined of the movement for the propagation of the national language in the second half of the sixteenth century? Moreover, what value can be attached to the vast number of purist discourses dating back to the beginning of the nineteenth century that were opposed to the growing influence of the French language in Germany and the Netherlands. After all, opinions of this kind can just as easily be interpreted as expressions of linguistic purism or as politically or moralistically motivated arguments.

The current study of Dutch concepts was not only considered to be valuable in itself, it was also thought to be a constructive complement to the research on German and French concepts. The Dutch project, that started in the early Nineties, identified a small group of concepts for study. It has proceeded on somewhat different pre-suppositions from the German projects. A comparative approach was required, and an exclusively national perspective was to be avoided. The study of Dutch concepts should also discard the German fixation on the *Sattelzeit* which can be viewed as a result of Carl Schmitt's and Otto Brunner's *Verfassungsgeschichte*. Of course, not every period is equally fertile in the creation of words, and every language changes, just as every era changes. But it can not be denied that in the field of politicization, the Renaissance was at least as rich in 'semantic turning points' as the Enlightenment. At any rate in Dutch, the late sixteenth and early seventeenth century, a period of extreme politicization, totally in keeping with Koselleck's hypotheses, constitutes a kind of *proto-Sattelzeit* that was to be decisive for the political system and conceptual structure. The semantics of the Dutch Revolt is a fascinating subject that – especially after

the 'linguistic turn' – deserves further study.[40] What was true of earlier eras is just as true of later transition periods. The second half of the nineteenth century, for example, characterized as it was by democratisation and ideologisation, has also been taken as a period that deserves intensive investigation.

Discarding the idea of a late-eighteenth-century *Sattelzeit* and opting for a longer period of time, away from the chronology of the *Geschichtliche Grundbegriffe* and the *Handbuch*, would, we considered, ultimately make the project more viable. This need for a pragmatic approach and consideration of different periods gives the Dutch project a flexible form and a wide scope. One might think of a series of studies of varying lengths and forms, much along the lines of Rothacker's *Archiv für Begriffsgeschichte*. In essence, the Dutch project would then be taking the advice Koselleck himself gave in 1990: in the course of time, the alphabetical order, or so he felt, had come to be an encumbrance to the *Geschichtliche Grundbegriffe*.

The necessity for team work was considered a second practical consequence of a more comprehensive approach. People who specialized in different periods were required to join together to study a certain concept or a number of related concepts. By way of an experiment, three work groups were set up a few years ago on the concepts Fatherland, Freedom and Civilization.[41] This type of team work provides ample opportunity to invite specialists from various disciplines, but requires good working procedure and methodology.

The Dutch project should avoid an exclusive focus on the national language. It might strive to compare concepts in Dutch with related concepts in other languages in the same period. As a small language, surrounded by French, German and English, Dutch was open to these influences. '(Our language) might impede us in penetrating the world with our word', Huizinga said, 'but it keeps us impartial, it gives us a mirror to catch whatever is alien'.[42] Isn't that quite a privileged position for a comparative perspective?

CHAPTER 2

Social History and Begriffsgeschichte¹

REINHART KOSELLECK

Those of us who are concerned with history – whatever that may be – and define it as social history, clearly restrict the themes we address. And those of us who specify history as *Begriffsgeschichte* or the history of concepts clearly do the same. Yet the two are ways of catagorizing history as a whole: they point away from the delimitation of those specialist histories of which it consists. The economic history of England, for example, or the diplomatic history of the early modern period or church history in the West are the sort of special fields that present themselves and are worth studying from material, temporal and regional perspectives. They represent, then, particular aspects of the past.

It is a different matter with social history and *Begriffsgeschichte*. Arising from their very theoretical self-justification emerges a claim to a universality that may extend to and compass all historical specialisms. For what history does not deal with the relationships between human beings, with all forms of social intercourse or with social stratifications, so that the designation social history may stake an irrefutable – as it were, anthropological – permanent claim that lies behind every form of history? Moreover, what history could exist that did not have to be conceived as such before developing into history? In this way, the study of concepts and their linguistic history is as much a minimum requirement for the very recognition of history as the definition that it deals with human society.

Historical Overview

Both social history and *Begriffsgeschichte* have existed as explicit approaches since the Enlightenment and its discovery of the historical world: that age when the social formations that had existed up until that point began to crumble and, at the same time, linguistic reflection fell under the transformative pressure of a history that was itself experienced and articulated as novel. If one follows the history of historical reflection and representation since that period, one encounters both approaches time and again, whether they are mutually elucidating, as in Vico, Rousseau or Herder, or go their own separate ways.

From the philosophical histories of the Enlightenment down to Comte and the young Marx, theorists set themselves the task of tracing all historical life manifestations to, and deriving them from, social conditions. They were followed, but already with more positivist methods, by the nineteenth-century histories of society and civilization, of culture and

peoples down to the regional histories encompassing all spheres of existence, the synthetic achievements of which, from Möser to Gregorovius and Lamprecht, may with justification be called social-historical.

On the other hand, since the eighteenth century there have also been consciously-focused histories of concepts[2] – the term *Begriffsgeschichte* apparently comes from Hegel – which gained a permanent place in histories of language and in historical lexicography. Naturally, they were addressed by all disciplines using historical philological methods which are obliged to verify their sources by means of hermeneutic approaches. Each translation into one's respective present implies a history of concepts whose methodological inevitability Rudolf Eucken demonstrated in an exemplary fashion for all of the humanities and social sciences in his *Geschichte der philosophischen Terminologie*.[3]

In research practice, we also find mutual references everywhere which combine the analyses of social and constitutional history in particular with issues from *Begriffsgeschichte*. Their shared context was always more or less apparent in Classical and Medieval studies. After all, particularly when sources on the ground are scarce, what subject matter could be understood without knowledge of the means of its conceptualization in the past and in the present? Certainly, it is striking that the mutual interdependence of social history and *Begriffsgeschichte* only came to be studied systematically in the 1930s; one thinks here of Walter Schlesinger and especially of Otto Brunner. In the neighboring fields the moving forces were Rothacker in philosophy, Carl Schmitt in jurisprudence and Jost Trier in linguistics.

As a matter of scholarly politics, the alliance between social history and *Begriffsgeschichte* took up arms against two very different tendencies, both of them dominant in the 1920s. On the one hand, the aim was to abandon concepts drawn from intellectual history and the history of ideas which had been pursued outside of their socio-political context, so to speak for their own sake. On the other, history was to be engaged in, not primarily as a chronicle of political events, but rather as a search for their longer-term preconditions.

As Otto Brunner emphasized in the preface to the second edition of his *Land and Lordship*,[4] he wanted to 'enquire after the concrete preconditions of medieval politics, but not portray the politics themselves'. He was interested in shifting the focus to the durable structures of social constitution and their – never merely momentary – transformation, and to do so by devoting separate attention to the various linguistic self-articulations of social groups, organizations and strata, as well as the history of their interpretation. Furthermore, it is no accident that the *Annales*, which emerged from an analogous research interest, instituted the rubric 'Things and Words' in 1930. For Lucien Febvre and Marc Bloch, linguistic analysis was an integral part of their social historical research. In Germany, the trailblazer for modern history was Gunther Ipsen who supplemented his social historical - particularly demographic - research with linguistic studies. Werner Conze took up these inspirations when he founded the *Arbeitskreis für moderne Sozialgeschichte* (Study-Group for Modern Social History) in 1956-57.[5] Thanks to Conze's initiative, the attempt to link questions from social history and *Begriffsgeschichte* forms part of the Study-Group's ongoing challenge, and with it the definition of the differences between the two approaches, which will be discussed below.

The Impossibility of an 'Histoire Totale'

There can be no history, no historical experience or interpretation, no representation or narrative without social formations and the concepts by means of which – whether reflexively or self-reflexively – they define their challenges and seek to meet them. To this extent society and language belong to the metahistorical givens without which history (*Geschichte, Historie*) is inconceivable. For this reason the theories, questions and methods of social history and *Begriffsgeschichte* apply to all imaginable fields of historical scholarship. It is for this same reason, though, that the desire to envision a 'total history' occasionally raises its head. If empirical studies by practitioners of social history and *Begriffsgeschichte* treat circumscribed topics for reasons of scholarly pragmatism, this self-restriction by no means diminishes the claim to universality that proceeds from a theory of a possible history, which must in any case presuppose society and language.

The demands of specialization dictated by methodology compel us to apply the approaches of social history and *Begriffsgeschichte* in an interdisciplinary manner. This does not mean, however, that their theoretical claim to universality could be posited as absolute or total. To be sure, they are under pressure to presuppose the totality of social relationships as well as their linguistic articulations and systems of interpretation. However, the formally irrefutable premise that all history has to do with society and language does not permit the farther-reaching conclusion that it is possible, as regards content, to write or even merely envision a 'total history'.

As numerous and plausible as the empirical objections to a total history may be, a further objection to its possibility follows from the very attempt to conceive of it. For the totality of a history of society and the totality of a history of language can never be projected wholly onto each other. Even assuming the empirically unattainable case in which the two fields could be treated as a finite, restricted totality, an unbridgeable difference would remain between any social history and the history of its conceptualization.

Linguistic understanding neither catches up with what happens or was actually the case, nor does anything happen that has not already been altered by its linguistic processing. Social history and *Begriffsgeschichte* are in a state of historically determined tension which refers the one to the other without any possibility of the tension ever being lifted. What you do today, only the next day can tell you, and what you say becomes an event by withdrawing from you. What happens between people or in society and what is said during or about this produces an ever-changing difference that hinders any 'histoire totale'. History takes place in anticipation of incompleteness; and any adequate interpretation of it must therefore renounce totality.

A characteristic of historical time is its constant reproduction of the tension between society and its transformation on the one hand, and its linguistic adaptation and processing on the other. All history feeds on this tension. Social relationships, conflicts and their solutions, and the changing preconditions for them are never congruent with the linguistic articulations on the basis of which societies act, understand, interpret, change and re-form themselves. This thesis will be tested in two cases: firstly, in relation to history occurring *in*

actu (*geschehende Geschichte*), and secondly, in relation to history that has already occurred in the past (*geschehene Geschichte*).

Geschehende Geschichte, the Spoken and the Written Word

When social history and *Begriffsgeschichte* are related to each other the definition of difference involved reciprocally relativizes their respective claims to universality. History neither becomes one with the manner in which it is conceived, nor is it conceivable without it.

In everyday events, the connection between the two is indissolubly given. As creatures gifted with language, human beings cannot, after all, be separated from the origins of their social existence. How might we determine the relationship? What is comparatively clear is the dependence of each individual event in the course of its occurrence upon its linguistic facilitation. No social activity, political argument or economic transaction is possible without verbal exchange, planning discussions, public debate or secret discussions, without orders – and obedience to them – the consensus of participants or the expressed dissent of the quarreling parties. Any history of everyday life in daily performance depends upon language in performance, upon speech and conversation; just as no love story is conceivable without at least three words: you, I, we. Every social occurrence in its multiple contexts rests on communicative groundwork and is the result of linguistic mediation. Institutions and organizations, from the smallest club to the UN, rely upon them, whether in spoken or written form.

However obvious this may be, this observation is equally obviously in need of qualification. What actually happens is clearly more than the linguistic articulation that produced or interprets it. The order or mutual resolution or elemental shout to kill are not identical to the act of killing itself. The expressions used by lovers do not amount to the love two people feel. The written rules of organization or their means of verbal enactment are not identical to the actions of the organization itself.

There is always a difference between a history occurring and its linguistic facilitation. No speech-act is the act itself which it helps to prepare, trigger and carry out. One must admit, to be sure, that a word often produces irrevocable consequences; one thinks of Hitler's order to invade Poland, to name one flagrant example. But it is precisely here that the relationship becomes clear. A history does not occur without speech, but it is never identical to speech and cannot be reduced to it.

For this reason there must be additional preparatory work and a means of enactment beyond spoken language which make events possible. Here one might mention, for example, the trans-linguistic field of semiotics. One thinks of bodily gestures, in which language is communicated only in encoded form, of magical rites extending to the theology of the sacrifice, which is historically located not in the word but in the cross, of group behaviours established by virtue of their symbols, or of modern traffic signs: each of these cases represents a sign language comprehensible without words. All of the signals mentioned here can be verbalized. They are also reducible to language, but their achievement rests precisely in the fact that spoken language must be abandoned in order to trigger or control relevant acts, attitudes or behaviors.

Let us recall some further extra-linguistic preconditions for possible histories: spatial proximity or distance, distances that, according to circumstances, may foster or delay conflicts; the temporal differences between the age-groups in a generational unit, or the bipolarity of the sexes. All of these differences involve events, conflict and reconciliation, which are facilitated pre-linguistically, even if they can, but do not necessarily, occur by virtue of linguistic articulation.

There are thus extra-linguistic, pre-linguistic (and post-linguistic) elements in all acts that lead to a history. They are closely attached to the elemental, geographical, biological and zoological conditions, all of which affect occurrences in society by way of the human constitution. Birth, love, death, food, hunger, misery and disease, perhaps also happiness, in any case abduction, victory, killing and defeat: all of these are also elements of, and means of enactment in, human history – extending from everyday life to the identification of patterns of political rule – whose extra-linguistic premises are difficult to deny.

The analytical divisions made here are, to be sure, scarcely conceivable within the concrete context of event-producing acts. People acquire all pre-linguistic notions linguistically and convey them in concrete speech with their conduct and sufferings. While the event is going on, spoken language or read writing, effective – or ignored – speech become interwoven with an event which is always composed of linguistic and extra-linguistic elements of activity. Even when speech falls silent, linguistic fore-knowledge which is inherent in human beings and enables them to communicate with their fellows, whether about other human beings, things, products, plants or animals, remains.

The more highly aggregated human units of action are, for example, in modern work processes with their economic interconnections or in the increasingly complex political arenas of action, the more important the conditions of linguistic communication become in order to preserve the capacity to act. One could demonstrate this for the expansion of linguistic mediation: from the audible range of a voice to technical communications providers, from writing, printing, the telephone, and radio down to a television or computer screen – including all of the institutions of transportation technology, from messengers, postal service and press to information satellites – and including the radical consequences for any linguistic codification. What is at stake here is always either lending permanence to the range of the spoken language in order to capture events, or extending and accelerating it's reach in order to anticipate, trigger or control events. This reference may suffice to demonstrate the interrelatedness of all 'social history' and 'linguistic history' in a given enactment of speaking and doing.

Spoken language or each read text and the event occurring at any one time cannot be separated *in actu*, but only analytically. Someone who is overwhelmed by a speech experiences this not only linguistically but also in his or her whole body, and someone who is 'struck dumb' by an act experiences all the more his or her dependence upon language in order to regain movement. This personal correlation between speech and act may be applied to all levels of the increasingly complex social units of action. The demonstrated interactions between so-called speech-acts and 'actual' occurrences range from individual speaking and acting to their multiple social interactions , by virtue of which events appear in their connections. This finding, which despite all historical variations constitutes every

occuring history (*geschehende Geschichte*), has substantial consequences for the portrayal of past histories, particularly for the difference between social history and *Begriffsgeschichte*.

History Portrayed (*dargestellte Geschichte*) and its Linguistic Sources

The empirical connection between acting and speaking presented thus far is exploded as soon as we turn our gaze from history occuring *in eventu* to the past history with which professional historians concern themselves – *ex eventu*. The analytical separation between an extra-linguistic and a linguistic plane of action assumes the status of an anthropological given, without which no historical experience could ever be transferred into everyday or scholarly statements. For whatever happens beyond my own experience, I experience only through speech or writing. Even if language – at least for a time – may be but a secondary factor in the performance of acting and suffering, as soon as an event becomes part of the past, language is promoted to the status of a primary factor, without which no memory and no scholarly transposition of memory is possible. The anthropological primacy of language for the representation of history as it has happened thereby takes on an epistemological status since we need language in order to decide what in past history was linguistically determined, and what was not.

Anthropologically speaking, every 'history' is formed by the oral and written communication of generations living together and conveying their respective experiences to each other. Only when the old generations die out and the orally transmitted space of memory shrinks does writing become the primary bearer of historical transmission. There are, to be sure, numerous extra-linguistic remains that bear witness to past events and circumstances: rubble that bears witness to catastrophes, coins to economic organization, buildings to community, governance and services, roads to trade or war, cultural landscapes to the labor of generations, monuments to victory or death, weapons to battle, tools to inventions and applications, and 'relics' or 'discoveries' – or images – that may bear witness to all of these things at once. All of these materials are processed by special historical disciplines. What 'actually' happened, though, is something that, all our hypotheses notwithstanding, only oral and written, that is linguistic, testimony can tell us for sure. It is at the linguistic sources that the road forks, dividing what happened in the past into the 'linguistic' and the 'actual'. Viewed from this standpoint, one may redefine the relationships between the disciplines and their further elaborations.

What belonged together while the event was occurring can only be determined after the fact by using linguistic testimonies, and, depending upon how one treats this linguistic inheritance, this oral or written tradition, the most diverse genres may come together while others split apart.

It is a characteristic of myths and fairy tales, the drama, the epic and the novel that all presuppose and address the original connection between word and deed, suffering, speech and silence. It is only this recalling of occuring history (*geschehende Geschichte*) that produces the meaning which remains worth remembering. And this is precisely the achievement of all those histories that make use of true or fictional speech in order to do justice to

events that are worth remembering, or that recall those words congealed into writing that bear witness to the amalgamation of speech and act.

It is the unique situations which bring forth their own transformation, and behind which something like 'destiny' may shine through, the study and passing down of which continues to challenge our every interpretation of self and the world. This genre includes, more or less neatly, all memoirs and biographies which, often bearing the title 'Life and Letters', emphasize the interactions between language and life, as well as all histories which follow events in their immanent dynamism. 'He said this and did that, she said such and such and did such and such, this led to something astonishing, something new, which changed everything' – numerous works are constructed according to this formalized pattern, particularly those, such as histories of political events or diplomacy, with access to sources that allow them to construct occurrences *in actu*. Viewed from the perspective of their linguistic achievements, these histories take their place in a long line that extends from mythology to the novel.[6] Only in their scholarly status do they feed on the – verifiable – authenticity of their linguistic sources which now must vouch for the link between linguistic acts and deeds that formerly went without saying.

That which can be separated analytically – the pre-linguistic and the linguistic – is brought together again in a manner 'analogous to experience' thanks to linguistic performance: it is the fiction of the factual. For what actually occurred is – in retrospect – real only in the medium of linguistic fiction. Language, in contrast to active speech in the history in progress, thus acquires an epistemological primacy which always compels it to reach a verdict about the relationship between language and conduct.

Now, there are genres which, when confronted with this alternative, articulate themselves in an extremely one-sided manner. There are, for example, annals which record only results – what happened, but never how it happened. There are handbooks and works of so-called narrative history which treat deeds and their success or failure, but never the words or speeches that led to them. The actors may be great men, or highly stylized active subjects who take action wordlessly, so to speak; states or dynasties, churches or sects, classes or parties or whatever other agents are being hypostatized. Rarely, however, does anyone inquire into the linguistic patterns of identification without which such agents could not act at all. Even where the spoken word or its written equivalents are incorporated into the portrayal, the linguistic evidence is all too easily suspected of ideology, or read only instrumentally in order to get at supposedly preexisting interests and evil intentions.

Even those studies undertaken from the perspective of linguistic history, which – on the other end of our scale – primarily address the linguistic evidence itself, easily fall prey to the temptation to apply it to a real history, which must itself first be constructed linguistically. The methodological difficulties inherent in relating speaking and language to social conditions and changes, a thought particularly challenging for sociolinguistics remain closely allied to the problem shared by all historians, the need to first construct with language the very field of which they are about to speak.

For this reason we also encounter the other extreme in our profession: the editing of the linguistic sources as such, the written remains of formerly spoken or written speech. In this case, *the point at which* the difference between extra-linguistic and linguistic acts is ad-

dressed in its own right is left to the accident of which records have survived. It is always the task of correct commentary to track down the meaning of written evidence, which cannot be found at all without a definition of the difference between speech and the facts.

In the above remarks we have depicted three genres which, given the alternative of linguistic act and deed, either relate the two to each other or, in the extreme case, address them separately. Epistemologically speaking, language always has a dual task. It refers both to the extra-linguistic context of occurrences and – in the act of doing so – to itself. It is, viewed historically, always self-reflexive.

Event and Structure – Speech and Language

Whilst we have only discussed history occurring and history occurred (*geschehende Geschichte* and *geschehene Geschichte*) and asked how, in each case, *in actu*, so to speak in a synchronic cross-section, speech and deed related to each other, the question expands as soon as diachrony is brought into the picture. Similar to the relationship between speaking and acting, here, too, synchrony and diachrony cannot be empirically separated in the enactment of the event. The conditions and determinants which reach, temporally sharply graded, from the so-called past into the present, intervene in the occurrence in question just as the agents act 'simultaneously' from their various models of the future. All synchrony is, *ipso facto*, simultaneously diachronic. *In actu*, temporal dimensions are always interconnected, and to define the so-called present as, for example, one of those moments that insert themselves from the past into the future – or which, conversely, slip from the future into the past as elusive points of transition, would be to contradict all experience. Theoretically, one could define all history as a permanent present containing the past and the future – or, alternatively, as the continuing interaction between past and future, which constantly causes the present to disappear. In the one case, which is exaggerated in synchrony, history deteriorates into a pure space of consciousness in which all temporal dimensions are contained simultaneously, while in the other which is exaggerated in diachrony the active presence of human beings would, historically, have no scope of action. This thought-experiment is only intended to point out that the differentiation, introduced by Saussure, between the synchronic and the diachronic can be analytically helpful throughout and yet incapable of doing justice to the temporal interlockings in history as they take place.

It is with this reservation that we use the analytical categories of synchrony which is directed at the current presentness of an occurrence in a given case, and diachrony, which is directed at the dimension of temporal depth also contained in every current occurrence. After all, many conditions affect history in the course of its enactment in the long- or middle-term – as well, of course, as the short-term. They limit the alternatives for action by facilitating or releasing only certain alternatives.

It is a characteristic of social history and *Begriffsgeschichte* that both, if in different ways, theoretically presuppose just this connection. It is the connection which is investigated historically between synchronic events and diachronic structures. Moreover, it is the analo-

gous connection between the spoken word in a specific, synchronic, case and the ever-present diachronically pre-existing language which *Begriffsgeschichte* addresses. What occurs in each case may be unique and new, but it is never so new that social conditions, which were present for a longer period, did not facilitate each unique event. A new term may be coined which expresses in language previously non-existent experiences or expectations. It cannot be so new, however, that it was not already virtually contained in the respective existing language and that it does not draw its meaning from the linguistic context handed down to it. Thus, both scholarly approaches expand the interplay of speaking and doing in which an event occurs to include its – variously defined – diachronic dimensions, without which a history is neither possible nor comprehensible.

Let us clarify this point with a series of examples. Marriage is an institution that, despite its pre-linguistic biological implications, represents a cultural phenomenon which has existed, in numerous versions, throughout human history. Because it is a form of association between two or more persons of different sexes, marriage belongs among the genuine topics of social-historical research. At the same time, it is obvious that we can only speak of it from the perspective of social history if written documents are available to inform us about how different kinds of marriage embodied the concept in a given case.

One might construct two methodological approaches, which will be expressed here in the condensed form of models. One is directed primarily to events, actions in speech, writing and deed, the other primarily at diachronic conditions and the changes in them over long periods of time. The latter thus looks for social structures and their linguistic equivalents.

1. Thus we may address an individual event, for example a princely marriage, about which dynastic sources offer ample information: what political motives were at stake, what contractual conditions were set, what dowry was negotiated, how were the ceremonies staged, and the like. The course of the marriage, with its sequence of events, can also be sequentially reconstructed and recounted, down to the terrible consequences that ensued when, for example, a war of succession followed a contractually expected inheritance upon the death of a partner. Nowadays, we are also in a position to reconstruct the analogous history of a concrete marriage between people from the lower social classes; a fascinating topic in the history of everyday life which uses many previously untapped sources. In each case we are dealing with unique individual histories with their own particular unsurmountable tension between good fortune and misery, and in each case they remain embedded in their religious, social and political contexts.

2. Social history and *Begriffsgeschichte* cannot exist without such individual cases, but such study is not their primary interest. To characterize the second methodological approach, both aim – again a condensed model – at the long-term conditions, effective across time, which made the given individual cases possible, and they enquire after the long-term processes which may be derived from the sum of individual cases. Put another way, they enquire after the structures and their transformation, the linguistic premises under which such structures entered the social consciousness, were understood and also changed.

Let us first follow a specifically social historical procedure and then proceed to one from *Begriffsgeschichte*.

The synchrony of individual marriages and the words or letters exchanged within them is not excluded from the social-historical gaze. It is, rather, diachronically enveloped. Thus, for example, the number of marriages is statistically processed using a social-historical approach in order to demonstrate the rise in the population by social class. At what point did the number of marriages exceed the number of households and farms of corporately organized society, which delimited their circumscribed economic space? How did the number of marriages relate to the corresponding wage and price curves, good or poor harvests, in order to weigh against each other the economic and natural factors for the reproduction of the population? How can the numbers of legitimate and illegitimate births be related to each other in order to measure situations of social conflict? What was the relationship between numbers of births and deaths, of children, mothers and fathers in order to explain the long-term changes in 'typical' married life? What was the shape of the divorce curve, which also allows us to draw conclusions about typologies of marriage? All of these almost randomly chosen questions have one thing in common: they help us to construct 'actual' processes of a long-term nature, which are not contained as such in the sources.

Tedious preparatory work is required in order to render the sources comparable, to aggregate sequences of numbers. Finally, we need to undertake systematic reflections beforehand in order to be able to interpret the aggregated series of data. The qualititative evidence from the sources is never sufficient to allow us directly to derive long-term structural statements from them. The sum of concrete individual cases which occur and are verified synchronically is in itself silent and cannot 'verify' long- or medium-term – at any rate diachronic – structures. If we are to glean lasting evidence from past history, we thus need theoretical groundwork: the use of specialized scholarly terminology which alone can sniff out the connections and interconnections which a given affected individual could not possibly be aware of at the time.

From the standpoint of social history, what 'actually' – and not just linguistically – happened remains, in the long run, a scholarly construction whose evidence depends upon how convincing the underlying theory is. To be sure, any theoretically based statement is subject to a methodological verification of the sources, in order to make a claim for past actuality, but the real character of long-term factors often cannot be sufficiently demonstrated using the individual sources as such. For this reason we could, for example, following Max Weber, create ideal types, which combine various criteria for the description of reality in such a way that the presumed connections become consistently interpretable. Thus – to draw on our series of examples – we might elaborate the types of peasant and 'subpeasant' (*unterbäuerlich*) marriage and families, which in each case would incorporate the average number of births and deaths, the correlation to wage and price series or to the sequence of poor harvests, to working hours and tax burdens, in order to find out what distinguishes a peasant from a 'sub-peasant' marriage and family, and how both changed in the transition from the pre-industrial to the industrial era.

The factors of individual cases, not the cases themselves, may then be structured in such a way that the economic, political and natural preconditions – depending upon the importance of the wage-price structure, tax burden or harvest yields – become comprehensible for a stratum-typical marriage. The question of which factors remain similar for how long,

when are they dominant and when recessive, then allows us to define periods or epochal threshholds into which the history of peasant and 'sub-peasant' marriages may be divided diachronically.

Up until now, our series of examples has been consciously chosen for those bundles of factors that allow primarily extra-linguistic series of events to be structured diachronically and related to each other. Setting it up presupposes a social-historical theory which allows us, using specialist terminology (here that of demography, political economy and public finance), to define duration and transformations, which can never be found in the sources as such. The claims made by theory thus grow in proportion to the distance to the 'self-reporting' of the sources that we must maintain in order to construct long time periods or typical societal forms.

Naturally, however, quite other bundles of factors than those already mentioned are also included in the history of those marriages to be posited as 'typical'. The factors in question here cannot be investigated at all without an interpretation of their linguistic self-articulation. And here we come to the procedure required by *Begriffsgeschichte* which – analogous to the distinction between event and structure – must distinguish between current speech and its linguistic premises.

Theology, religion, law, morality and custom set the framework for each concrete marriage, which precedes the individual case diachronically and generally outlasts it. Taken as a whole, these are institutionalized rules and patterns of interpretation which set up and delimit the living space for a given marriage. To be sure, these also determine 'extra-linguistic' patterns of behavior, but language remains the primary mediating instance in all of the cases mentioned.

The linguistically articulated premises, without which (if to a diminishing degree) a marriage can be neither contracted nor conducted, range from customs and legal acts to sermons, from magic and the sacraments to metaphysics. We must thus study the types of texts, with their diverse social classifications, in which the marriages were variously defined. These may be texts that arose spontaneously (e.g., diaries, letters or newspaper reports) or, at the other end of the spectrum, those formulated with normative intent (e.g., theological treatises or legal codifications complete with commentaries). Traditions tied to language, which diachronically fix a potential marriage's sphere of life, are at work in all of these cases. And if changes do emerge, it is only when marriage has been subjected to a new definition.

Thus the theological interpretation of marriage as an indissoluble institution ordained by God with the chief purpose of preserving and propagating the human race remained dominant well into the eighteenth century. The stipulations within traditional corporative law (*Standesrecht*) that a marriage was permissable only if the economic foundation of a household was sufficient to support and raise the children and to secure the spouses' mutual assistance were consistent with this view. Thus, numerous people were legally excluded from the opportunity of contracting a marriage. As the nucleus of the household, marriage remained integrated within corporate society. This changed in the wake of the Enlightenment, which defined a new contractual basis for marriage in the [Prussian] General Legal Code (*Allgemeines Landrecht*). The economic tie was loosened and the spouses' freedom as

individuals was expanded to the extent that divorce – theologically forbidden – was made legal. The General Legal Code by no means abandoned theological and corporate definitions, but the concept of marriage shifted several degrees in the direction of greater freedom and self-determination for both partners – a shift which only conceptual history allows us to register.

At the beginning of the nineteenth century, we encounter a wholly new concept of marriage. The theological justification was replaced by an anthropological self-justification, the institution of marriage stripped of its legal framework to make way for the moral self-realization of two persons who love each other. The 1820 Brockhaus Encyclopedia celebrates this postulated autonomy in emphatic phrases, coining the innovative term 'love-marriage' (*Liebesehe*). Here marriage has lost its former primary aim of producing children; economic considerations have been left of the picture and Bluntschli later went so far as to declare a marriage without love to be immoral. Such marriages were to be annulled.[7]

We have now sketched three stages within *Begriffsgeschichte*, each of which structured the traditional normative stock of arguments differently and, in important respects, innovatively. From the perspective of linguistic history, the development of concepts within the new legal code and Romantic liberalism assumed the character of events. They then had repercussions for the entire linguistic structure within which marriages could be understood. It was not the diachronically given language as a whole that had changed, but rather its semantics and the new linguistic practices released thereby.

The methods of *Begriffsgeschichte* by no means allow us to deduce that the history of actual marriages proceeded along the lines of this linguistic self-interpretation. The economic constraints described in the social historical overview remained in force, restricting, complicating and burdening marriages. Even when legal barriers were lowered, social pressures remained effective in ensuring that the typology of the love match did not become the only empirical norm. To be sure, there is much to be said for the hypothesis that the notion of the love-match, once developed, so to speak in temporal anticipation, found increased chances of realization in the long term. Conversely, it is undeniable that even before the Romantic conceptualization of the love-match, love as an anthropological given also found a place in those marriages contracted under corporative law which do not mention it at all.

The conclusion to be drawn for the relationship between social history and *Begriffsgeschichte* is that they need and depend on each other, but can never be made congruent. What 'actually' became effective in the long term and what changed cannot be deduced wholly from the written evidence that has come down to us. For this we first need theoretical and terminological groundwork. What, on the other hand, can be demonstrated using *Begriffsgeschichte* – on the basis of the written evidence – refers us, to be sure, to the linguistically delimited space of experience; it documents innovative ventures which may have recorded or initiated new experiences. However, this still does not permit us to make assumptions about an actual history. The difference between action and speech which we have demonstrated for history in the process of occurring prevents social 'reality' from ever converging with the history of its linguistic articulation, even in retrospect. Even if, in a synchronic cross-section – itself an abstraction – speech and acts remain intertwined, diachronic change – which remains a theoretical construct – does not proceed (in

terms of 'real history' and *Begriffsgeschichte*) in the same temporal rhythms or sequences. Reality may have long since changed before the transformation was ever given a name, and likewise, concepts may have been formed that released new realities.

Yet an analogy exists between social history and *Begriffsgeschichte* which remains to be pointed out in conclusion. What happens in each case uniquely in occurring history is only possible because the assumed preconditions repeat themselves with a long-term regularity. Subjectively, the act of marrying may be unique, but it also articulates repeatable structures. The economic preconditions for a marriage, which depended upon the results of harvests that fluctuated annually or on conjunctures that changed over long periods or on tax burdens which bled the planned household monthly or yearly (not to speak of the peasant population's regular services) are only effective because they were repeated regularly with more or less constancy. The same holds true for the social implications of a marriage which can only be specifically grasped linguistically. The givens of custom, the legal framework and – perhaps still – theological interpretation; all of these institutional ties are only effective *in actu* in that they are repeated from case to case. And if they change, it is only slowly, without any damage to their iterated structures. What is known as the 'longue durée' is historically effective only in that the unique time of events contains repeatable structures whose velocities of change differ from those of the events themselves. In this interaction, which is defined only inadequately by 'synchrony' and 'diachrony', lies encapsulated the subject of all social history.

The interaction between current speech in any given case and pre-existing language should be defined analogously, but not identically. When a term, such as 'marriage' is used, it stores in language experiences of marriage with long-term effects which have established themselves in the concept. Furthermore, the pre-existing linguistic context regulates the range of its meaning. Each time the word 'marriage' is used, the linguistic premises which structure its meaning and understanding are repeated. Here too, it is iterated linguistic structures that both release and limit speech's scope of action. Each conceptual alteration that becomes a linguistic event occurs in the act of semantic and pragmatic innovation, which allows us to grasp the old differently and the new in the first place.

Social history and *Begriffsgeschichte* have differing velocities of change and are grounded in distinct structures of repetition. For this reason, the scholarly terminology of social history depends on the history of concepts to help it verify linguistically stored experience. And for this reason, the history of concepts remains dependent upon the findings of social history, in order to keep in view the gap between vanished reality and its linguistic evidence, a gap that remains forever unbridgeable.

Speech Acts, Languages or Conceptual History?

IAIN HAMPSHER-MONK

This chapter discusses the work of the two most prominent names in Anglophone history of political thought, and offers some comparison between their work and the project of *Begriffsgeschichte* as approaches to the history of political concepts broadly conceived.[1] J.G.A. Pocock and Quentin Skinner both studied at the University of Cambridge where Skinner is now Regius Professor of History. Pocock has held permanent posts at Canterbury University in New Zealand, at Washington University, St. Louis and at Johns Hopkins University, Baltimore, where he is now professor emeritus. Each has published major methodological and substantive historical work of their own, but each has also initiated and directed major collaborative works which, whilst not as minutely concerted as the German *Lexikons*, certainly bear comparison with them in terms of scope and ambition. Together, as I hope to show, they represent a competing programme of how to understand historical changes in social and political concepts.[2]

Quentin Skinner has been a moving force in two major publishing initiatives undertaken by Cambridge University Press which have come to dominate anglophone scholarship in this field. The first of these was the 'Ideas in Context' research monograph series which now has some thirty titles in print. The declared aim of the series was to present studies of the development of new 'procedures aims and vocabularies' within the then existing intellectual context. It expressed the hope that such an approach would dissolve 'artifical distinctions between the history of philosophy, of various sciences, or society and politics, and of literature'.[3] The second publishing venture promoted by Skinner has been the publication of a massive range of cheap yet high-quality editions of original works of political theory, many of which were unavailable in modern editions, or indeed, in many libraries, at all. The 'Cambridge Texts in the History of Political Thought' now comprises some 83 titles, and reflects, as the series description claims, the needs of modern scholarship for access to less well-known texts in order to make sense of the major. Although Skinner has not hitherto been involved in systematically collaborative research work, he is now chair of the co-ordinating committee of the European Science Foundation Network on Early Modern European Republicanism which will, under his editorship, produce a major internationally collaborative publication.

It is in this collaborative field that Pocock has excelled. He chaired the steering commit-
tee of the Center for the Study of British Political Thought, established at the Folger Li-
brary in Washington in 1984. An original series of six huge seminars covering British Po-
litical thought from the end of the Wars of the Roses to the American War of Independence
('From Bosworth to Yorktown') ran from 1984-1987. This involved scholars from all over
the world and was later supplemented by further seminars, recapitulating certain periods
and extending the historical range down to the period of the French Revolution. The
Folger seminar series produced an impressive five-volume *Proceedings* and a fertile synoptic
volume of essays by the conveners of the individual seminars, as well as a number of works
relating to their own historical periods or interests.[4]

Unlike the editors of *Begriffsgeschichte*, neither Pocock nor Skinner attempted to impose
uniformity of sources, treatment or structure on their contributors whose work characteris-
tically comprised the free standing academic essay or monograph. Nevertheless there is a
shared intellectual approach and sense of common enterprise in both sets of work which,
together which the sheer scale of the enterprises, makes comparison with the great collabo-
rative German enterprises not inappropriate.[5]

Since other contributors make reference to the context within which *Begriffsgeschichte*
arose and the positions it was opposed to, it might help also to make some prefatory re-
marks about the Anglophone context in which the 'historical revolution' arose and with
which Skinner and Pocock's work has become identified.[6] For the academic audience that
both Skinner and Pocock addressed at the start of their careers were 'political theorists'
practitioners who, whilst they often studied political theorists of the past, did not do so in a
self-consciously historical fashion.[7] Whilst such historical work had been conducted in
British and American history departments (often by European emigres) it was rarely central
to Anglophone historiography. 'Political theory', however, was a subject taught in
English-speaking universities across a range of departments – political science and philoso-
phy as well as history. In the academic study of 'political theory', critical attention was paid
to a wide variety of texts produced under a huge range of historical circumstances from an-
cient Greece to industrial modernity. Such study could assume that the object of the au-
thors of all these had been to provide some (often comprehensive) and certainly enduring
philosophical account of political concepts and it was commonly conducted – particularly
outside history departments – as though all these authors were alive and well, and working
just down the corridor. Although in philosophy and political science departments it was
common to separate 'political theory' into the study of a chronological sequence of 'au-
thors' on the one hand, and an a-temporal study of 'concepts' on the other, no disciplinary
distinction was commonly made in approaching these two exercises. Just as the history of
philosophy, for twentieth-century anglophone philosophers has often been a training
ground, a repertoire of problems and arguments, a jumping-off point for the *practice* of
philosophy and not an historical subject matter in its own right;[8] so political theorists too,
– working to philosophical criteria of coherence, consistency, comprehensiveness, as well as
considerations of perceived political relevance – sought to use past theorists, just as much
as a-historical conceptual analysis, as a basis for their own theorising activity.[9]

Exhilerating as such a philosophical treatment was, it was often outrageously unhistorical in two important senses. Firstly, in the synchronic dimension, the critical emphasis meant that in approaching any individual thinker insufficient attention was commonly given to recovering the intended meanings (or indeed the agenda) of the texts as written. This was particularly exacerbated by a prevailing Cold-War manichaeism which deemed it imperative to assign to authors (for whom such terms could have had no meaning) championship, or even responsibility for the emergence of the then prevailing totalitarian and liberal ideologies. Thus writers as diverse as Marsilius of Padua and Hobbes were identified as articulating the foundation of liberalism, whilst Plato and Rousseau were held to be advocates of totalitarianism, or at least of those patterns of thought, whose logical outcome was the camps of Auschwitz and the Gulag.[10]

Writers were commonly criticised for failing to address certain problems or concepts, as though, if they were competent political theorists, they ought to have known that such 'eternal problems' ought to have been addressed.

Skinner's path-breaking article 'Meaning and Understanding' mercilessly exposed the various mythologies generated by such a-historical expections.[11] The mythology of 'doctrine' – by which expectations that a certain subject matter had to be addressed lead commentators to construct a position to be ascribed to writers, or to criticise writers for 'failing' to have addressed it. The mythology of 'coherence' – by which writers were presumed to have aspired to present closed and coherent systems which it was the task of the exegete to reveal, lead to a failure to countenance the possibility that the author in question may – as a matter of historical fact – have contradicted themselves, changed their minds, or failed to notice some tension or contradiction in their thought. In the mythology of 'prolepsis', the meaning or significance a work could have had for its author, is conflated with that subsequently ascribed to it by present-day commentators. In the myth of parochialism, the commentator, faced with some truly alien thought-world or conceptual framework, construes it as one that is familiar and meets their expectations.[12]

The second important sense in which 'political theory' was not historical – even when it did treat texts in an historical sequence as 'the history of political thought' – concerned the diachronic dimension. A sequential canon of texts selected for philosophical interest, tended both to obscure important historical connections (where *historically* important works were missing from the canon),[13] and to foster the ascription of historical connections between canonical texts where none were in fact present.[14]

It was the recognition of these two important deficiencies that largely fuelled, from the late Sixties, an 'historical revolution' in the Anglophone study of political theory, and with which the names of J.G.A. Pocock and Quentin Skinner are rightly associated.[15] They thus shared with *Begriffsgeschichte* at least two major aims, namely that of recovering – from Lovejoyan trans-historical ideas in the case of English, from Historicism in Germany – the meanings which historical actors and writers brought to their activity; and secondly that of looking beyond the 'great texts' to a wider usage in order to recover histories of meanings. Beyond this agreement – important as it was – however, lay deep divergencies which we will turn to after the positions of the two anglophone writers are outlined.

John Pocock and Political Languages

Pocock's offensive against un-historical political theory started from an attempt to clarify what a genuine *history* of political thought might be, and to distinguish the sequence of philosophical meditations on historically unsituated texts that often passed for it,[16] from the genuine attempt to identify historical meaning and the detailed shifts and changes that actually took place in it. Using the metaphor of topography also favoured by Lovejoy, Koselleck and Rolf Reichardt, he claimed that what had passed for the history of political thought had involved a progression from one mountain top of abstraction to another (Grotius to Hobbes to Locke, say), assuming that the shape of the connecting ridges in be-tween could be deduced from the disposition of the peaks. By contrast, the true historian must empirically investigate these contours to ensure whether the peaks were indeed re-lated to one another in the ways claimed.[17]

To continue the analogy, the medium for this landscape or topography was identified with a linguistic repertoire which might include very abstract and high-level works as well as relatively specific and mundane ones. His claim was that, at least in stable societies, rela-tively discrete vocabularies of politics comprised concepts grouped together in an internally ordered domain with a grammar and syntax, even a literature and repertoire of associations (topoi even!), which mimicked that discoverable in a natural language.[18] Often, particularly in early modernity, such languages were deployed by distinct occupational or status-groups which re-enforced sociologically the discrete character of the language.[19]

Pocock's recent remark that 'the history of political thought has been becoming all my life less a history of thought than of language, literature'[20] is both a truth of his personal in-tellectual biography and of the determinedly linguistic character of anglophone philosophy in the last forty years. Since we cannot identify thoughts except as they are articulated, the history of political thought must collapse into the history of their articulations. The postu-lation of thoughts as entities distinct from the articulations of them parallels the postula-tion of noumena as distinct from phenomena, and is vulnerable to the same criticisms.

The work done by the concept of language in Pocock's thinking - with a short detour via the paradigm[21] - has accordingly increased over time, acquiring a Suassurian vocabulary to distinguish not only the diachronic from the synchronic dimensions, but the characteriza-tion of the language (*la langue*) as a whole from the particular performances (*le parole*) un-dertaken in it.[22]

Pocock saw the primary interpretive task of the historian as that of identifying and re-constructing the languages in which politics had been discussed and their mutation over time. The most famous example is the recovery of the language of civic humanism in early modern Britain. But language could also perform an explanatory role with regard to an in-dividual thinker's thought which could be understood by identifying its relationship with the language – or languages – being deployed by the writer. For example, Edmund Burke's peculiar conception of reason could be illuminated by reconstructing the common-law lan-guage and associations from which it derived.[23] Explanation was thus a two-way, janus-faced enterprise, in which either the *langue* or the *parole* could be used to explain the other. A *langue*, and indeed its history, could be reconstructed from reading a variety of the

paroles performed in it, and a particular *parole* could be illuminated by a fuller appreciation of the *lange* in which it was couched, or *langues* it attempted to combine or synthesize.

Pocock was aware of the potentially trivial character of such explanations, and stressed the importance of maintaining a distinction between *langue* and *parole*. The author's parole is one performance amongst many possible in any given *langue*. If the language cannot be identified independently of the text which exemplifies it, it can exercise no explanatory power.[24] The investigator must satisfy him- or herself that the language they have identified was indeed an existent and discrete cultural resource for the writer and 'not merely a gleam in the historian's interpretive eye.'[25] At one point, Pocock even identified a series of verification criteria to test for the independent existence of a language,

a) different authors carried out a variety of acts within it,

b) they discussed one another's use of it, sometimes giving rise to meta-languages

c) investigators are able to predict the implications, and intimations, entailed by its use in particular circumstances

d) they can discover its use in unexpected places

e) they successfully exclude languages from consideration on grounds of non-availability.[26]

The historian's articulation of a language – or a statement articulated in it – always involved the temptation to render coherent a position which was not, and Pocock was initially concerned to draw attention to the (for anglophone political theorists) irresistible temptation to confuse the *doing* of political theory (the attempt to create a coherent account of the political world), with the writing of histories of it (the construction of an historically accurate account of such an attempt or attempts). Escaping such pitfalls involved correctly assessing the level of abstraction at which any given composition was intended to operate, as well as the extent to which the author intended a reflective or reconstitutive philosophical activity or a rhetorical exhortation to action.[27] Thinkers at a high level of abstraction uncovered and sometimes sought to restructure basic linguistic relationships fairly self-consciously (one thinks of Hobbes's self-proclaimed intention to 'set before men's eyes the mutual relation between protection and obedience' and his more covert and subversive one of defining outward acts and faith in such a mutually exclusive way as to virtually preclude the possibility of conscientious Christian disobedience).[28] By contrast, less abstract thinkers' activities could be explained by bringing to the reader's attention relationships between concepts and patterns of speech now lost which the subject of the study had assumed rather than made explicit. The major success here was the recovery of Harrington who was rescued from virtual oblivion and turned into a figure of crucial importance in a range of discourses concerning the application of republican ideas to England, and eighteenth-century understandings of the constitutional implications of the socio-historical changes of the sixteenth and seventeenth century.

Pocock claimed that the identity of the appropriate local languages and the appropriate level of abstraction for dealing with a text were historically verifiable questions, not open-ended or a matter of choice for the investigator. Interpretation was constrained (although not determined) by objectively identifiable characteristics of the text. To Stanley Fish's sceptical 'is there a text in the class?' Pocock's robust answer was that whatever other practitioners' find, or fail to find, in theirs 'there certainly was a text in the historian's class'.[29]

Despite Pocock's commitment to 'present the text as it bore meaning in the mind of the author or his contemporary reader'[30] it has been a criticism that his narratives have sometimes operated at a level of abstraction 'far exceeding that attained by the writers he studied.'[31] However his identification of languages as the appropriate transhistorical units of study provides him with some justification for doing this. Inasmuch as a language may be said to comprise a set of relationships – logical and associative – and potentials, these might be unrealized by its users, who nevertheless rearticulated and transmitted them and so rendered them available to subsequent users of it.[32] A language can never be reduced to the propositions actually advanced in it at any one time.

Fertile, powerful, and suggestive as Pocock's methodological reflections are, they seem essentially subordinate to, or at least arising out of, and developing through periodic reflections on his practice.[33] Indeed it is tempting – looking back at *The Ancient Constitution and the Feudal Law* – to see Pocock's method as immanent in one of his earliest and recurrent subject matters: the common law mind and the customary character of even the most theoretical performances.

Quentin Skinner and Speech Acts

Quentin Skinner's earliest works, by contrast, were already self-consciously declaring a very precise methodological programme resting on the analysis given by John Austin and John Searle of speech acts.[34] Skinner's strategic focus was synchronic: on the performance of individual speech acts, rather than Pocock's diachronic concern with language. History was to be constructed from an analysis of successive significant innovatory (or conservative) speech acts performed by individuals in a given language or, as he sometimes called it ideology.

What did the idea of the speech act bring to this programme? According to speech act analysis, speaking or writing is not adequately characterized as the production of audible sounds or graphic shapes, nor yet as words, nor even (usually) as referring (to some state of the world), or predicating (some property of some thing or person in the world). Language is not (usually, or at least not interestingly) used to describe some state of affairs in the world. Certainly political uses of language are rarely so one-dimensional. Rather, in politics, speech is used to *affect* the world. Political speech is paradigmatically speech *action*.

The idea of the speech act draws attention to the fact that in speaking or writing we commonly perform actions, and in the most simple cases the descriptions of these actions are cases cognate with the verbs the actor might him or herself use in performing the act. These were, in Austin's terms 'performative utterances', utterances which at the same time perform the action referred to.

Thus if I say 'I warn you that I might go on like this for another half an hour' I have, in that very statement itself performed the act of warning. In saying, 'I warn', I do in fact warn you, I have performed an action in speech, or a speech-act.[35] In saying, 'I promise not to stop even if the audience falls asleep.' I perform the act of promising. Such verbs were 'illocutionary'.[35] The fact of using them was sufficient (under certain definable rules) to successfully perform the action they described.[36]

Yet a further class of words described actions, the successful completion of which required some extrinsic effect to result. I can legitimately claim that in publishing this paper, I am trying to persuade my readers that all this has something to do with the study of the history of political ideas, without fear of refutation, for such is indeed my intention. What I could not claim, without independent corroboration, was that I was convincing you that it did. Your being convinced is not accomplished by my trying to persuade you, but only by your, in fact, being persuaded. *Illocutionary* acts characterize the deployment of authorial intentions in some linguistic performance, warning, advising, exhorting, denouncing, ridiculing, exposing etc. *Perlocutionary* acts describe intentions which intend to produce and do indeed bring about some change in the listener's understanding of the situation. Persuading, convincing, revolutionizing, de-legitimating (on at least most counts of what it is to legitimate), include both intention and its successful completion. Of course not all would-be perlocutionary acts achieve their intended effect. The distinction, although only formalised by Austin, was used to good effect by Shakespeare. In the following exchange he depicts Harry Hotspur exploiting it to ridicule Owen Glendower's boorish attempt to impress his fellow conspirators by claiming supernatural powers:

Glendower: I can call spirits from the vasty deep
Hotspur: Why, so can I, or so can any man;
 But will they come when you do call for them? [37]

Skinner's claim then was that theorists and writers, no less than actors, do not simply write or say things, but that *in* writing or saying something they perform some illocutionary action and often a perlocutionary one as well. To understand any given linguistic performance one had to grasp its illocutionary force, and to do this one had to familiarize oneself with the linguistic conventions available to the author. That is to say, one had to understand *what* Machiavelli was doing in writing *The Prince,* or Hobbes in writing *Leviathan.* Crucial here was the notion of intention, and its possible relationship to convention.[38] I can promise, because I can formulate the intention to promise, and that intention is available to me because of the existence of the institution of promising in my language, and amongst those to whom I promise. Promising without the intention – least controversially in the case of someone who does not know the language and simply utters the sound – fails to perform the appropriate speech act. Knowingly promising (other things being equal), commits the promiser to their course of action – she cannot evade the obligation by claiming that 'I promise' is only a sound, or 'promising' only a convention.[39]

Against both textualists (who insisted that we simply read the text) and contextualists (who insisted that we use the (social) context to explain its meaning), Skinner urged, not that we could dispense with either activity, but that recovering the repertoire of socially given meanings and conventions available to the actor was a logical prerequisite of two activities.

The first one is locating their linguistic performance within the author's contemporary world of meaning, and so being able to show minimally, what an author might legitimately be taken to have *meant* when they wrote what they wrote. This suggested a non-trivial prin-

ciple of interpretive exclusion: where certain linguistic meanings or conventions are not available to a writer or speaker, they could not possibly be construed as performing them and their work could not be so understood. Since all meaning is social in the sense that the meanings of a word are to be recovered from its possible uses in a given society of language users,[40] the recovery of meanings available to the author was an essential [but by no means exclusive or sufficient] criterion of scholars' interpretations of the author's own meaning. Since, at least on this account of meaning, authors could not have framed an intention to convey a meaning which their existing linguistic resources didn't allow, and any historical actor whose conception of prevailing linguistic conventions departed *too* far from that of his audience, would fail disastrously to bring off his linguistic performance.[41] Interpretations which presupposed such intentions could successfully be rejected. Thus, Machiavelli's *Prince* could not be a satire, Chapter V of Locke's *Second Treatise* could not be an apology for capitalism, and Rousseau's *Du Contrat Social* could not be a justification for Totalitarianism, since none of these categories were available to those authors, and could not have entered into their intentions in writing them.

But the second and crucial task which an understanding of existing conventions permitted us to perform was that of identifying innovation, conflict and subversion when it was taking place. As Skinner pointed out to those who accused him of being unable to account for innovation – knowledge of the prevailing meanings and genres was actually a condition of even recognizing innovations in usage when it was achieved, let alone of giving a successful account of it.[42] The claim was that an understanding of speech-*acts* – the accomplishment of some social or political performance through linguistic utterance – rested not only on the identification of conventional meaning, genre and practice, but also and perhaps more importantly, on the identification of departures from these.[43] Thus we could only understand the *Prince* properly by understanding the conventional performances thitherto conducted in that genre (handbooks for princes) and the way in which Machiavelli disconcerts, subverts, and in various ways departs from the expectations normal to that genre.[44] This analysis involved exploiting the margin which, in any linguistic world, divides, or one should rather insist, connects, the sayable and the unsayable.

It was precisely in this innovative, or at least a-typical, deployment of linguistic conventions that we could understand what an author was doing in writing the way he or she did. Such accounts are particularly salient it might be added, to the recovery of *political* meaning since the act of political persuasion most commonly involves the rhetorically innovative extension or restriction of conventional meanings or repertoires as the author seeks to capture or deny the commendatory force of the term or to extend or restrict the particular application of it under discussion.[45]

Although the speech act was best introduced and understood by reference to its deployment in the standard, uncontroversial exemplars – such as promising – with which Skinner lucidly illustrated his accounts, its deployment in understanding the history of political ideas was primarily in assisting analysis of the ways in which (innovatory) speech acts departed from these conventions.[46] There are thus two levels at which speech action can be identified – the conventional, and the subversive, which is of course parasitic on the exist-

ence of the conventional, and which is of course itself then liable itself to become conventional.

One classic example of such a political speech act seeking to subvert conventional meanings for political purposes occurred in the ratification debate for the American Constitution. The period of the American Founding is one which offered great possibilities for all three forms of analysis discussed in this chapter.[47] One particular strand in that debate concerned the contested meaning of that open-textured term 'Republic'. During the course of the War of Independence 'republic' had gained increasingly commendatory overtones.[48] But what exactly – apart from the absence of a monarch – was a republic? Americans were concerned that conventional political wisdom of the time – epitomized in Montesquieu – stressed that republics had to be small. The anti-federalist opponents of the new Constitution, and indeed Thomas Jefferson himself, increasingly tended to identify a 'republic' with either a direct democracy or at least a majoritarian and possibly mandated representative democracy. John Adams, whilst arguing that equality before the law defined a republic, nevertheless conceded that Democracy was one species of republic. The drift towards identifying the buzzword 'republic' with direct and or small-scale democracy was seized on by the anti-federalists, and posed a problem for Madison seeking to enamour his readers with the new constitution – which, it could be objected – consolidated rule at the federal rather than the state level, and which did so through relatively remote representative bodies. As anti-federalists occasionally protested, such an elected ruling class of the better sort was conventionally understood as a form of aristocracy. Madison's 'linguistic move' was to exploit the still negative connotations of 'disorderly democracy' by claiming that this was what his opponents wanted. Conceding in this way the relevance of the Aristotelian classification might have allowed the damaging conclusion that what Madison and the 'Federalist' supported was indeed an aristocracy. But in a complex yet unified linguistic move, Madison, in persuading his readers that direct 'democracy' was not a kind of republic (which must be elective) at all but an alternative to it, not only denied his opponents' claims to be republicans, but evaded the otherwise almost irresistible implication that what he was defending must be the alternative – a kind of aristocracy – an elective one. The term 'Aristocracy' he now reserved for what had been but one species of it – hereditary aristocracy – the commendatory overtones of 'republic' were captured for what had hitherto been designated elective aristocracy.

Skinner's insistence that speech act analysis directs our attention not only at the conventional level of speech action but to what someone is doing *in* claiming or arguing what they do here pays dividends. For we can recognise the complexity, innovation and elegance of Madison's rhetorical move is that *in* the (conventional speech act of) persuasively defining a republic as essentially representative government he, in that very same move, both saddles his opponents with the much more we equivocal identity of democrats, and precludes his own party's vulnerability to the charge of aiming to establish an aristocracy.[49]

Thus Skinner could – and did – argue that not only did his method restore the priority of the true *historical* meaning of any political theory or argument, and was uniquely capable of characterizing innovation and by implication historical change and process, but a

general theoretical understanding was being given of what it was that made them *political*, in the sense of seeking to change, for the purposes of recommending action, some conventionally established meaning or application, and that this understanding could only be gained by situating the speech act in its synchronous context.

Comparisons and Reflections

Some commentators make a virtue of sharply distinguishing between the methodological foundations of Skinner and Pocock, and indeed at one time they seemed concerned to do so themselves.[50] However, their two positions can be seen – and I think are now recognized by themselves – to merely place emphasis on different moments of an essentially unified account of political language use.[51] Pocock places the emphasis on identifying the *language* of political discourse which he has helpfully described as 'a complex structure comprising a vocabulary, a grammar, a rhetoric, a set of usages, assumptions and implications, existing together in time and employable by a semi-specific community of language-users for purposes political'.[52] This, as we saw, comprises both the identity of what is being historically investigated – language is the historical subject – and a means of explaining the writings or speech of an individual actor. Skinner's focus is on the single performance of a linguistic actor, and his criticism of the explanatory power of 'language' was that mere identification of the language did not tell the historian what [speech] actions were being performed in it.[53] Nevertheless, his claims about the embeddedness of use, and hence the importance of context, genre and convention show that an understanding of the individual speech act is logically dependent on (although not guaranteed by) an understanding of the language in which it is performed. For example, to understand an English speaker's deployment of the term 'virtue' in the eighteenth century we need to know to what extent they understood themselves to be invoking (and so intended to invoke in their hearers) civic or puritan language or associations. Conversely Pocock's detailed charting of linguistic change proceeds by identifying what he has only recently started to label, but what is clearly indistinguishable from Skinner's account of, the innovatory or defensive speech acts performed by linguistic actors.[54] Consequently despite their different philosophical starting points and emphases, Skinner and Pocock have each had to concern themselves *both* with the diachronic question of the identity of the language and its conventions over time *and* with the synchronic question of the individual locutions performed within it at any one moment. As a result Skinner, – who famously once delivered an iconoclastic paper to the Political Studies Association entitled 'The Unimportance of the Great Texts' – like Pocock, is concerned with empirically identifying and according significance to the less abstract works of political theory as well as – indeed as a way of identifying – the more singular and innovative theorists, so as to create a history of political ideas of a genuinely historical character.[55] Each see the same historical commitment as grounding scepticism about the possibility of identifying for investigation purposes anything more abstract than the actual linguistic patterns and arguments which can be found *in use*. In characteristic Anglophone empiricist

fashion they would reject the notion that anything as abstract as a 'concept' could be a possible subject of primary historical investigation.

Comparative Remarks

Neither Skinner, nor, until recently, and then only briefly and tentatively, Pocock, have addressed the *Begriffsgeschichte* enterprise directly.[56] This is particularly remarkable since each of them have addressed problems central to it.[57] However, Skinner has been outspoken (and unrepentant) in his denial that a history of concepts was a possible enterprise.[58] Although a number of writers have devoted occasional essays to a consideration of the genre, or of comparisons between it and the work of Skinner and Pocock, only Melvin Richter has engaged in sustained championship of *Begriffsgeschichte* in the anglophone world.[59]

I stressed at the start the possibility that *Begriffsgeschichte* and linguistic approaches might have ultimately different objects.[60] One way of bringing this out is to note the different routes taken in arriving at the approaches.

In Germany, *Begriffsgeschichte* was conceived of as an approach to *social* history. Keith Tribe writes: '*Begriffsgeschichte* is not intended as an end in itself but rather as a means of emphasizing the importance of linguistic and semantic analysis as a contribution to the practice of social and economic history.'[61] It nevertheless shares with the anglophone theorists two concerns

1. the 'critique of a careless transfer to the past of modern context-determined expressions (..)[and] the practice of treating ideas as constants'.[62]
2. establishing instead the 'minimal claim that the social and political conflicts of the past must be interpreted (..) in terms of the mutually understood, past linguistic usages of the participating agents.'[63]

Koselleck makes clear that whilst *Begriffsgeschichte* can offer insights into a history, the subject of which is purely theoretical, this is only a preliminary and that he is concerned with the relationship between two distinct domains, the linguistic/conceptual and the social/material: '*Begriffsgeschichte* lays claim to an autonomous sphere which exists in a relation of mutually engendered tension with social history'.[64] And he cautions us that, 'once this history of concepts is laid bare the autonomy of the discipline must not be allowed to lead to a diminution of the actual historical materiality simply because the latter is excluded for a specific section of the investigation.' His objection is that this would lead to the view that nothing could be said to have happened historically that was not conceptualised as such. Koselleck wants to use conceptual history to register 'a tension between concept and materiality'.[65] The relationship between these two spheres is elusive, but they are presented as possessing distinctive epistemological, if not ontological, identities. For him extra linguistic conditions for historical occurrences include not only 'natural and material givens', but 'institutions and modes of conduct'.[66] Historiography for him involves essentially two levels – the recovery of the past as it bore meaning for the actors involved, and the application of ex-post categories (for example those of modern economics) onto historical material. *Begriffsgeschichte* not only exposes this dichotomy, but forces us to con-

front the resolution of it, and so write an adequate history. It is not, however, itself that adequate history.

By contrast the object of anglophone history of political thought tends to understand conflicts in the development of political discourse and vocabulary either as an object of historical investigation in its own right, or as *constitutive of political reality*, and not a factor in or relative to a reality existing independently of it.[67] Even anglophone writers who write the history of concepts insist: 'there is a general temptation (..) to understand conceptual change as a *reflection* of political change (..) this temptation must be avoided at all costs'[68] The reason for this is that they see political institutions, practices and conflict as constituted in and through the languages used by, and constructing and restricting the self-perceptions of, those who hold office, perform or compete politically; moreover political action is and can only be understood as linguistic action: commanding, negotiating, conceding, exhorting, mobilizing, compromising, agreeing and all the other verbs comprising the vocabulary of political action are verbal performances. Declaring Independence, no less than Founding a Constitution are actions not only inconceivable without language, but without, at least to me, any evident residual non-linguistic content.[69]

Some of the most exciting reinterpretive work on the French revolution associated with the names of Francois Furet, Lynn Hunt and Keith Baker has insisted not only on a kind of intimate relationship between social reality and language, but on the constitutive character of the language of revolution. Inasmuch as 'social and political arrangements are linguistically constituted (..) efforts to change them (or to preserve them) can never occur outside of language (..) social and political changes *are* linguistic.'[70] The revolution was first and foremost a linguistic act, it was by inventing and deploying the language of revolution that the Revolutionaries effected one. To understand it in this way is 'to emphasize its character as a cultural construction – a symbolic ordering of human experience – rather than as a predetermined [or, one might add, even a non-predetermined] social process.'[71] Indeed one might argue that the failure of the British radicals to effect a similar revolution is to be explained by their failure to perform the appropriate linguistic actions. They for the most part, became bogged down in the interpretive question of whether they *had*, already performed the act in question in 1688, rather than devoting themselves to the business of declaring or performing it in the 1790s.[72] It is only if we can conceive of moving beyond politics to the realms of naked power, that we can move beyond the linguistic world, yet all social power is exercised linguistically. We can indeed kill Kings with swords or axes, but it is only with words that we can abolish monarchies. In this sense is the pen truly mightier than the sword, and to this extent too, linguistic reality and action cannot be seen as conceptually distinct from an independently existing political or social reality: political reality cannot be other than linguistically constituted.

A second point concerns the different relationship which a language-focus sees between its internal parts and its own existence over time, from that suggested by Koselleck for *Begriffsgeschichte*. *Begriffsgeschichte*, he claims, seeks to establish the diachronic dimension, along and within the changes observable in particular distinct concepts, by extracting these from their synchronic contexts and then only subsequently reassembles these discrete strands in order to recreate a totality.[73] He claims that it is only by doing so that the tension

between a social or political concept '*and its corresponding structure*' or its '*extra linguistic content*' can be recovered.[74] This is revealing both of the assumption that concepts in some kind of way *represent* or *correspond to* an independent social reality and that concepts not only are but must be traceable independently of the linguistic contexts in which they are deployed.[75]

Anglophones, by contrast, not only stress the linguistic constitution of political reality, they see concepts as necessarily taking their meaning from the specific patterns of discourse, or more grandly, theories within which they are deployed. Diachronic change occurs within and can only be recognized in the context of, larger units – languages, discourses. *Even those anglophone writers who have become involved in the analysis of individual concepts* have characteristically insisted that 'concepts are never held or used in isolation, but in constellations which make up entire schemes or belief systems. These schemes or belief systems are theories...'[76] Diachronic analysis on this view *must* operate primarily at the language/discourse level, and not at that of the concept, since it is only within the language that use-change can be observed.[77]

One further point which relates back to the connection between the history of thought or speech and social history. The programmatic statements about *Begriffsgeschichte*, share with social history the tendency to see history as a field of impersonal processes, in which humans are almost passive vehicles. Conceptual change is a process, the locutions characteristically used to describe its dynamic are natural metaphors: 'flow, processes, phenomenon, structure',[78] rather than being driven by identifiable agents.[79]

By contrast the two anglophone writers I have discussed – Skinner perhaps more than Pocock – see linguistic change as the actions – sometimes admittedly, incompletely comprehended – of agents, and both the questions they tend to ask as well as the way they seek to answer them seem to presume that explaining linguistic change involves catching a language user red-handed - in the [speech] act as it were. To what extent history is a history of agent's acts, as opposed to processes is a matter for dispute, and it might be a political as well as an historical issue. Skinner at least sees the recovery of agency as incompatible with the history of an idea, for what

'we cannot learn from any such history is in the first place, what part, the given idea may have played in the thought of any individual thinker (..) what questions the use of the expression was thought to answer, what status the idea may have had, what point (..) or range of uses it may have sustained (..) there *is* no history of the idea to be written but only a history necessarily focussed on the various agents who used the idea and their varying situations and intentions in using it.[80]

Now – particularly in recent French thought – seeing particular languages, their concepts and configuration as constitutive of the human world and history can seem to entail the denial of human agency, and to present speakers, authors and actors as determined by the language and texts which they appear to perform. This is to reproduce within the linguistic construction of reality, the determinism which pervades some kinds of material history. But the stress on linguistic agency makes the opposite claim, and rightly so, it seems to me: for

whilst men (and, as is increasingly recognised, women) do not make their history in the linguistic circumstances which they have chosen, they do nevertheless make their history. Making history involves deploying the available language(s) in innovative, creative, and agent-full ways. To wish that they could do so without language – which must always be a specific language – is to believe, with Kant's dove, that their creative flight would be less constrained without the only medium which in fact makes it possible at all.

CHAPTER 4

Concept - Meaning - Discourse. Begriffsgeschichte reconsidered *

HANS ERICH BÖDEKER

I.

'*Begriffsgeschichte* in a narrow sense', as Reinhart Koselleck, one of the leading protagonists of the history of concepts, once succinctly stated, 'is a historiographic achievement. It is concerned with the history of forming, using, and changing concepts.'[1]

Begriffsgeschichte - the history of concepts - deals with the synchronic and diachronic interpretation of words viewed as 'concentrations of multiple meanings'[2] and 'lead concepts of historical movement'.[3] Their analysis generates structures and greater contexts of events. These 'basic concepts' are viewed simultaneously as indicators of extra-linguistic objects – such as changing social structures – and as factors or promoters of historical development – such that in society they carry out actions. *Begriffsgeschichte* aims to identify the social scope of concepts, makes an issue of the binding, influencing power that concepts exert on political and social groups, and deals with epochal changes in social and political structures to the extent they can be grasped in linguistic terms as a shifting in experience, expectations, and theory.[4]

Only in this dual interpretation of language as both indicator and factor does the methodology of *Begriffsgeschichte* constitute a research field of its own.

Different dimensions of *Begriffsgeschichte* can be worked out under these premises.[5] First of all, it is a complementary subject to the (historical) social sciences and linguistics in that it offers a specialized method of source criticism which analyzes the meanings of central concepts. Second, it is very closely tied to social history, representing as it were the 'conditio sine qua non of social history issues'.[6] *Begriffsgeschichte* supplements its synchronic analyses, which focus on situation and time frame, with diachronic analyses, which follow changes over time in the meanings of concepts, bringing this all together in the history of the concept. The various diachronic layers of a concept alone serve to derive long-term structural changes. It would be inadmissible to be too quick to equate analyses of *Begriffsgeschichte* with those of social history.

* Translated from German by Allison Brown.

Finally, *Begriffsgeschichte* constitutes itself to the extent that it methodologically maintains its assumptions through a subsidiary function as a separate branch of science, the subject of which is the linguistic expression of changes in experience and theory. *Begriffsgeschichte* can make structural statements on the basis of the temporal relationship between event and structure, and the non-simultaneity of the simultaneity of concepts and objects. These statements, in the form of hypothetical inquiries and challenges, can be aimed at a social history that has always been concerned with structures, time periods, and simultaneity.

Begriffsgeschichte, as founded by Koselleck, makes use of the same methods as historico-critical textual analysis, hypotheses in a traditional history of ideas and (social) history, and semasiological and onomastic analyses taken from linguistics.[7] The 'method' used by Koselleck's *Begriffsgeschichte* was conceived as a critique of traditional philosophical and philological forms of Begriffsgeschichte. In 'Social History and *Begriffsgeschichte*' (1972), Koselleck developed two central elements of the new approach:

> Criticism of the uncritical transfer of present and temporally fixed expressions of constitutive life to the past' and 'criticism of the history of ideas, insofar as these are introduced as constants.[8]

Modern *Begriffsgeschichte* emerged in contrast to a history of events and politics oriented merely toward a chronological series of events, to positivistic, 'antiquated' historiography that rejects even the heuristic use of theories and hypotheses, and to a history of ideas void of its socio-political context, i.e., a shrunken form of historicism to which it certainly cannot be reduced. It would thus also be wrong to equate *Begriffsgeschichte* oriented toward structural history with a critique of historicism.

The concept of *Begriffsgeschichte* is closely tied to the joint work *Geschichtliche Grundbegriffe* (Basic Concepts of History).[9] The starting hypothesis of the book is a so-called bridge period from 1750 through 1850,[10] during which – accompanied by the dissolution of corporatively structured society – the socio-political world of concepts also underwent fundamental changes leading up to modern times. This hypothesis has definitively influenced considerations on the method used in *Begriffsgeschichte*. It is then specified further by the assumptions that: (1) concepts previously known only among the educated are gaining access to other social classes (democratization); (2) that basic concepts are serving more and more as polemical weapons, thus becoming ambiguous (ideologizability); and (3) that – at the expense of the experiences they comprise – they are assuming more and more expectations and goals, thus having become future-oriented 'concepts of movement' ('temporalization' and 'politicization'). The working hypotheses are merely heuristic anticipations and results of efforts for and on *Geschichtliche Grundbegriffe*, sub-titled 'Historical Dictionary of Sociopolitical Language in Germany'.[11]

'The dictionary is related to the present', as Koselleck explains its purpose, 'insofar as it deals with the linguistic record of the modern world, its becoming conscious, and its creating consciousness through concepts that include our own'.[12] Research on *Begriffsgeschichte*

cannot be reduced to these hypotheses. Koselleck himself recently said that 'hypotheses about the existence of such a period play no part in the method used in *Begriffsgeschichte*'.[13]

The work was received positively as a programme of a historical view of language, but was criticized in that in some respects it was not on a par with the original prospectus.[14] The lexical organization was criticized as being neither optimal nor adequate in differentiating hypotheses of *Begriffsgeschichte* according to social and communicative references.[15] At the core of the criticism, again and again, was also the issue of the selection of sources in the articles, namely that these 'basic concepts' lead to 'lofty notions on the history of ideas' that prefer the great 'canonized' theorists from Aristotle to Karl Marx, without proving that they were representative of society and without their making their way into the everyday language of politics.[16] With that, critics felt the level of a traditional history of ideas was not surpassed and, by not having socially representative sources, socio-historical standards were not met.

Objections to a limitation on 'representative' philosophical texts were directly connected to criticism of the essentially diachronic trend expressed by the *Begriffsgeschichte* studies.

In addition to reservations regarding research methods, criticism was fired with respect to the theoretical, methodological approach of *Begriffsgeschichte*. From a linguistic perspective, the partly intuitive methodological foundations that fluctuated between linguistic and historical premises, such as the conceptualization of the relationship between history of the word and that of the concept, were criticized. Parallel to that is the basic objection that the socio-historical relevance of *Begriffsgeschichte* could not be convincingly justified in theoretical terms. Aspects of this criticism have been taken up by the new variant of *Begriffsgeschichte* as conceived, and to some extent realized, by Rolf Reichardt.[17]

In order to measure the options and limitations of hypotheses pertaining to the history of concepts, it is necessary to explore the structure of 'meaning' (III); the question of how a 'word' refers to an 'object' (IV) and the possible relationships between *Begriffsgeschichte* and discourse history (V) must also be discussed. However, this examination must start with the 'concept' (II), the central object through which to access *Begriffsgeschichte*. Some of the criticism of theory formation in *Begriffsgeschichte* has evolved from claims that the theory of the 'concept' is inaccessible, since it remains unexplained in terms of linguistic philosophy.[18] This essay aims to take us yet a step further, even if it is not possible in many respects to entirely explain open questions and methods of a potential *Begriffsgeschichte*.

II.

Research in the field of *Begriffsgeschichte* has its basis in words; terms; in general, linguistic signs. It does not deal with words as singular graphemes, however, but as symbols for categories of similar words, or words of a special kind. A constitutive property of *Begriffsgeschichte* is the distinction between word and concept – a distinction that is by all means problematic in linguistics, epistemology, and a theory of signs. In concise terms, Koselleck regards concepts as nothing more than words with a special historical meaning.[19]

Thus the subject of *Begriffsgeschichte* emerges only as an outcome of the research process itself.

Koselleck has repeatedly tried to grasp the difference between word and concept in theoretical terms. He fundamentally sees the distinction as qualitative, as one of different sign types seen from the same perspective. 'The meaning of the word', he once wrote paradigmatically,

> always refers to that which is meant, whether a train of thought or an object, etc. The meaning is therefore fixed to the word, but it is sustained by the spoken or written context, and it also arises out of the situation to which it refers. A word becomes a concept if this context of meaning in which – and for which – the word is used, is entirely incorporated into the word itself. The concept is fixed to the word, but at the same time it is more than the word.[20]

Therefore, a concept is a word that has 'incorporated the full extent of the context of meaning in which the word is used'. Words thus have 'potential meanings'. Concepts inherently bring together a 'wealth of meanings' and, 'in contrast to words, they are always ambiguous'.[21] A 'wealth of meanings that cannot be divided into different potential meanings' – if this is an accurate expression of Koselleck's intended understanding of the terminology, then his concept of 'concept' coincides with the use of the term in the philosophy of language to describe second degree predicates, the meaning of which is obtained by abstraction.[22]

This distinction exists largely due to evidence offered by empirical examples. At the same time, according to Koselleck, words and concepts should also be distinguishable in terms of definition.[23] And on top of that, for both, the 'ambiguity' that always emerges should facilitate smooth transitions between the categories. It is obvious that the concept of ambiguity is in fact indispensible in explaining shifts and new relations in historical arguments.

Koselleck sees concepts, in contrast to words as 'concentrations of multiple meanings that are incorporated into the word from the historical reality, which is different in every case (..). Put succinctly, the meaning of words can be defined more exactly, concepts can only be interpreted.'[24] A multiplicity of interpretations is Koselleck's criterion for a concept as a way of perceiving and as a schematic for interpreting historical reality. This concept of 'ambiguity' or 'multiple meanings',[25] which can in part be traced to linguistic features of some words, should make it possible to draw methodological links to questions of social history and ideology criticism.

The 'concepts' of *Begriffsgeschichte* cannot be explained using the methods of linguistic semantics,[26] as the premises of *Begriffsgeschichte* allow neither a generally accepted definition of a concept nor its extensional determination. Consensually indisputable meanings can serve neither as indicators of nor as factors in the social process. They remain inconspicuous, giving no reason for a conflicting interpretation and ruling out any conceptual dynamics. Only that which is uncertain as a name and potentially controversial according

to its assignment to 'objects' offers grounds for discursive turbulence, thus becoming historically conspicuous.

Begriffsgeschichte views a concept as a collection of experiences and expectations, perspectives and explanations, of historical reality. Therefore, from the outset, a concept exists within a theoretical constellation or conceptual diagram. A single concept can hardly be understood without reference to other concepts.[27] *Begriffsgeschichte* seen as a history of knowledge conveyed through language must always keep the relational structure of the concepts in the field of vision. It is not an individual concept that forms the subject of consciousness in *Begriffsgeschichte*, but the whole of a mutually self-supporting conceptuality. Concepts organized into structured aggregates define each other reciprocally. From the start, then, the subject of *Begriffsgeschichte* is the classification of the concepts. In other words, *Begriffsgeschichte* analyzes concepts as elements in a semantic or linguistic field. In this sense it follows, as Koselleck states, that 'the investigation of a concept cannot be carried out purely semasiologically; it can never limit itself to the meanings of words and their shifts in meaning'.[28] Research in *Begriffsgeschichte* goes beyond the history of the word, determining semantic structures. In particular, opposite, related, and parallel expressions must be analyzed in detail in their relation to the term under investigation. In addition to synonymous and equivalent expressions, attention must also be paid to related judgmental concepts (*Wertungsbegriffe*). Judgments, and generally the potentially competitive or strategic character of expressions or definitions of concepts, must also be examined.

These 'intentional components',[29] which need to be put in concrete terms, generally also with respect to individual utterances and speakers, are what is meant when attempts at conceptualization in *Begriffsgeschichte* continually demand contextualization. Only then will discursive strategies be incorporated into contexts of social action.

Different types of concepts appear in passing in Koselleck's continued efforts to determine a concept of *Begriffsgeschichte*, though he never explains them. In his 'Introduction', for example, he mentions constitutional concepts (*Verfassungsbegriffe*), key words, self-namings (*Selbstbenennungen*), lead concepts (*Leitbegriffe*), core concepts, etc.[30] More meaningful from a *Begriffsgeschichte* perspective, however, are concepts such as 'struggle concepts' (*Kampfbegriffe*), 'future concepts', 'goal concepts', and 'expectation concepts'.[31] These words name possible functions that concepts can assume in argumentative contexts. All of them indicate that the concepts do not serve theoretical knowledge alone. A 'struggle concept', for example, describes the pragmatic function that a word has in political confrontation. 'Staatsbürger' (citizen) was a struggle concept used by Prussian reformers around 1800, since it indicated a 'polemical goal' directed against the 'traditional, corporatively structured society' and 'corporative inequality of rights'.[32] 'Staatsbürger', as a new word, was a 'struggle concept', since any use of it demanded as it were the aspired equality from all those who refused to relinquish their traditional privileges.

Again and again, Koselleck stresses that a 'should' can also be included within the concepts. In writing about the word 'Staatsbürger', he says that it refers, before the fact, 'to a constitutional model yet to be implemented'.[33] This type of wording can often be found in Koselleck's works, for example, when he speaks of 'future concepts' serving 'to linguistically pre-formulate positions (to be achieved in the future)'[34], or when he later speaks of democ-

racy as an 'expectation concept', which then gradually forces all other constitutional forms 'into a state of illegality'[35], or when he once said that in the course of historical developments, the 'demand for implementation' inherent in many concepts continuously grows.[36] With that, Koselleck expresses an awareness that a word that seems to simply name the essence of objects or things can actually at the same time be used to express a 'should'. This is especially noticeable in Koselleck's use of the German *gerundive* (*zu verwirklichende* – to be implemented; *zu erringende* – to be achieved), such as in the words 'illegality' and 'demand', the meaning of which Koselleck says could be contained in the concepts. He thus makes it clear that the virtual aim and function of historical concepts is especially to express a 'should'. In doing that, Koselleck takes not only the descriptive part of a word's meaning into account, but its prescriptive part as well; in other words, the deontic (i.e., referring to moral obligation) meaning of lexemes. By virtue of the 'should'-components of the meaning that are inherent in and also intended by the words themselves, words serve as the vehicles or abbreviations of thoughts, not only with respect to what is, but also to what should be.

'Movement concepts' are for Koselleck typical, strongly programmatic surpluses in the conceptual content, combined with a nominative lack of clarity.[37]

This makes tangible a dimension of *Begriffsgeschichte* that Koselleck never explicitly theorizes on, but often expresses. It is a dimension in which concepts function as struggle concepts, goal concepts, etc. in such a way that they stand for, and are used for thoughts that are condensed, so to speak, in them. The word always calls the thought to mind; it is coined in the context of the thought and in order to express it succinctly. Hence the word is a reference cipher or abbreviation for the thought. Without the thought, the word cannot be at all understood. Every time the word is repeated, the thought is revived, since – as that which is presupposed – it must continually be made real in the present in order for the word to be understood in the context in which it is uttered. It is true to the same extent for struggle concepts as for future, goal, and action concepts that through them, the respective thoughts subsumed under them are rehearsed and inculcated every time they are actively spoken, or even heard or read. Every time a word is used, it contributes to the reinforcement or abandonment of one language usage or another. This competition among words and their meanings is of historical interest precisely because the difference in language usage is accompanied by a difference in thought usage. 'Every concept serves to set certain horizons and limits of potential inquiry and imaginable theory.'[38] If, in agreement with Koselleck, one understands the concept, or word, as a reference cipher, a vehicle used by thoughts, then it is obvious that regarding the habitual use of certain words – such as 'class' – habitual thinking of commonplace thoughts is implied and, over and over again, induced. This is often indicated by historians in particular.

Later efforts at conceptualization within the scope of *Begriffsgeschichte* have been able to continue along the lines of these approaches, which view a concept as a function that is filled with changing arguments, thereby acquiring its predicative character. This is how Rolf Reichardt attempts to classify – using the headword 'Bastille' – the semantic field that is staked out by words connected with this word in a text. He divides the associated words into four categories. The paradigmatic field of reference includes concepts and phrases that 'di-

rectly define' the concept under examination. The syntagmatic field of reference is comprised of words connected to the concept under examination that 'give it content, describe it, and clearly delimit it'. A third category is made up of 'concepts and names that describe the causes and creators of the 'Bastille' and its intended practice', and, finally, the fourth category includes all systematic opposites (functional antonyms) of the examined concept.[39]

Reichardt carefully distinguishes the different practical realms of communicative utterances. Their analysis, as well that of the supporting layers of the concepts, are essential elements of a *Begriffsgeschichte* based on a history of consciousness. His analyses approach his study on everyday consciousness and the related linguistic constitution and its conditions. The associated fields at the core of the analysis, here, are actual 'head-words', the sole purpose of which is to indicate the formation and changes in epistemic networks, without imparting any consciousness-constituting force to the headwords themselves. This also applies for Koselleck. For him, too, a concept viewed as a linguistic or cognitive structure has as little immanent dynamics as does a word: 'It does not move, it is moved',[40] and by that he means in its usage.

III.

As long as the relationship between concept and meaning is not clarified, the historiographic *Begriffsgeschichte* – in the sense of a history of consciousness – is constantly in danger of remaining merely a history of ideas.[41] Are concepts, as meanings of expressions, language-immanent phenomena? In other words, does a word refer to something extra-linguistic by the mere fact that it expresses a concept, or not until it becomes the term (*Bezeichnung*) for manifestations included within the concept? Do we assume concrete or abstract entities behind the meanings of an expression? Or is the meaning of an expression asserted in the way it is used in language? These questions basically point to two opposing explanations. On the one hand, 'meaning' is described as a characteristic of words or sentences; on the other hand, as an event or process in which linguistic signs obtain a meaning only if they take on a function in a communicative act. In that case, the meaning of an expression is the way it is used in language. The methodology in *Geschichtliche Grundbegriffe* leaves the concept of meaning generally undefined. At the core of his discussion of methods used in *Begriffsgeschichte*, Reinhart Koselleck said that:

> The meaning of a word always refers to that which is meant, whether an idea or an object. The meaning is therefore fixed to the word, but it is sustained by the content intended by the thought, by the spoken or written context, and by a social situation.[42]

This distinguishes between the meaning of the word and the referential relation. A word is not used to refer to that which is meant; rather, the 'meaning' refers to it.[43] In addition to the sign-to-object relation of a classical theory of signs, here Koselleck introduces the word-to-thought relation. The thought, linking word and object as the third pole of the triangle, was considered that which is described. The thought in that concept is replaced in Koselleck's theory by the meaning. Meaning is thus no longer the relation of a sign to that

which is described; instead, it is an epistemic entity not defined in detail that can itself, in turn, be seen in relation to that which is described.

In this conceptualization, meaning becomes something statically fixed to the word itself. It seems as if scholars of *Begriffsgeschichte* assumed that 'meaning' or 'sense' is to be understood as object-like, or tangible. This as it were essentialistic conception of meaning views the relation between linguistic signs and their meanings as more or less fixed relations of two invariable magnitudes. Acts of meaning-forming linguistic communication, in this conception, are ascribed to the meanings – fixed, identical, and essential – of the individual linguistic signs. The use of the concept is thus envisioned as something added accidentally to the meaning of the word. The concept-critical model pays little attention to the potential diversity of possible communicative meanings and to potential dependence, with respect to situation and context, of linguistic use of signs. An understanding of concepts as 'words containing considerable meaning' rules out the cognitive function of the communicative act in constructing the concept.

Behind the necessary link between semasiology and onomastics in practical *Begriffsgeschichte*,[44] however, as repeatedly asserted by Koselleck, is the view that abstract objects can be known and analyzed, independent of their being recorded in linguistic terms – i.e. words that describe them. Yet this contradicts the proclaimed goal of historiographic *Begriffsgeschichte* to attain the constitution of reality contained therein with the aid of an analysis of meaning of linguistic communication about historical experience. The attempt to situate historiographic *Begriffsgeschichte* between semasiology and onomastics – or a history of words and a history of things, or experience and ideas[45] – carries a risk that concept-critical analyses will not achieve any of their epistemic goals, either because they are too rash to subordinate one to the other, or because they strongly bias one pole.

Conceptualization efforts in *Begriffsgeschichte* have often not been able to avoid equating 'concept' and 'meaning' by considering them more or less static 'ideas'. This paved the way in practical *Begriffsgeschichte* for the traditional history of ideas to be revised, burying insight into the specifically linguistic aspect in the construction of knowledge and reality.

However, conceptualizations of *Begriffsgeschichte* are also based on the possibility of grasping a concept as a category that conceives cognitive achievements in connection with linguistic acts of communication. Koselleck posits this dimension in his introduction to the *Geschichtliche Grundbegriffe*, stating: 'The *Begriff* (..) must retain multiple meanings in order to be a *Begriff* (..) The meaning of words can be defined more exactly, concepts can only be interpreted.'[46]

Koselleck distinguishes between 'pure words' and 'concepts' with respect to their capacity to have a fixed meaning. This distinction serves to assert that the history of use that is called up assumes greater proportions for some concepts than for others. Even if linguists do not agree with the claimed difference in the capacity of words to have a fixed meaning, this does not change the fact that in conceptualizations in terms of a history of concepts, the process of meaning formation is in principle incorporated at least to some extent in the communicative interaction. This is demonstrated by Koselleck's insistence that the use of concepts in historical contexts be examined, as well as through his desire to determine the 'social scope' of concepts.[47]

Scholars of *Begriffsgeschichte* see the contexts of meaning as tracing back to the use of individual ('concept'-)words, which are intended as such to be the focus and concentration of diverse reference structures. In reconstructing these contexts of meaning, there is a constant risk of overestimating the functions that individual words assume in the continuum of communicative actions and texts. This can result in idealizing linguistic units which do not take on their understood existence until subjected to analysis, making them substantial factors in the construction of consciousness. Concepts do not acquire the significance for an analysis of consciousness that Koselleck and other scholars of *Begriffsgeschichte* attribute to them until taking on this analytic function as an 'overview of the non-updated combination of semantic features' and as the 'structural composite of potential uses'. They are not seen as units of current language-use in which words always have a current meaning.

More than Koselleck, Reichardt emphasizes the linguistic construction of consciousness. 'Social history is the history of concepts', he expounded, in contrast to Koselleck, 'not so much because concepts mirror the material reality of the past in a more or less broken fashion, but above all insofar as they are based on the social character of the language.'[48]

Reichardt, too, agrees in the end with the working hypothesis of *Begriffsgeschichte*; that history can expose a 'material reality' behind the linguistic construction of consciousness (which as such is always historical and, consequently, relative). More precisely than in traditional *Begriffsgeschichte*, he attempts to distinguish between the social reality of historical times, on the one hand – which history can better access if it analyzes everyday sources that participate in the historical process and do not 'merely' reflect on it – and the historically relative consciousness of the respective contemporaries, on the other – which is influenced by linguistically constructed knowledge. Reichardt is aware that the historical consciousness of social institutions and processes of an epoch are at least as influenced by 'institutional' sources as by social reflection. This is obvious when he states that,

> by means of everyday experiences, the meanings of concepts (..) [form] sedimented stocks of 'social knowledge' put into language that participate in 'processes of meaning formation' from sensory perception, selection of subjects and motive structures, to action.[49]

Thus Reichardt sees meaning-formation processes about social reality as being controlled by the overall context of linguistic, social action. The social use of language to be analyzed includes everyday actions in social institutions and processes, as well as reflections on reality. Accordingly, the practical side of *Begriffsgeschichte* looks beyond the analysis of individual products of language to the language standards and conventions of society that substantiate them. Nevertheless, this variant of *Begriffsgeschichte*, too, is not aimed at a 'construction' of 'objects' in a comprehensive sense by means of spoken language; rather, it is an attempt at a normative summary, standardization, and flexible differentiation of certain potentials for meaning and sense.[50] In other words, 'social communication constructs the object as an object that is typically ordered and summarized in a certain way, but it does not construct the "material" organized in a standardizing manner'.[51] Even this version of historiographical *Begriffsgeschichte* does not go so far as to grasp 'meaning' in Wittgenstein's sense as 'use'.[52]

According to such an understanding, knowledge of the use of a word would be knowledge of its communicative validity or, to be more precise, knowledge of the 'meaning'.[53]

IV.

The central theoretical claim in Koselleck's understanding of *Begriffsgeschichte* is that 'external history' is incorporated into *Begriffsgeschichte,* and that the two mutually refer to each other. This makes the relation of 'words' to 'objects' a key problem for *Begriffsgeschichte*. According to Koselleck, *Begriffsgeschichte* is 'concerned with the convergence of concept and history'.[54] In contrast to the claims of linguistic methods, Koselleck declares precisely the socio-political function of the relationship between word and object to be the subject of research in *Begriffsgeschichte*.[55] Thus *Begriffsgeschichte* encompasses the entire field of interaction that exists between the subject areas that include concepts and the language through which the concepts are articulated. Each of them, the subject areas and the language, has its own history, which are held together by the demands of *Begriffsgeschichte*. In this sense, Koselleck sees 'concepts' as superordinate units that connect 'word' and 'object'. They have two dimensions. On the one hand, they refer to something extra-linguistic, i.e., the context in which they are used. On the other hand, this context, this historical reality, is perceived in linguistic categories. 'Put metaphorically, concepts are like joints linking language and the extra-linguistic world.'[56]

Koselleck has interpreted the relationship between word and object by generally describing the source language of a particular epoch as 'metaphors for history'.[57] However, his many attempts to determine this relationship have been rather vague; for example, he has said that word and object refer to one another reciprocally, correspond to each other, and exist in a mutual tension, but they never merge into one.

In the methodological concept of *Geschichtliche Grundbegriffe*, two perspectives typically appear juxtaposed and unrelated: first, the relationship between words and objects as an external relation between two independently identifiable factors, and second, the interpretation that the existence and way of functioning of one is a prerequisite for the other.

Some of Koselleck's expositions on the concept of *Begriffsgeschichte* give the impression that a concept has referential qualities only. His thoughts that a historico-semantic analysis should expose the history of the object that lies behind the concepts can be interpreted in this way. In his interpretation of concepts 'as indicators of historical movement', among others, the danger of a problematic, realistic ontology appears, which fixes 'objects' as 'entities'.[58] But can historical objects even be seen as 'objects', as is the case with things of everyday life?

On the other hand, Koselleck's project by no means assumes a thorough correspondence of words, concepts, and objects. He correctly indicates that 'preserved ('durchgehaltene') words (..) [are] not in and of themselves sufficient indications of unchanging objects'.[59] It is precisely the discrepancies that comprise the essential epistemological interest of *Begriffsgeschichte*.

The methods used by *Begriffsgeschichte*, instead, break through the naive circular argument leading from word to object and back (..). Rather, there is a tension precisely between concept and object that can lift, can reappear, or can become virtually permanent. Again and again, a hiatus between social objects and the language use aimed at or transcending them can be registered. Changes in meanings of words and changes in objects, situational changes and pressure to rename objects correspond with each other in respectively different ways.[60]

Hence there is no reason to assume that the end of changes in *Begriffsgeschichte* are in sight, at least not as long as 'language' and 'object' are in an ongoing process of change.

In the 1980s, Koselleck developed – in a series of attempts – what he believes should be understood by 'object'. In 'Social History and *Begriffsgeschichte*', he tries to explain an 'object' that transcends conceptualization:

There are thus extra-linguistic, pre-linguistic (and post-linguistic) elements in all acts that lead to a history. They are closely attached to the elemental, geographical, biological and zoological conditions all of which affect occurrences in society by way of the human constitution.[61]

Consequently, 'objects' are for him 'comprehended and conveyed in linguistic terms'.

In the debate on structuralistic discourse theory, Koselleck recently explained his conceptualization of the relationship between word and object, or, to put it in another way, language and reality. Here, using the example of the French Revolution, he has worked out three options:

(a) In principle language can be understood instrumentally and examined in socio-linguistic terms in its function for political action groups. Language always remains an epiphenomenon of so-called real history.
(b) Language and reality can be placed in a mutual relationship to each other by determining differences, without their being entirely reducible to each other. For Luckmann, for example, it has to do with a linguistic world of meaning formation that both releases and limits – to the same extent – possible experiences in the real world. I, myself, use a dual aspect for *Begriffsgeschichte*, in which concept formations are both a factor in historical movements and an indicator of those very movements. Reality is always conveyed through language, which does not rule out its also having non-linguistic constitutional conditions.
(c) The third possibility is sharply opposed to the first. Here, texts are taken as reality itself, which is Foucault's position. By neutralizing the social classification of texts and epistemologically equating all potential textual statements, text is reduced to text only, without its being able to be read as a source for something. This approach (..) is methodologically consistent, though it leaves some questions open. This would mean that history is tied only to language. It would then be just as consistent for German historiography about French texts to be impossible, and vice versa. History would then

face danger of being conceivable only as a history of consciousness. Texts would be silent as it were in view of semantics, which always refers beyond itself, namely, to the object concerned.[62]

It is precisely the prerequisite of a meshing of diachrony and synchrony, and the 'precondition that historical change and duration be traced at the same time'[63] that would have to prevent viewing the relationship between concept and object as identical simply because the concepts are identical.

Koselleck's warning against breaking down history into discourse corresponds to his theory that 'no speech act is the act itself, which it helps to prepare, trigger and carry out'.[64] The premise that there is a difference between occurring history and its linguistic facilitation thus determines *Begriffsgeschichte* methods.

Later, however, he seems to accept both the active character and the meaning-formation role of speech acts, though this is done with definitive theoretical reservations, as he warns of linguistically reducing action: 'Even if every instance of speech comprises an act, every action is nonetheless far from being an act of speech.'[65]

Language's function in constructing meaning, despite some approaches in historiographic *Begriffsgeschichte*, has not found acceptance with respect to its full consequences. This probably comes from the efforts of some scholars of *Begriffsgeschichte* to find 'structures', 'movements', and 'contexts' with an (attributed) existence outside the history of their being recorded linguistically.

Earlier, Koselleck had already presented objects to be explained in terms of a concept analysis as extra-linguistic, even though at the same time he stressed that historical processes and structures first emerge as conscious objects through the context of use of the descriptive words. This would make it possible to reduce *Begriffsgeschichte* to the search for appropriate word-use contexts for objects that already exist since they were prerequisites for the analysis in the first place. To be more precise, there is a risk of *Begriffsgeschichte* losing its cognitive function of recognizing historical reality as a structure of consciousness – tied to language, which affords accessibility – and thus an object-construction as well.

Understanding the conceptuality of past epochs is prerequisite to moving on to the 'object' itself:

> Research from a perspective of *Begriffsgeschichte* does not study unconceived historical manifestations, but their linguistically graspable reflections in consciousness. *Begriffsgeschichte* thus does not ask, for example, what 'domination' ('Herrschaft') is per se, but what has been considered 'domination' generally and with respect to different groups.[66]

In this sense *Begriffsgeschichte* seeks the self-image of past times, how that was reflected in concepts, and how it was expressed. In a narrow sense it does not involve an examination of connections between history of words and history of objects; instead, it is concerned with how concepts become indicators of and factors in processes of meaning formation. *Begriffsgeschichte* in this sense, i.e., oriented toward social history, does not deal with the

mere reflection of social phenomena and their definition as concepts, but with the process of coping with them intellectually.

Reichardt's social historical semantics, with its basis in epistemic sociology, expressed a critical – albeit tentative – distance from Koselleck's programme. He said that 'concepts and their respective meanings [are not] mere indicators of the history of objects, but are a perceptive faculty, a collective consciousness and action of given factors that have no less reality than material relationships'.[67] This depicts language and in particular socio-political conceptuality not primarily as an indicator of extra-linguistic objects, but rather as an essentially independent social factor, an element capable of consciousness formation and action disposition.

V.

In strict opposition to viewing the traditional history of ideas as the history of 'immutable' ideas, 'the history of concepts deals with the use of specific language in specific situations, within which concepts are developed and used by specific speakers'.[68] Although *Begriffsgeschichte* studies generally start with an analysis of the relevant concept-word, it is from the outset integrated into a larger word field. The orientation of a symbol toward specific linguistic signs essentially serves as a title in delimiting an area of research. In other words, *Begriffsgeschichte* semantically transcends the word level and the individual text level. It does not, however, deal with individual lexemes; rather, its focus is on a 'vocabulary', an 'entire sector of language'.[69] This means that *Begriffsgeschichte* is not primarily concerned with the study of individual linguistic signs, but with the epistemic conditions and discursive strategies enabling their meaningful use.

Thus *Begriffsgeschichte* tries to make explicit the epistemic and cognitive prerequisites for use of a concept. Only in this way can it do justice to its task of explaining the processes of historical consciousness formation by means of a historical analysis of meaning. Words and their meanings in historical contexts can only be described adequately if their role in historical contexts of expression is explained – including their institutional conditions and protagonists, with all the related connections and references. Knowledge in historical contexts can only be reconstructed or constituted if the relationships, structures, or semantic proximity of concepts are first analyzed. Relationships between individual concepts or words can also become effective as relationships between statements, statement complexes, or implicit semantic prerequisites for meanings of words, statements, or statement complexes. At the same time, this exposing of conceptual contexts means uncovering effective epistemic factors that are all too quickly taken for granted and thus do not become conscious. *Begriffsgeschichte* as a history of consciousness aims to uncover even the deeper levels of social experience, becoming a social history of experience.

In this sense, *Begriffsgeschichte* was conceived to assume that concepts are always 'inherently reflected upon from a social perspective',[70] and that they impact 'language in social interaction'.[71] This is contained in Koselleck's search for the 'intentions behind' word meanings and their social and political contents, for the *cui bono*, and for the target groups of concepts.[72] Obviously, linguistic findings must be analyzed according to communication situations and restrictions, group codes, and text pages.

Begriffsgeschichte claims to represent a connection between the history of thinking and speaking and that of institutions, facts, and events within the concept structure, which can be viewed as discursive contexts.[73]

A type of semantics oriented toward contexts beyond the word level has, then, been referred to as 'discourse'. Discourse is seen as the site where linguistic signs become differentiated and thus at the same time mutually interpreted. Koselleck recently responded to critics, with definitive reference to pragmatic-discursive dynamics that concepts can develop in social communication. He stressed that a history of concepts and a history of discourse mutually refer to one another:

> Although basic concepts always function within a discourse they are pivots around which all arguments turn. For this reason I do not believe that the history of concepts and the history of discourse can be viewed as incompatible and opposite. Each depends inescapably on the other. A discourse requires basic concepts in order to express what it is talking about. An analysis of concepts requires command of both linguistic and extra-linguistic contexts, including those provided by discourses. Only by such knowledge of context can the analyst determine what are a concept's multiple meanings, its content, importance, and the extent to which it is contested.[74]

A more detailed analysis of these relations, however, still needs to be conducted.

PART II

Themes and Variations

CHAPTER 5

The Origin and the Meaning of the Reason of State

MAURIZIO VIROLI

After decades of nearly total silence, studies on reason of state are flourishing again.[1] Students of history of political thought now have a much clearer picture of the diffusion of the language of reason of state over 17th century Europe. They can identify the main protagonists, visualize the lines of circulation, trace the changes and the adaptations that occurred within the main body of the theory. And yet, though we know more about its developments, we still need to investigate the origin of the concept. We are yet to find a convincing answer to the question of why the locution 'ragione di stato' was put into use, if not invented. Why, in other words, did 16th century thinkers who used the words 'ragione di stato' believed that conventional terms available in political language were no longer apt?

Unless we find a satisfactory answer to these questions concerning the origin of reason of state, our understanding of the subsequent history of the language of reason of state will also be wanting. As I have argued elsewhere, after the publication of Giovanni Botero's *Della Ragion di Stato* in 1589, a new language inspired by the concept of reason of state spread throughout early 17th century Europe. This new language sustained and justified a new interpretation of the goals and the means of political action. Politics was no longer understood as the art of preserving a political life through justice and the pursuit of virtues – as the conventional definition of politics before the appearance of the concept of reason of state recites – but the art or science of preserving a state – any state – by any means.[2] The point that still needs to be clarified is that the innovative quality of the concept of reason of states consists in the conjunction of 'reason' and 'state', a conjunction of which we have no examples in the conventional language of politics until the early 16th century. In this essay, I shall therefore focus on two specific questions: which *reason* is reason of state; which state is reason of *state* the reason of? As I have remarked, the main focus of this essay is the origin of the language of reason of state. For this reason, I must specify that I am confining my inquiry to Italian political thought up until the early 17th century.

Which Reason is Reason of State?

Before answering the first question – *which reason*? – I must stress that I am referring here to the earliest formulations of the concept of reason of state, that is Guicciardini's *Dialogo del reggimento di Firenze* and Della Casa's *Oratione a Carlo V*. If we want to understand the

historical meaning of the emergence of the concept of reason of state in those texts, we must situate both the *Dialogo* and the *Oratione* within two contexts: that of the conventional language of politics and that of the 16th century language of the art of the state.

Since the 13th century, when a recognizable language of politics re-emerged, politics held the monopoly of reason: ruling in justice, shaping just laws, framing and preserving good political constitutions were, in fact, regarded as the most genuine achievements of reason. Politics was the exercise of reason in counselling, deliberating and legislating to preserve a community of men living together in justice – reason in the sense of *recta ratio in agibilium* and *ratio civilis*. As Brunetto Latini wrote in his immensely influential *Trésor*, politics teaches how to rule the inhabitants of a kingdom and a city (ville) and a people and a commune, both in times of peace and war, according to reason and justice ('selonc raison et selonc justice').[3]

The connection between right reason, justice and politics was refined and expanded by 14th century jurists, most notably by Baldus de Ubaldis, who was continuing the Roman tradition of 'civilis sapienti' or 'civilis ratio'. The source of the idiom 'civilis sapientia' was probably Ulpian: the knowledge of civil law ('civilis sapientia'), he wrote in Bk. 50 of *The Digest*, is indeed a most hallowed thing ('res sanctissima').[4] A collection of similar expressions like 'civil science' ('civilis scientia'), civil philosophy ('civilis philosophia'), civil reason ('civilis ratio'), may be found in Cicero. Unlike Ulpianus' 'civilis sapientia', Cicero's civil science, or reason, or philosophy, does not mean just the knowledge or the competence in civil law, but the more general art of ruling the republic, that is to say, politics, as Cicero himself says in the *De Finibus*, 'the topic which I think may fitly be entitled Civil Science ['quem civilem recte appellatur'] was called in Greek *politikos*'.[5]

The identification of politics and law and therefore of politics and 'recta ratio' which is the foundation of law, found in Coluccio Salutati its most eloquent advocate. Politics and the laws, wrote Salutati his dialogue *De nobilitate legum et medecinae*, are actually the same thing ('idem esse politicam atque leges').[6] The concept of 'political reason' ('politica ratio') that he introduces in Chapter 20 of the *De nobilitate* is a synonym of the Ciceronian 'civil reason' ('ratio civilis').[7]

As Cicero has taught us, writes Salutati, law is the rational norm of human life. Though we say that law is a human creation, in fact true law comes from nature and as such its origin is ultimately divine. No human law can be called a true law if it violates the highest norm of equity, which is *the precept of eternal reason*.[8] The task of political reason is that of introducing measure, proportion and justice into the human world – a task accomplished through law, which is the arrangement and the rule of political reason ('politicae rationis institutio atque preceptio').[9]

If we now read the *Dialogo* and the *Oratione* in this context, we are in the position of elucidating a first important layer of meaning, that is that in both texts the crucial contrast – crucial to understand the meaning of reason of state – is between two reasons: the reason of state vs the *recta ratio* and the *ragione civile* that were the foundation of the concept of politics that re-emerged in 13th century Italy. Reason of state, in other words, was invoked or mentioned as a reason that allows for a derogation from civil reason.

Let me briefly analyse the passages in which Guicciardini introduces the concept of reason of state. In the *Dialogue'* Guicciardini's spokesman is Bernardo del Nero. The real Bernardo del Nero was beheaded by the republican government in 1497 because of his long connection with the Medici. The fictitious Bernardo represents the experienced statesman who explains to two inexperienced republican zealots – Piero Capponi and Paolantonio Soderini – what the preservation of a state requires in practice. In the context of a discussion of the problems of the Florentine dominion over Pisa and other Tuscan cities and territories, Bernardo tells his interlocutors the story of the Genoese who failed to release the prisoners they captured at the battle of Meloria in 1284, thereby inflicting an irreparable blow on their Pisan enemies.

'I have no difficulty in conceding', Bernardo argues, 'that what the Genoese did was a cruelty of which moral conscience can never approve. Nor can moral conscience justify a war waged to expand or to defend dominions. Florence, like any state, has no legitimate title over the territories of the dominion. She just conquered them either by sheer force or with money. However, since all states – with the sole exception of republics within their own territories – are grounded on nothing but sheer violence, it is necessary for them to resort to all means to preserve themselves. If I say that it was necessary for the Genoese to kill or to keep imprisoned the captives of war', remarks Bernardo, 'I am perhaps not speaking as a good Christian, but I am speaking according to the reason and customs of the states' ('secondo la ragione e uso degli stati').[10]

In saying that all states (even republics, insofar as they are states that hold dominion over subjects) have their origins in violence, and that there is a reason of states that transcends moral reason, he meant to say that the language of politics as civil philosophy was seriously defective. He wanted to be able to say that in extreme circumstances reason may justify cruelties and injustices. However, since the reason embodied in the conventional notion of politics allowed no room for that, he had to appeal to another 'reason', and since no reason in the political philosophy of the time was available, he had to construct it.

The opposition of civil reason and reason of state is also the central theme of the famous *Speech of Monsignor Giovanni della Casa addressed to the Emperor Charles the V concerning the restitution of the City of Piacenza*. To return the city of Piacenza to the legitimate ruler Duke Ottavio Farnese, would be, stresses Della Casa, an act conforming to the norms of civil reason ('la ragione civile'). To keep it, would instead be an act conforming to reason of state, which considers only the interest of the state, disregarding all principles of justice and honesty.

Et perchè alcuni accecati nella avarizia e nella cupidità loro affermano che Vostra Maestà non consentirà mai di lasciar Piacenza, che che disponga la ragion civile, conciosiachè la *ragion degli Stati* nol comporta, dico che questa voce non è solamente poco cristiana, ma ella è ancora poco umana.[11]

All that helps us, I think, to understand in part the historical meaning of the concept of reason of state; to clarify why Guicciardini and Della Casa used that concept, but there is more to be discovered, if we take another context into consideration, namely the confiden-

tial, or private language of the art of the state. By confidential or private language of the art of the state I mean the language that was spoken in private gatherings, in memoranda and letters and in the discussions that took place, for example, in the restricted advisory bodies of the Republic of Florence and Venice.[12]

Guicciardini himself, in the *Dialogo* tells us that the kind of things on the *ragione degli stati* that he had just said should not be discussed in public: 'la occasione ci ha tirati in questo ragionamento, el quale si può comportare tra noi, ma non sarebbe però da usarlo con altri, né dove fussino più persone'.[13]

Examples of the private or confidential language of the art of the state are the records of the *Consulte* and *Pratiche*, the semi-official boards summoned by the various Councils of the republic (The Council of Eight, the Ten of Peace and Liberty) to give advice on issues of domestic and foreign policy. The citizens invited to attend the *Pratiche* were among the wealthiest and most distinguished families of the city; and the records of these discussions offer us unique documents of the political language of the 16th c. Florentine elite.[14]

From the records of those discussions, we can see that the usual practices of art of the state – waging an unjust war, treating the citizens injustly, using public institutions for private purposes, condemning an innocent, breaking an alliance, deceive, simulate – could claim no rational justification and were justified only by appealing to the *uso* of the states, not to a reason.

Reason was a key word that played a central role in the discussions of the *Pratiche*. In the *Pratica* summoned to debate the suspected treason of Paolo Vitelli, the participants discussed whether Vitelli ought to be treated 'according to reason'; and by 'reason' they meant 'justice', following the Ciceronian notion of justice embodied in Latini's definition of politics.[15] Since Vitelli might have been dangerous if left alive, one of the speakers said that in his case 'we should not proceed according to the precepts of reason ['secondo e termini di ragione'] and that matters of state are not to be handled according to reason ['e così non si suole nelle cose delli stati'].[16] The usual practice of the art of the state is then invoked to justify a decision that contradicts the rational principle of justice embedded in the republican idea of politics. This was of course, and this point seems to me a central one, a *weak* justification. As long as the art of the state could only appeal to the *uso degli stati* to justify the derogation from moral or civil reason, it was condemned to remain in a position of inferiority with respect to the language of civil philosophy. Civil philosophy had reason on its side; the art of the state had just the *uso*. And even though customary practices can claim some rights in particular circumstances before reason, reason remains the highest authority.

The endowment of the art of the state with its own reason was Guicciardini's (and later Botero's), not Machiavelli's achievement. The scholars who have stressed that although Machiavelli did not have the word, but advocated both in the *Prince* and in the *Discorsi* the substance of what was later described as reason of state, are surely right. But the fact that he did not bring himself to offer the derogations from the moral and civil laws *its own reason*, was not a minor detail. Without its reason, the language of the state would not have emerged from the semi-clandestine status; it would not have gained the intellectual respectability that it later gained. Only when it had its own reason, not just the *uso*, was it in the position of successfully competing with the old language of politics.

The transition of reason of state from the private or confidential to the public status, was however neither Machiavelli's nor Guicciardini's, but Botero's achievement. Through his work, Botero severed the notion of reason of state and the language of the art of the state from the negative moral connotations that had so far accompanied them. I cannot accept, stresses Botero, that an impious writer like Machiavelli and a tyrant like Tiberius are regarded as models for the government of states. And, above all, I hold it truly scandalous to oppose reason of state to the law of God and dare to say that some actions are justifiable on the ground of reason of state and others by conscience. By purifying it from Machiavellian and Tacitian connotations, Botero gave the art of the state a new, more acceptable meaning. The whole language of the art of the state emerged into the light after a long sojourn in the shadows of the noble language of politics.[17]

Which *State* is Reason of the State the Reason of?

In the case of Guicciardini's *Dialogo* and Della Casa's *Orazione* state means just dominion - that is a dominion imposed by force or money, or shrewdness. It is a state that has no moral justification whatsoever. In this sense, reason of state was the reason of the states that are not republics.

> E el medesimo interviene a tutti gli altri, perchè tutti gli stati, a chi bene considera la loro origine, sono violenti, e dalle repubbliche in fuori, nella loro patria e non più oltre, non ci è potestà alcuna che sia legitima, e meno quella dello imperadore che è in tanta autorità che dà ragione agli altri; nè da questa regola eccettuo e' preti, la violenza de' quali è doppia, perchè a tenerci sotto usono le armi spirituali e le temporali.'[18]

In Della Casa's *Oratione*, it is even clear that the state of reason of state is just a domination imposed by force. The Emperor had seized Piacenza: had he decided to keep instead of returning it to the legitimate ruler, he would have acted according to the reason of state. Botero's later definition of reason of state – 'Ragione di Stato è notitia di mezzi atti a fondare, conservare e ampliare un dominio cosí fatto'[19] – does not contradict its original meaning. By 'state' he means 'dominion' in general; hence, since a tyranny is a dominion, reason of state can be the knowledge of the means apt to preserve a tyranny.

It is important to remark at this stage of the argument that in the Quattrocento, historians and political philosophers used 'state' [*stato*] and 'republic' as mutually exclusive concepts. By *stato*, they often meant the network of partisans loyal to a powerful citizen or a family (e.g. 'lo stato dei Medici) that enabled that citizen or that family to control the government and the magistrates. By 'republic' they meant, according to the Ciceronian definition, 'respopuli', that is the commonwealth that belongs to the people as a whole. 'State', in this sense and 'republic' were therefore antithetical concepts, and the two corresponding arts – the art of the state and the art of politics – were also understood as being substantially different.

The difference between politics and reason of state, however, does not exclude an overlap. Reason of state can be also the reason of republics. Just as republics were also states;

politics, at times, overlapped with the art of the state. A republic is a state *vis à vis* other states and their subjects, if it possesses a dominion, as was the case with Florence. Moreover, the republic is also a state in the sense of a power structure built upon the apparatus of coercion. In dealing with other states, subjects or rebels, the representatives of the republic may easily find themselves 'necessitated', as they used to say, to derogate from the rules of civil and moral reason: fighting an unjust war unjustly, treating subjects harshly, repressing a rebellion with cruelty. The most perceptive theorists of Renaissance Italy, Machiavelli and Guicciardini, clearly spelled out the need for a ruler to be prepared to use both the art of good government and the art of the state.

The theoretical and practical overlapping between politics and the art of the state do not alter the fact, however, that the two languages competed in the Italian scenario as fundamental enemies, even if they did occasionally look at each other with interest or even fascination. *Historically*, and this is an important point, the ideology of reason of state was *perceived* as the enemy of the republic because it justified tyranny.

Nowadays we vulgarly call reason of state, remarked Campanella in 1631 with distaste, what once we used to call political reason ('ratio demum politica'). We call reason of state, he wrote in the same year, the same political reason ('ratio politica') that was in the past identified with equity and justice. Reason of state, stresses Campanella, is in fact false politics, a degeneration of true politics ('falsam illam politicam, quam vocatis de statu rationem').[20]

As Campanella remarks in his *Aforismi politici*, the ancient political reason ('ratio politica') should not to be confused with the modern concept of reason of state ('Ratio Status hodierna'). The former consists of equity ('aequitas') and authorises the violation of the latter – but not the aim – of the law on behalf of a higher and common good; the latter is an invention of tyrants ('inventio tyrannorum') that justifies the violation of civil, natural, divine and international laws in the interests of whoever is in power.[21] Other 17th century political writers lamented that even learned people had only confused ideas about the connection between politics and reason of state. As Ludovico Zuccolo wrote, some wrongly equate politics with reason of state while others maintain that the former is just a component of the latter without going any further than that.[22] Elsewhere he observed that in the common opinion politics aims at the common good, while reason of state pursues the interest of the rulers.[23]

Another example of a perception of the difference between politics and reason of state can be found in Filippo Maria Bonini's *Ciro Politico* (1647). Politics – he wrote – is the daughter of reason and the mother of the law; reason of state is the mother of tyranny and the sister of atheism. Politics indicates to the prince the right way of governing, ruling and defending his own people both in times of peace and war. Reason of state is, on the contrary, the knowledge of the means – just or unjust – apt to preserve any state. For this reason politics is the art of princes, reason of state that of tyrants.[24]

Understood as the art of good government, politics was regarded by Bonini and other 17th century writers as the highest human art whose task is to fight injustice. However, this high consideration of politics was not at all a product of the 18th century political philosophy, as it has been said, but a reiteration of Aristotelian themes that had been circulating

since the 13th century and had lost most of their power after the emergence of the concept of reason of state. Like other 17th century writers, Bonini was celebrating the old conception of politics that had been corrupted by the new concept of reason of state.[25] In addition to that, it must be said that the celebrations of politics were in some cases clearly ironical in tone. The word 'politics', wrote Giovanni Leti for example, is so sweet that nowadays everyone wants to look for it; even the vile populace that cannot practise politics, wants at least to talk of it.[26] What he means, however, is that the word 'politics' was used in an improper way, to conceal nefarious practices of bad government. His celebration was actually a critique of politics as his contemporaries understood and practised it.[27] As he perceptively observed, the names of things have changed. Princes have successfully banished the frightening name of tyranny and introduced that of politics.[28] Whereas the ancients used to call tyranny by its name, modern politicians call it 'politics'.[29]

The change of the meaning of politics and its loss of status also emerges in the works of the most pius Giovanni De Luca, the author of *Il principe cristiano pratico*. Modern political writers, remarks De Luca, do not mean by politics good government and good administration, but the preservation and the aggrandizement of the power of a person or a family. According to the common-sense view, politics is nothing but lying, deceiving, and plotting to pursue one's own interest and ambition. By current standards only fools believe that politics is sincerity, truth and honesty.[30] The consequence of this ideological and linguistic 'revolution' was that 'politics' ceased to be the pleasant and noble name it used to be.

Politics ceased to be seen as the intellectual daughter of ethics and law. Matters of state, remarked Ammirato, cannot be taught by legalists, who know only of civil and criminal litigations. The prince should listen rather to the advice of political philosophers who know about history and have studied the deeds of great princes and people. The divorce of politics and jurisprudence, however, was bitterly contested. In his *Ritratto del Privato Politico Christiano* (1635), the Bolognese Virgilio Malvezzi wrote that law is politics (*La legge è una politica*), but nowadays few legalists are politicians (*politici*). In the past politics was the legitimate daughter of jurisprudence. Now politics is a mechanical activity, and the legalists have become empiricists.[31]

If we go back to the question that I raised at the outset of this paper, namely why political philosophers constructed and put into use the locution 'ragione di stato', we can answer that they did it because they needed a new concept of reason apt to excuse derogations from moral and civil law imposed by the necessity to preserve or expand states understood as *dominions*. And as a corollary to this, we may add that the appearance of the concept of reason of state contributed to change the meaning and the range of application of the concept of politics. It marked the beginnings of what has been aptly called 'the politics of the moderns' as opposed to 'the politics of the ancients', that is the view that politics is simply the art of pursuing, securing, expanding power, not, as the ancients and their naive humanist followers seemed (or pretended) to believe, the art of founding and preserving a republic. Whether the transition from the former to the latter conception of politics should be regarded as an intellectual progress or as a decay is a highly contested matter, but it cannot be denied that the transition, did indeed take place; and it began when those two words, reason and state were put together.[32]

Conceptual History and the History of Political Thought

TERENCE BALL

Concepts, like individuals, have their histories, and are just as incapable of withstanding the ravages of time as are individuals.
Kierkegaard [1]

Four centuries ago Cervantes showed how the moral codes and concepts of one age are apt to be unintelligible in another. In the novel that bears his name as its title Don Quixote attempts, in vain and with comic results, to resurrect and to follow the code of knight errantry. He does so, however, in an age that thinks and speaks in an entirely different vocabulary. The bookish Don fails to recognize that the concepts constitutive of that code – honour, chivalry, courtly love and the concept of a quest – are out of place in his time and are meaningless to his contemporaries. Because Don Quixote not only speaks and thinks but attempts to act in accordance with this archaic code, his contemporaries see him as a comic character and his quest (we would say nowadays) as 'quixotic'. Thus Cervantes helps us to recognize the reality of conceptual change – and to appreciate the vast differences between past peoples' conceptually constituted practices and our own.

To encounter and attempt to understand these beliefs and practices in all their strangeness requires the stretching of our own concepts and categories. If philosophy begins in wonder, conceptual change gives us something to wonder about in the first place. One of the tasks of the conceptual historian is to address this sense of strangeness, of difference, not to make it less strange or different, but to make it more comprehensible, to shed light on past practices and beliefs, and in so doing to stretch the linguistic limits of present-day political discourse.

My aim in this article is to sketch what I take to be several important features of 'conceptual history', especially as it relates to the ways in which we think about and write the history of political thought. I plan to proceed in the following way. First I shall attempt to tie an interest in conceptual history with the 'linguistic turn' in twentieth-century philosophy. Then I shall outline what one might (with some slight exaggeration) call two 'schools' of, or 'approaches' to, conceptual history – the German *Begriffsgeschichte* and its Anglo-American counterpart, with particular emphasis on the latter. Next, I shall try to delineate what I take to be the distinguishing or defining features of *political* discourse as a field of investigation.

Then I shall say something about what I call 'critical conceptual history' as an approach to the investigation of political innovation and conceptual change. And finally, I shall conclude with a brief and selective defence of this perspective as it bears on the way we write the history of political thought.

Completing the 'Linguistic Turn'

Although the recorded history of the human species is the story of almost continuous conceptual change, the political and philosophical import of this fact has too often been ignored or played down by modern philosophers. There are of course a number of notable exceptions. Hegel, Kierkegaard and Nietzsche had a lively appreciation of the historicity and mutability of our moral and political concepts. Amongst anglophone philosophers R.G. Collingwood, Hannah Arendt, and Alasdair MacIntyre have been among the brilliant exceptions to the dismal rule that modern philosophers, particularly of the Anglo-American 'analytical' variety, have tended to treat moral and political concepts as though they had no history, or as though their having a history was a matter of little or no philosophical interest or importance.[2]

This neglect seems at first sight surprising, considering that twentieth-century philosophy supposedly took a 'linguistic turn'.[3] And yet, in emphasizing the minute analysis and clarification of 'the' meaning and use of particular concepts, 'linguistic' or 'ordinary language' philosophy or 'conceptual analysis' as practised in Britain and the United States, tended to focus upon the language of one age and culture, namely our own. This narrowing not only blinded philosophers to the fact that meaning and usage change from one age and generation to the next, but it also led them to believe their enterprise to be a politically neutral one of clarifying and analysing what 'we' say, as though 'we' were a single speaking subject, undivided by partisan differences, and unchanged and unchanging over time. In thus assuming that there is a unified 'we', ordinary language philosophy largely ignored the twin issues of political conflict and conceptual change.

This is not to say that the potential for such a focus was utterly lacking in 'linguistic' philosophy, only that the potential was not at first realized. The cases of Wittgenstein and J. L. Austin – two otherwise very different founders of what came to be called ordinary language philosophy – are instructive in this regard. Both paid closer attention to the history of language and conceptual change than did most of the philosophers who followed, as they thought, in their masters' footsteps. Wittgenstein, like his forebears Karl Kraus and Heinrich Hertz, had an acute appreciation of the historical variability and mutability of linguistic meaning. Every concept is the repository of earlier associations and uses. As previous meanings recede into the background, new ones take their place. By way of illustration Wittgenstein invites us to consider 'The concept of a "Festivity". We connect it with merry making; in another age it may have been connected with fear and dread. What we call "wit" and "humour" doubtless did not exist in other ages. And both are constantly changing.'[4]

Austin makes a similar point, albeit in a rather different way. Our concepts have histories, he says, and come to us with 'trailing clouds of etymology'. These are the traces left by earlier speakers who have worked and reworked our language, extending its range and pushing its limits by drawing new distinctions, invoking new metaphors and minting new terms. The language we now speak is the result of the most long-lived and successful of those earlier attempts at conceptual revision; it 'embodies all the distinctions men have found worth drawing, and connections they have found worth marking, in the lifetimes of many generations'.[5] Austin was widely read – or rather, I suspect, mis-read – as an advocate of conceptual clarification *simpliciter*, and a hidebound conservative who held that our language is already well-nigh perfect and in no need of further revision. If so, he (or at any rate those who read him in this light) makes the same mistake that Marx ascribed to the political economists of his day – the mistake, that is, of assuming that there once was history, but there is no longer any.

Now, however, there are indications that the linguistic turn is at last being completed. A static and a-historical view is giving way amongst Anglo-American philosophers to a more historical approach to the study of language, and in particular, the languages of political theory. There is now a noticeable move away from the static and a-historical enterprise of 'conceptual analysis' to a more dynamic and historically oriented emphasis on conceptual change and the construction of conceptual histories.

Approaches to Conceptual History

The two main approaches to conceptual history have proceeded along parallel tracks. On one track is the modern German genre known as *Begriffsgeschichte*; on the other, Anglo-American 'conceptual history' or what I call 'critical conceptual history'.[6] Let me offer, by way of introduction to these two approaches, a broad-brush and somewhat crude characterization of each.

Reinhart Koselleck, arguably the leading defender and practitioner of *Begriffsgeschichte*, observes that 'without common concepts there is no society, and above all, no political field of action'. But which concepts are to be the common coin of discourse becomes, at crucial historical junctures, a veritable field of battle. 'The struggle over the "correct" concepts', says Koselleck, 'becomes socially and politically explosive'.[7] The conceptual historian attempts to map the minefield, as it were, by examining the various historical turning-points or watersheds in the history of the concepts constituting modern political discourse. This involves not only noting when and for what purposes new and now-familiar words were coined – ideology, industrialism, liberalism, conservatism, socialism and altruism, amongst many others, but tracing the changes in the meaning of older terms such as 'constitution' and 'revolution'. This is just the task outlined and given theoretical justification by Koselleck and undertaken in painstaking detail by the contributors to the massive *Geschichtliche Grundbegriffe*, the *Handbuch politische-sozialer Grundbegriffe in Frankreich 1680-1820*, and other works.[8]

German conceptual historians have attempted to test a number of hypotheses. One is that the eighteenth century was a period of unprecedented conceptual shifts. Another is

that these shifts involved not only the minting of new terms and the reminting of older ones, but that they point to an increased tendency toward ideological abstractions. Thus the late eighteenth and early nineteenth centuries saw the rise of the various 'isms' – socialism, communism, industrialism, etc. – which, by supplying speakers with a new means of locating themselves in social and political space, actually reconstituted that very space. Political conflict accordingly became more overtly ideological, more concerned with questions of principle (or even first principles) than was previously the case. Concepts that had heretofore had concrete class and geographic referents became free-floating abstractions about which one could speak in an ostensibly universal voice. 'Rights', for example, ceased to be the rights of Englishmen and other national or legal groups, and became instead 'the rights of man' or, as we are apt to say nowadays, 'human rights'. The studies undertaken by Koselleck and his colleagues have, on the whole, tended to confirm these conjectures.

I noted earlier that German and Anglo-American conceptions of, and approaches to, conceptual history proceed along parallel tracks. The metaphor is apt: the definition of parallel lines is that, however close they come to each other, they never intersect. Anglo-American conceptual historians both resemble and differ from their Continental counterparts in a number of ways. They are alike in at least two respects. First, both are interested in the linguistic limitations and political possibilities inherent in historically situated vocabularies. Both are, accordingly, concerned with the linguistic dimensions of political conflict. Second, neither has an explicit, systematic, and fully worked-out methodology (although the practitioners of *Begriffsgeschichte* have perhaps come closer to developing one). But there the similarities end, and the differences become apparent.

The German conceptual historians have, firstly and unsurprisingly, so far concentrated their considerable learning largely (though by no means exclusively) on mapping conceptual changes in earlier German and French political and philosophical discourse. Their English-speaking colleagues have focussed almost exclusively on the history of anglophone political discourse. Secondly, the German conceptual historians have employed a lock-step way of proceeding, have worked collectively, and have attempted to be encyclopaedic in range and scope. Their English-speaking cousins have for the most part worked individually, have subscribed to no single approach or procedure, and have been more selective than encyclopaedic in their ambitions and choice of concepts.

I cannot, of course, speak authoritatively about anybody's views but my own. In a very limited way some of my own work amounts, in effect, to a comparative test of several of the hypotheses about conceptual change advanced by the German conceptual historians. For example, several of my inquiries in *Transforming Political Discourse* (1988) suggest that the eighteenth century was indeed a period of profound and unprecedented conceptual transformation in anglophone political discourse, at least regarding the concepts of 'party' and 'republic'.[9] And my interest in conceptual history has as much to do with the present as with the past. As significant as earlier, and especially eighteenth-century, shifts were, conceptual change is not safely confined to the past but is continuing even as, and because, we speak. My own view, which may be more a suspicion than a testable hypothesis, is that we are living through and participating in a period of profound, exhilarating, and in some

ways deeply disturbing conceptual shifts. I have attempted in my own and in collaborative works to give voice and substance to this suspicion.[10]

Political Discourse

If we are to take a 'conceptual-historical' approach to the study of political phenomena, then we need to identify the defining or distinguishing features of political discourse as a field of investigation. Moreover, we need to be clear about the concepts comprising our own discourse. Let me begin with the latter, and go on to consider the former.

In referring to this or that 'language', I do not mean the natural languages analysed by linguists – Attic Greek, for example, or modern Dutch – but allude to what one might at first cut call a moral or political language. A language of this sort includes those 'shared conceptions of the world, shared manners and values, shared resources and expectations and procedures for speech and thought' through which 'communities are in fact defined and constituted'. This is immediately complicated, however, by a second consideration. A community's language is not a seamless web or a single structurally unified whole but consists instead of a series of sub-languages or idioms which I call discourses.

A 'discourse', as I use the term, is the sub-language spoken in and constitutive of a particular discipline, domain, sphere or sub-community. Examples of such sub-languages might include the discourse of economics, of law, of medicine, of computer programming, and a score of other disciplines or domains.

But what of *political* discourse? Is it merely one discourse amongst many, or does it have unique distinguishing features of its own? Here matters become much more complicated. One of the key features of political discourse is to be found in its central tension, which may be described in the following way. Political discourse is, or at any rate purports to be, a bridging language, a supra-discourse spanning and connecting the several sub-languages; it is the language that we supposedly share in our common capacity as citizens, not as speakers of specialized sub-languages. But, at the same time, this linguistic-political ideal is undermined in two ways.

First, political discourse borrows from and draws upon more specialized discourses; it is compounded, as it were, out of lesser languages. When the concepts and metaphors constituting the discourse of economics, for example – or of computer programming or law or religion or medicine or any other discipline enter the field of political meanings, they alter the shape and structure of that field by altering its speakers' terms of discourse. This process of transgressing – either intentionally or inadvertently – is a prime source of conceptual change.

Second, political discourse characteristically consists of concepts whose meanings are not always agreed upon, but are often heatedly contested by citizen-speakers. The possibility of communicative breakdown is an ever-present feature, if not indeed a defining characteristic, of political discourse. As de Jouvenel observes:

The elementary political process is the action of mind upon mind through speech. Communication by speech completely depends upon the existence in the memories of

both parties of a common stock of words to which they attach much the same meanings....Even as people belong to the same culture by the use of the same language, so they belong to the same society by the understanding of the same moral language. As this common moral language extends, so does society; as it breaks up, so does society.[11]

Passing this observation through a finer (and less mentalistic) mesh one should add that the elementary political process is the action of speaker upon speaker about matters of public or common concern. However, what is and is not 'public' – and therefore presumably political – is itself a subject of political dispute and argument. Disagreements about the scope and domain of 'the political' are themselves constitutive features of political discourse.

In aim and aspiration, then, political discourse anticipates agreement and consensus, even as its speakers disagree amongst themselves. This discursive ideal is as old as Socratic dialogue and as recent as Habermas' ideal speech situation. That this ideal remains unrealized in practice has been taken by some political philosophers to be a defect of political discourse, or at any rate a flaw attributable to the speakers engaged in it. From this they conclude that political discourse needs reforming, or at least that certain sorts of speakers need chastening, either by learning to speak this new language or by being silenced. One of the aims of my inquiries has been to suggest that the hope of ending such disputes and of arresting or even reversing conceptual change is misdirected, inasmuch as it rests upon a misunderstanding of the structure and indeed the very point of political discourse. In focusing exclusively upon the anticipation of consensus, one grasps only one of the poles of political life. By grasping the pole of anticipated consensus and playing down conceptual conflict one denatures political life and the language that makes that life both possible and necessary. Disagreement, conceptual contestation, the omnipresent threat of communicative breakdown, and the possibility of conceptual change are, as it were, built into the very structure of political discourse.[12]

A number of contemporary political philosophers, following the lead of W.B. Gallie, have attempted to articulate and analyse this feature of political discourse by suggesting that moral and political concepts are 'essentially contested'.[13] A concept is essentially contested if it has no single definition or criterion of application upon which all competent speakers can agree. For reasons that I have elaborated elsewhere, I do not believe that the thesis of essential contestability takes us very far in any analytically useful direction.[14] For to claim that a particular concept is essentially contested, is to take an a-historical view of the character and function of political concepts. Not all concepts have been, or could be, contested at all times. Conceptual contestation remains a permanent possibility even though it is, in practice, actualized only intermittently. The now-ubiquitous disputes about the meaning of 'democracy', for instance, are of relatively recent vintage, while the once-heated arguments about 'republic' have cooled considerably since the late eighteenth century (indeed they now rage only amongst historians of political thought, and not amongst political actors or agents).[15]

We might say, then, that the essential contestability thesis holds true, not as a thesis about individual concepts, but as a valid generalization about political language as a species of discourse. The language of political discourse is essentially contestable, but the concepts

comprising any political language are contingently contestable. Which concepts are believed to be worth disputing and revising is more often a political than a philosophical matter. In some situations it becomes important for political agents to take issue with their opponents' and/or audience's understanding of 'party' or 'authority' or 'democracy'. Out of these challenges, or some of them anyway, come the conceptual changes that comprise the subject-matter of critical conceptual history.

Critical Conceptual Histories

The task of the critical conceptual historian is to chart changes in the concepts constituting the discourses of political agents both living and dead. The kinds of questions to be asked about the transformation of political discourses will typically include the following. How might one identify or describe these discourses and the specific changes made in them? Which concept(s), in particular, had their meanings altered? How and why did these changes come about? Who brought them about, for what reasons, and what rhetorical strategies did they use? And, not least, what difference did (or does) it make?

These questions will often, though not always, be answered in some part by pointing to a particular political tradition or, if one prefers, a tradition of discourse.[16] Examples of such traditions might include republicanism, liberalism and Marxism, amongst many others. And these can in turn be further divided into sub-traditions such as classical and Renaissance republicanism, Soviet Marxism, Manchester liberalism, and the like.

Political discourses, and the concepts that constitute them, have histories that can be narratively reconstructed in any number of ways. Such histories would show where these discourses functioned and how they changed. These changes may, moreover, be traced to the problems perceived by particular (classes of) historical agents in particular political situations. Conceptual changes are brought about by political agents occupying specific sites and working under the identifiable linguistic constraints of a particular tradition as it exists at a particular time. The vocabularies within and upon which these agents work are to some degree flexible, although not infinitely malleable. They can to some extent transform their language; but, conversely, their language also subtly transforms them, helping to make them the kinds of creatures they are. The ways in which speakers shape and are in turn shaped by their language are the subject-matter of critical conceptual history.

But – a critic might ask – why speak of concepts instead of words, of 'conceptual' change rather than 'linguistic' change, and of conceptual history rather than linguistic history?[17] And what – my critic might continue – is *critical* about 'critical conceptual histories'?

The first question is easily answered. A political vocabulary consists, not simply of words, but of concepts. To have a word for X is to be in possession of the concept of X. Yet one may possess a concept without having a word to express it. It is, for instance, clear that Milton knew about, and valued, 'originality', otherwise he would not have thought it important to try to do 'things unattempted yet in prose or rhyme'. But although Milton quite clearly possessed the *concept* of originality, he had no word with which to express it, for 'originality' did not enter the English language until a century after his death.[18] Much the same is true of moral and political concepts. For example, the concept of rights long pre-

dated the word.[19] Moreover, the same word can, in different periods, stand for quite different concepts. The 'rights' of Englishmen, for example, were quite unlike the 'rights' of man or the 'human rights' defended or violated by modern regimes. Nor did 'the state', or at any rate *lo stato*, mean for Machiavelli, what it means for us.[20] Nor did 'revolution' mean for Locke and his contemporaries what it means for us. They understood a revolution to be a coming full circle, a restoration of some earlier uncorrupted condition; we understand it to be the collective overthrow of an old regime and the creation of an entirely new one.[21] 'Corruption' has decidedly different meanings in the discourses of classical republicanism and modern liberalism.[22] 'Ideology' was originally, in the eighteenth century, the systematic scientific study of the origins of ideas; now it refers to a more or less tightly constrained set of political ideas and ideals.[23] A 'patriot' – nowadays an uncritical supporter of his country's government – was once one who dared to be an opponent and critic of his government.[24] These and many other examples suggest that words do not change, but concepts and meanings do. In an important sense, then, words do not have histories but concepts do.

The history of *political* concepts (or more precisely, concepts deployed in political discourse) cannot, however, be narrated apart from the political conflicts in which they figure. Political concepts are weapons of war, tools of persuasion and legitimation, badges of identity and solidarity. They are in the thick of partisan battles for 'the hearts and minds of men' (to reinvoke that old Cold War cliché). To study the history of political concepts is to revisit old battlefields and reconstruct the positions and strategies of the opposing forces. What concepts were on this occasion available, for what purposes and with what effect(s) were they used? How were their meanings altered in the course of their deployment? To put my point less dramatically, what distinguishes critical conceptual history from philology or etymology is its attention to the political contests and *arguments* in which concepts appear and are used to perform particular kinds of actions at particular times and at particular political sites.[25] Histories of political concepts are, in short, histories of political arguments and the conceptual contests and disputes on which they turned and to which they gave rise. This is not, of course, to claim that all political conflicts are (reducible to) linguistic or conceptual contests. Many, though not all, major political conflicts and disagreements are *in part* about the 'real' or 'true' meaning of key concepts – 'liberty', 'equality', 'justice', 'rights', 'representation', and many others besides. One need only think, for example, of current debates about multicultural citizenship, ethnic identity, group rights and representation: do 'rights' properly belong only to individuals, or can they be ascribed to groups according to ethnicity, gender, and/or sexual preference? These and other questions raised in the modern multicultural minefield are at once 'conceptual' and political.

A second and more complicated matter still remains to be addressed. What, exactly, is critical about 'critical conceptual histories'? Several answers can be given. The first is that these are histories written with a critical intention of showing that conceptual change is not only possible but is virtually a defining feature of political discourse. Second, such histories will, if successful, show how particular political agents became aware of the subtle and heretofore unrecognized ways in which their discourses had transformed them (and their contemporaries) before setting about the task of transforming political discourse. Third, a critical conceptual history shows in some detail how these agents actually transformed the

discourse of their day. This requires that the historian identify the processes and mechanisms by means of which specific agents brought about particular changes. These include, pre-eminently, the discovery, exposure and criticism of ostensible contradictions and incoherences in dominant discourses, and the arguments and rhetorical stratagems employed for that critical purpose and for the more positive purpose of constructing an alternative discourse.[26] Far from being the domain of detached armchair philosophers, this kind of critical activity affects the ways in which political agents themselves think and act. What Alasdair MacIntyre says of the role of criticism in changing moral concepts is no less true of its role in changing political ones:

> philosophical inquiry itself plays a part in changing moral concepts. It is not that we have first a straightforward history of moral concepts and then a separate and secondary history of philosophical comment. For to analyze a concept philosophically may often be to assist in its transformation by suggesting that it needs revision, or that it is discredited in some way. Philosophy leaves everything as it is – except concepts. And since to possess a concept involves behaving or being able to behave in certain ways in certain circumstances, to alter concepts, whether by modifying existing concepts or by making new concepts available or by destroying old ones, is to alter behavior. A history which takes this point seriously, which is concerned with the role of philosophy in relation to actual conduct, cannot be philosophically neutral.[27]

Nor, by the same token, can conceptual histories be politically neutral. This is not to say that they are necessarily partisan in any narrow sense, but rather that they are critical, inasmuch as they alert their audience to the ways in which and the means by which their communicatively constituted world has transformed them and how they in their turn may yet transform it.

Political Agency and Conceptual Change

I want to conclude by suggesting some of the ways in which an emphasis on conceptual change might bear upon the way we narrate and understand the history of political thought. In particular, I want to suggest that a focus on conceptual change does not require a radical refocusing of the historian's attention, although it does entail more careful attention to the conceptual character of much political conflict. And I want to insist that attention to conceptual conflicts and innovations does not – *pace* some meta-scientific 'realists' and postmodern 'discourse theorists'[28] – require that we eschew political agency or intentionality; quite the contrary.

Perhaps the most important point to note is that a focus on conceptual change is not tantamount to a Copernican Revolution in the historiography of political thought. It is but one lens through which to re-view and perchance revise the history of political thought. It helps one to become aware of things that might otherwise be overlooked. In particular, 'conceptual histories' highlight the languages – the concepts and categories, the metaphors

and rhetorical stratagems – in which political problems are framed, discussed, debated, and sometimes even resolved, by partisans of various stripes.

A second feature is the truism that political actions (including those that alter or extend the meanings of political concepts) are intentional – that is, they are attempts to *do* something, to make something happen, to bring something about. But a recurring – and arguably a defining – feature of human action is that actions often misfire, producing consequences unforeseen, perhaps even unforeseeable, by the actor(s) themselves. That purposive political actions can, and typically do, produce unintended consequences need not pose any grave difficulty for an approach that views conceptual change as a product of intentional human action or activity. To appreciate just how and why this might be so, let us look outside the immediate purview of political theory.

Suppose I arrive home late one evening. Entering my house, I flip the light switch and several things happen. The light comes on, as I intended that it should. But the light's coming on also wakes the cat, alerts a burglar in the adjoining room, annoys a neighbor, causes the dial in the electric meter to rotate, and raises my electric bill. Flipping the switch is my 'basic action'.[29] The light's coming on is my action under an intentionalist description: that is what I was doing, or trying to do, when I flipped the switch. I did not intend, and could not have intended, to wake the cat or to frighten the burglar, since I was in no position to know that the cat was asleep or that the burglar lurked in the adjoining room. And yet I *did*, i.e. brought about, all these things, not all of which were intended but all of which were made possible by my acting intentionally.

The performance of a political action – including the act of writing a treatise on political theory – is not unlike flipping the light switch. The basic action of putting pen to paper can be given an intentionalist description: the author was doing, or attempting to do, a certain thing – to defend or to criticize royal absolutism, to justify or decry regicide, to promote or oppose religious toleration, or any number of other things. But an author's action may well (and typically does) produce unintended consequences. His argument might, for example, later be used for purposes that the author did not address, and did not or perhaps could not have intended, or even foreseen. This truism is not exactly a novel insight. However, a focus on 'conceptual history' leads us to pay close attention to the concepts used in constructing that argument, and the linguistic conventions according to which it was constructed in the first place, and reinterpreted or reconstructed by later authors and/or audiences. A particular (line of) argument may well be misunderstood (or deliberately ignored) by later writers who wish to appropriate, extend, or perhaps amend what they took this earlier writer to have been doing. Some of these misunderstandings and/or rank misrepresentations may prove fruitful for other actors with their other, doubtless very different, aims and agendas. And a focus on conceptual change can bring this into bold relief. An example might serve to illustrate my point.

Margaret Leslie and Joseph Femia have criticized Quentin Skinner for his historicist and contextualist critique of 'anachronistic' readings of earlier thinkers.[30] Strained analogies, and even anachronisms, they contend, may, in the hands of an ingenious writer such as Antonio Gramsci, prove to be politically persuasive when addressed to a certain sort of audience. In re-describing the Communist Party as the 'modern prince', Gramsci adapted and

made creative use of what he took to be Machiavelli's notion of a ruthless and all-powerful *principe*.[31] On Gramsci's reading, the communist party, like Machiavelli's prince, must be prepared to use guile, cunning, deceit, and violence to achieve worthy ends. By substituting 'Party' for 'prince', Gramsci was able to adapt Machiavelli's arguments to a more modern and distinctly different context. That Gramsci's use of Machiavelli's text was admittedly anachronistic is beside the point. For as a political actor Gramsci had, and used, the political equivalent of poetic license.

Skinner's contention, in effect, is that no such license is granted to historians of political thought. They, unlike Gramsci and other political actor-authors, are held to more stringent scholarly standards. If conceptual historians are to understand the meaning that particular terms, utterances, claims, and arguments had for certain authors and their audiences then surely we must, at a minimum, know something about the linguistic conventions of the day and the political concepts, languages, or idioms available to them, and the changes that these concepts have undergone in the interim. A critical conceptual historian's reply to Leslie and Femia would note, *inter alia*, that the modern concept of the 'political party', as understood by Gramsci and his audience, was not available to Machiavelli and his contemporaries.[32] One might also note that certain key concepts in Machiavelli's vocabulary, such as *fortuna*, have no place in, and are arguably at odds with, Gramsci's own rather more deterministic Marxian framework. To make these observations is of course to take nothing away from Gramsci, who wrote not as a scholar, but as a political actor and activist who was in Skinner's sense an 'innovating ideologist'.[33] Gramsci, in other words, used an existing and already well-known stock of concepts and images to re-describe and lend legitimacy to an institution widely regarded as suspect. An interpretation like Gramsci's may be adjudged good (innovative, ingenious, path-breaking, persuasive, etc.) on political grounds, even as it is adjudged deficient on historical or scholarly grounds, and vice-versa.

Political innovation and conceptual change often occurs piecemeal and by way of rather ragged processes. It comes about through debate, dispute, conceptual contestation, partisan bickering – little if any of which satisfies the standards of Socratic *elenchus* or the Habermasian ideal speech situation in which 'the forceless force of the better argument' carries the day.[34] We must remember that political actors, past and present, are apt to fight dirty by, for example, misrepresenting opponents' views, constructing arguments *ad hominem*, reasoning anachronistically, and using almost any rhetorical weapon that comes to hand. And success in such endeavors depends, as often as not, upon one side's skill or sheer good luck in hitting upon an illuminating image or telling metaphor to make its case persuasive or at least palatable.[35] It is also important to note that such arguments and appeals must be tailored to the tastes, standards, and outlook of the audience at which they are aimed. If a political actor-author fails to take his audience's standards into account, he runs the grave risk of having his actions viewed as unintelligible and/or illegitimate. Both *desiderata* – intelligibility and legitimacy – are, for *political* agents, considerations of surpassing importance. As Skinner notes, 'the problem facing an agent who wishes to legitimate what he is doing at the same time as gaining what he wants cannot simply be the instrumental problem of tailoring his normative language in order to fit his projects. It must in part be

the problem of tailoring his projects in order to fit the available normative language'.[36] Hence,

> however revolutionary the ideologist . . ., he will nevertheless be committed, once he has accepted the need to legitimate his behaviour, to attempting to show that some of the *existing* range of favourable evaluative-descriptive terms can somehow be applied as apt descriptions of his own apparently untoward actions. Every revolutionary is to this extent obliged to march backward into battle.[37]

Or, if you prefer the idiom of Marx to that of Skinner, political actors do remake their language, but they do not transform it just as they please; they alter their concepts under circumstances directly encountered, given, and inherited from the past.[38]

At the same time, however, a political actor/author – particularly one on whom we (retrospectively) bestow the honorific title of political theorist – not only does things *with* language, but also *to* language. His or her actions produce changes (sometimes intended, sometimes not) in the vocabulary available to his or her audience and to subsequent speakers of the language. Through the use of argument, analogy, metaphor and other means he or she may be able to alter the language of description and appraisal in certain ways, perhaps by extending the meaning of a term, or even (though more rarely) by coining a new one.

The value of conceptual history resides in its sensitizing us to the conceptual character of political conflict, to the terms or concepts contested therein, and the changes wrought as a result. The most fitting fate for 'conceptual history' is that it will cease to be regarded as an exotic, distinct, and perhaps optional 'method' or 'approach' to writing the history of political thought, and will become a standard feature of the way in which historians pay attention and do their work.

Conceptual History in Context: Reconstructing the Terminology of an Academic Discipline

BERNHARD F. SCHOLZ

Finding arguments in support of an intellectual enterprise like conceptual history would seem easy enough. In the various strands of the ongoing 'conversation of mankind', to use Michael Oakeshott's felicitous phrase,[1] what one may expect to find are continuations, transformations and adaptations of arguments, followed by disruptions, distortions, and reductions which, in turn, can be undone by revivals, rediscoveries, and renascences of strands of conversation. What one is unlikely to encounter, since there is no epistemology shared by all participants of that conversation through the ages, are categorial beginnings and endings like those demanded of a good tragedy by Aristotle's *Poetics*,[2] or instances of newness or outdatedness of the sort foisted upon us by the masters of planned obsolescence. Research into the histories of concepts, then, can perhaps best be viewed as a methodical attempt at reflecting on and reconstructing specific strands of that conversation.

Problems arise, however, as soon as one attempts to be more specific about the characteristics of the strands one wishes to reconstruct, or about the relations of those strands to other strands of the conversation. How are the strands in question to be delineated? In whose strand of conversation are we going to trace a particular set of concepts? In the strands associated with particular scientific or scholarly disciplines, and controlled by a particular social group? Or is an attempt to be made to account for the manner in which a historically delineated social 'life world' as a whole used to converse on a particular topic? Are the concepts in question to be culled exclusively from the discourses of particular disciplines? Or are they to be gathered from the welter of voices of a 'lifeworld'? Are the concepts in question to be understood as objects named by the terms of a discipline-specific terminological repertoire, objects, that is, which have themselves been 'defined' and 'differentiated' in the process of being associated with the terms of such a repertoire?[3] Or are they to be understood as objects named by the expressions of everyday language, prior to any methodological defining and disciplining of that language? Questions such as these are rarely if ever raised in the programmatic literature on the history of concepts. Instead, the onset of methodological reflection on the possibility of conceptual history tends to be a point at which these questions have already been answered, in most cases implicitly. Since my aim in this paper is to argue for the feasibility of a discipline-specific manner of 'writing

conceptual history', rather than to take the justification of such an approach to conceptual history for granted, I shall begin with a brief discussion of the principal options open to the historian of concepts, which are implied in these questions. I shall then discuss some of the salient characteristics of a discipline-specific version of conceptual history. And I shall conclude with a presentation and discussion of a lemma from a forthcoming dictionary of literary terms and concepts.

Strands of Conversation

Assuming the basic correctness of the view that the gradual emergence of the various natural and cultural sciences can be described as the results of ongoing processes of functional differentiation of previously less differentiated lifeworld complexes of action,[4] it would follow that the terminologies of these sciences, too, can be described in terms of ongoing processes of functional differentiation, this time of the variants of language utilized in the everyday lifeworld. The advantage of this view of the emergence of the sciences and their respective languages for the student of conceptual history lies in the fact that it will allow him or her to identify the entities the histories of which he wishes to study, the 'concepts' of his domain of objects, as belonging to one or the other strands of conversation which emerge as a result of these ongoing processes of differentiation.

Some of these strands, like those of mathematics and physics, will contain highly formalized languages. Others, like those of the law courts, though not formalized, will be characterized by the use of strictly defined concepts and highly ritualized forms of expression. Yet others, like those used in the public and the private domain, will be seen to contain a mix of concepts of varying degree of definition and precision.

In settling on his domain of objects, the student of conceptual history will, trivially enough, perhaps, focus on one or more of such strands, and he will derive his materials from the types of text which circulate among the participants of the strand of conversation in question. In some strands, he will only encounter texts which have been purged as much as possible of non-apophantic elements; think of the attempts in the early days of the Royal Society to expurgate the use of rhetorical tropes from the papers published in its proceedings.[5] In other strands of conversation, by contrast, like those of the public sphere of politics, he will find texts which make it plausible to distinguish, as Koselleck does, between the *Erfahrungsgehalt* (experiential content) and the *Erwartungsraum* (expectational space) of a concept.[6] Clearly that would be a highly implausible thing to do with the concepts encountered in the texts of strands of conversation which characterize the empirical natural sciences.

The point I am trying to make about the need to opt for one or the other strand of conversation, and to be aware of what to expect once that option has been made, will become clear if we reflect for a moment on what Reinhart Koselleck, has to say about concepts in general:

Ein Wort kann nun – im Gebrauch – eindeutig werden. Ein Begriff dagegen muß vieldeutig bleiben, um ein Begriff sein zu können. Auch der Begriff haftet zwar am Wort, er ist aber zugleich mehr als ein Wort: Ein Wort wird zum Begriff wenn die Fülle eines politisch-sozialen Bedeutungs- und Erfahrungszusammenhanges, in dem und für den ein Wort gebraucht wird, insgesamt in das eine Wort eingeht. [...] Ein Wort enthält Bedeutungsmöglichkeiten, ein Begriff vereinigt in sich Bedeutungsfülle. Ein Begriff kann also klar sein, muß aber vieldeutig sein.[7]

It would be easy enough to be uncharitable and call this a higher form of academic nonsense. But let us follow Paul Ricoeur's advice and read this passage through the glasses of a hermeneutics aimed at a recollection of meaning rather than an exercise of suspicion.[8] What Koselleck is describing is clearly not the manner in which concepts function in the strands of conversation which are characteristic of the cultural sciences where terminological precision is of the essence. He is not even describing – one hopes – the use of concepts in his own field of research, *Begriffsgeschichte*. What he is giving us instead is a very adequate description of the manner in which concepts (and words) circulate in the strand of conversation which serves in the construction and maintenance the social reality of the lifeworld.[9] The *Begriffe* to which Koselleck is referring in this passage are clearly not the objects named by terms occurring in the strictly apophantic texts of the sciences. They are the mental correlates of expressions which are to be encountered in pamphlets, tracts and treatises, newspapers and periodicals, in edicts and governmental decrees and proclamations, hansards and official bulletins, on posters, in diaries and in private correspondences and other types of texts not subject to the constraints of scientific methodology. They represent, furthermore, the propositional content of a large variety of speech acts ranging from contracts to promises to orders to statements. Moreover, they represent the propositional content of those speech acts not *in vitro*, so to speak, de-contextualized, but *in situ*, with the illocutional and perlocutional characteristics of those speech acts firmly attaching to the concepts. Hence the justification to speak of the *Erfahrungsgehalt* (experiential content) and the *Erwartungsraum* (expectational space) of a concept, notions which, as I mentioned before, would sound odd if attached to the concepts to be encountered in other strands of conversation.

Conceptual history as a scholarly discpline, then, I would suggest, has to settle explicitly on one or more of the strands of conversation of a particular lifeworld, and it must try to consciously adapt its analytical tools to the manner in which 'concepts', and the 'words' naming them, circulate in the strand(s) in question.

Disciplinary Architectonics

Begriffsgeschichte is sometimes thought of as a discipline in its own right which, in turn, may contribute to more broadly delineated fields of study like intellectual or cultural history, social history, the history of mentalities, or the history of philosophy.[10] It then functions, as it were, as a means towards realizing the ends of those other disciplines, and it can subsequently be assigned a place among the elements of what one might call an

architectonic of the cultural sciences based on means-ends relations between diverse disciplines. Let us call this a teleologically-based architectonic. [11]

Apparently, however, an acknowledged place in an architectonic of the cultural sciences of the means-towards-ends type does not provide the practice of *Begriffsgeschichte* with a sufficiently clear notion about how to proceed with tracing the history of a particular concept, nor does it supply the criteria which are needed in deciding which concepts to focus on. Not surprisingly, therefore, programmatic statements and theoretical reflections on *Begriffsgeschichte* frequently involve discussions of what one might call flanking concepts like *Wirkungsgeschichte* and *Problemgeschichte*, concepts, that is, which, rather than identifying the place of *Begriffsgeschichte* in the architectonic of the cultural sciences, are intended to help the practitioner of conceptual history to decide on how to organize the narrative of the history of a particular concept. To these flanking concepts has to be added the concept of 'Grundbegriff' which, as the metaphor already suggests, is meant to lead to a manageable selection of foundational concepts which play, or at some time used to play, a significant role in the construction and maintenance of social-political reality.[12] *Wirkungsgeschichte* and *Problemgeschichte*, in fact, are also thought to play a role in settling on those 'Grundbegriffe' whose story needs to be told. In that case their role is one of helping to identify the 'Sitz im Leben', the life-span, of the concepts selected as 'Grundbegriffe'. When *Wirkungsgeschichte* is used as a flanking concept the goal is not only to ward off the 'Naivität des (..) Historismus' (the naïveté of historicism) which, according to Gadamer, consists in overlooking the historicity of one's own understanding.[13] In conjunction with the concept of the 'fusion of horizons' (Horizontverschmelzung) it serves to identify the horizon within which the selection of foundational concepts is to be made by assisting the practitioner of conceptual history in the effort of what Gadamer called the 'Gewinnen der rechten Frage',[14] arriving, that is, at the proper question. Arriving at that question is obviously all-important in a hermeneutics modelled, as Gadamer's is, on the interplay of question and answer.

When *Problemgeschichte* is used as a flanking concept, a similar tapering off of the stream of concepts calling for investigation is what is hoped for. Thus when Erich Rothacker in the *Geleitwort* to the first volume of the *Archiv für Begriffsgeschichte*, which he had founded, drew attention to the 'vielschichtige Verwickelung von *Problemgeschichte* und *Terminologiegeschichte*',[15] (the many-layered interrelatedness of the history of problems and the history of terminology) the purpose was, one feels, not only to point out that both types of history were in fact inextricably interwoven. It was also to tie the study of the history of terminology to the history of problems worth investigating.

What has been said of the role assigned to *Wirkungsgeschichte* thus also applies, *ceteris paribus*, to *Problemgeschichte*. In both cases the 'other' history, *Wirkungsgeschichte* or *Problemgeschichte*, allows for mooring conceptual history in the present, or at least in a present, and for linking it up with the interests of a present life world. The historian focusing his gaze on the *longue durée* will undoubtedly be able to identify a number of periods in history which would qualify as periods of major conceptual change, as *Sattelzeiten*, that is, in the sense in which Reinhart Koselleck uses that term. Conceptual history by itself, it can be argued, does not and cannot possess a criterion for selecting a particular *Sattelzeit* for ur-

gent consideration. So the decision to focus on the period between 1750 and 1850 as the *Sattelzeit par excellence* to be investigated must derive its plausibility from elsewhere, and it undoubtedly does so from our awareness that – as the theory of *Wirkungsgeschichte* suggests – the results of the semantic shifts which took place during that period still inform our current social and political discourse.

With the employment of either flanking concept in conjunction with *Begriffsgeschichte*, the unity of the stories told by *Begriffsgeschichte* is largely secured from the vantage point of the stories told by other types of historiography. *Wirkungsgeschichte*, Reiner Wiehl has suggested, is needed to provide the 'Einheitsbedingung', i.e. the condition for the possibility of unity for *Begriffsgeschichte*.[16] Wiehl, although he made a point of stressing the fact that stories with beginnings and endings were told in the writing of *Begriffsgeschichte*, did not attempt to follow up the narratological implications of his observations on the unifying role of *Wirkungsgeschichte*. Concepts, it can be argued, are usually first introduced or – if we decide to continue the use of concepts already in use – re-explicated at moments of problem shifts.[17] Looked at from the point of view of those problem shifts their introduction or their re-explication are thus secondary events which depend on the events taking place which will prompt their occurrence. Narratologically speaking, they are therefore not themselves suited to serve as agents of the stories which conceptual history wishes to tell.[18] So it could be argued with some justification that conceptual history, in focusing attention exclusively on concepts and conceptual change, rather than on the problems and problem shifts in whose wake these follow, is always in danger of hypostatizing concepts into agents of the changes of events in which they only participate. It is always in danger, that is to say, of inadvertently adopting an idealist stance. Seen in this light, the turning towards *Wirkungsgeschichte* and *Problemgeschichte* as flanking concepts, but also the frequent calls for linking up *Begriffsgeschichte* with social history can be understood as attempts at shifting agency in the stories which are to be told back to where it used to rest before the institutionalization of conceptual history as a near-autonomous discipline.

It should be stressed at this point that assigning a place to conceptual history in the architectonic of the cultural sciences is not just a matter of presenting the findings of conceptual history in context. The pivotal concept of this architectonic, the concept, in fact, which calls up the need to locate conceptual history in an archtitectonics of this kind in the first place is that of *agency*. If indeed, as Rainer Wiehl has suggested, stories with beginnings and endings are to be told by conceptual history, those stories (in the sense of '*recit* of narrative theory) require identifying the agents of the histories (in the sense of *histoire*).[19] The crucial question to be answered in conjunction with this type of architectonic will therefore be, where to locate the principal agency, how, in other words, to conceive of the architectonic in causal terms. Settling on an architectonics for conceptual history, and, in doing so, settling on an answer to the question of agency will therefore always involve an ontological commitment on the part of the practitioner. Writing conceptual history from a materialist perspective will involve a different commitment from writing it from a *wirkungsgeschichtlich* perspective in the sense in which Gadamer uses that term,[20] from an outright idealist or from – so far a *desideratum* only – a systems-theoretical one. In each case a different set of causal relations will be claimed to hold between elements of the

realms of objects of the various discourses in the architectonic. The architectonic in question thus owes its salient characteristic shape to the perception on the part of the practitioners of conceptual history that an adequate representation of the history of a concept or a set of concepts requires taking certain causal relations into account. Let us therefore call this second type of architectonic, which places conceptual history in the context of endeavours such as *Wirkungsgeschichte* and *Problemgeschichte*, 'causally based'.[21]

It will have been noted that disciplines like semasiology, onomasiology, but also *Sachgeschichte* (history of the subject matter denoted) have not been mentioned so far in our discussion of the place of conceptual history in either a means-towards-ends architectonic or a causally based one. The reason for treating them separately is that in relating the realms of objects of these disciplines – i.e. words, terms, and objects referred to – to the realm of objects of conceptual history – i.e. concepts undergoing change – we are dealing with semiotic rather than causal relations or means-towards-ends relations. We can therefore identify a third architectonic in which conceptual history can find a place, this time a 'semiotically based one'. The pivotal concept of this type of architectonic, at least if we wish to subscribe to the doctrine of the arbitrariness of the sign, is in this case neither 'means/ends' nor 'agency', but 'convention'.

The relations holding in this semiotically based architectonic are the ones familiar from the semiotic triangle, i.e. the referential relations – one usually speaks of a single triadic relation – which bind together sign, concept and 'significatum'.[22] No explicit or implicit ontological commitment of the kind which characterized the causally based architectonic is required of the practitioner of the history of concepts with regard to this triadic relation, unless, naturally, one wishes to view both the arbitrariness thesis and the nominalist orientation of modern science as intrinsically involving a commitment of this sort.

Opting for a Strand of Conversation, Opting for a Disciplinary Architectonic

Having distinguished between a number of strands of conversation and between several kinds of disciplinary architectonics as options of doing conceptual history, we now need to say something about the (temporal) relation between these two types of options. In most cases, one imagines, the decision about the strand of conversation comes first, and the decision regarding the relevant types of disciplinary architectonics follow from that original decision.

The decision to write the conceptual history of a specific scientific discipline rather than of an unregulated strand of conversation of the lifeworld can illustrate this point. The domain of objects to be studied along conceptual historical lines is in this case made up of the terms and concepts of the scientific discipline in question; terms and concepts understood in the narrow sense of explicitly agreed on elements which together constitute the terminological and conceptual repertoire of the discipline in question. What is not of interest are – possibly related – expressions and ideas which are encountered in a variety of 'life-world' texts and contexts. In order to become suitable elements of the terminological and conceptual repertoire the terms and concepts in question had to undergo processes of definition,

explication and abstraction, processes which, among other things, had the explicit purpose of making them context-invariant.[23] For the historian of concepts concerned with a discipline-specific variant of conceptual history, that not only means that the corpus of texts from which concepts are to be culled is strictly defined: only texts which contain the context-free variants of terms and concepts need to be considered. It also means that he will be justified in directing his attention first and foremost to those moments in the history of a concept when the above-mentioned triadic relation of sign (term) concept and 'significatum' was first explicitly established in connection with an attempt at defining a concept, and then again to moments when that relation underwent changes in the context of efforts at re-explication and re-definition. The primary focus of an historical concern with the repertoire of a particular scientific discipline will therefore be on the relations with the other histories specified by the semiotically-based architectonic rather than with those specified by the causally based one or by the architectonic based on means-end-relations.[24]

Lexicographical Conceptual History

Having located conceptual history in relation to several strands of conversation, and having indicated the various disciplinary architectonics of the cultural sciences to which it can be assigned, we can now turn to the specific variant of conceptual history referred to in the title of this paper. It is the variant of conceptual history which is practised by lexicographers of various stripes who have taken it upon themselves to reconstruct the historical development of the conceptual and terminological apparatus of one of the cultural sciences, and of presenting their findings in lexical order. In our case, it is the lexicographical ordering of the terminological repertoire of literary scholarship.

There are a number of significant differences with non-lexicographical forms of conceptual history which follow from this intended use. First, there is no possibility of recourse to the notion of *Grundbegriffe* as a criterion for the selection of concepts whose histories are to be traced. Nor is there a need for such a notion since comprehensiveness rather than motivated selectivity is what is expected of the lexicographer. But there is now also no possibility – no plausible need to do so either – of writing the story of a set of concepts in the shadow of *Wirkungsgeschichte* or under the guidance of *Problemgeschichte*, nor is there a need to identify a particular period of conceptual shift as the *Sattelzeit* to be focused on. What is called for instead is as comprehensive as possible an attempt at tracing the histories of the various elements of a terminological repertoire, regardless of whether a particular term refers to a literary genre or mode which is currently productive or to one which ceased being productive long ago.

Nomenclature and Terminology in the Narrow Sense

The terminological repertoire of literary scholarship is not a homogeneous totality.[25] There are several reasons for this. One has to do with the fact that the elements of that repertoire have accumulated during different phases of the development of that discipline; another

with the fact that a great number of different schools and approaches have been and are still involved in producing the various items of that repertoire. A third reason, finally, can be seen in the fact that the elements of that repertoire vary considerably in status. Thus there are at one extreme of a scale expressions which are not tied to any particular conceptual framework, paradigm or school. Such expressions are commonly used as general names for the items which make up the realm of objects of the discipline in question. Typical examples of this group of expressions are familiar terms like 'tragedy' or sonnet, 'iambic pentameter' or 'trochee', 'metaphor' or 'metonymy', 'Romanticism' or 'Symbolism'. All of these are terms which possess a status which is similar if not identical to the status of expressions from everyday language. They can be and frequently are used without reference to specific attempts at definition and explication. At the other extreme of the scale there are expressions which are tied to specific conceptual frameworks, theories, approaches or paradigms, and which, as soon as they are used, tend to call up, no matter how vaguely, that original context of introduction. Typical examples of that group might be 'chronotope' which has a clear Bakhtian ring to it, *différance* which to friend and foe will call up Derrida's notion of deconstruction, or clusters of concepts like 'icon', 'index' and 'symbol' which, viewed separately, might be subsumed to the first group, but which, if referred to as a group of three, will call up Charles Saunders Peirce's semiotics. In between these extremes there are a number of intermediate cases, terms like 'myth' or 'plot' which, although they originally entered the repertoire as elements of a specific conceptual framework, in this case that of Aristotle's *Poetics*, have since left that background behind. Thus we can talk meaningfully about the plot of a novel without knowing anything of the *Poetics*. On the other hand, we may at times wish to recall precisely the Aristotelian context of introduction. An occasion for doing so might arise when we wish to say something about the plot of Brecht's *Mother Courage*. The play, we may wish to say, does indeed possess a plot, but not one of the sort Aristotle had in mind when he defined 'plot' in his *Poetics* as an imitation of an action that is one and whole.[26]

Taking up a suggestion by the Polish literary theorist Janusz Slawinski, I shall label the extremes of the scale the 'nomenclature' and the 'terminology in the narrow sense' of literary scholarship respectively. Terms like 'plot', 'myth', 'character', but also 'novel' and 'short story' can then be said to oscillate between the poles of nomenclature and terminology in the narrow sense. We can always decide whether we want to use them broadly as general names of elements from the realm of objects of literary scholarship, or narrowly and with an eye to one or the other of the explications they have received in the course of time.

It is clear that the elements at each extreme of the scale will raise rather different problems when we try to write conceptual histories for them. In the case of elements belonging to terminology in the narrow sense, such a history will have a clear beginning in an identifiable text; it will involve a reconstruction of the original introductory context, i.e. of the definition or explication of the term in question, and, in case that term was adopted and adapted by one or more schools of criticism, it may contain references to the subsequent discussions of the term. But with that, the task of the historian of concepts is done.

The story is quite different for expressions from the nomenclature of a discipline. In this case there is usually no authoritative first definition or explication which would mark the

moment of introduction into the repertoire. Instead, there is often a gradual development to be noted in the course of which the expression moves from everyday language into the terminological repertoire. But that is usually not a development which will cut the link between the expression in question and everyday language. Think of 'text', 'image', 'recognition', 'catastrophe', to name but a few. Terms such as these retain some of the signifying potential of everyday language even when they have entered into the nomenclature of literary scholarship. In fact it is largely thanks to this link between everyday language and nomenclature that literary scholars and art historians on the one hand, and the 'common' reader and the 'common' listener on the other can continue to communicate in a way which would probably not be possible for the physicist and the 'common' arsonist, or the chemist and the 'common' substance user.

For the student of the history of concepts, it hardly needs stressing, the real problems begin when he or she sets out to trace the conceptual history of an element of the terminological repertoire which falls under the heading of nomenclature, rather than terminology proper. For now not only one or more definitions and explications of the term under consideration will have to be considered, but ideally also the history of the everyday use of that term, its onomasiological and its semasiological history as an element of everyday language.

Having distinguished the two extremes of the scale on which the elements of the terminological repertoire of a discipline like literary scholarship can be arranged, I need to say a few words about the items which are denoted by the various items of the terminological repertoire. Winnie the Pooh, it will be recalled, lived in a house 'under the name of "Saunders"', and in the picture which accompanies that information in the illustrated edition of A.A. Milne's classic, we actually see him sitting under a board on which the name 'Saunders' has been painted. The contingent relationship between name and object named which one may find exemplified by Pooh Bear's living 'under the name of Saunders' is characteristic, I believe, of a rather large number of the elements of the terminological repertoire of literary scholarship. The corpus of artifacts which makes up the primary realm of objects is an ever-expanding open set in which some types of text stopped being productive at some point in the past, while others have continued to remain productive through the ages, with new variants added sporadically, and still other completely new genres coming into existence not infrequently.

To the non-homogeneous terminological inventory thus corresponds an equally non-homogeneous realm of objects. The Linnean ideal of a taxonomic nomenclature is therefore clearly out of reach since at no point is it possible to claim that more than a tiny segment of the realm of objects is standing in a one-to-one relation with the items of the repertoire which are meant to denote it. The terminology of metrics may come close to the Linnean ideal, while the terminology of literary genres is incorrigibly fuzzy due to the fact that there will always be texts which can be subsumed under more than one genre term.

From this it follows that as far as the disciplines devoted to the study of literature and the arts are concerned, the history of concepts must be supplemented by the history of the objects to which the terms of the repertoire refer. The conceptual history of a concept, that is to say, has to be supplemented by the corresponding *Sachgeschichte*, and there has to be an awareness by the practitioners of either type of historiography that there may be com-

merce in both directions. Shifts in direction in the history of a particular concept may be due to the emergence of new variants in the textual corpus which need to be accounted for conceptually. Shifts in direction in a particular *Sachgeschichte* may be due to changes in the manner in which a term is explicated with the advent of a new conceptual framework. The first type of commerce, that from *Sachgeschichte* to *Begriffsgeschichte*, is characteristically instanced by the advent of bourgeois drama in the 18th century which necessitated a re-explication in non-Aristotelian terms of such terminological items as 'character', 'thought', even 'unity of plot'. The second type of commerce, that from *Begriffsgeschichte* to *Sachgeschichte* is instanced every time a literary programme for a future shape of literature is formulated and carried out by a group of writers.

The Programme of the New *Reallexikon der Deutschen Literaturwissenschaft*

In what follows I shall first say something about the kind of items included in the *Reallexikon*, then something about the organization of each lemma, and I shall conclude by way of example with a brief discussion of one of the lemmata.

According to the programme of the third edition of the *Reallexikon* [27], each lemma should consist of four clearly distinguished sections labelled 'explication' [Expl], *Wortgeschichte* [WortG] (onomastic history), *Begriffsgeschichte* [BegrG] (concept history), *Sachgeschichte* [SachG] (history of subject matter designated by the term in question), and *Forschungsgeschichte* [ForschG] (history of research).

Of the three discplinary architectonics of *Begriffsgeschichte* which we identified earlier on, it is therefore only the semiotically based one which is assigned a programmatic place in the new *Reallexikon*. At first sight that decision may be thought to involve ignoring a large amount of potentially significant information about the historical development of the nomenclature and terminology of literary scholarship. Can we ignore the social and political circumstances under which Russian Formalism developed during the first decades of this century, and thus the circumstances under which a number of key terms of modern literary scholarship first entered the repertoire ?[28] And can we leave aside the social and political circumstances under which, at the end of the Second World War, American New Criticism became the model of progressive literary criticism in the West for more than three decades, and, in its wake, introduced a whole range of descriptive terms into the terminology of literary scholarship?[29]

Objections such as these can suitably be discussed in terms of Karl R. Popper's familiar distinction between 'questions of fact' and 'questions of justification or validity', and, in its wake, the distinction between 'the process of conceiving a new idea, and the methods and results of examining it logically.'[30] If we further distinguish Popper's questions of justification or validity into questions of logical justification or validity and questions of practical justification or validity, we end up with three sets of questions which closely correspond to the three types of disciplinary architectonic we distinguished earlier on. Focusing on the causally based architectonic can then be seen to involve raising questions of fact: what were the circumstances under which a term or concept was first introduced, what were the cir-

cumstances under which the term or concept in question gained currency? Focusing on the teleologically based architectonic, by contrast, prompts questions of practical justification or validity, questions, which is what Koselleck touched on when he spoke of the 'expectational space' (*Erwartungsraum*) opened up by a term: which role did a term, a concept play in the (social) construction of reality?[31] Focusing on the semiotically based architectonic, finally, will lead to questions about the logical validity of the terms of the nomenclature and the terminology in the narrow sense. These will involve issues like the reconstruction of the intension and the extension of a term, or the various definitions it received in the course of time.[32]

It would seem obvious that the three lines of questioning can be pursued independently of each other. An eventual integration of the results into an overall 'institutional' history of a scholarly discipline is thereby certainly not ruled out.

In the programme under consideration the onomasiological and the semasiological history of a term/concept are dealt with under the headings of *Wortgeschichte* and *Begriffsgeschichte* respectively, the history of the *res* denoted by the term in question under the heading of *Sachgeschichte*, and the history of research on the *res* under the heading of *Forschungsgeschichte*. What emerges from this programmatic use of a semiotically based architectonic of explication, *Wortgeschichte*, *Begriffsgeschichte*, *Sachgeschichte* and *Forschungsgeschichte* is something like a system of checks and balances which seems to be at work when both the terminological repertoire and the realm of objects develop and evolve side by side. The existence of such a system of checks and balances can be gathered from the processes by which new types of literary artifacts eventually find a place in the terminological repertoire. I am thinking in this context of concrete poetry or of the gradual dissociation of Modernist and Postmodernist texts. It can also be gleaned from the manner in which false terminological starts are corrected, and terms and explications dropped when they have turned out to have a *fundamentum in re*. A striking example would be the fate of the concepts of 'generative poetics' and of 'poetic competence' which in the early 1970's were introduced into the terminological repertoire in an over hasty attempt at importing certain Chomskyan notions which had been proved successful in linguistics into the study of literature.

From a theoretical point of view the most interesting question raised by the scheme to be followed for every lemma is very likely the relation between the explication of a particular concept and its *Begriffsgeschichte*. As explicated by Carnap and others, [33] an explication of a concept amounts to a rule-governed construction which aims, among other things, at entering that concept into a context of other concepts, the precise meaning of which have already been established. An explication of a concept therefore always involves a given conceptual framework which in turn supplies the criteria for deciding on the adequacy of the proposed explication. With the formulation of the editors of the *Reallexikon*: the explication of the concept in question amounts to an 'Abgrenzung von benachbarten Begriffen' (distinction from adjacent concepts); it should offer a 'Vorschlag zu einem wissenschaftlich vertretbaren Gebrauch des Wortes' (a proposal for a scientifically/critically justified use of the expression). The focus of the explications of the *Reallexikon* is therefore on the possibility of using the concepts thus explicated in contemporary scholarship. In view of the ca-

cophony of competing schools and approaches which characterizes the contemporary scene of literary scholarship, the decision as to what is and what is not 'wissenschaftlich vertretbar' will undoubtedly involve a certain amount of dogmatism in some eyes. The editors and authors of the *Reallexikon* have not opted in favour of a specific school of criticism or a particular approach to literature which is subsequently expected to provide the criteria for deciding what is 'scientifically acceptable' and what is not. They have opted instead for the methodological criteria of contemporary definition and explication theory as has been developed by Analytical Philosophy.

In theory, at least, this offers the possibility of viewing the *Begriffsgeschichte* of a term and the concept named by it as a history of past explications, each carried out in accordance with the norms of 'wissenschaftlich vertretbarer Gebrauch' which were in force at the time. It remains to be seen, however, whether this possibility can be realized in practice.

A question which might be raised at this point is: why does a field of study like literary scholarship need a *Begriffsgeschichte* of its terms in the first place? Would it not be sufficient to produce an explication for each of the items of both the nomenclature and the terminology proper of literary scholarship and leave it at that? There are indeed literary scholars, especially those with a strong affinity with structuralism or semiotics, who would be quite satisfied if we had at our disposal a set of terms with which to order and analyze systematically both the literary corpus and the regularities, rules and conventions which come into play in the production and reception of literature. However, adopting this view would amount to ignoring the fact that the literary corpus should not only be described in terms of a simultaneous present of all its elements which might conceivably be accounted for in terms of one set of systematically interrelated explications. Apart from being described as system, literature also needs to be viewed under the description of a process. And this process is not one governed by law-like regularities. It is a process which gains its direction and its momentum from an intricate interplay of several strands of discourse which provides orientation for the production, reception and cognition of literature. If we label the strands of that discourse 'poetic' and 'aesthetic' and 'noetic' respectively [34] we can locate all of the elements of the terminology proper of literary scholarship, and a large number of the elements of its nomenclature, in various phases of the development of one or the other of the strands of that discourse. Each concept then can be understood to contribute to the articulation of a period-specific set of conditions of the possibility of producing, perceiving and knowing literature.

This way of looking at both the nomenclature and the terminology of literary scholarship does not deny the possibility of providing each and every term with a systematic explication. Both approaches are in fact complementary, and the set of current explications will, when the process of literature has taken another turn, emerge as yet another phase in the development of several phases of the multi-stranded discourse on literature.

A Case Study: the Lemma 'Emblem'

Let me illustrate this claim by turning to my last point, the lemma 'Emblem' of the new edition of the *Reallexikon*. Rather than going through the whole text which, I fear, would

be quite boring to the non-specialist, let me focus on the difference between the explication and the *Begriffsgeschichte* of the term 'Emblem', with only now and then a brief glance at the history of research on the emblem and the information gathered under the heading of *Sachgeschichte*.

The explanation attempts to define the emblem as a type of text, listing, as it does, a number of features which distinguish it from similar types of text. In doing so it proceeds roughly along the lines which are familiar from traditional theory of definition: identifying first the genus, and then the specific differences with related types of text. Here everything clearly depends on the composition of the set of types of texts with which the emblem is contrasted: whatever features are ascribed to it are features which it possesses in contrast to other types of texts in the set. Placed in a different set, the emblem would emerge as possessing different features. That it possesses the features the explication claims it possesses is therefore contingent on the contemporary decision which is based on a contemporary consensus about the most suitable context for discussing the concept of emblem. That consensus, one might put it, articulates the current horizon of expectations regarding the features a type of text should possess if the predicate 'emblem' is to applied to it.

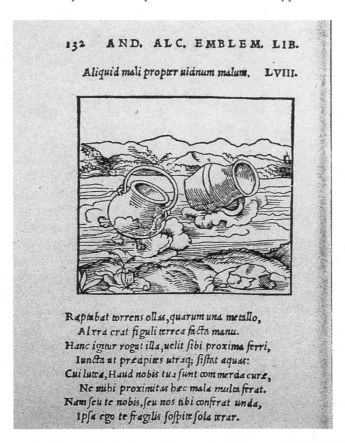

FIGURE 1 Emblem from Andreas Alciatus, *Emblematum libellus*, Paris 1542

Significantly that consensus has changed considerably since 1531 when Alciato's *Emblematum liber*, the first emblem book was published by the Augsburg printer Heinrich Steiner. I've written elsewhere about the details of the circumstances under which that publication took place.[35] Only one point needs to be mentioned in conjunction with the question of the relation between an explication and a *Begriffsgeschichte* of the concept of emblem. When the first copies of the *Emblematum liber* reached their first readers, learned humanist friends of Alciato, none of the three strands of the discourse mentioned above was established for this type of combination of word and image. Alciato himself thought he had written a book of epigrams in the tradition of the *Anthologia Graeca*, to which Heinrich Steiner, the Augsburg printer, had – for commercial rather than aesthetic reasons – added a number of woodcuts. For Alciato *Emblemata* was the title of a book of epigrams; the expression 'emblema' thus functioned as a proper name rather than a term. The *Begriffsgeschichte* of the concept of emblem thus begins with a shift of an expression from the category of proper name to the category of general term. And that shift took place when subsequent readers and imitators began to view the woodcuts supplied by Heinrich Steiner not as contingent illustrations, but as obligatory elements of a new type of text. An explication of 'emblema' in 1531 would have yielded something like 'type of mosaic', 'inlaid work'. However, it would not have involved as a genus a type of literary text in relation to which the emblem could have been viewed as one of the species. When the categorial shift had taken place by the end of the 16th century, the emblem was firmly established as a literary genre which called up certain expectations as far as the features were concerned which a word-image text had to possess if it were to be considered an emblem.

The *Begriffsgeschichte* of the term 'emblem', then, must trace the shift of the expression 'emblema' from the category of proper name to the category of general term, and subsequently the series of explications which that term received as the corpus of texts associated with it grew in the course of some two and a half centuries. The *Sachgeschichte*, in turn, has to record the stages of the development of the corpus of texts called emblem, and it has to focus attention on those stages which prompted a re-explication of the term 'emblema'. It would be a mistake, however, to assume that such re-explications were only prompted by new variants added to the corpus. Perhaps even more significant are re-explications due to changes in the choice of conceptual framework adopted for the explication of the term 'emblema'. The most important of these changes in the period between the first half of the sixteenth and the second half of the eighteenth century when the emblem genre was productive was the shift from an Aristotelian to a Cartesian conceptual framework; a shift, that is, from an explanation of artifacts in terms of the four Aristotelian causes (*causa materialis, causa efficiens, causa formalis* and *causa finalis*) to a framework which accepted as causal only one explanation in terms of the *causa efficiens*, and which shifted the focus of attention from what in Aristotelian terms were second substances to first substances.

Concluding Remarks

The *Begriffsgeschichte* of the term 'emblem' is undoubtedly somewhat unusual in that it provides the student of conceptual history with a view of the inception of a particular con-

cept. However, it is not unique. The situation is indeed similar to the essay in the tradition of Montaigne or the Brechtian *Lehrstück*. Usually the items of nomenclature studied by conceptual history have, for all practical purposes, always been used, but because of its somewhat unusual conceptual history the emblem allows us to highlight a few features which, it would seem to me, are typical of *begriffsgeschichtlich* analyses of concepts from the disciplines whose domains of objects are made up by the *corpora* of the various arts.

If *Wirkungsgeschichte* and/or *Problemgeschichte* constitute the conditions of unity ['Einheitsbedingungen'] of the histories of concepts belonging to the social and the political sphere, the unity of histories of concepts from the disciplines devoted to the arts is constituted by the interplay of *Sachgeschichte* and what I would like to call the history of the multi-stranded discourse on the arts. Undoubtedly there are also a few concepts to be found in the disciplines devoted to the arts which, if their *Begriffsgeschichte* were to be written, would derive their unity from *Wirkungsgeschichte* or from *Problemgeschichte*. One need only think of concepts like 'art', 'artist', 'poet', 'poem', 'work of art', 'creativity', 'imagination'. These might even be thought of on a par with the *Grundbegriffe* of the architectonic approach to *Begriffsgeschichte*. However, on closer inspection it turns out that the stories to be told about concepts such as these do not quite fit in with the rest of the concepts whose history needs to be understood by the literary historian or the art historian. It is not quite easy to see why this should be so, but a plausible explanation might be that these are not really concepts in the strict sense. They are rather much more vaguely delineated conceptual units which one might prefer to call 'ideas', and whose history should therefore be dealt with by the history of ideas rather than by conceptual history.

Conceptual History, Social History and Cultural History: the Test of 'Cosmopolitism'

WILLEM FRIJHOFF

Did conceptual history and social history really meet each other? The question may seem incongruous, indeed paradoxical in the eyes of those who consider the German *Handbuch politisch-sozialer Grundbegriffe in Frankreich 1680-1820*, initiated by Rolf Reichardt and Eberhard Schmitt, as an excellent example of the second stage in conceptual history: that of semantics under the socio-historical viewpoint. Indeed, in his introduction to this series of short monographs, published thirteen years ago (1985), Rolf Reichardt declared that the socio-historical embedding of semantics introduced in this collection had to be considered as a 'middle course' between lexicometrics, rejected as excessively synchronistic, hence unhistorical, and first generation conceptual history such as Reinhart Koselleck's *Geschichtliche Grundbegriffe*, in which the semantics of historically retrievable concepts hides in many places behind uncontextualized ideas. In this introductory manifesto, Rolf Reichardt places the socio-historical foundation of conceptual history in the social character of speech itself.[1] Hence the essentially social origin of meanings, history being the tool by which the historian tries to get hold of it.

'Social History' and 'Cultural History'

Everything depends, of course, on what one understands by 'social history'. In the light of the German historical debates in the 1970s and '80s, the *Handbuch* may certainly be considered a momentous novelty. Indeed, it intends to intimately knot together the semantics of a concept (i.e. its cultural trajectory) and its social trajectory, not only on the high discursive level of literature but also in the low-life of street talk. It is rightly assumed that popular literature may be as crucial for the development of conceptual meaning as is the learned reflection of intellectual or social elites. However, social history itself has developed much since the 1980's. From a rather positivist and quantitativist historical enterprise obsessed with long-term evolutions, processes and structures, the 'objective' existence of which was taken for granted from the sources, social history has focussed more and more on the constructed dimension of historical 'reality', on the social mediation of perception and representation, and on the cultural sedimentation of social reality itself. The question

whether social reality exists independently of the concepts in which it is expressed, is not really on the research agenda any more – since all historical knowledge is admittedly a particular form of narrative, and, reversely, narrative is always embedded in social practice.

This is not to say that social history no longer bothers about 'reality', but it has become less ingenuous in its approach to the apparent reality of the past. In fact, by now social history mostly adopts a middle term between positivism and narrativism, and tends to stress the social, i.e. collectively mediated aspects of the world of culture, the latter to be taken in the broadest sense of the word, as everything concerned with meaning. The recent discussion in the (former) *Annales. Économies, sociétés, civilisations* on the definition of the periodical's scope underlines this socio-cultural turn.[2] In its new title as from volume 49 (1994), *Annales. Histoire, sciences sociales*, the thematic approach of history has been replaced by a programmatic confrontation with social theory. However, the meaning of 'social' theory itself is quite often, and specially so in the *Annales* tradition, drifting out from conditions and structures to cognition and culture, to voluntarism and symbolism instead of determinism and materialism.[3] Even Norbert Elias's sociogenetic theory essentially works with models of cultural behaviour and systems of shared meanings.

Whereas social history was in its first decades essentially concerned with man's activity – in the way sociology or social anthropology study present societies, it now focusses more and more on the relationship between human agency and meaning. Such shifting focuses and boundaries tend to blur the sub-disciplinary definitions. Some twenty years ago, when the *histoires des mentalités* arose as a cultural alternative to a positivist social history, historians might have nursed the illusion of a clear division of labour between the two sub-disciplines. But soon the definition of *histoires des mentalités* itself appeared unclear, since it referred, according to the historians' position, either to the *psychical* dimension of any human activity, or to the *cultural* dimension of specific fields of social activity.[4] In the second case, it embarked, although from a slightly different angle, upon themes and topics which hitherto had been considered the proper territory of social history: the history of power, labour, kinship, sexuality, communication, social institutions, etc. In the first case, however, *histoires des mentalités* is not so much a sub-discipline with a proper object, as a particular methodological approach of the overall historical reality. The linguistic turn of modern historiography in creating what some historians have called the 'new cultural history' may have given an appearance of autonomy to this field of research, but it might well be doubted whether it would be wise to stress autonomous features of 'cultural history'.[5] In the meantime, *histoires des mentalités* and 'cultural history' continue to exist as academic specialisations, searching for an adequate definition of their somewhat volatile object.

Hence, ever since the very emergence of new forms of cultural history, historians have suggested that cultural history should not be considered a new sub-discipline but as a specific approach to social reality, fundamentally embedded in the mainstream of social history, since culture is the way society expresses itself. Significantly, in their social history of the French Enlightenment some fifteen years ago Gumbrecht, Reichardt and Schleich proposed a conception of 'social history' in which the psycho-physical structure of man would be historically integrated. In opposition to the vagueness of the *histoires des mentalités* concept, they defined the new social history as a history of the historical layers of sensation and

consciousness – *Sozialgeschichte als Geschichte historischer Gefühls- und Bewusstseinslagen.*[6] Since the scope of this contribution is not to summarize a historical discussion but simply to ask some relevant questions, I would like to limit my argument to quoting Reinhart Koselleck's exposition of the relationship between social history and conceptual history, printed elsewhere in this volume.[7] For Koselleck, social history and conceptual history are the only two universal forms of historical work, since speech and society are the two poles of historical understanding: no history without society, no historical knowledge without conceptualisation. Speech acts express the interaction of concepts and society, but interaction is not identity: linguistic concepts and social 'reality' develop along their own rhythms, still illuminating each other. In this view, the mutual involvement of both disciplines would consist of the mutual check of the historical consistency between experience and language, in the detection of discrepancies in their rhythm of evolution, which would affect meaning, and in the way in which concepts influence society, and the reverse. In fact, the concept of 'reality' has been rightly evacuated from this view, since historical 'reality' is always conceptualised, narrated history.

Therefore conceptual history bears in itself the promise of being a mediator for bridging the unacceptable gap between culture – as the expression of society – and society – as the 'reality' side of history. How far did it realize this initial promise to become, both in France – as a form of historical semantics – and in Germany – as *Begriffsgeschichte*, the privileged *trait d'union* between social history and *histoire des mentalités*?[8] In fact, conceptual history fell out of step, for in the meantime these two historical sub-disciplines have met each other elsewhere, in diverse research fields such as cultural anthropology, sociolinguistics and cultural history, each with their own research agendas, leaving conceptual history largely aside. Yet in the last ten years several volumes of the *Handbuch* have been published. In other countries, to begin with in the Netherlands, similar research programs have been initiated. For the outsider, however, conceptual history seems condemned to remain a specialism in itself, without establishing the necessary alliances with neighbouring research fields. In France, historical semantics is not far from agonizing. Significantly, the latest book of one of the most promising young French scholars in this field, Antoine de Baecque, is not about concepts but about 'metaphors and politics'.[9]

In other European countries, it remains, as far as I can see, largely enclosed within the realm of the history of ideas, abstract concepts, and idioms; without properly achieving the expected breakthrough towards society as a historical category.[10] The 'new cultural history' goes its own way by focussing on narrativism and cultural analysis, on languages and symbols, on models and images, without bothering very much about concepts, the history of which is at best considered by many as a new variety of the old history of ideas. Peter Burke's and Roy Porter's *Social history of language* (1987)[11] mainly follows the path of sociolinguistics; and Burke himself balances at present between the history of conversation and that of silence. The new 'social history', in its turn, following in the footsteps of cultural anthropology, is much more fascinated by the speech act itself than by what is actually said, and in what words, or by the political meaning of it. Since 'social history' now seems to return to a closer attention on group representations and the appropriation of meaning, con-

ceptual history might be expected to be more warmly welcomed – but for the time being, the results are rather meagre.

This picture may, of course, appear too pessimistic to the believers, and I must confess that my knowledge of what is actually going on all over the world is far from perfect. However, I am not sure that a closer scrutiny of the recent bibliography gives much hope for a more optimistic image. The purpose of this short contribution to the discussion is to examine whether the actual practice of conceptual history, as demonstrated in one of the published case-studies, gives us some clues for a better understanding of this relative lack of expansion in social history, and perhaps some ideas for remedies as well. I do not adopt a theoretical viewpoint, since there is barely a want of theoretical contributions in this field. I prefer a more practical approach, in the form of a short analysis of one of the entries of the *Handbuch*. My comment upon this item will result in some questions. Purposely, I have chosen an entry which is particularly fit for an interrogation of a socio-cultural character, since the concept under consideration refers both to a cultural attitude and to a social practice. I mean the words 'cosmopolite' and 'cosmopoli(ti)sme', studied in Volume 6 of the *Handbuch* by Gerd van den Heuvel, under the general concept of cosmopolitism.[12] Besides, their semantic field is close to concepts studied within the framework of the Dutch project, such as fatherland, patriotism, or freedom. My approach is not meant to be a criticism of Van den Heuvel's analysis itself, since he only applies the principles fixed for the whole work. On the contrary, I consider his article an exemplary form of what conceptual history, as expressed in the introduction to the *Handbuch,* has to offer. Therefore my comments are intended to have a more methodical tenor.

Cosmopolitism and the Republic of Letters

The entry *Cosmopolite, Cosmopoli(ti)sme* is rather short – fifteen pages –, which suggests that its semantic evolution was simple, at least in the French setting. It is subdivided into seven headings, including a historical introduction. In that introduction, the attention of the reader is drawn to cosmopolitism in the Classical Antiquity and the Renaissance. As for Antiquity, it is thought to be expressed in the idea of the natural equality of all men in all the different political entities of the world. During the Renaissance, Erasmus of Rotterdam and Montaigne, were, of course, the main interpreters of the ideal of a single political human brotherhood, fraternizing beyond the frontiers. '*Ego mundi civis esse cupio, communis omnium vel peregrinus magis*', is one of sentences in which Erasmus, quoting similar phrases of Tertullian, Zenobios or Cicero, expresses his detachment from local bonds and claims his solidarity with a larger, indeed a supranational community.[13] However, unlike the biblical metaphor of the heavenly Jerusalem, or St Augustine's concept of the *Civitas Dei*, recharged with the idea of *Christianitas* during the Middle Ages, the Renaissance concept of a supranational brotherhood was fundamentally not a religious or an ecclesiastical, but a lay concept like the *Orbis terrarum concordia* of Guillaume Postel (1544).[14] It supposed a free choice of the individuals involved, in favour of humanity and toleration.

The same development of an ecclesiastical into a lay concept may be detected behind the evolution of other terms fitting within the same concept and indicating a virtually supranational community of learning. Since the second half of the fifteenth century, the 'university' became gradually an 'academy', a term which is also used for the learned academies of scholars. The first university formally founded as an academy was that of Wittenberg in 1502, which soon developed from a profoundly humanistic enterprise into the first Reformation university.[15] The two aspects are more closely linked than is generally thought. Indeed, the humanistic 'academy'-concept, straddling the darkness of ecclesiastical scholasticism, attaches itself to the true form of education in Greek and Latin Antiquity, which is the free congregation of those engaged in the advancement of learning, including religion.[16]

It is not clear in the *Handbuch* entry whether the term 'cosmopolitisme' itself was in use since Classical Antiquity.[17] The first public use of it in French was, at any rate, by the same Guillaume Postel in the title of one of his books published in 1560, or better, in the self-definition of the author, since he designated himself 'Guillaume Postel, Cosmopolite'. Significantly, the book was about the Turks, and it was not published in the nation's capital Paris, but in remote provincial Poitiers. In fact, the word 'cosmopolitan' was used alternatively with that of 'world citizen' ('citoyen du monde'). In this literal sense, i.e. the 'cosmopolitan' as an inhabitant of the world or a member of mankind, he was not limited by qualities such as national citizenship. During the seventeenth century the term was used in works of natural philosophy or, more exactly, alchemy. But in that context it clearly had a symbolic meaning: attaching man explicitly to the cosmic order.[18] In the mid-sixteenth century, Florence's grand duke Cosimo I de' Medici had played with this symbolism when he created the harbour town of Portoferraio on the isle of Elba, called *Cosmopolis*, both as a pun on his own name and to mark its quality as a 'universal city'.[19]

This tradition of cosmological symbolism links the sixteenth-century term 'cosmopolitan' with its reappraisal in the eighteenth century, but it is not clear whether – and if so, until what point – such symbolism still permeated eighteenth-century semantics. At any rate, in a letter written in 1648 Cyrano de Bergerac – the real one – seems to use the term as a mere cosmographical, at best a political concept. For him, the *honnête homme* is not a Frenchman, not a German, not a Spaniard, but 'he is a citizen of the world, and his fatherland is everywhere'. This cosmographical concept of a world citizen is gradually filled in with a greater moral charge. Ever since, the term 'cosmopolite' has seemed to prevail.[20] The *Dictionnaire de Trévoux* recorded the word as early as 1721, whereas the *Dictionnaire de l'Académie française* listed it in its 1762 edition, with an explicitly negative moral connotation: '*Cosmopolite*: he who adopts no fatherland' (A cosmopolitan is not a good citizen).

However, cosmopolitism was not only a concept, it was also a way of being. During the seventeenth and eighteenth centuries, cosmopolitism was, for example, the main form of social behaviour in the supranational community of the Republic of Letters. In stating this, Van den Heuvel however remains very cautious as to the truly international character of this Republic. Especially in France, he argues, national boundaries remained strong, and rather few French people traveled abroad. As for periodization, in Van den Heuvel's opinion the Republic of Letters was above all a matter of the late seventeenth and the early

eighteenth century. But even then the enlightened elites of France appear as rather enclosed within the boundaries of their fatherland, physically and intellectually.[21] It is here, however, that the first real problem arises for the social historian. There is in fact no doubt whatsoever about the antiquity of the Republic of Letters. Recent research on communication among early modern educated people clearly shows how precociously the Republic of Letters functioned as a true international network: in fact as early as Erasmus's own correspondance, in the first half of the sixteenth century.[22] As for France, learned cosmopolitans like Guillaume Postel or François Hotman, and famous scholars like Jacques Cujas or Jean Bodin, were excellent sixteenth-century examples of network-builders: attracting foreign students from everywhere, reacting actively to foreign publications, or corresponding with foreign scholars. Friar Marin Mersenne and councillor Nicolas Fabri de Peiresc have illustrated early seventeenth-century scholarship, whereas the very summit of Leiden learning, Joseph Justus Scaliger from Agen, wanted to leave his country only after much insistance and for unheard-of conditions.[23] He brought with him one of the most astonishing networks of correspondents.

Such networks implied for each member of this non-territorial Republic a shared identity, in fact a multiple solidarity: with his country (expressed, e.g., in the 'nations' of the universities), with the supranational network of the Letters, and with his – mostly also supranational – religion, or religious order. Nevertheless, that network was a social and cultural reality, and more so as the geographical structure of its centre can be described as a quadrangle going from Rome and Naples in the South, to Amsterdam, Leiden, Oxford and Cambridge in the North, and from Paris and Lyon in the West, to Gdansk, Leipzig, Prague and Vienna in the East. Within this quadrangle, were located virtually all the big libraries, all the manuscript collections, all the really important universities and learned academies; all the international periodicals were published there, and all the publishers of works of arts and sciences were active in that region. In fact, the quadrangle functioned as early as Guillaume Postel's first self-designation as a cosmopolitan. Ever since, it has only been slightly enlarged towards the North (the Dutch Republic) and the East (Berlin).

The point of my observation is however not the very existence of the Republic of the Letters, but its gradual shift from the use of a supranational language which in its very existence symbolized the concept of cosmopolitism, to a nationally embedded language, actively promoted by people from the speakers' nations: i.e. the shift from Latin to French as the main language of international communication. This change from the language of Church and religion to a language of national interest facilitated the secularization of the world of learning, particularly in the rising new science, in medicine and letters. It also brought new tensions, this time among social groups; since French is the language of politeness, not of middle-class culture. No wonder that even in Protestant countries, it was among theologians that Latin resisted longest its international erosion. Perhaps this was because theology was for the unfavoured classes instrumental to their social emancipation: the sacred ministry being the best accessible gateway to upward social mobility for the next generation.

Of course, even after the shift to French as the language of court, diplomacy, commerce, and upper-class society life, Latin would still remain for some centuries the official language of the universities and hence of a lot of scholarly correspondence. But ever since the first half of the seventeenth century, French was, outside the traditional institutions of culture, adopted more and more all over Europe as the language of elite behaviour, polite conversation, and educated correspondence. This was more so as the Revocation of the Edict of Nantes in 1685 generated a truly international and very influential network of French intellectuals in key positions abroad – from Berlin to London and from Holland to Switzerland. Pierre Bayle wrote his seminal *Dictionaire historique et critique* (1697) in Rotterdam in French, and his *Nouvelles de la République des Lettres* (since 1684) were printed in French by a Dutch editor who served virtually all Europe and did so mainly in the French language.[24] Everywhere in eighteenth-century Europe, Gallophilia was an upper class disease ardently combated by the rising nationalism of bourgeois and other educated elites who found here one of their first causes and through this opposition could learn to sketch the first outlines of their own political creed.[25]

Hence the question of how the semantic field of cosmopolitism adapted itself to this new social reality. Especially in this supranational area, the concept of cosmopolitism in its French version is at least as much tributary of politically foreign, non-French authors as of indigenous French use. The French language as codified by the *Académie Française* and by the manuals of fashionable French *gens de lettres* does not adequately reflect its actual riches; it most probably tends to neglect non-national idiomatic French, and thus to underestimate eventual semantic changes in the concept's appropriation prepared elsewhere, be it – quite literally – in the margins of the French-speaking world. As far as cosmopolitism is concerned, French (as a language) is emphatically not identical to France (as a nation). For the social historian, the equation between the semantic field of the French language on the one, and the political field of the French nation on the other side, appears therefore as the first assumption to be questioned.

Secondly and more profoundly, the question is to know whether, from the viewpoint of social history, the exclusive focus upon the evolution of the concepts and their change in the eighteenth century does not obscure significant changes in other, previous periods. There is indeed reason to believe so. One of the very first key periods that comes to mind is the Renaissance. Indeed, a prior major change in the use of the concept of cosmopolitism is its virtual secularization in the Renaissance period, since at the same time this involved a profound individualization. Cosmopolitism, or world citizenship, was no longer attached to a religious or political body like Christianity, but was related to an individual's behaviour, or his state of mind. To put it schematically: cosmopolitism was not a given corporate property any more, but became the questionable result of a personal choice. There was then the new ability of the concept to express social forms of free association. Cosmopolitism and world citizenship could now be used as equivalent to the membership of the supranational Republic of Letters, which indeed ever since the time of its inventor Erasmus was idealistically thought of as a free association of educated men all over the civilized world, without discrimination of birth, religion or social status. Although the Republic of

Letters was a socio-cultural reality, only social representation could make it a true expression of cosmopolitism.

Cosmopolitism, Social Class and Cultural Models

After his introduction, Van den Heuvel subdivides his entry into six headings, each corresponding to a stage in the semantic evolution of the concept of cosmopolitism. In the first of these six paragraphs, the equation of the cosmopolitan with the Enlightenment philosopher is brought forward. In his self-consciousness, the French *philosophe* pertained indeed to an international elite, distinguished by reason, and obliged to toleration and humanity, in order to foster the progress of mankind.[26] Voltaire is, of course, the most brilliant representative of this self-chosen mission.[27]

For d'Alembert, the *homme de lettres* was necessarily a 'cosmopolitan author', and the entry *Cosmopolite* in the *Encyclopédie* in its 1754 edition, eight years before the *Dictionnaire de l'Académie française,* still gave a neutral, indeed a positive definition, turned towards the values of the European elites: 'A cosmopolitan is a man who is a stranger nowhere'. Four years earlier, the French libertine Louis-Charles Fougeret de Montbron (1706-1760) had published the brilliant autobiographical manifesto of the Enlightenment cosmopolitan abroad, under the title *Le Cosmopolite, ou le Citoyen du Monde* (1750),[28] in which both terms appear as expressions of the same concept. For Fougeret, the true cosmopolitan is the man who feels at home everywhere, who enjoys every culture, and whose liberty to join every single nation is founded upon his absolute individualism, without recognizing any tribute to social ethics. Fougeret's cosmopolitism is a variety of radical scepticism and a token of sovereign independance, but it is also typically a writer's vision of his time, wrapped up in the literary metaphors and cultural models of the eighteenth-century satirist.[29] It is precisely this Enlightenment focus upon the cultural element of the definition, i.e. the cosmopolitan as a man of letters who aims at the transfer of his Enlightenment ideals through knowledge, writing, and education; which reveals the concept's embedding in the long social history of the European intellectuals. This should of course be handled in the concept's analysis.

Formally, the French philosophers did not include a political programme aiming at the abolition of any national state in their cosmopolitan self-definition. More than the state, it was the stratification of the society of orders, or the social classes, which was the target of their criticism: cosmopolitism was equivalent to a progressive policy, be it in social matters or in economics (e.g. physiocracy). But some clues may certainly suggest a more differentiated approach. Thus, in the mere conceptual vision of cosmopolitism, as given in the entry of the *Handbuch*, the particular position of Jean-Jacques Rousseau (1712-1778) with regard to cosmopolitism is attributed to this author's political philosophy.[30] For Rousseau, cosmopolitism was against human nature, since it was idealistic, and it misjudged the true needs and interests of man. In his eyes, the cosmopolitan was nothing more than an antisocial, egotistic being, who replaced authentic commiseration with his neighbour by a universally extended, but unreal union with mankind, and who was unable to embrace the cause of his fatherland as a true, patriotic citizen because he did not recognize a fatherland

any more. Rousseau's disenchanted ideas on cosmopolitism date from after his rupture with the Encyclopedists. This benefits us with a socio-cultural clue, pertaining to the order of social representation, and alternative to the internal evolution of his political ideas, since Rousseau, as Jacques Oerlemans has shown, invested heavily in the social grudge which he had built up against the social and intellectual elites who did not admit him in their midst on an equal footing, and which he afterward transformed into a more or less coherent political philosophy.[31] Out of his own social experience, Rousseau warned in his *Émile, ou de l'éducation* (1762) against 'ces cosmopolites qui vont chercher au loin dans leurs livres les devoirs qu'ils dédaignent de remplir autour d'eux. Tel philosophe aime les Tartares, pour être dispensé d'aimer ses voisins'.[32]

Rousseau's image of the cosmopolitan as a friend of the universe but an enemy of his neighbours was to mark the semantic field of the concept of cosmopolitism for a long time. In the eyes of politics, the cosmopolitan became an opponent to the fatherland, although Rousseau, much more than Herder and the German patriots, justifies his patriotic claims by an appeal to 'universal' properties of the whole of mankind, as expressed in *la volonté générale*, 'the general will'.[33]

Up to what point Oerlemans' suggestion that the problem of the frustrated intellectuals has to be considered responsible for this semantic evolution, remains a point of discussion. Although in his own eyes perhaps an 'alienated intellectual', Rousseau was not exactly a Grub Street writer. Again, social representation, not necessarily social reality, is here the clue for the interaction between the concept and society. As Robert Darnton, Roger Chartier and others have shown, in France, as well as in England and Germany, and even in the Netherlands, Grub Street writers and other socially discriminated intellectuals constituted a particular fertile social class for semantic change in the political idiom.[34]

The last three paragraphs of the *Handbuch* entry deal precisely with this semantic change in the early years of the French Revolution. The term 'cosmopolitan' apparently started by having a rather neutral meaning – i.e. that of an international businessman (*commerçant* or *négociant*). This neutral sense of a man being above parties echoes in the title of a French pamphlet said to have been published in Amsterdam: *Le caffé politique d'Amsterdam, ou entretiens familiers d'un François, d'un Anglois, d'un Hollandois et d'un Cosmopolite, sur les divers intérêts économiques et politiques de la France, de l'Espagne et de l'Angleterre*.[35] But its meaning was easily on the verge of being perverted, since it could apply to groups perceived as politically homeless (e.g. the international business network of the Jews). The Revolution itself adopted the concept of 'cosmopolitism' as a means and a model of diffusing its ideas on universal fraternity, either in the secular field of politics or in religious matters – the *culte cosmopolite* of universal reason and morals. It is surely no coincidence that the most exemplary cosmopolitans of the French Revolution were foreigners, not Frenchmen, i.e. foreigners having adopted French as their idiom and France as their new homeland. The most picturesque among them was certainly the Cleves baronet Anacharsis Cloots (1755-1794), an avowed *Gallophile* of Dutch Catholic origin who proclaimed at the same time to be 'the orator of mankind'.[36] For him, apparently, patriotism and universalism were not mutually exclusive. It may be supposed that the same applies to other eighteenth-century cosmopolitans.[37] The link between the concept of cosmopolitism

and revolutionary society now runs through the social representation of the baronet's universal homeland.

Soon, however, idealistic cosmopolitism clashed with the First Republic's need for true patriotism.[38] The semantic shift has roots in both social conditions and cultural models. Cloots himself, in spite of his symbolic quality, was the living example of the growing contradiction between unitary patriotism and federative, or elective, internationalism. In the same session of the National Assembly where he proposed his Universal Republic of all Mankind, he was given the French nationality together with seventeen other world citizens. According to Cloots's conceptions, this Universal Republic had to be governed by a 'fraternal government, which is nothing else than a huge central bureau of correspondence for the official advertisement of all knowledgeable events to the cosmopolitans'. Once again, the federative model of the Republic of Letters is obvious. But his enemies were much more aware of its political implications. Cloots was arrested on the accusation of being a 'foreign agent' (!), and executed on 24 March 1794.

For the social historian, it is perhaps not so much the semantic opposition of cosmopolitism to patriotism which accounts for the negative image, indeed the stigmatization with which the cosmopolitans were victimized after 1792, but much more the use of two cultural models for the perception of the political reality: first the model of centrally conceived unity as against federative, necessarily centrifugal association, implying the opposition of constraint against freedom. Secondly the model of the good insider as opposed to the necessarily bad outsider, making common cause with the enemies abroad, and hence himself a foreign agent. The logic of war reinforced the actual impact of such models. It stressed their adequacy for a new reading of social relations in a changed political situation. But the models themselves were quite ancient. They represent traditions in the perception of social forms which are transmitted through education and embodied in language itself.

A last step in the concept's social evolution was the equation between cosmopolitism and elite culture, but this time social representation worked negatively. Since the trading elites, the aristocracy and the ruling classes travelled abroad frequently, either for education, for business, or for leisure, elite culture was gradually stigmatized during the French Revolution as a treacherous form of anti-patriotism, recognizable in cosmopolitan behaviour. Foreign, or international culture became equivalent to the treason of cosmopolitism. Hence, after the Revolution, the reversal of the terms: the real culture, true civilization, was forcibly supranational, universal. Local culture was mere popular culture, folk culture, still to be elevated to an international level.[39] We then see the invention of local anthropology in the aftermath of the French Revolution, as an instrument for the cultural control of the nation by the elites.[40] However, the French case is far from unique. The first debates on the reform of popular culture in the Netherlands in the late eighteenth and early nineteenth centuries reflect the same convictions, and outline the requisites of a civilising offensive directed toward the lower middle classes or the masses. On close scrutiny, however, even this equation between popular culture and local culture appears to go back to the great waves of in-depth Christianization in all the confessions, Catholics and Protestants alike, in the period between Humanism and Enlightenment, roughly the late sixteenth and the seventeenth centuries. As early as 1679, the French parish priest Jean-Baptiste Thiers (1636-

1703) of the Le Mans diocese identified in his influential *Traité des superstitions*, repeatedly reprinted, superstition as identical to local culture, whereas true religion, hence true culture, was for him necessarily universal.

Concluding Remarks

It would of course be possible to pursue this demonstration and to show with more appropriate examples how semantic changes were rooted in new forms of social representation, in changing social relations or in the updating of old schemes of perception or cultural models of social organization. In order to see them, one needs the spectacles of a social or a cultural historian. Such spectacles imply a proper point of view from where to look at them, in other words, the proper statement of a new historical problem, or a new alliance with another discipline. Let me simply draw here some conclusions from the preceeding considerations.

The first conclusion is not more than an impression, but nevertheless a strong impression. It is that the development of conceptual history as an interlocutor of social history is hindered by its too close connection with the *Sattelzeit* hypothesis. Conceptual history, in its German version, focuses all its attention upon the conceptual shifts and their political implications at the end of the eighteenth century. It virtually neglects possible shifts of another nature in other periods which may illustrate other semantic properties of the concept under review. For the relative outsider, which I am, conceptual history tends sometimes to become a history without surprise, with a prime theory defined once for all, all the rest being application. In this short analysis of the concept of 'cosmopolitism', at least, the Renaissance too appears to be a period of great semantic shifts; still other periods may be highlighted by further research. It is, at any rate, probable that the limitation of the period covered to 1820 by the *Handbuch* is too closely linked with the *Sattelzeit* hypothesis, and taken too easily as a ready-made theory. The concept of cosmopolitism was still to enjoy a healthy life in France and elsewhere.[41] In international Communism, it would even be gratified by Stalin with a quite remarkable semantic shift which drove it straight back to the Terror period in the French Revolution.

As a second conclusion, we may state that what fails more pragmatically, is contextual information other than linguistic, literary, or idiomatic. Who uses which word, where, when, why, what for, and with which meaning? Images, symbols, objects, status consideration, group behaviour, stratification, and so on, are elements of the contextualisation and the positioning of concepts in a field of social or cultural representation, and of social use. In brief, they are evidence of forms of collective *appropriation*, which can be illuminating for a new understanding of conceptual shifts. Concepts are necessarily in interaction with such elements of social 'reality', which they constitute as forms of social representation and elements of historical knowledge. He or she who fails to scrutinize this interplay in the closest possible way condemns him- or herself to easy misinterpretations.

What seems lacking, thirdly, is a more systematic attention to the perception of the concepts as elements of a world-view, and for the interconnections in time and space between the words which express them. When studying a particular concept, conceptual history

should always examine equivalent or synonymous terms with similar connotations, the more so, since many concepts are at the same time current words; and it is very difficult to make a sharp distinction between a concept and a word. This applies quite clearly to the concept of cosmopolitism. If we agree that cosmopolitism as a *concept* is, as in the title of Fougeret's booklet, semantically equivalent to the term 'world citizen', then we should at the same time analyse the other term, without forgetting that the *word* 'cosmopolitan' may have diverging connotations, as, for example, in the case of alchemy. Hence concepts should not be studied without simultaneously analysing the whole field of connected terms, both horizontally (the broad semantic field of the concept, encompassing a variety of words) and vertically (the participation of the same word in virtually diverging semantic fields or concepts). Studying the concept of cosmopolitism makes no real sense without analysing, at the same time and with the same thoroughness, the terms, concepts or social constructs of *Christianitas*, the Republic of Letters, or world citizenship; and without forgetting to confront the results with virtual antonyms such as fatherland or patriotism.

Still, conceptual history should be considered an indispensable tool for social history. It clarifies the range and depth of the semantic fields involved in cultural and social representation, at the crossroads between language and society. Social and cultural history, in its turn, may clarify the stratification of such semantic fields as related to group behaviour, and illuminate their position in group representations and in the overall world-view of a given collectivity. Conceptual history, I would say, is the investigator and the guardian of the semantic elements of the cognitive reality which social history brings together into a single, necessarily global picture. That means that social history is not specifically concerned with 'reality', but with the ways in which past societies are explored, analysed and accounted for as properly historical societies. Its privileged tool for the understanding of these ways may well be conceptual history. In its turn, conceptual history needs to be rooted in social evidence if it wants to unearth social meaning. At any rate conceptual history should not give way to the temptation of all sub-disciplines to constitute itself as an isolated body of knowledge. When conceptual history is the proper tool of historical knowledge, it should more than ever try to situate itself at the very center of historical practice.

CHAPTER 9

Conceptual History and Conceptual Transfer: the Case of 'Nation' in Revolutionary France and Germany

HANS-JÜRGEN LÜSEBRINK

Methodological reflections

Conceptual history – particularly *Begriffsgeschichte* – has been predominantly investigated within the fields of national languages and cultures, and has been restricted mostly to the analysis of isolated concepts in their historical evolution. The present contribution tries to overthrow this perspective and to extend the field of conceptual history in a double manner: in taking the intercultural 'genesis' of the conceptual field of 'nation' in France and Germany as an example, it will try to develop both a comparative and intercultural mode of investigation in conceptual history. We propose therefore to distinguish five dimensions (or levels) of analysis (both valuable in national conceptual history and in comparative and intercultural perspectives):

1° the *lexicological dimension* of concepts and conceptual fields. This level is based on the morphology of lexicological items (words for example) and their interrelations;

2° the *semantic dimension* of semantic fields and their interrelations is based on the meaning of concepts and implies different degrees of extension concerning their semantic 'overlapping'. Methodological issues are the analysis of frequencies, on the basis of a more or less restricted corpus of texts, then the constitution of semantic fields and third the analysis of co-occurrences in syntagmas (in sentences, but also in more complex structures);

3° the *intermedial dimension* aims at the presence of concepts in different materialities of communication, like orality, literacy, semi-orality, rituals, narrative or non-narrative fictions, etc.;

4° the *socio-cultural dimension* concerns the use of concepts and conceptual fields by political or social groups and in different societies and cultures;

5° the *intercultural dimension* finally aims at the study of the transfer of concepts and conceptual fields to other cultures.

Conceptual history has largely privileged the two first dimensions and directed its attention, among the third level, mainly and often exclusively to argumentative structures, whilst neglecting visual representations, rituals, narrative fictions and semi-oral or oral me-

dia (like songs) which contribute as well, and in an often more emotionalized and effective way, to the social diffusion of concepts and conceptual fields.

The fifth level of intercultural relations has remained a relatively little-explored field, especially with regard to the intercultural dimension. This means: the processes of relations between two or various cultures, taking forms like reception processes, translations, imitations, adaptations, productive reception or, more generally, the phenomena of cultural transfer. This intercultural approach to cultural phenomena should be distinguished sharply from a comparative level of investigation which is sometimes (but not necessarily) related to it. A comparative perspective includes the analysis of two (or several) cultural phenomena – for example concepts – which are not necessarily linked together by direct relationships or contacts, whereas the intercultural approach focusses on the direct interrelationships between cultures (by means of texts, human interaction, or other forms of communication).

Intercultural Breaks

At the end of the 18th and the beginning of the 19th centuries, Franco-German cultural ties attained an intensity of exchange never equalled before or since. They embraced a wide area of cultural practices and phenomena, and in France in the second half of the 18th century concepts such as 'Culture' and 'Littérature' expanded, as did the concept 'civilisation'[1] to cover them. They embraced the area of transfer of knowledge, translation, the field of artistic and scientific activities and forms of expression as well as the collective concepts of perception and identity, under which the concept of the 'nation' took on an outstanding role in the last decades of the 18th century. From this concept of 'nation', the mental and cultural breaks can be more precisely determined, which during the last decades of the 18th century lead towards a growing autonomy of national culture in Germany and France, towards an alienation from foreigners and 'imported' cultural products; and above all, a mental distancing from every self-evident cultural exchange and the acquisition of foreign languages and culture, which distinguished the elite cultures of the 18th century.

This distancing manifested itself in different ways in Germany and France through contemporary political and journalistic discourse. In France in 1793/94, above all in political discourse, one notices an increasingly negative use of the concepts 'étranger' (foreigner), 'culture étrangère' (foreign culture) and 'cosmopolitisme' (cosmopolitism). 'Étranger' was associated at that time exclusively in the political dimension of meaning with concepts such as 'foreign party' (parti étranger), 'exile' (exil) and 'aristocrates' (aristocrates). They stood as a threat to revolutionary and republican France through the political and military coalition between the foreign feudal powers and the exiled French aristocracy. In the years 1794 and 1795, like other politicians in the culture and language of the Jacobin phase of the French Revolution, Henri Grégoire and Bertrand Barère gave the terms of 'étranger' (foreigner) and 'langue étrangère' (foreign language) an additional cultural dimension, in so much as they classified the use of foreign, 'alien' ('fremder') languages in the administrative, educational and communications sector within the French territory as a threat. Barère, for example, described in his very influential *Rapport du Comité de Salut Public sur les*

idiomes the languages used within the French territory for everyday, administrative, and written purposes as 'langues étrangères' (foreign languages) and saw in their spread an instrument of 'fanatisme' (fanaticism) and superstition, which, above all, helped 'les ennemis de la France' (the enemies of France).[2]

In the German language and cultural sphere at the end of the 18th and beginning of the 19th century, the process of national autonomy and segregation from every so-called foreign culture also began to manifest itself. It did so by viewing itself, above all, as a process of a dawning of national consciousness. This was expressed not so much as a political concept and pattern of discourse, but more as the construction of a mythological national identity and related symbolic figures. Early German nationalism was different from the national discourse in France, which in essence remained closely attached to the ideal of the universalistic anthropology of the Enlightenment until the Third Republic while keeping its basic elements down to the present. This German nationalism of the turn of the century, by contrast, had already laid the foundations for a specifically German identity in 1800. More widely determined than in France, the nationalistic discourse in Germany broke free from the 'norm of universalistic humanity' ('Norm universalistischer Humanität') and, for example, according to the thesis of Aleida Assmann, 'allied itself with the special characteristics of a nation deeply rooted in its language, history and territory'.[3] The genesis of a conception of a national identity followed as a result of the French Revolution and the war of liberation. This national identity is said to be intrinsically inculcated in every member of a nation, but must be strengthened through education. This was formulated in the words of the historian Ernst Troeltsch at the beginning of the 20th century through 'wir wollen deutscher werden als wir waren' ('we want to become more German than we were').[4] Instead of a process of a national dawning of conciousness, this process – from the angle of an interculturally organized social history of the culture – is understood as a complex process of reception and productive processing of very diverse sequences of terms and chains of discourse whose main focus was the filiation of ideas between France and Germany.

Intercultural Relations – The Concept of 'Nation'

The analysis of the German-French dictionaries of the epoch 1770-1815 first of all covers a broad and surprising transfer of the semantic field of 'nation' from French into German. All together there are almost 70 terms concerning this semantic field, of which 59 appear in German translation and are defined in dictionary entries.[5] Closer examination of the contemporary French-German dictionaries reveals that in addition to the 39 terms in the available listed concepts in A. Abdelfettah's study,[6] which hitherto was the only one that deals with French-German concept transfer, proof of at least 20 more terms within the mentioned field of concepts has been established. Among these are the terms 'Nationalfahne' (national flag), 'Nationalmuseum' (national museum), 'National-Panthéon' (national Panthéon), 'Nationalpalast' (national palace), 'Nationalgeist' (national spirit) and 'Nationaltödtend' – a translation from 'Nationicide', which is translated by Reinhard in his dictionary as 'genocide', 'Volksmord' or 'Volksmörderisch' (genocidal), and

by Snetlage and Lacoste as 'Nationalmörder' (murderer of a nation) – as well as the concepts 'National' (national) and 'Nationalfamilie' (national family).[7]

Gödicke, in particular, brings out the concept of 'national' by underlining the expansion of meaning which it underwent from the beginning of the revolution. According to his dictionary entry for 'national', 'this word has gained one of the largest expansions, that which a word is only capable of when its meaning can be easily understood out of context'. In the German translation of Snetlage's dictionary by Lacoste, the term 'national family' is hidden in the relatively extensive entry for 'Republik, französische' (republic, French). The entry appears remarkable for it concisely and manifestly stresses this democratic-republican dimension of meaning of the French concept of nation. Since the 18th century, and especially since the years 1792/93, this dimension of meaning has fundamentally differed from the signification of the German semantic field *Volk-Nation-Vaterland* (people, nation, fatherland).

According to the authors of the Lacoste-Snetlage dictionary, the solidarity of the nation is founded on common republican values and morals, such as the establishment of a common weal ('Einrichtung auf das allgemeine Wohl'), the satisfaction of general needs ('Befriedigung allgemeiner Bedürfnisse'), love, freedom and brotherhood ('Liebe, Freiheit und Brudersinn') and the conviction 'daß alle Bürger in Ansehung ihrer Rechte und Obliegenheiten gleich sind' – that all citizens in view of their rights and obligations are equal.[8] Furthermore, as derived from these characteristics of the definition of 'nation', the national territory and it's composition as well as the cultural and linguistic qualities of the inhabitants are mentioned, whose 'differences [...] had to attract the attention of the legislator'[9].

The influence of the French model of the nation whose wide range and intensity displays the outlined semantic field, manifested fascination with various things French. Georg Forster, Johann Heinrich Campe and Karl Friedrich Reichardt, German intellectuals and travellers to France, expressed an open admiration of the new French model of the nation in their political and journalistic works. Forster's was, without a doubt, the most intense, revealed in his political demand that the left bank of the Rhine should go to the Republic of France. Johann Georg Heinzmann, in a work from the year 1800, traces back the military superiority of France directly to the 'spirit of the fatherland and national consciousness' (Vaterlandsgeist und Nationalsinn), which in other European countries, and especially in Germany, was practically non-existent. A large number of articles in the German press demonstrate a fascination for the French national celebrations, which were also celebrated in parts of the German linguistic and cultural sphere due to the occupation of the left bank of the Rhine. This fascination is partly mixed with a certain scepticism towards the mobilizing powers of the new French concept of nation and its institutionalisation. A detailed anonymous report, which appeared in the magazine *Minerva* in 1806, saw the French national festivals as the revival of ancient traditions, particularly of the Roman victory celebrations.[10] The author of a report on the French national celebrations, entitled *Über die französischen Nationalfeste*, which appeared in the *Journal der neuesten Weltbegebenheiten*, was more sceptical since it saw the festivals as largely depicting mechanisms of a factional spirit ('größtenteils Spielwerke des Faktionsgeistes').[11] In a commen-

tary, the publisher of the magazine characterized national celebrations during the time of the revolution. He particularly emphasized the counter-example of the military national celebrations, the martial dimension of which shows a disproportionate degree of national mobilisation from the more political and moral-philosophical ones:

> Der Verfasser erwähnt der *Siegesfeste* nicht, die jedesmal den größten Eindruck machten. Die kriegerische Musik, die Hymnen des Vaterlandes, die erbeuteten Trophäen, der Nablick der verwundeten Krieger und der Urnen, die den Mann der verstorbenen Helden geweiht waren, erfüllten die Zuschauer mit heiligem Schauer und hoher Begeisterung. *Buonaparte* wird sie auch nicht *während des Krieges* vernachlässigen.[12]

Even if the English example of promoting 'Nationalgeist' (public spirit) (Archenholtz) played a particular role in the decades of radical political and cultural change around 1800 in Germany, the conceptions of a rebirth ('Wiedergeburt') of the German nation and of a nationalization ('Nationalisierung') of the German people were already nonetheless in essence thought of against the backdrop of the development of new concepts of nation and their institutionalization in France. The ideas of 'Nationalerziehung' (national education), 'Nationaldichter' (national poets), 'Nationalfeste' (national celebrations) and of the 'Nationaltempel' (a concept that was supposed to take on concrete form by 1807 through the Walhalla project), which had developed between 1795 and 1815 and were widely discussed in German journalism, had the French national model of the revolution as their fundamental frame of reference. The French national model of the revolution was accepted and assimilated in Germany through various means; through direct travel experiences, through the reading of French works in the original, but most of all through translations. Schubart's obituary of Klopstock's death,[13] for example not only had the headline 'National-Verlust' (a new word creation, translation of the French term 'perte nationale' – a national loss), but refers to the model of the 'Ecrivain national' (national writer) through his entire conceptual pattern. This was a model which had been created during the late Renaissance (above all through the cult of Voltaire) and the French Revolution. It stated

> the function of the national poet as "patriot" and at the same time spokesman of the nation indicates the necessity of securing for him a firm place in the collective memory of the nation through monuments, "a classical edition of his works" ('eine klassische Ausgabe seiner Werke') and lastly through a biography.[13]

Upon examination of the translations from French to German, one finds that in the period 1770-1815 almost 200 writings were translated into German in which the words 'nation' and 'national' appear in the title. These were predominately in the form of magazine articles. Of the translated texts almost all the programmatic writings of revolutionary French nationalism can be found. Among a wealth of anonomous literature the translated writings of Barère, Sieyès, Robespierre, Lepelletier de Saint-Fargeau (who exercised a determinant influence on the national pedagogical writings of Fichte), Mercier, Narbonne, Grégoire

and Laréveillière-Lépeaux can be found.[14] This last work, translated into at least two editions, formulated concepts concerning the development and institutionalization of national celebrations and secular festivities in the framework of the new republican national model. This work runs parallel to the similar deliberations of Henri Grégoire and Boissy d'Anglas in the years 1793/95.

Two lines of argument are prominent. Each is to be found, in similarly discursive form, in the spokesmen of the early German nationalism one to two decades later. One stresses the necessity for abstract political terms such as 'Gesetz' (law), 'nationale Gemeinschaft' (national community), 'Verfassung' (constitution) and 'öffentliche Meinung' (public opinion) in order to make the collective event of public celebrations and ceremonies more aesthetic and meaningful, with the purpose of implanting itself in the minds of the population.

In the other, Réveillière-Lépeaux emphasizes the importance of non-literary media and forms of expression in the framework of the conceived national celebrations, under which the fine arts, and above all, music and song stand out. His arguments here refer to views on aesthetics and the effects of media, as they were developed between 1795 and 1800 in the circle of *Idéologues*, among others by J.-L. Roederer in the magazine *Journal d'Economie politique*.[15] These approaches bind the media-aesthetic and rhetorical points of view with basic anthropological assumptions which were adopted in a modified form in the German, as well as in the French nationalistic discourse of the 19th century.

At the same time *asymmetries* and *semantic distortions* become clear in a detailed comparison of the translation and the original. 'Cérémonies civiles' (civil ceremonies) as well as 'institutions civiles' (civil institutions) are translated into German as 'bürgerliche Gebräuche', which has an entirely different dimension of meaning from the original French one. The concept 'bourgeois' or 'bürgerlich', which is more a specific social status, cuts out the collective egalitarian dimension of the term 'citoyen' (citizen) as well as its historical embedment in the revolutionary occurrences of the years 1789-94. A similarity can be observed in other translations of certain concepts: 'Constitution' is translated through the compound 'Landesverfassung', which makes one think of the term 'Reichsverfassung' (imperial constitution); 'loix civiles' (the civil code) with the term 'bürgerliche Gesetze'; 'vie civile' (civil life) through 'bürgerliches Leben'; the term 'citoyen' (citizen) finally is not translated as 'Staatsbürger', but simply in the narrow sense of the term 'Bürger'. The new attitude of the French towards state and nation, which is described through the term 'dévouement' (devotion) and consists of an active and action-oriented element of meaning, is translated by the more passive insinuating term 'Ergebenheit' (submissiveness). The term 'Esprit public' (public spirit), which in the context of the 18th century showed a narrow semantic bond with the term 'Opinion publique' (public opinion), is translated as 'Gemeingeist', a term which in German emphasises an inherited idea of *Patriotismus* even more.[16] The term 'espèce humaine' (human race) finally reappears in the translation of the even stronger individualising term 'Mensch' (man). In the original text this term displays a collective and universalistic dimension and should have been translated with 'Menschengeschlecht'.

Réveillière-Lépeaux's writing, which is characteristic of the transfer of the French model of the nation and its conception, indicates the basic problems involved in the translation of French political vocabulary into Germany at that time. Due to their integration into an inherited web of terms, in which 'bürgerlich' (civil), 'Gebräuche' (traditions) and 'Verfassung' (constitution) (in the sense of 'Reichsverfassung' (imperial constitution)) occupied a central status, important dimensions of meaning of the French original text were weakened or faded out. This encouraged forms of productive reception of the French model of nation in Germany, which, according to Ernst Moritz Arndt, took the aesthetic-semiotic model of the French concept of nation, its forms of rhetoric and pattern of expression as a model, but at the same time provided it with an entirely different ideological dimension.

Conceptual Transfer and Productive Reception – The Example of E.M. Arndt

Early German nationalism was specified by a more or less radical rejection of those multicultural and especially Franco-German dimensions, which characterized the elite culture of the 18th century. Its most important spokesmen were Ernst Moritz Arndt, Johann Gottlieb Fichte, Ludwig Jahn and Theodor Körner. Nevertheless in the way they saw themselves, there was a clear break not only with the anthropological and political-philosophical conceptions of the Enlightenment, but also with the Revolutionary French idea of nation. Arndt and Jahn countered this with an ethnically based model of the nation, the hypostatization of the *Volk*-terms, which, according to Arndt, moved into the place of the foreign word 'nation' and the construction of a 'deutschen Eigenart' – a German individuality.

At the same time Ernst Moritz Arndt insisted on the danger of a premature acquisition of foreign languages in an entire series of writings which were published in the years 1804 to 1815.

> Whoever exercises and pursues a foreign language from his youth must inevitably confront his opinions, thoughts and feelings with strange ones, will finally have to perceive his native Germanness incorrectly and the characteristic "self" must always remain a mystery.[17]

According to Arndt, what is even more dangerous than the regular usage of a foreign language in verbal or written communication is its employment as the language in which lessons are conducted in the general school system. Arndt uses the metaphor of the drip in this connection in order to describe, from his point of view, the resulting fatal consequences: The drip erodes the rock, and in the end nothing more remains save for a hollow and insubstantial shell. In 'ethnicizing' to a certain extent Humboldt's conception of the integration of language and philosophy, he regards an early acquisition of foreign languages as a danger and a final fundamental weakening of 'das eigentliche Wesen' (the true profound being). In doing so, he creates the new German concept of nation, which took the form of a radical distancing from the contemporary French one. It was founded on the idea

of the justified dichotomies of 'Eigenes' (own) and 'Fremdes' (foreign), and of 'Muttersprache' (native language) and 'Fremdsprache' (foreign language) whereby each was provided with specific semantics. The first ones were said to be 'rein' (pure), 'keusch' (chaste), 'kühn' (bold), 'tugendhaft' (virtuous), 'anmutig' (graceful) and at the same time 'männlich' (manly) and 'schwer' (powerful), whilst the French language, as a Romance language par excellence, embodied the (negative) qualities of 'das Sinnliche' (sensory), 'das Spielende' (playful), 'das Schimmernde' (glimmer), 'das Scherzende' (jest) and 'das Plappernde' (chatter). Arndt put these qualities into the field 'Weiblich' (feminine), using it as a metaphor for the nature of the French.

> That means that the language that they speak is the reflection of a people; it is clear to me from the language of a people what they want, what they strive for, what they tend to, what they love and experience the most, in short, in which direction their true life and aspirations range. One now sees what I am leading to. I want the practice and usage of the French language in Germany abolished.[18]

Arndt seized the dichotomy of 'Muttersprache' (native language) and 'Fremdsprache' (foreign language) which should be learnt, according to him, as late as possible, with the help of an imagery based on gender oppositions. Contrasts are thus not only deprived of their diverse nuances and their transitional stages, but at the same time become, to some extent, naturally determinate due to this gender opposition.

The same is even true for the national patterns of identity which Arndt and Jahn conceive as a national being. In doing so, they follow a long tradition of stereotyping and at the same time create a perception of other peoples, which in turn creates a collective identity. However they extend it in a political and (proto-)ethnic dimension, which points towards the German nationalism of the 19th and beginning of the 20th century. This long tradition goes back to Tacitus' *Germania*, which was readopted in numerous German and French Tacitus-translations of the 17th and 18th century, and which had also preserved a language-politics and cultural dimension along with the German language patriotism of the Baroque period. Thus in his major work *Deutsches Volkstum* (1808), Ludwig Jahn places introductory observations before the chapter entitled *Volksgefühl*. 'Volksgefühl' is a term to which he gives preference over the word translated from the French, 'Nationalgefühl' (national sentiment). In the observations he demands the complete replacing of every foreign cultural influence in the German language sphere. In Chapter seven of his work, which is entitled *Vermeidung fremder Wörter* ('the avoidance of foreign words') one reads: 'Foreign expressions for people, titles, offices, actions and traditional objects must be entirely abolished, and should be avoided in laws, decrees and in business, and only retained there, where it remains comprehensible.' On the cultural level, Jahn's discourse is determined by the fundamental polarity of 'Ausländerei' ('foreigness' or all that which is foreign) and 'Deutsches Volkstum' (German national traditions and folklore). In this he sees German national traditions embodied in the language, public festivals and *Volkstracht*, the national costume.

In Arndt's theory this dichotomy expands into a confrontation of lexically complex and ramified semantic fields which form groups around the opposition of 'Eigene' (own) and 'Fremde' (foreign). He thus sees the French national character through the qualities of – to begin with the most used term – 'Zierlichkeit' (daintiness, petiteness, delicateness), 'Empfindsamkeit' (sensitivity, sentimentality), 'Geselligkeit' (sociability, conviviality), 'Geist' (spirit, mind) and 'Lebendigkeit' (liveliness), but also of 'fehlende Tiefe' (lack of depth), 'Flatterhaftigkeit' (fickleness), 'Eitelkeit' (vanity) as well as tending toward wastefulness and luxury ('welscher Tand', French trinkets). These are qualities which he believes are found in the form of aesthetic mutation in the classical French literature of the 17th and 18th century (Corneille, Racine, Voltaire). He sees, on the contrary, the lexically characterised national identity of the inhabitants of the German linguistic and cultural sphere as embodying the qualities of 'Aufrichtigkeit' (sincerity), 'Ehrlichkeit' (honesty), of 'männlicher und rüstiger Kraft' (manly and sprightly power), of the 'Tiefe des Gemüts' (the depth of disposition) and of the 'Fähigkeit zur großen schöpferischen Tat' (the ability to perform a great and creative feat). This vocabulary predominantly contains the terms referring to German identity such as 'das Deutsche' (German), 'deutsche Art' (the German way) and 'die Deutschheit' (Germanness) but also 'Uranlage' (ancient profound identity), 'Germanischer Charakter' (Germanic character) and 'Germanisches Gemüt' (Germanic nature, disposition).

The field of concepts in Arndt's discourse which describes intercultural relations, above all between German and French culture, in the end contains almost 40 terms which characteristically display a consistantly negative meaning. Arndt describes the linguistic, and in a broader sense, cultural relations between both national cultures with terms which either fall back upon the metaphors of infection ('Pest' – plague; 'Krebs' – cancer), of paralysis and blindness ('erstarren' – to be paralysed, petrified; 'lähmen' – to paralyze, to cripple; 'verblenden' – to blind), of disguise and obliteration ('verwischen' – to become blurred; 'verkleiden' – to disguise; 'verlarven' – masking), of emasculation (Verweichlichung – softness; 'Abglätterung' – smoothness) or, as the fifth metaphor web, fruitless imitation ('äffen' – to ape; 'Nachäffung' – aping; 'pfauen'[19] – to strut). Arndt lastly describes cultural syncretisms as a 'Mischmasch des Verschiedenen' (diverse mish-mash),[20] its mediators and social bearers as frogs and frenchies, Frenchified Germans and absurd half-breeds ('Welschlinge', 'verwälschte Deutsche', 'lächerliche Halblinge'), as well as 'halbe Engländer und Franzosen, zuweilen wohl Türken und Polacken' – half Englishman and Frenchman, occasionally Turk or polack.[21]

Arndt's political and anthropological ideas, which embedded national differences into ethnic polarities, found their way into a discourse with a clearly militant character in the years 1804 until 1807, after the traumatic experience of the Prussian defeat by Napoleonic France.

Lampoons such as *Geist der Zeit* (1806), *Über Volkshaß und den Gebrauch einer fremden Sprache* (1813), *Das Wort von 1814 und das Wort von 1815 über die Franzosen*, der *Soldatenkatechismus* (1813) and a large number of patriotic songs and poems expressed performative linguistic gestures which openly called for hatred of the french enemy and for its military and physical annihilation. A lampoon such as *Über den Volkshaß* or poems such as

Des Deutschen Vaterland (which had been written in the historical context of the Battle of the Nations and were then published) absorbed conceptual images such as the 'Vergiftung' (poisoning) of their own identity through foreign languages and cultures (particularly the French culture). Arndt integrated them in a discourse which was no longer only observant and descriptive, but provoked aggressive actions and emotions. And thus in one of his most well-known and widely adopted poems *Des deutschen Knaben Robert Schwur*, the keywords 'Deutsches Vaterland' rhyme with 'welscher Tand' and the term 'Haß' with 'ohne Unterlaß'. The linguistc style is determined through the oath's para-religious pathos:

> Auch schwör ich heißen blut'gen Haß
> Und tiefen Zorn ohn' Unterlaß
> dem Franzmann und franz'schem Tand
> Die schänden unser deutsches Land.[22]

A poem such as *Deutsches Kriegslied* from the year 1813 uses a political vocabulary, which corresponds almost entirely to that of the songs of the French Revolution (1789-1815). For example, in the Marseillaise, the word 'battle' is linked with the idea of sacrifice for the Fatherland. In the place of the imperative 'Allons (enfants de la patrie)' 'Frischauf!' (Let us away!) and 'Heran!' (Come on!) appear. Other keywords of the national revolutionary discourse, and the way they are personified in the Marseillaise, are found in a direct translation in Arndt's poem. One therefore finds 'Tyrann' for the term 'tyran' (tyrant), 'Henkerschwert' for 'épée du bourreau' (the executioner's sword), 'Vaterland' for 'patrie' (fatherland), 'Freiheitsfeind' for 'ennemi de la liberté' (enemy of freedom), 'blut[i]ger Kampf' for 'lutte sanglante' (bloody battle) and 'Sklaven' for 'esclaves' (slaves). These are terms that consistently constitute a pattern of identity and concepts of the enemy.

Onto a translated French political term, Arndt thus loads a fundamental (proto-)ethnic dimension of meaning to the German translated potential which had been already spread in France with an uncommonly broad range of translations into German in the years 1789-1815. He does this in a similar way to Jahn and Körner, the most important representatives of the German nationalism at the beginning of the 19th century. Even though semantic fields are fundamentally, mutually, and exclusively structured and in parts lexically identical, the terms such as 'Tyrannen' (tyrants), 'Vaterland' (Fatherland) and 'Freiheitsfeind' (enemies of freedom) were given another meaning in the context of German nationalism. They were connected to ethnic registers of perception instead of to political concepts such as 'Aristocrates', 'Emigrés' and 'Contre-Révolutionnaires' as in the Marseillaise, or in the revolutionary song *Ça ira* and were henceforth directed at the German and French peoples in their entirety. Even though Arndt's linguistic gestures of hatred and the physical annihilation of the opponent were directly formed on the lexical and pragma-linguistical level from the speech-act structures which were prevalent in the political discourse of contemporary France, on the semantic level they did not focus on a politically and socially defined enemy, but rather on the French nation as a whole.

According to Arndt, the formulation and social dissemination of antithetical patterns of the perception of all that is foreign, are in the end an indispensable basic requirement for

the creation and strengthening of the national consciousness. National identity and national concepts of the enemy are – as in the political discourse of the French Revolution – directly linked together; only Arndt defines them *ethnically*. In his article *Über deutsche Art und das Welschtum bei uns* he writes: 'So let us hate the French ever so much. Let us hate our Frenchmen when we feel that they are weakening and unnerving our virtue and strength, they who dishonour and ravage our power and innocence! As Germans, as a people, we require this antithesis, and our fathers were a far better people than we are now, at that time when this opposition and revulsion for the French was at its most fervent.'[23]

Even if the term 'Rasse' (race) is not explicit (as a lexical term) in Arndt's discourse, it is indeed semantically anticipated in many respects through terms such as 'innerster Kern des Teutschen' (the heart of the Germans), 'Germanische Art' (Germanic way), 'Deutschheit' (Germanness), 'deutsche Volkstümlichkeit' (German folk character) and 'Uranlage' (ancient 'profound being'). Arndt's concepts of the identity of the 'Deutsche Nation' (German nation) are linked furthermore to an unmistakeable anti-semitism and a rejection of every cosmopolitanism or 'Weltbürgertum' which he sees as a radical contrast to the 'Nationalgeist' (national spirit). Arndt's nationalistic discourse consequently founded a virulent rejection of any multi-cultural structure of the German society and nation. His discourse shows clear lexical and structural similarities with the political discourse of the late Renaissance and of the French Revolution. In his essay *Über Sitte, Mode und Kleidertracht* Arndt writes:

> We Germans will remain wretched slaves if we do not destroy the foreign way, traditions and language from within our borders and look at our people, our way and traditions, with the pride that they deserve.[24]

Conceptual Transfer and Media Pragmatics

It might seem quite paradoxical that Arndt's nationalistic discourse which is very close, in its ideological dimension, to Fichte and Jahn, the two other leading figures of the early German nationalism in the beginning of the 19th century, was derived by a man, who throughout his entire life intensively adopted the French culture not simply intellectually (he was a reader and translator of French writings) but also physically by travelling through France. Ever since his grammar school days in Greifswald, Arndt was a fascinated reader of Jean-Jacques Rousseau (above all his pedagogical writings), Montesquieu, Louis-Sébastien Mercier and Morelly whose *Code de la Nature* he attributed to Diderot and translated into German with an extensive commentary.[25] Above all, his almost six-month long journey through the France of 1799 should have exerted a lasting influence on Arndt's concept of France and his reception of the political culture of the French Revolution. At the end of a stay in Austria and northern Italy, he travelled through the south of France in the spring of 1799 and spent the summer months in Paris. He described the life of the skilled workers, the media communications as well as the radical change in the political culture of the late Directory (1795-1799) in a style of expression which clearly characterizes the reading of

Louis-Sébastion Mercier's *Tableau de Paris*. He did so with a thoroughly remarkable sensitivity for everyday culture and the forms of sociability. He seemed to be particularly impressed with the fervour of the French 'Volks- und Nationalgeist' – which was entirely lacking in Germany, as he noted: 'A people of 30 million have become the ridicule of Europe because the national spirit is lacking'.[26] In his travel log, he describes his conviction of the necessity for an extensive and systematic national education as an instrument of 'Nationalisierung' (nationalizing) the divergent social stratum. This occurred after visiting the new republican schools which had caught his attention just after he had arrived on French soil in Nice, the creation of national symbols and places of rememberance (Panthéon, statues and monuments), as well as witnessing the public staging of national celebrations.

The transfer and conceptual realization of the French 'Nationalpädagogik', its conceptuality and its media structure, resulted in an entire series of political and journalistic writings in the years 1807 through 1815. Arndt, indeed, lexically adopted the political discourse of the late Enlightenment and the French Revolution, in which he gave the concepts a new dimension of meaning that partly went back to the 17th century, German-language, patriotic tradition of the stereotyping of a people. He also enlarged a militant field of terms, in which the terms 'Erbfeind' (traditional enemy), 'Volkshaß' (hatred of a nation) and 'Deutschheit' (Germanness) took on a central role. In addition, he projected the conception of a national identity onto a broad field of cultural, as well as natural phenomena, which extended from the landscapes, to the festivals and traditions as well as to the language and the problem of the national frontier. This was done in the same way as other spokesmen of the early German nationalism did. In his writing *Der Rhein. Deutschlands Strom und nicht Deutschlands Grenze*, he rejects the French discourse on the 'natural frontiers' (of France) explicitly and with a radical distancing. He links his conception of national frontiers with the term language borders, which, for example, completely contradicts Danton.

> I say: language is the only valid natural boundary. God created the distinction between languages so that a larger, lazier and worthless crowd of slaves did not exist on Earth. The different languages create the natural separation of peoples and countries. They create the large internal differences of the people, in order that the stimulus and struggle of lively powers and urges come into being, through which the spirits keep their fervour.[27]

But the actual originality of Arndt's nationalistic discourse, in comparison, for example, to Fichte, Körner and Jahn, lies less within his vocabulary and semantics than it does with the *structure* and *extent* of the employed media and forms of expression, which for the most part explicitly or implicitly fall back on the French model. His war-songs (such as *Deutches Kriegslied*), patriotic catechisms (like the *Katechismus für den deutschen Kriegs- und Wehrmann*), and his appeals to the German people and those politically responsible (among other works *Fantasien für ein künftiges Deutschland*, 1815) shows the genesis of a political mass literature within the German language and cultural sphere which is directed

at a wide readership through its lexical structure, its semantics and its genre. His *Aufruf an die Deutschen zum gemeinschaftlichen Kampfe gegen die Franzosen* from the Battle of Nations of 1813, for example, not only falls back on the *semi-oral style*[28] of the Address, through which the author tries to transpose the emotional linguistic gestures of oral speech in the form of writing and tries to address the 'nation' and 'those in power', but connects three different genre structures in his text form which are often found in this combination in late 18th-century French literature.[29] First an argumentative text, whose characteristic style is that of a speech, which begins and ends with an appellative imperative, i.e. 'Deutsche!'; secondly a song or poem, for example the two poetic texts von Kotzebue which appear later on; and lastly political aphorisms, which have the structures of the slogan and aphorism and extend through the text, to a certain extent like catechismic mnemotechnic sentences with para-religious insinuations. In the beginning he writes: 'Germans! Thy proverb is: Honesty is the best policy. It is a holy statement, that time can not destroy, that no tyrant can condemn.' And in the second part of the text, entitled *Aber Landsleute, noch zweierlei zur Erinnerung* ('Fellow countrymen there are still two things to remember') there are the following aphorisms:

> firstly: stay true to thy character under every circumstance. Be just to thy friends and thy enemies (..). Secondly: Thou hast a thousand-fold proofs that thy enemy's work are lies and deceptions. Do not then become inconstant through its feigned innocence and hypocritical pretences, when it speaks of its purposes through its impertinent boasting and when it speaks of its feats.[30]

One can also observe similarities in the transfer and the productive acquisition of other popular structures of genre. A work such as Arndt's *Lob deutscher Helden* from the year 1814 follows the same purpose of development and the spreading of a lay pantheon of political and military heroes. This work took its basis from the *Eloge des héros français*, which had already been published as a collection of lampoons in 1791 and from which Arndt derived the title of his work. His patriotic satire *Kurze und wahrhaftige Erzählung von Napoleon Bonapartes verderblichen Anschlägen* from the year 1813 directly took up a form of political popular literature, which had also been created by the French Revolution in the area of the narrative genre, above all in the form of the almanac. The characteristic titles such as the terms 'kurz' (short), 'wahrhaftig' (honest) and 'verderblich' (corrupting), the very explicit subtitle, which reveals the content of Arndt's work, and the style of text take on the narrative form of the *Bibliothèque Bleue*, the almanac, as well as the leaflet. These forms are provided with political commentary modeled on the texts of the Revolution. The leaflet had also been circulating within the German and French language spheres in a similar form.

A look at the diverse connections between the origin of the modern concept of nation in Germany and France allows one to speak legitimately of the 'inter-cultural genesis' of German nationalism, its conceptual framework and its media strategies. The reaction in the discourse of German nationalism to the French concept of the nation, its semantics, rhetoric and aesthetics was influenced even more by the processes of exchange, of transfer and of the productive reception of concepts and structures of genre than has so far been presumed.

This was made possible through an epoch of intensive cultural transfer, above all between France and Germany. This transfer possessed a particularly extensive and politically influential area on the level of the semantic field of 'nation'. At the same time the development of the German concept of nation – with the central terms of 'Volk' and 'Vaterland' – which was identified by publishers like Arndt in the context of the wars of liberation, and the idea that was linked to it, had far-reaching (inter-)cultural consequences. This lay in the radical questioning of inter-cultural relations, in a new discourse of identity and in the creation of concepts of foreigner and enemy. During the 19th century these concepts, which in the end proved fatal, not only established the collective patterns of identity, but were also decisively to reduce and restrict the intensity and structure of the trans-national cultural transfer.

PART III

Concept and Image

Words, Images and All the Pope's Men

Raphael's Stanza della Segnatura and the Synthesis of Divine Wisdom

BRAM KEMPERS

"'If I'd meant that, I'd have said it,'" said Humpty Dumpty. Alice didn't want to begin another argument, so she said nothing.'[1]

Painted words are a crucial part of Raphael's images in the Stanza della Segnatura, one of the most important rooms of the Vatican Palace. He painted this extensive pictorial programme between 1509 and 1511 for Pope Julius II. Its meaning is, at least in part, indicated by inscriptions. The ceiling of the vaulted room contains four medallions with texts on painted tablets in the hands of small angels, each of them flanking a female figure. The painted words read as follows: CAVSARVM COGNITIO, IVS SVV[M] VNICVIQ[VE] TRIBVIT, NVMINE AFFLATVR and DIVINAR[VM] RER[VM] NOTITIA (FIG. 1). These texts accompany figures with the following attributes: two books (with the titles NATVRALIS and MORALIS) and a throne; a sword and balance; a book, a lyre, a laurel crown and a blowing figure; and an olive crown.

It is generally assumed that these four painted inscriptions are direct quotations from canonical texts, and that they have a clear meaning: philosophy, jurisprudence, poetry and theology. They are supposed to clarify the large scale frescoes on the walls below, which are known as the School of Athens, the Parnassus, the Disputa and the Jurisprudence (or Justice) wall. However, the titles, descriptions and interpretations of the paintings appear to be the result of subsequent ideas, in which various aspects of much later stages in the history of philosophy, politics, art and theology are reflected. A reconstruction of the post-Renaissance interpretations and a reconsideration of the sources and their context may be helpful to understand and correct some major fallacies; the meanings ascribed to the frescoes happen to have changed together with their intellectual context; the inscriptions themselves may serve as a starting point to unravel the riddle that is obscured by several anachronisms.

Raphael was one of the artists employed by Pope Julius II (1503-1513) in the Vatican Palace. More than his colleagues, with the exception of Michelangelo, Raphael acquired everlasting fame. A first overview of his work and reputation was Vasari's extensive testimony published in 1550 and 1568. Vasari also provided an iconographic analysis of the frescoes on the ceiling and the walls. He stated that the 'School of Athens' was painted first, and

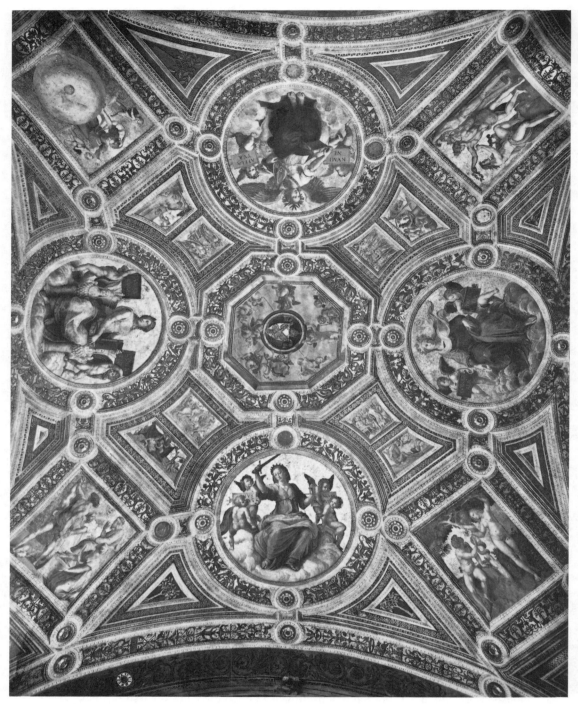

FIGURE 1 Raphael, Ceiling of the Stanza della Segnatura, fresco

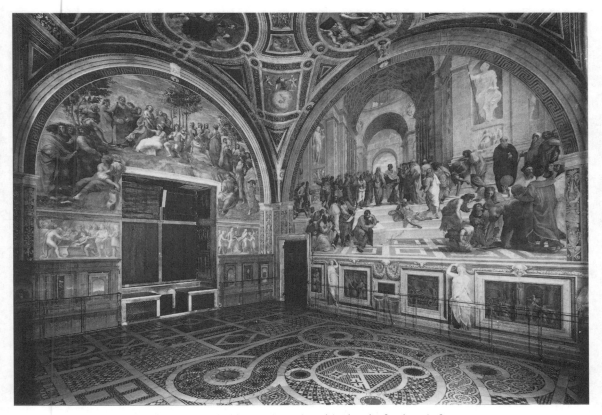

FIGURE 2 Raphael, 'Parnassus' and 'School of Athens', fresco

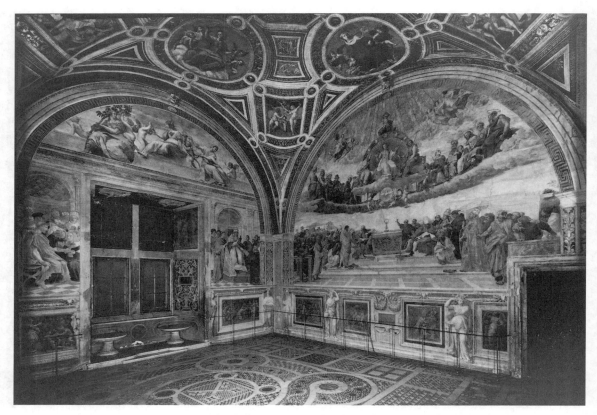

FIGURE 3 Raphael, 'Jurisprudence wall' and 'Disputa', fresco

that the Evangelists, to the viewer's left in the foreground of that fresco, played a crucial role, harmonizing Greek philosophy and Christian revelation (FIG. 2). In the second half of the seventeenth century Raphael was considered the culmination of artistic standards, but by then the iconography of the 'School of Athens' was seen in a radically different way, and this fresco was considered stylistically much more mature than the 'Disputa' on the opposing wall. This change in the interpretation of Raphael's images in the Stanza della Segnatura, more then a century after Vasari, is exemplified by the French author Fréart de Chambray and the Italian painter Bellori. Their ideas became generally accepted, whereas Vasari's were dismissed as being confused and thoroughly misleading. Vasari was thought to be wrong in dating the 'School of Athens' before the 'Disputa' and in giving a theological reading of this fresco; he was critized for confusing the two images, and for this mistake an explanation was provided: he had used prints with misleading texts attached to the copies of Raphael's frescoes. The prevailing view is, that the 'Disputa' is a purely theological image and that the 'School of Athens' – being later and superior in all respects – represents philosophy (FIG. 3). These two concepts are seen as the major elements in a fourfold classification of knowledge – with poetry and jurisprudence – that are linked to the four faculties of the universities, or to the *artes liberales*.[1]

Essential to any interpretation is an understanding of the words that accompany Raphael's frescoes, but these themselves appear to be problematical, partly because their translation and interpretation is anachronistic. The relation between word and image in Raphael's frescoes in the Stanza della Segnatura poses several questions about the philosophical, political, theological and artistic background of Raphael, his patron Julius II and their advisors, as well as of the later critics, in particular Vasari and Bellori. Both painters, who published their ideas in extensive treatises, played a crucial role in what may be called the critical history of Raphael's images. Their interpretations are considered to be one of the red herrings in art history and also, though less prominently, in cultural history. Even the modern titles of the frescoes are part of the problem.

An Inverted History of Ideas

A vast art historical literature exists on the Stanza della Segnatura, which, for the greatest part, is highly specialized and not easily accessible to the non-specialist. Modern scholars followed the view that had been developed in the late seventeenth century: Vasari had confused the two major frescoes, and prints with misleading inscriptions were the ground for his errors.[3] Therefore, it may be helpful to have a closer look at the history of interpretations, both of words and images, because the history of ideas about this Stanza is itself of considerable interest to the theme of concept and image, and the ways they are connected.

Even in editions of Vasari's *Vite* and direct quotations from the *Vite*, editors add the remark that the author confused the 'Disputa' and 'School of Athens'. Milanesi devoted a note to this issue and Vicenzo Golzio, in his publication of Raphael documents of 1936, added the following note: 'Il Vasari confonde insieme la *Scuola d'Atene* e la *Disputa del Sacramento*; a ciò forse fu tratto dal voler dare al primo dipinto una interpretazione cristiana'; Golzio took the confusion for granted and explained this by Vasari's wish to give

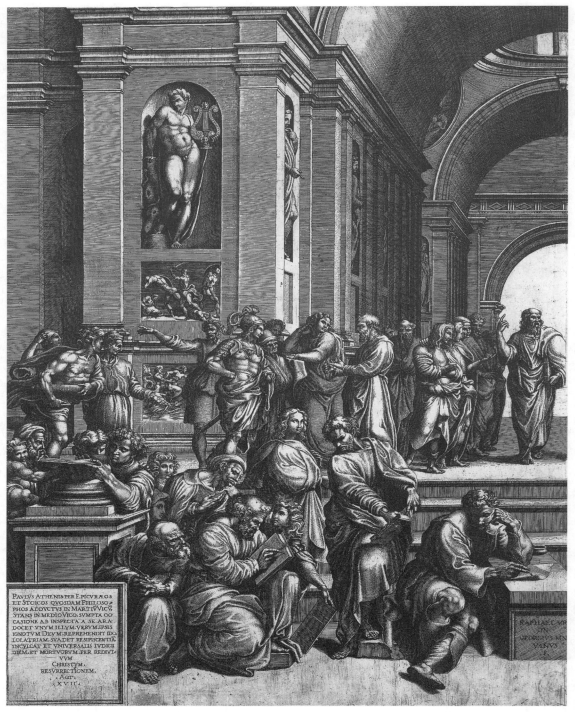

Within the engraving, the inscription reads:

PAVLVS ATHENIS PER EPICVRÆOS
ET STOICOS QVOSDAM PHILOSO=
PHOS ADDVCTVS IN MARTIVVICV̄
STANS IN MEDIO VICO, SVMPTA OC=
CASIONE AB INSPECTA A SE ARA
DOCET VNVM ILLVM, VERVM. IPSIS
IGNOTVM DEVM. REPREHENDIT IDO=
LOLATRIAM, SVADET RESIPISCENTIÁ
INCVLCAT ET VNIVERSALIS IVDICII
DIEM, ET MORTVORVM, PER REDIVI=
VVM
CHRISTVM.
RESVRRECTIONEM.
. ACT¬.
: XVII.

RAPHAEL VR
XIN
GEORGIVS MN
VANVS

FIGURES 4A and 4B Giorgio Ghisi, print after Raphael's 'School of Athens'

HIERONYMVS COCK PICTOR EXCVDEBAT.1550. CVM GRATIA ET PRIVILEGIO P AN .i.

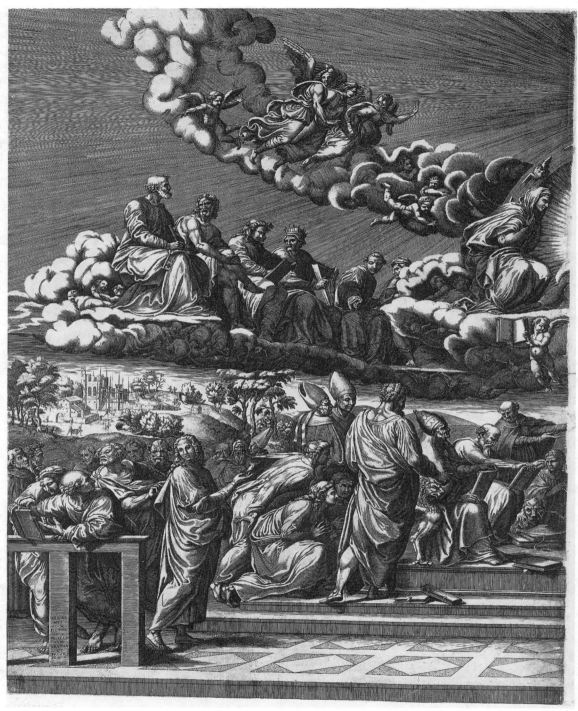

FIGURES 5A and 5B Giorgio Ghisi, print after Raphael's 'Disputa'

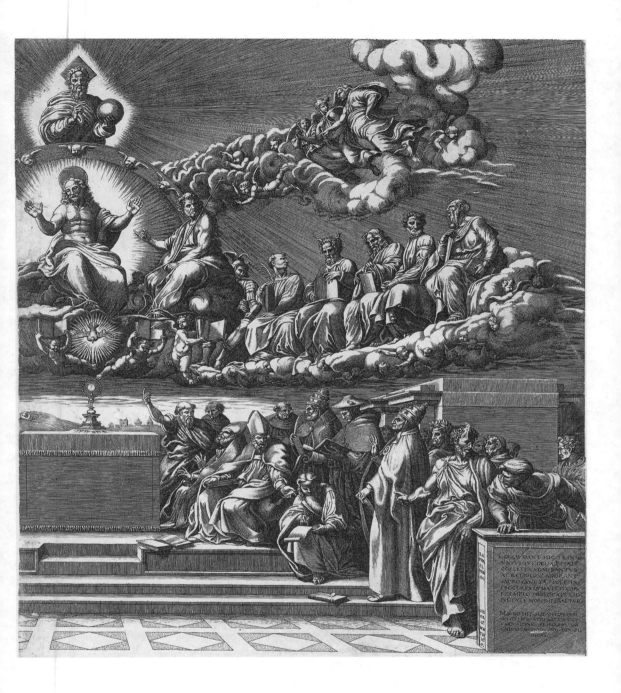

the School of Athens a Christian meaning. He gave the same explanation for Ghisi, who in 1550 made a print after the School of Athens, and added a quotation from the Acts of the Apostles (FIG. 4A, 4B).[4] The Penguin Classics edition has very few explanatory notes, but here George Bull added: 'Vasari's account of Raphael's work is very muddled. Very briefly: Raphael was working in the Stanza della Segnatura (..). Here the two chief frescoes are known as the *School of Athens* and the *Disputation concerning the Blessed Sacrament*'.

In spite of an occasional claim that Vasari was more correct than later art historians were willing to acknowledge, Gombrich, Von Einem, Shearman, Pfeiffer, Wood, Winner and most other specialists favoured Bellori's view over Vasari's.[5] Scholars who passed a milder judgement on Vasari in this respect, were not particularly successful.[6] However, Vasari's interpretation is much closer in time and context to Julius II, as appears from books dedicated to him, than Fréart's or Bellori's, writing more than one and a half centuries after Raphael had composed his sophisticated and highly original pictorial programme. Recent historiography in the field of humanism which pays attention to the 'theological humanism' at the papal court has hardly changed this well established art historical interpretation, which, in fact, remains very close to Burckhardt's.[7]

Step by step, philosophy and theology were separated.[8] Auguste Comte, for example, interpreted the history of knowledge as a process in which philosophy surpassed theology.[9] Between 1750 and 1850 philosophers considered themselves as intellectual authorities in all branches of knowledge, at the expense of the priests and other theologians.[10] In the words of Kuhn, paradigms had changed, and this scientific and artistic revolution was so successful that the past was also interpreted in the light of the new paradigm. These changes caused a very questionable reading of Raphael and Vasari.[11]

Fréart de Chambray and Bellori on Vasari and Raphael

In the cultural context of the new Academies, both in Paris and in Rome, admiration for Raphael made corrections of Vasari most welcome, and the new reading allowed the 'School of Athens' to become the emblem of the Renaissance, as a revolution in art and science. In fact, not Bellori but the French author Roland Fréart de Chambray (1606-1676) was the first to attack Vasari. He was the protagonist of classical doctrine in France, and opposed the moderns who became so conscious of the achievements in the natural sciences that they challenged the absolute authority of antiquity. His arguments were partly influenced by institutional changes: the Academies had become organisations claiming authority in art and science, but officially without any competence in theology.[12] Both Fréart and Bellori needed a legitimation of the Academies in Paris and Rome. Raphael proved to be useful for their purposes, but only once Vasari's interpretation of him could be falsified. They had to criticize Vasari's reading of the 'School of Athens' in order to use this fresco in their plea for academic classicism. In doing so, Fréart and Bellori introduced, although in a rather impressionistic fashion, the principle of falsification in art historical discourse.

In 1650 Fréart published his *Parallèle de l'architecture antique et de la moderne* in which he laid down the rule of strict adherence to Vitruvius and ancient architecture. Fréart appears to be very critical of everything that diverged from the standards set by antiquity. On

the basis of mere descriptions and not of actual architecture, he accepted the superiority of Greek artists. A year later the *Trattato* of Leonardo da Vinci appeared in print, both in Italian and in a French translation by Fréart himself. Then he started to write a work of his own, *Idée de la perfection de la peinture*. In this 'Idea of the Perfection of Painting', published at Le Mans (the birthplace to which he returned after a not very successful career in Paris), Fréart asserted that Vasari had completely misunderstood Raphael's iconography.[13] This book appeared in 1662, ten years after a partial translation of Vasari's 'Life of Raphael' into French which, however, omitted most of the account of the 'School of Athens' because an engraving of this image was, Fréart said, well known.

Fréart judged the art of his own time and the art of the past according to a new set of criteria: Invention, Proportion, Colour, Movement and Disposition – the latter including mathematics and perspective. These principles were used to analyse three engravings after Raphael, the *Judgement of Paris*, the *Massacre of the Innocents* and *The Descent of the Cross*. He considered Michelangelo's *Last Judgement* to be the major cause of the decline in painting, breaking as it did the rule laid down by the ancients. When Fréart arrived at the 'School of Athens', he changed his method more and more from description to critique. His exposé finally became an overt attack on Vasari's text rather than an analysis of Raphael's images.

He started with a criticism of the inscription on Giorgio Ghisi's print of 1550, which linked the scene to the Apostle Paul on the Areopagus of *Acts* Chapter XVII; this inscription is an abridged reformulation (FIG. 4A, 4B).[14] Ghisi's print marked an important step in what was to become a long and complicated history, including both concepts and images. Ghisi did not give a justification for the words he added and his later critics did not provide an argument as to why he was wrong.

Ghisi's engraving was published at Antwerp by Hieronymus Cock who established the printing house *Aux Quatre Vents* that was to become the most important firm in the Low Countries. He also published a print of the 'Disputa' (FIG. 5A, 5B). Carel van Mander recounted that Michiel Coxie 'was not pleased' with this publication of *de Schole* by Raphael. Coxie used the fresco as a basis for his *Death of the Virgin* in Saint Goedele at Brussels. Until the early seventeenth century learned artists in both Italy and the Netherlands took the Christian and Biblical nature of Raphael's fresco for granted. The French classicist Fréart was the first to attack this *idée reçue*, and he launched his attack in a remarkably agressive way.

Fréart defended 'Raphael, nostre principal et premier object' against Vasari's Christian interpretation. His section 'CINQVIESME ESTAMPE. DV GYMNASE OV ACADEMIE DES PHILOSOPHES D'ATHENES' starts with a bold statement about the eminent fresco, described according to this title:

> Or dans cette liberté de chois, je n'en veux point chercher d'autre que celle que j'ay presentement entre les mains, puisque l'occasion me l'offre auec assez d'auantage pour m'en contenter; car en effect elle me paroist vne des plus belles ordonnances qu'il ait iamais peintes, et d'vne tres grande Idée et tres-magnifique. C'est la representation d'vn de ces fameux Gymnases de la Grece, où l'on void vne assemblée generale de tous les Sçauants de l'Antiquité, tant Philosophes que Geometres, Astrologues, et autres Illustres (92).

It must have been an unbearable thought to Fréart that the best painting by the most excel-lent modern artist, and one closest to his image of 'classical antiquity', was interpreted by Ghisi and Vasari in the light of ideas so remote from his neo-classical ideal. For him, the early reception of Raphael was a culture shock. Therefore he claimed that Vasari, as an his-torian, was a complete ignoramus, as was the *Graueur*, who added the words 'Paulus Athenis per Epicureos et Stoicos quosdam etc.' to his copy (93). The print maker was 'mal informé du Sujet', witness the link between Paul in Athens ('Cette Histoire est dans les Acts des Apostres, au Chapitre dixseptiesme', Fréart added) and Raphael's fresco. It would have been much better, had Vasari been content to be a 'simple Historien' (101), but by adding interpretations he fell victim to accumulating mistakes (104), and became rather 'le personnage d'vn Pascariel et d'vn Harlequin que d'vn Historien…'. This is all the more regrettable because 'vne des plus raisonnables Compositons de Raphael' (102) is at stake. Fréart argued that Vasari misidentified most of the figures and that he neglected both the rules of decorum (by identifying one of the figures to be Diogenes) and the unity of time and place (identifying the left hand group as Evangelists, and Ptolemy and Zoroaster to the viewer's right). These criteria were crucial to Fréart's conceptual and institutional frame-work, the French Academy of his own time, whereas unity of time and place was much less relevant to Vasari and Julius II.

To prepare the ground for his attack, Fréart first quoted Vasari in Italian and then gave a French translation 'de ce long passage' because 'la langue Italienne n'est pas à l'vsage de tout le monde' (94-97). He concluded that without these long quotations 'je n'aurois jamais pû persuader l'ineptie et la bassesse des raisonnemens de ce grand Diseur de rien' (100). In his eye the blending of the Christian and the pagan was an evident anomaly. As a fierce classi-cist he took part in the *Querelles* between the ancients and the moderns, and shared the po-lemical tone of that debate, using phrases such as: 'le discours amphibologique de Vasari' and 'ses imaginations extrauagantes' (107).[15] To Fréart one of the most rational composi-tions and one of the most easy to understand, iconographically, was completely obscured by Vasari's reading of the image.[16] His conclusion was as follows:

> There is therefore no need to search for anything further in this Picture, than can be seen explicitly (*expressément*), and rest assured that Raphael had no intention to present to us anything of an Emblem in this Subject, which is nothing other than a straight-forward (*naissue*) representation of one of those famous Gymnasia of Greece, where the Philosophers and all kinds of Academicians made their place of Assembly, to discuss their Studies, and enjoy themselves with Exercises.[17]

In this academic context, it is all the more remarkable that Fréart criticized Vasari for his symbolic interpretation of Raphael's frescoes, using the argument that everyone, i.e. the learned *amateur*, could see what Raphael painted, and intended. If one considers Vasari as one of the first to give extensive iconographic interpretations, Fréart deserves the epithet of the first critic of iconography and iconology. And he proved to be remarkably successful in that respect, partly because the Roman painter Giovanni Pietro Bellori read his book and accepted his view, although with some moderation and an addition on chronology.

Eventually Bellori became more influential than Fréart who had given his book to Nicolas Poussin, the French classicist painter then resident in Rome, and a possible go-between. Fréart described Poussin in his *Parallèle* as 'l'honneur des Français en sa profession et le Raphaël de notre siècle'.[18] In 1695, Bellori's interpretation of Raphael's frescoes in the Stanza della Segnatura appeared in print.[19] Already on the first page, Bellori claimed that he is forced, *non senza dispiacer*, to correct Vasari because of his great mistakes. He gave an even more elaborate description of Raphael's frescoes than Vasari had done, correcting him in some fundamental respects and with regard to several identifications that were less crucial.

Bellori's and Fréart's intellectual background differed widely from Vasari's, who was still familiar with the culture of the papal court of the early sixteenth century. In Bellori's and Fréart's time and in particular in their circle, classical antiquity was no longer considered as a predecessor of Christian civilisation, but as something of its own and, according to some, even superior to medieval theology. The idea of conceptual progress remained, but the classifications had changed and the priorities shifted. Therefore Vasari's theological interpretation of the 'School of Athens' required a correction, according to the standards in science and art of the late seventeenth century.

Bellori explicitly rejected the idea of a reconciliation of philosophy and astrology with theology because he was convinced that a combination of classical philosophers and theologians or Evangelists was absolutely inconceivable, which, indeed, it was in his circle. Such a synthesis in Raphael's most famous fresco seemed to him impossible. 'Wrong is the name given by Vasari: concord between Philosophy, and Astronomy with Theology, because there are no Theologians nor Evangelists, as he wrote at length, perhaps confusing the second picture with the first one of the Theology and the Sacrament.' The changes in classification and conceptualization were such, that a fellow painter of over a century ago was accused of confusing the two most famous frescoes that he discussed in his book.

Vasari's chronology was also doubted by Bellori. In his depiction of the theologians – the 'Disputa' – Raphael still followed the 'old painters', in that he used real gold, both on their clothes , and in the background. Bellori failed to remark that gold was also used on the 'School of Athens'. He was, even more then Vasari, absorbed in a concept of artistic progress, and interpreted Raphael's iconographic device in a purely stylistic way. Gold was not considered by Bellori to represent a new Golden Age or the light from heaven connected with the Holy Ghost, but an artistic element inherited from the Middle Ages and soon abandoned by the mature Renaissance artist that Raphael became as a painter of the 'School of Athens'. In this way Bellori added both chronology and style to Fréart's critique of Vasari.

Bellori's reinterpretation was linked to an idea about intellectual progress. Medieval theology was, in his time, considered to be inferior to classical philosophy and most of the papal theologians of the early sixteenth century had lost their authority in academic circles. A theological reading of what he called the *imagine dell'antico Ginnasio di Atene ò vero la Filosofia*, was, therefore a mistake, that had to be historically explained. Like Fréart, Bellori considered this image to be purely philosophical, in the sense of his time, and saw the 'Sacramento dell'Eucaristia' as exclusively Christian. He related the themes to the medallions above, and gave them the titles *La Teologia* (quoting the inscription as *Scientia Divinarum rerum*) and *La Filosofia*, the other two *La Giurisprudenza, ò vero Giustizia* and *La Poësia*.[20]

In the footsteps of Fréart, Bellori considered a print by Giorgio Ghisi (Giorgio Mantovano as he called him) as a major step in the history of this misunderstanding: 'Improprio è l'argomento, che si legge impresso sotto l'intaglio di questa imagine, cavato degl'atti di San Paolo...'. According to Bellori, a print after Raphael's fresco contained an inscription that, incorrectly, assigned this image a theological meaning, and Vasari used this print as his source. Hence, he claimed, Vasari's description was a mistake. Bellori added yet another element; according to him, such errors occured after Raphael's death. One of the first to commit this error was Agostino Veneziano in his print published in 1524, 'where the figure of Pythagoras is transformed into the evangelist Saint Marc, and the youth leaning by his side with the Pythagorean diagram came to be transformed into an angel with the text of the angelic salutation.'[21] Bellori went on to argue in favour of the title 'School of Athens', or even better *Ginnasio di Atene*, and these concepts, together with the frequently used polarity between philosophy and theology, served him as tools for reinterpreting the images.[22]

Vasari on Raphael and the Christian Paradigm

In 1550 and again, in his second, enlarged edition of 1568, the Tuscan painter and architect, Giorgio Vasari, published an extensive account of the frescoes in the Stanza della Segnatura. It is the most detailed iconographical interpretation of his book. Obviously Vasari was content with what he had written, because the text on the Stanza della Segnatura was hardly changed or enlarged in the second edition. This unusually detailed description was part of Vasari's artistic biography of Raphael, which belonged to his *Vite de' più eccellenti pittori, architettori e scultori*, starting with Cimabue and ending with Michelangelo, Raphael being one of its heroes.

In his *vita* of Francesco Salviati, Vasari recounted how they acquired access to the Stanze and were allowed, in 1532, to make sketches while Pope Clement VII (1523-1534) went to hunt near his villa at Magliana. Four of Vasari's drawings have been preserved, now belonging to the Louvre in Paris.[23] As a young painter Vasari had direct access to these rooms in the Vatican; he copied the original frescoes from morning to night in the freezing cold, as he remembered not without pride and nostalgia.[24] His memory, notes and drawings were, as were his historical sources, supplemented by oral information and prints made after Raphael's frescoes, but these proved to be of more limited importance than has been supposed.[25] The first complete print was published in the same year as Vasari's book. In his second edition he only made, with regard to the Stanze, marginal alterations. At the beginning of his account of Raphael's career in Rome, Vasari stated:

> However, after he had been welcomed very affectionately by Pope Julius, Raphael
> started to paint in the Stanza della Segnatura a fresco showing the theologians re-
> conciling Philosophy and Astrology with Theology, in which there are portraits of all
> the sages of the world shown disputing among themselves in various ways. Standing
> apart are some astrologers who have drawn various kinds of figures and characters
> relating to geomancy and astrology on some little tablets which, by the hands of some
> very beautiful angels, they are sending to the evangelists to expound.

After a long description, including an identification of many persons present on the fresco, Vasari goes on:

> There were also some medallions, four in number, and in each of these Raphael painted a figure symbolizing the scenes beneath. Each figure was on the same side as the story it represented. For the first scene, where Raphael had depicted Philosophy, Astrology, Geometry, and Poetry making their peace with Theology, there is a woman representing Knowledge, seated on a throne supported on either side by a figure of the goddess Cybele shown wearing the many breasts with which the ancients used to depict Diana Polymastes.

Vasari implied that this personification of Knowledge (FIG. 6) is a new invention.

Concerning the second tondo, Vasari choose a different approach. According to him, 'Raphael depicted Poetry, in the person of Polyhymnia crowned with a laurel' (FIG. 7). This would imply a repetition, because all nine Muses are depicted on the wall below, as Vasari related a little later. Identification of the female figure as one of the Muses, though it did not fit into a fourfold system, was Vasari's solution for this iconographical problem. Not able to find a direct precedent for this figure, Vasari proposed an identification of his own.

In the third medallion Raphael depicted, according to Vasari, Theology (FIG. 8) and in the fourth, Justice (FIG. 9). Vasari's interpretation implies a classification that is not perfectly systematic: a new invention (Knowledge), a Muse, Theology and a virtue (Justice). With regard to the four medallions, Vasari's reading has been followed by most later authors, including Bellori.

In spite of several uncertainties, one can safely conclude that the four female figures are all new inventions, making use of existing personifications and props. The inscriptions comment upon the identity of the female figures, and vice versa. New concepts are closely related to new images, and the former's function is primarily to add meaning to the latter; in their turn, the images illustrate the inscriptions which refer to canonical texts, and to people – from the past to the present.

All the Pope's Horses and All the Pope's Men

The Stanza della Segnatura was one of the last in an enfilade of rooms on the third floor of the Vatican Palace. It had a ceremonial entrance to the right of the portico of Saint Peter's. Julius ordered a monumental staircase to be built from Saint Peter's to the Sala Regia, the great hall of the Vatican Palace (FIG. 10). To its left was the Sistine Chapel and to the right were two slightly smaller halls. The fourth floor was at the time occupied by a terrace on the east wing and a loggia and a birdhouse to the north; the adjacent Borgia tower had a large room for the papal collection of rare books and other precious objects.[26]

The ceremonial stairs were ordered by Julius II, as part of an overall renovation of the Vatican Palace, which was to be transformed from a medieval castle with towers into a Renaissance palace with loggias. On the east wing of the third floor, facing the courtyard there were the private chapel, the pope's bedroom and his *anticamera*. Through a small corridor

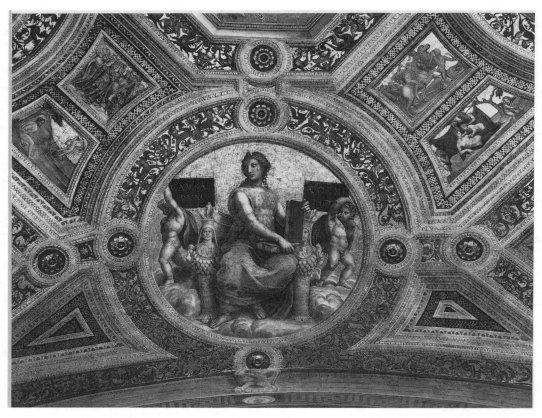

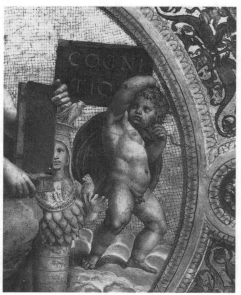

FIGURE 6 Raphael, Medallion with CAVSARVM COGNITIO, detail of the ceiling, fresco

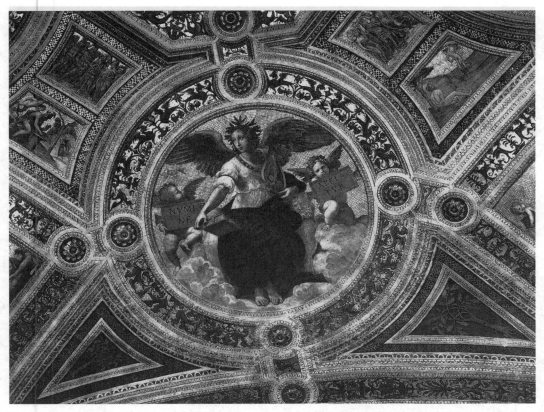

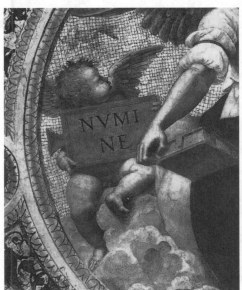
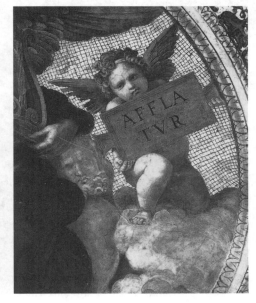

Figure 7 Raphael, Medallion with NVMINE AFFLATVR, detail of the ceiling, fresco

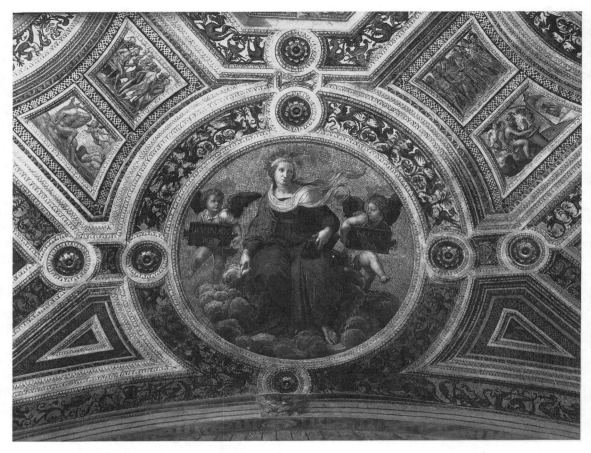

FIGURE 8 Raphael, Medallion with DIVINARVM RERVM NOTITIA, detail of the ceiling, fresco

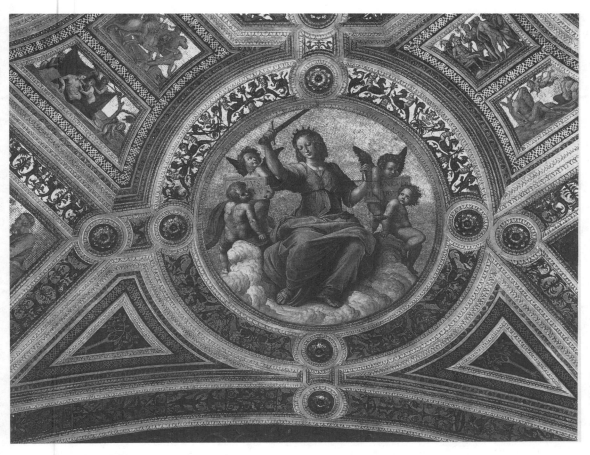

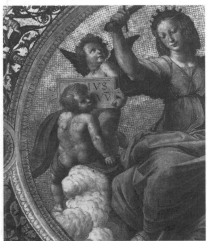

FIGURE 9 Raphael, Medallion with IVS SVVM VNIQVIQVE TRIBVIT, detail of the ceiling, fresco

FIGURE 10 Plan of the Vatican Palace and old and new Saint Peter's

the pope could go from his appartment to an enfilade of workrooms in the northern wing of the palace, which was built as a square around a courtyard. Thus, turning left a second time, visitors would enter these four rooms, parallel to the two halls mentioned above, but situated on the north side.

This north wing was constructed by Nicholas V (1447-1455); Sixtus IV (1471-1484) had put the great papal library on its first floor; Alexander VI (1492-1503) had decorated the rooms on the second floor, and added a monumental tower to this wing. The third room of the northern wing on the third floor was called the Stanza della Segnatura by Vasari. It was flanked by two rooms of the same size and form: the Stanza di Eliodoro and the Stanza dell'Incendio. Then came the rooms in the tower, built by Alessandro Borgia and finished by Julius II. Its decoration on the third and fourth level was undertaken by Julius II.[27] He finished the 'guardaroba' on the level of the Stanze, and ordered his private library to be arranged on the floor above. Finally Julius was the patron of a wooden dome, designed by Bramante, and constructed on top of the Borgia tower. On the level of the *bibliotheca secreta,* a loggia was built that ran parallel to the Stanze below.

The Stanza della Segnatura served the Pope as his main workroom. It was to the early sixteenth century Popes, what the Oval Office in the White House is for the President of

the United States. In this room, the Pope would sign official papers, such as a *motu proprio*, and witness when bulls were affixed to official documents; he could have any small scale official meeting in the Stanza della Segnatura. The Pope could meet advisors and ambassadors there, who would have had the pleasure or the obligation to wait in one of the adjacent rooms. Ambassadors came from the southern and eastern part, and waited in the Stanza di Eliodoro, all the Pope's men could use the Stanza dell'Incendio as their *anticamera*. The Stanze were directly related to one another as *anticamera*, workroom and *retrocamera*, being the link between the Pope's own rooms and the official halls.

So the Stanza della Segnatura was a semi-public room, accessible to learned men of high social standing from Rome, Italy and the major cultural centres of Europe. Most of the people to enter this room were well educated, in art and science. Yet they did not come exclusively for high culture, which, in this context, was not only to serve an artistic goal, but had to convey a message as well; a message that focussed on the reigning Pope himself: painted and in reality. The inscriptions served as one of the keys to understanding the meaning of the images, and an important one. Learned painters, such as Vasari and Bellori, formed only one section of the public who tried to understand these frescoes, rather than be caught in a riddle.

Inscriptions as a Conceptual Invention

In the Raphael literature, the four texts on the ceiling are supposed to correspond to a well established classification of philosophy, jurisprudence, theology and poetry. As a source, mostly the university faculties are mentioned, and sometimes the organisation of libraries, or the *artes liberales*. However, the identification of the inscriptions with these four concepts is misleading because it tends to anachronism and it obscures a great deal of the meaning that the painted words could have conveyed to the educated people visiting the Stanza della Segnatura at the time of Julius II. It suggests that philosophy and theology were mutually exclusive; lines are drawn where they did not exist. The holistic structure of both words and images is misunderstood in favour of a system of separate disciplines which, at that point had not yet been invented.

Moreover, in the early sixteenth century concepts such as PHILOSOPHIA, THEOLOGIA or IVSTITIA were available and, indeed, were used as inscriptions, but these words were not chosen in the Stanza della Segnatura – a deliberate choice and one to be taken seriously. In the Borgia appartment, on the floor below the Stanze, Pinturicchio painted personifications of the seven arts and sciences, an example that was not followed by Raphael. Whilst still a cardinal, Julius II had commissioned the tomb of his uncle, Sixtus IV. The sculptor, Antonio Pollaiuolo, shows the dead Pontiff lying on a matress. On the sides of the tomb ten female figures represent, as the inscriptions testify: 'grammatica', 'rhetorica', 'dialectica', 'musica', 'geometria', 'arithmetica', 'astrologia', 'prospectiva', and, placed next to the Pope's head, 'philosophia' and 'theologia'. To these concepts short sentences were added, derived from authorative texts, although not in the form of quotations.

So even although there was some variety of classification available at the time, the words that were actually painted in the Stanza della Segnatura do not follow any canonical classi-

fication precisely. To mention another important system, neither the concepts nor the images of the Stanza follow the programme of learning that characterized the *studia humanitatis*: grammar, rhetoric, poetry, history and moral philosophy.[28] There existed no official fourfold classification consisting of philosophy, jurisprudence, poetry and theology as the direct result of papal patronage at the court of Julius II. Poetry was not considered one of the faculties, and the fresco below the medallion with NVMINE AFFLATVR shows more than poetry alone – even taken in the wide sense characteristic of antiquity; the 'Parnassus' boasts persons who were renowned for music, astronomy and history. Raphael's words and images differ from the known systems of *artes liberales*, usually seven, sometimes nine, but never four, only rarely mentioning philosophy, and never including poetry. Generally, the *artes liberales* – the *trivium* (grammar, dialectics or logic and rhetoric) and the *quadrivium* (geometry, arithmetic, astronomy and music) – contribute to the mother of all knowledge, philosophy, which in turn is considered to be the servant of theology, *ancilla theologiae*. Neither does Raphael's pictorial programme follow a standardized principle according to which libraries were organized. His father, Giovanni Santi, had described the library of his patron, Federico da Montefeltro, Duke of Urbino, mentioning, among others *theologi*, *philosophi*, *poeti*, *legisti* and *medici*. Inventories of libraries, including the Vatican Library on the ground flour and the new *bibliotheca secreta* which was founded by Julius II in the Borgia tower, show considerable variety in number and formulation of categories.[29]

Hence, the four inscriptions are a remarkable conceptual invention, indeed referring to established traditions, but not copying them. They reflect a syntax and semantics with intellectual possibilities that surpass the meaning of four nouns: philosophy, jurisprudence, theology and poetry. The inscriptions stress interdisciplinary wisdom, based on a variety of sources, conveyed in different genres and serving several purposes.

Allusions and Reminiscences

To complicate matters even more, this conceptual innovation does not follow any text literally, as is suggested in most of the secondary literature. Art historians have provided several texts that would explain the painted inscriptions, but none appears to be an exact quotation; some texts by famous authors contain one or more of the words that Raphael painted, but close reading indicates that none of the inscriptions is a verbatim quotation.[30]

In his *Topica* (XVIII, 67), Cicero concluded: 'causarum enim cognitio cognitionem eventorum facit'. This book provided an adaptation and explanation of Aristotle's book of the same title; they both discussed a wide range of concepts in the field of argumentation, oratory and invention of speech. Cicero's concise definition means: 'for a knowledge of causes produces knowledge of results'.[31] In this section of his *Topica*, Cicero discussed the relevance of the knowledge of causes and effects for orators, poets, historians and philosophers. In a wider context, he argued that knowing causes means one has an ability to know the past, understand the present and predict the future, which connects 'cognitio' to 'prudentia' and to other virtues.

Cicero used the word 'cognitio' throughout his work, and in a very wide sense, not restricting 'cognitio causarum' to its first meaning, natural philosophy (and what much later became known as physics or the natural sciences as a specialized discipline), but linking this concept to moral values. The words 'causarum cognitio' also appeared in Virgil's *Georgica* II, 490 (the concluding section of the second book): 'felix, qui potuit rerum cognoscere causas' – 'blessed is he who has been able to win knowledge of the causes of things'. The importance of such knowledge as a contribution to human well being was stressed time and again by the poet Lucretius in his *De rerum natura*; this work, to which Cicero responded without mentioning Lucretius, was christianised to a lesser degree than Cicero and Virgil.[32] Lucretius was a pre-Christian poet who was not sympathetic to most aspects of religion, but did include themes such as knowledge of heaven, gods and religious ritual. His critical attitude towards the belief of his era and his ideas about atoms did not imply an anti-religious view *tout court*; Lucretius was not primarily proto-scientific in a modern sense, but a poet with a prophetic vision, a philosopher of nature and, in some respects, even a theologian, interested in the Muses, Cybele, Venus and Epicurus, whom he venerated almost as gods. In the *Georgica* Virgil harmonized Lucretius, Cicero and traditional religion.

Before Lucretius, Aristotle, whose thought was transmitted and popularized – together with other Greek texts – by Cicero, frequently used both the concept of 'cognitio' and 'causa'. In Cicero's works these concepts, as well as 'notitia' and 'afflata'[33], occur often. Together with *res, cognitio* and *causa*, Cicero's concepts and definitions acquired a crucial place in the juridical vocabulary. Hence they occur in Justinian's *Institutiones*, that was included in the *Corpus iuris civilis*, as this collection from the early sixth century had been officially known since 1583, although this name was current much earlier. Bonaventura's *De perfectione evangelica* provides another clue: 'Sapientia est cognitio causarum'.[34] In short, 'causarum cognitio' is not bound to any single author, book or sentence; on the contrary, 'causarum cognitio' occurs in several rhetorical, poetical, juridical, philosophical and theological contexts. Similar observations hold true with regard to the other three inscriptions.

Justinian's opening sentences define justice, law and the science of law. 'Justice is the constant and enduring will to give to each what is his due right. Jurisprudence is acquaintance with divine and human things, the knowledge of what is just and what is unjust'.[35] In this way civil law was introduced, both in the *Digesta* and in the accompanying textbook that was to instruct students. This was a book which itself had the force of law since it was an integral part of the Emperor's compilation. These general definitions were derived from Ulpian, the main source of Justinian's codification. In his turn he alluded to Cicero who defined justice as 'animi affectio suum cuique tribuens', that is the inclination of the heart to give each his due.[36] In these juridical definitions moral, philosophical and theological considerations were considered relevant. The *Corpus* referred to the study of things divine and human. It also stated that legal experts could be compared to priests, and recognized the value of philosophical knowledge in making right judgements.[37] The main source for concepts and definitions was Cicero.

The importance of theology is stressed time and again, by Dante, for example in *Purgatorio* XXX, 31-3: 'She is crowned with olive, and her clothes of white, green and red are the colours of the theological virtues, Faith, Hope and Charity'. This corresponds to the

personification flanked by the *putti* with DIVINARVM RERVM NOTITIA and to the virtues below IVS SVVM VNICVIQVE TRIBVIT. Dante aimed to integrate theology with philosophy, in a poetic form and with a political-juridical goal in mind.

This combination of 'divine and human things' also occured in the title of a text by Marcus Terentius Varro. He studied philosophy at Athens and was the most encyclopedic antiquarian in classical Antiquity; with Cicero he played a major role in making the Greek heritage available to the Romans. His *Antiquitates rerum humanarum et divinarum* were for the most part lost, but the work was extensively used by Augustine. In his *De civitate Dei*, he provided a detailed summary of Varro's argument, to which he gave a Christian reading. To Cicero, Varro addressed his *De lingua latina*, where he discussed concepts such as 'deus' (God) and 'numen' i.e. divine will or way (VII, 85), but neither 'cognitio' nor 'notitia'. Cicero introduced all these concepts; in his *De natura deorum* he used 'notitia', although less frequently than 'cognitio', stressing the importance of both for understanding causes and God.[38]

To the educated viewer, NVMINE AFFLATVR recalled Virgil's *Aeneis* VI, 50: 'adflata est numine quando iam propiore dei'– 'since now she feels the nearer breath of deity'. This is said with regard to the Cumaean sibyl, asked by Aeneas to prophesy the future. The inscription is close to Virgil, but not identical, which adds new connotations to Virgil's famous words. Mainly because of other Virgilian phrases, in particular the beginning of the fourth *Ecloga*, this could be interpreted in a Christian way. The sibyl of Cumae was inspired by divine will and foretold the coming of Christ; in *Ecloga* IV, 4 Virgil stated: 'Ultima Cumaei venit iam carminis aetas; magnus ab integro saeculorum nascitur ordo, iam redit et Virgo'; the new period implied the return of the Virgin and the birth of the child which, according to medieval interpreters since Lactantius, was a prophesy predicting the coming of Christ, while most ancients assumed it referred to Augustus. 'Numen' is the mysterious power which the Muses also possessed, a concept that is more abstract than 'deus'; this classical concept was integrated in the Christian vocabulary.[39] So Virgil's text, mentioning the sibyl of Cumae, is used here in different contexts, but it certainly was the intention that the viewer would think of Virgil, whom Raphael depicted below on the 'Parnassus'. Throughout his work Giles of Viterbo, a contemporary of Raphael, frequently referred to the Bible and to Virgil's *Aeneis* as well as his fourth *Ecloga*; he explicitly alluded to the divine inspiration of the sibyl.[40]

Divine inspiration, which is a very strong formulation indeed, is used by Raphael both in a pagan and in a Christian sense. This inspiration included those who wrote about astronomy and history, partly because the first Greek and Roman texts on these subjects were written in a poetical form. The *vates* knew the *kosmos* and could communicate the truth revealed to him as a visionary, influenced by a particular *furor*. Poets, dealing with universal truths, were considered superior to the narrative historians who wrote prose. Plato's *Ion* was one of the older texts to point out the importance of divine inspiration for poets. Plato and others derived their gift for prophesy from this, as one way to understand world order and the future of man. This insight was shared by Cicero who also used the concept of being 'afflata' by the divine. Plato's and Cicero's dialogues vividly described what Raphael depicted with ἐναργεια: learned men and one woman, reading, lecturing, writing, listening,

drawing, arguing and thinking. Inspiration, reason, observation and revelation were connected. In the eyes of Italian humanists, this inspiration could extend to later interpretators and translators of texts. It should be clear how much this theological and artistic paradigm differed from the definition of, for example, history and astronomy since the late seventeenth century and even more so in the twentieth.

Summing up, Raphael's inscriptions were intended as references to famous texts, without being verbatim quotations; they were meant as a hermeneutic bricolage, a sophisticated mosaic of words, phrases and texts. All four inscriptions were literary inventions, alluding to a number of canonical texts and *topoi*, investing the pagan words with a Christian meaning. In other words, the painted inscriptions were adaptations and reminiscences of texts – both classical, Christian and contemporary. They refer to a well established tradition of ancient writings and later text books, compendiums, introductions for students, commentaries and *adagia*, all derived from classical and Christian sources. At the same time, the words comment upon the images on the ceiling and the representations on the walls below – also adaptations and reminscenses of earlier images.

Words and Images

Connecting four inscriptions, two containing nouns and two consisting of sentences was both unusual and intellectually very sophisticated. Inscriptions were, as a rule, either a series of nouns or formed one single sentence. Such a play on words and images was rare in classical antiquity, but it became popular in the sixteenth century, witness all the puns in the work of Erasmus, the flowering of *imprese* and the rise of *emblemata*.[41] In this case they can be read separately, and in conjunction with one another: in every possible combination, each of them making sense, although an uninterrupted reading from left to right might have had priority over the other options, adding up to more than fourteen: four times on their own; six times as a pair; at least three times as a combination of three and several readings of all four.

The four inscriptions on the ceiling of the Stanza della Segnatura can be read on their own. At the same time they belong to four painted medallions that form a quartet. *Putti* carry the painted words CAVSARVM COGNITIO, IVS SVVM VNICVIQVE TRIBVIT, NVMINE AFFLATVR and DIVINARVM RERVM NOTITIA. These have a grammatical structure that is more complex than an enumeration of four nouns. The closest relation between concept and image is that between the tablets and the personifications they accompany, but many more connections – between the words, between the images and between words and images – might be relevant to the people in the room.

Although one has to be careful with translations – translations are at the same time interpretations that run the risk of being biased or even misleading – these Latin texts may be translated as follows. CAVSARVM COGNITIO means knowledge of causes; not only in nature but also in the human sphere of ethics and jurisprudence, and even in the divine realm. The concepts are not restricted to empirical knowledge in the sense of facts and causes, but extend to the human world, including emotions, values and norms, and do not exclude the realm of cosmology, divinity and God. The text does not by any means exclusively refer to

what came to be called the natural sciences. The tablets consist of a noun in the nominative and one in a genitive, so both words can be part of a sentence containing a verb.

IVS SVVM VNICVIQVE TRIBVIT is a sentence, that can be read in two ways: he or she or it assigns everyone his due, and law gives everyone his due. In the first way, the subject may be the reigning Pope right below the inscription, the Pope Emperor depicted on the wall, justice or the nouns on the same ceiling; each of the painted personifications or even God Himself were more abstract candidates to complete the sentence.

DIVINARVM RERVM NOTITIA has a structure similar to CAVSARVM COGNITIO. It has a double meaning in that the words imply both insight in divine things and knowledge of Holy Mass: the translation of the first in liturgical form within a fixed ecclesiastical structure. The last of the three words is again a noun, but in this case it can be read both as a nominative and as an ablative. The three words refer to theology, but they are not identical with that concept.

NVMINE AFFLATVR refers to divine inspiration: she or he or it is inspired by divinity or the Godhead, a 'reading' similar to IVS SVVM VNICVIQVE TRIBVIT being possible. This text is a short sentence with a verb; its subject could be one of the nouns on the ceiling, the personification nearby, each one of the Muses and poets below, or the main persons in the room, in particular the Pontiff himself.

Knowledge is inspired by divinity, and so is insight in Holy Mass. The sentences can be related to one another by 'et', and this provides a new statement that makes sense as well, because all branches of knowledge were inspired by divinity. And all were necessary to assign everyone his due. Insight into the divine may be the subject of TRIBVIT, as could be knowledge of causes. 'Est' may link CAVSARVM COGNITIO to DIVINARVM RERVM NOTITIA, the one not being possible without the other. A second reading is that knowledge is due to or dependent on insight in the divine and knowledge of the Holy Mass, NOTITIA being read as an ablative.

In addition to this, all words together form a grammatically correct and meaningful sentence that can be read in a number of ways, partly due to the, at first sight, surprising lack of a metrical structure. Taken as a whole the four inscriptions could mean, to a viewer willing to associate on what he sees and prepared to add an 'et' here and there, 'knowledge of causes gives everyone his due, thanks to insight in the divine and is inspired by divinity'. Another reading would be 'knowledge of causes is inspired by divinity and insight into the divine gives everyone his due' or 'insight into the divine is inspired by divinity and knowledge of causes gives everyone his due'. A fourth meaning would be, 'due to insight in things divine knowledge of causes is inspired by divinity and law gives everyone his due'. In this case meditation allows for 'ius' to be a subject (and not the object, linked to 'suum', of 'tribuere'), which is closer to the Ciceronian definition of justice that was the basis for Justininian's adaptation in a Christian context, where 'ius' is, indeed, the object of 'tribuere'. The four inscriptions could inspire a continuous meditation of themes such as universal wisdom, divine inspiration and good judgment. Reflection is guaranteed by the multiple meaning of the sentences, depending on where the reader starts, and whether he takes NOTITIA to be a nominative or an ablative, and 'ius' as a nominative or accusative. Discovering a circular structure of the sentence implied continuous contemplation on universal

truth, inspired by the painted words. Within the context of a culture that cherished enigmatically hidden truths of universal scope, the revelation of the possibility of such an interpretation was deliberately left open. However, it was deliberately implied rather than defined, and of course only for the happy few with a talent for inspiration.[42] The play with concepts, and images in the Stanza della Segnatura is unique, yet not without precedent.[43]

Universal wisdom is not only implied by all of the words taken together but also by each of the inscriptions themselves, the same being true for the images. Yet there are differences between the inscriptions and the images. NVMINE AFFLATVR emphasizes the divine source of wisdom and the superhuman value of artistic expression; IVS SVVM VNICVIQVE TRIBVIT stresses the effects of wisdom on judgement and government; COGNITIO CAVSARVM and DIVINARVM RERVM NOTITIA both refer to the content of wisdom, with largely overlapping fields of knowledge – the one paying more explicit attention to the sphere of humanity and nature, the other focussing on divinity, both in its pagan and its Christian sense. Again, the main source of wisdom differs: reason and revelation.

Everywhere a holistic vision is suggested that surpasses a clear cut classification of separate and complementary parts. *Artes liberales* or *disciplinae* are not specified one by one, yet geometry, music and arithmetic are implied on the painted walls; synthesis dominates analysis, integration is superior to specialization. Yet the unifying principle is left to the reader to define. Taking the Holy Spirit – the white dove in a magnificent golden light as painted below DIVINARVM RERVM NOTITIA – as the dominant visual clue, the visitor could think of divine wisdom, God's grace, the Holy Trinity, Christ and divine revelation. Christian abstractions could be linked to pagan Greek and Roman concepts such as the world-soul, the first cause, excellent expression in words and images, the truth, the universe and the one. The meaning of Raphael's words depends on the ways they are connected and on the ways they are linked to the images, and to the people in the room, to whom they refer and who will interpret what they see. It is, by all means, a way of thinking that differs profoundly from science in modern universities and their nineteenth or even late seventeenth century predecessors. As a paradigm it is especially far from neo-positivist Anglo-Saxon scholarship. The comprehensive view, as it is formulated and visualized, could be characterized as Christian Neo-Platonic, in the sense that it attempts to integrate Greek knowledge, Latin eloquence and Christian faith.

In the first place the words comment upon the personifications they accompany and connect them to each other in a meaningful way. In addition they bear a relation to the other pictorial elements, such as the persons on the walls below. There are also meaningful relations with the rectangular images on the ceiling. The judgement of Solomon, for example, requires wisdom, and, indeed, he is giving everyone his due. The allusions to Cicero, Lucretius and others add to the meaning of this rectangular image between the two medallions. The universe is depicted in the next rectangular image; above the globe appears a personification of harmony and its principle cause; she maintains order in the universe according to the principle of the musical harmony that was related to astronomy through the idea of the harmony of the spheres.[44] This harmonious order is related to universal knowledge of causes, and at the same time it originates from divine inspiration, which also implies a musical harmony of the spheres.

Apollo, in the next rectangular image, is a deity and, as a god, disposes of knowledge of the divine: therefore he is crowned, whereas his opponent Marsyas is punished, by which he was purified; at the same time this is another example of justice; Apollo is himself a major source of divine inspiration, operating partly through the Sibyls and partly through the Muses; his laurel is both a sign of the inspired poet who is crowned 'poeta laureatus' and of the victorious in contest – beating Marsyas who relied on his own *ars* and considered himself independent of divine inspiration. Therefore he was punished according to justice. Then come Adam, Eve and the serpent; believing the animal, who promised them wisdom, Adam and Eve lack sufficient 'notitia divinarum rerum', and are therefore punished according to justice.

Verbal references were elaborated further by the portraits below (FIG. 3 and 11). Julius II was himself portrayed on the right hand side of the window that had a view on the courtyard; and he was present in the room itself when it was in use. The Roman Emperor and Julius II both promulgate laws, written on the basis of the jurist's 'cognitio' and originating from the divine. Typological comparisons that inspired the viewer to thoughts from the abstract to the concrete and back again, were almost everywhere in the room. This unusually rich play on words with images and people is continued on all the walls below, where the authors alluded to are portrayed in a way that does justice to the interrelation of the concepts as analyzed above.

Harmony in the Era of Julius II

Such a sophisticated invention, verbal and visual, appealed to the intellectuals – to indulge an anachronism – at the court of Julius II, such as Paolo Cortesi, Marco Vigerio, Cristoforo Marcello, Egidio da Viterbo, Tommaso Inghirami and Tommaso de Vio, called Cajetanus or Gaetano. They held influential positions as, respectively, protonotary, cardinal (and the only cardinal who studied theology), preacher and author, prior general of the Augustine order, papal librarian and master general of the Dominicans. At the same time, they wrote influential texts and held important orations. These intellectuals were of particular importance, both in writing and in speech, because they were also the chief orators at the Julian court, be it as preacher in church or chapel, or at the palace. They gave expert advice to Julius II and Raphael, in particular Vigerio, Egidio da Viterbo and Inghirami. Their common goal was to blend the three main elements: knowledge of the Greek philosophers (known from later compilations, mostly codified at the university of Padua, and directly from original Greek texts and recent translations into Latin), the grammar and elegance of Latin, especially that of Cicero, and the wisdom of Christian theologians – a revelation derived from Sacred Scripture, clarified by the Church Fathers as well as the scholastic authors, and linked to the papacy in general and to Julius II in particular.

Papal advisors tried to join universal wisdom and piety with eloquence, using newly edited texts of both classical and Christian antiquity. They ascribed divine inspiration to a number of Greek and Latin authors, as well as to pre-Christian Jewish authors: Aristotle or Virgil could be read as David or Isaiah. Like the words of John the Evangelist and the letters of Paul, they were all inspired texts. Yet the pre-Christian era did not have the fullness

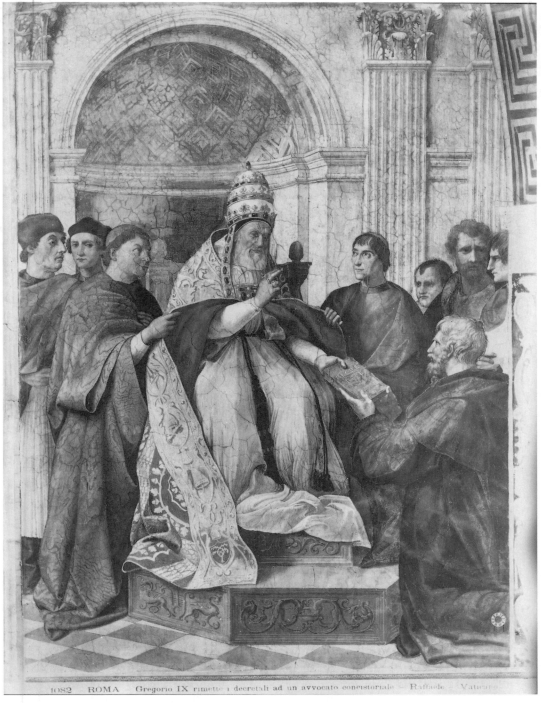

FIGURE 11 Raphael, Julius II and his courtiers, fresco

of truth and revelation, and therefore the Christians had to harmonize the Jewish and pagan texts with what was canonized as the New Testament. Ever since Paul preached at Athens and disputed with the Stoic and Epicurean philosophers there, the relation between the Christian paradigm and the older ones had become a major intellectual concern. Different assessments of the relationship had been given by Tertullian, Lactantius, Jerome and Augustine, to name but the most important. In the early sixteenth century the papal scholars felt obliged to reassess this connection, first in response to the new ideas and methods of textual criticism, put forward by Valla and Poliziano among others, and later by those who subscribed in varying degrees to reformation thought. Their view on universal harmony was also criticized, especially outside the papal court.

Litterati of Raphael's time could rely on a long sequence of earlier attempts to integrate nearly all branches of wisdom, in particular pagan philosophy and poetry with its much appreciated Latin style, and Christian theology which was considered superior in religious content. Consciousness of style, textual criticism and the rediscovery of texts required reformulations of the traditional view of harmonizing the ancient and the Christian theologians. Due to the new discoveries old controversies about the limits of harmony received a fresh impetus. The Florentine Marsilio Ficino not only translated Plato – whose work had recently become much better known than previously – into Latin. He also commented upon his work, constructing a very long tradition of *prisci theologi*, including Pythagoras and Hermes Trismegistus among others. They are probably depicted to the right and left in the background of the 'School of Athens' (FIG.12).[45] The civic humanism of the Florentines was transformed into an ecclesiastical humanism in Rome for which Ficino's *Theologia Platonica* served as a point of departure. His work became a source for scholars from different places, all striving for unified and universal wisdom. Yet Ficino's treatment of theology and natural philosophy as such was limited. He was not sufficiently outspoken in the political and juridical implications of the synthesis he favoured for the papacy as an institution and for the reigning Pope as a person. For different reasons Ficino and his contemporaries, such as Giovanni Pico della Mirandola (*princeps Concordiae*, referring to his residence and harmonizing ambition), were helpful but not conclusive. Several scholars, a generation or so younger than Ficino, settled in Rome, and codified a new paradigm under the patronage of Julius II.[46]

This early-sixteenth century world view, with roots going back to Paul in Athens, happens to be in remarkable accordance with Vasari's testimony regarding the fresco, which in the seventeenth century came to be called the 'School of Athens'. This set of ideas appears to be consistent with the interpretations in the prints made after the frescoes and with the orations and textbooks by Julius' chief advisors.[47] Harmony between all branches of knowledge was at the heart of their thinking, and this was precisely what Vasari considered the subject of Raphael's fresco with Plato and Aristotle in the centre. They were harmonized together, with their predecessors and with the Evangelists. Texts and images share, until the 1620s, the idea that this fresco also has a theological and biblical meaning, and that it does not focus exclusively on classical philosophy, interpreted in a secular, non-theological way.

Vasari, Veneziano and Ghisi were probably correct. The figures to the left in the foreground of the 'School of Athens' may well be Mark, Tatian, Matthew, John, Luke and Paul,

three of them to be identified partly on the basis of the stones and their biblical connotations. The 'Disputa' probably has also non-Christian scholars in the foreground, such as the bald Varro and the bearded Seneca to the viewer's left. The man, addressing a pagan youth in an apologetic way, on the right hand side, may be Dionysius the Areopagite, converted by Paul on the Areopagus, speaking to Timothy. Conversion is crucial to this fresco, which possibly has Theophilus between Seneca and Lactantius (FIG. 13).[48] So Christianity was introduced step by step to the pagans, Lactantius – in the company of his pupils to the left of Gregory the Great – being the *trait d'union* with the Church Fathers and the by then well established Christian tradition. From left to right Raphael probably depicted on the 'Parnassus': Horace, Ovid, Petrarch, Virgil and Sappho below Dante, Homer and Statius, and, in the foreground, Ennius, Lucretius and Cicero (FIG. 2). This blending of the secular and religious, antique and medieval, classical and Christian had many precedents, not only in words but also in various images, where Evangelists, Paul and Peter and scholastics were portrayed together with Plato, Aristotle and Hermes Trismegistus. All *litterati* who are depicted by Raphael in this Stanza surpass the boundaries of a clear cut mono-disciplinary classification.

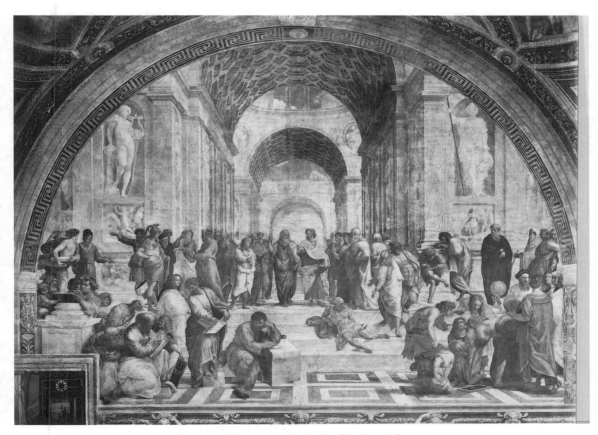

FIGURE 12 Raphael, 'School of Athens', fresco

FIGURE 13 Raphael, 'Disputa', fresco

In 1504, Paolo Cortesi published his *Liber sententiarum ad Iulium II Pont Max*, a concise commentary on the four books with *Sententiae* by Petrus Lombardus.[49] The book was a success, because its first edition, printed in Rome, was followed by the editions in Basel and Paris. In the *prooemium*, Cortesi argued in favour of integrating philosophy and theology with humanist eloquence. A sophisticated literary form would contribute to theological understanding, and Cortesi himself tried to blend classical language with Christian meaning. In his *introductio* to Julius II he adds to his arguments in favour of an eloquent theology that Augustine did not disdain the more elegant types of speech, and referred to Paul's style and to Jerome's grammar. He claimed that Christian theology deserved a polished style, and that it was up to the reigning Pontiff to settle the remaining disputations. In this way, the pagan heritage could be used in the best possible way, by interpreting it from a theological point of view; at the same time professional theologians could profit from the new humanist eloquence, and the increased knowledge of pagan poetry. This argument was presented with an unprecedented self-confidence and in a style that would please the humanists as well. Basically Cortesi's argument is simple: the Greek mathematicians, astronomers, geometricians had their merits, but lacked one fundamental source of knowledge:

divine revelation. Thanks to the Church Fathers and the theologians since Lombardus, to whom the title refers, it became possible, to place the Greek heritage in a proper perspective, and make good use of it. *Philosophia, Arithmetica, Geometria, Prospectiva, Musica* and *Astrologia* had to be seen in the light of *Theologia*, and this synthesis of wisdom had to be formulated in a correct, Ciceronian style. His book was a success.

Subsequently, Cortesi published *De Cardinalatu*, which aimed at a similar synthesis of all knowledge. Cortesi again crititized the interest in the natural sciences insofar as it neglected theology, and argued in favour of direct inspiration through Sacred Scripture which was the fundamental source of certitude, as well as knowledge of the soul, the planets and the elements.

Marco Vigerio presented an illuminated copy of his *Decachordum christianum* to Julius II, whom he praised extensively in his *praefatio*: 'Ivlio Pont. max. dicatum'. In 1507, a printed version of this extensive text was published at Fano.[50] Vigerio argued in favour of a synthesis between philosophy and theology, making use of several metaphors of harmony. One symbol is the figure X, similar to the Greek letter *Chi*, with which Christ's name begins and the Latin letter that is analogous to the cross, as well as to the Latin number ten. His book is composed of ten parts and the harmonious implication of this was reflected in the title of this treatise which was to a large degree a commentary on the Gospels. The symbol X was likewise used in the 'School of Athens': on the tablet with the theory of harmony, derived from the Greek philosophers. A young man shows the tablet to an old man – the Evangelists John and Matthew – who did not invent the theory of harmony, but used it. To theologians, as well as jurists, *consonantia* was a frequently used metaphor for the integration of texts, that, at first sight, showed differences in content. In this way the tablet with its symbols of *consonantia* is a key to this fresco and the programme as a whole.

Julius' favourite preacher Egidio da Viterbo or Giles of Viterbo conducted influential orations.[51] His arguments are similar to those of Cortesi and Vigerio. In his treatise *Sententiae ad mentem Platonis*, an unfinished commentary on Lombardus, Giles of Viterbo had tried to reconcile Platonic philosophy with Christian theology.[52] In his *Historia XX saeculorum*, also unpublished, he continued his pursuit of harmonizing Jewish, classical and Christian thought.[53] In his writings Giles of Viterbo tries to link all knowledge to the Sacred Scripture and the tradition of Church Fathers and later theologians, while making use of the pagan tradition.

In *De anima universalis traditionis opus* of 1508, Cristoforo Marcello attempted an elaborate synthesis of philosophy, theology and rhetoric.[54] Similar ideas were expressed in speech, such as his *Oratio in die omnium sanctorum*, delivered and published in 1511. Tommaso de Vio used other genres as well, writing pamphlets that defended the Pope's authority. The young Dominican wrote commentaries on the *Summa theologiae* of Thomas Aquinas, and two years later in 1509, on Aristotle's *De anima*. Like the others, he accepted the priority of theology and linked this to a wide range of other themes, such as papal primacy.

Marcello and Vio were, in 1510, less influential than Vigerio and Egidio da Viterbo. They too worked within the same papal paradigm. Tommaso Inghirami, also a crucial figure to the Pope and his artists, followed the same pattern, harmonizing rhetoric, grammar and poetry in particular.

In sum, many orations and treatises, all from the period of Raphael's frescoes, contain a common intellectual message.[55] The conceptual world painted by Raphael was present in the new library that Julius II founded. He created a *bibliotheca secreta*, consisting of more than two hundred books, mostly manuscripts and some printed works. Among this small but choice collection were several treatises that were dedicated to Julius II himself, such as Cortesi's *Liber sententiarum* and Vigerio's *Decachordum christianum*.

These books reflect the dominant way of thinking at the court of Julius II, in which the tone was set by a competent and self-confident approach to knowledge, ethics, art, religion and ceremony. The leading scholars of the day firmly believed they had attained a perfect synthesis of all that had been conceived before, based on empirical observation, arithmetic, logic, grammar, and most importantly: divine revelation, the only way to redemption and salvation. Due to this source of wisdom they considered themselves superior to the classical Greek authors whose knowledge they combined with the higher insight of Christian writers, understanding divine revelation which was still veiled to the ancient philosophers, the *prisci theologi*.[56]

The encyclopedic intellectuals serving Julius II claimed harmony of all knowledge, embracing heaven and earth, history and the time that was to come. Past, present and future: they were confident of their full understanding. From divine revelation on the one hand to the politics of the papacy on the other, they were sure of possessing a monopoly on the truth. Their texts were eclectic in that they synthesized almost everything that had been written before into a system which as such was a novelty.

Later, unexpectedly, the works by Marco Vigerio, Paolo Cortesi and Cristoforo Marcello, originally meant to be encyclopedic text books for the centuries to come, became books marginal to the mainsteam of scholarship, and even fell into oblivion. Most of the texts by Egidio da Viterbo and Inghirami remained unfinished manuscrips. The intellectual climate changed together with the political position of the papacy. Connecting all branches of knowledge under the joint aegis of theology and philosophy lost its attraction to both philosophers and theologians: their paths to the truth began to diverge.

However, in the time of Julius II theological and philosophical treatises – as well as poetry and commentaries on laws – were part of one paradigm that served a managerial function. The new papal textbooks – with titles, also for the chapters and sections, and usually with marginal notes and an index – contributed to the ideology of papal primacy in the world. Papal authority, in all respects, was personified by Julius II, who was portrayed in the room and was present there when it served its intended purposes. All elements came together in Julius II himself: painted and real. This was all the more important because he had to consolidate the Papal State in central Italy. Apart from the military threat of foreign states, in particular France, Julius was confronted with the attack in the form of a General Council, organized in Pisa, an issue that was addressed by Vigerio in a lost pamphlet, and by Vio, Jacobazzi and others. The portrait of Pope Julius II refers to this issue. The reigning Pontiff blesses the author of his new DECRETALE, while on the adjacent wall a general council of all the sages in the world, inspired by divine revelation, comes together. Concepts and images show the Pope's superiority to the secular princes. In all respects, Julius personified the new intellectual and political *consonantia* or to use the Ciceronian concept, *harmonia*.

The synthesis of all wisdom, divine and human, that was claimed by the leading curial intellectuals, changed only decades after it was formulated, published and visualized. Already to Veneziano, Ghisi and Vasari it had become difficult to interpret Raphael's frescoes, to identify the persons and to understand its texts – in spite of the fact that they were close to his world of thinking. Changes in the function of the Stanza della Segnatura and in the political context also contributed to the remarkable shift in meaning that was to take place. The room had lost its function as the nucleus of papal politics and the papacy could not preserve all its 'worldly power'. In a series of remarkable revolutions since the seventeenth century, ideas on knowledge underwent profound changes and the synthesis codified in the early sixteenth century fell apart, leaving us with its magnificent visualization by Raphael.

Painted Words in Dutch Art of the Seventeenth Century

EDDY DE JONGH

The last decades have witnessed a heated debate concerning the meaning and hierarchy of the two main elements of works of art, form and content, particularly in the field of seventeenth-century Dutch art.[1] The discussion has brought to bear a variety of viewpoints, which, roughly speaking, can be divided into two tendencies. To use the two simple designations which were employed with relative frequency by earlier generations of art historians, in one, attention to the 'how' of the work of art predominates, while in the other it is the 'what' that matters. For example, forty years ago Jan Steen's *Girl Eating Oysters* (FIG. 1) prompted the following consideration: 'We must remember that a painting as a work of art is never important for the "what", but only for the "how".'[2] In fact, this was a credo.

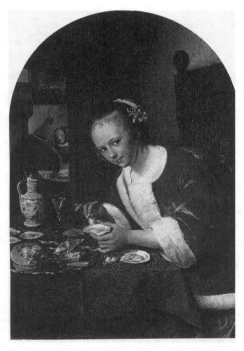

FIGURE 1 Jan Steen, *Girl eating oysters*. Mauritshuis, The Hague.

The recent discussion has arisen partly because of the great success achieved by the protagonists of the 'what' approach, that is, the iconologists. The iconological method had managed to clarify much about the meaning, background and function of works of art, particularly seventeenth-century Dutch art. Naturally, there is no consensus as to how iconology should be interpreted and applied. However, it can be said that those advocating this method willingly look for the quintessence of the work of art in its underlying ideas and in iconographic and cultural definitions.

Critical iconologists argued that one-sided attention to the 'how', that is, style, colour, composition, proportion and expression, brings about a distortion of historical perspective. After all, the seventeenth-century artist and his clientele themselves attached great value to the subject matter of paintings, or even more, to what that subject implied in terms of symbolic and cultural interrelationships. This can be primarily determined on the basis of circumstantial evidence. In his *Nuttige tijd-korter voor reizende en andere luiden* (loosely translated: 'A useful way for travellers to pass the time') of 1663, the preacher Franciscus Ridderus expressed an opinion undoubtedly shared by many, namely that 'paintings should not be judged by the figures they contain/ but in terms of the art itself/ and the nice meanings.' 'Nice' should here be understood as clever or inventive.[3]

Fifteen years ago, however, the undisturbed progress of the iconologists was rudely interrupted by the appearance of the self-conciously polemical book by the American art historian Svetlana Alpers, *The art of describing*.[4] According to her, the meaning and the essence of a painting must be sought exclusively in the visual means and their applications, and not in abstract ideas. This is a viewpoint which is logically related to Alpers' conception of seventeenth-century Dutch culture as a typically visual one. She considers the iconological approach to the art arising from that culture to be more or less irrelevant. By drastically sweeping away iconology in favour of the primacy of visual means, Alpers established a hierarchy between artistic design and the content of works of art, which she regards as an historical fact. I dare say that Pastor Ridderus, quoted above, would have thought that strange, and in doing so I reveal something of my own view.

We do not know exactly what Alpers would say about Steen's *Girl Eating Oysters*, but we do have her interpretation of a masterpiece painted a few years earlier, a *Self-Portrait and Vanitas Still Life* by David Bailly from 1651 (FIG. 2). Here I will only touch upon her interpretation, as it clearly exposes the contrast to the obvious iconological explanation of Bailly's painting.[5]

In Alpers' view, this picture concerns things which materially demonstrate their properties, their nature, analogous to what she dubbed 'Baconian ambitions'. The philosopher Francis Bacon wrote: 'I admit nothing, but on the faith of the eyes' – albeit after the necessary empirical experience. It is the techné of craft, Alpers suggests, which enables us to understand nature. Bailly wanted to show us a dazzling mixture of artistic creativity and artistic illusion, an intention closely informed by Bacon's philosophy.

Even those who are not surprised by this claim and do not question whether Bailly was familiar with Bacon's writings, will at the very least want to know the meaning of the painting's ostentatious *vanitas* character. The many objects, including the skull and hourglass, the air bubbles, the text from *Proverbs* (Vanitas vanitatum et omnia vanitas), together with

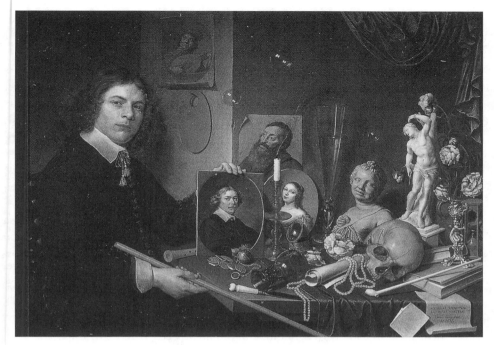

FIGURE 2 David Bailly, *Self-portrait with vanitas still life* (1651). Stedelijk Museum 'de Lakenhal', Leiden.

the two self-portraits of Bailly as a youth and as an old man, are difficult to understand as anything other than a traditional statement of man's mortality.

However, in Alpers' view, matters are not so simple. The abundant references to mortality are supposed only to refer to the material of the painting itself. According to Alpers, the actual message communicated by the image is the display and enjoyment of craft as 'a version of a Baconian experiment', whereby the artist recognises only secondarily that his creation is subject to transience.

How to Read a Genre Scene

A few years after the appearance of *The art of describing*, a younger generation of art historians began to criticise iconology. While these scholars did not follow in Alpers' footsteps, they too shifted the focus of attention from problems of meaning to those of design and material expression. Some of them also raised objections to the premise of many iconologists, namely that seventeenth-century art had a didactic and paradoxically obscuring character.[6]

A problematic aspect of the debate is that there are no seventeenth-century writings on artistic theory in which the meaning of genre scenes, portraits, still lifes and landscapes are discussed in any kind of detail. This fact was not ignored in the polemic. If, as the

iconologists argue, the content of genre scenes and other categories of painting was considered so important by contemporaries, why – runs a favourite question of the critics – do we hardly find anything about this in theoretical treatises?[7]

An appropriate answer to this is, in my view, that the theoreticians concentrated predominantly on history painting, that is, on biblical and mythological scenes or on themes derived from history and literature. They considered genre scenes to be beneath their dignity or that of their profession. If we bear in mind that genre scenes must have been made in the hundreds of thousands, then such an elitist attitude tells us something about the discrepancy between theory and practice; and at the same time also about the value and range of our theory in this respect. The situation with regard to portraits hardly differs. Many tens of thousands were commissioned in the seventeenth century, but the theoreticians either chose to ignore the subject, or barely touched upon it.[8]

What has been written on genre painting and genre painters in the literature on Dutch art from Karel van Mander (1604) to Gerard de Lairesse (in 1707) would probably fit on two, or at most three pages and is therefore negligible.[9] How, therefore, could specific aspects of genre painting, such as representation and meaning, have received serious attention? It is often insufficiently realised that treatises on art theory are actually part of a rhetorical tradition and the tradition of poetics, in which it was not the custom to investigate questions of content, such as the ascription of meaning to a theme or the inclusion of symbolic elements. In this context, it is illuminating to make a comparison with Joost van den Vondel's *Aanleidinge ter Nederduitsche Dichtkunste* (Introduction to Dutch Poetry), a literary-theoretical essay from 1650, which formulates a series of fundamental propositions on language and style for the benefit of those desiring to become proficient in the writing of poetry. In it, no attention whatsoever is devoted to subject or meaning, while in Vondel's own considerable oeuvre the importance of just these two elements cannot be overestimated.[10]

Unfortunately, art history lacks a seventeenth-century treatise which places genre scenes, still lifes, landscapes etcetera in an iconological perspective, as is done with personifications in Cesare Ripa's *Iconologia*, the influential manual for allegory, which first appeared in a Dutch translation in 1644.[11] Just as Ripa prescribes how an artist must paint allegories of Generosity, Chastity, Abundance, the continent of Europe or Holy Rome, an imaginary primer for the genre painter could have contained directions for how a particular amorous situation could be depicted, which ingredients were needed to dress a specific virtue in bourgeois idiom, or how mortality could be alluded to in the visual vocabulary of the everyday. As this treatise was never written, no direct seventeenth-century answer can be obtained to the crucial question of how we should read a seventeenth century genre scene.

Words and Images

The debate on the question of form and content does not convince me that the subject and meaning of works of art were generally of little relevance to the seventeenth-century painter and his public. We have too much evidence to the contrary, namely motifs and representations whose communicative intention is difficult to doubt and whose semantic value is rea-

sonably demonstrable. Of course, with the exception of allegories and the like, it can, strictly speaking, seldom be entirely proved that the artist intended to instill specific meanings into certain parts, or indeed into his entire depiction, but in countless cases the probability on this point turns out to be so high that neglect or denial of the message of the content would point to a fear of interpretation or of an 'art for art's sake' bias. Furthermore, it would be doing an injustice to the artists, for in the seventeenth century a part of the joy of creation lay in the ingenious construction of the content and in references to matters outside the painting.

Nevertheless I would not want to give too rose-tinted a picture of the legibility of iconography. Seventeenth-century artists have often made it difficult enough for art historians with exegetic ambitions. It turns out that many representations cannot be traced back to a specific meaning, let alone a precise identification of their tone or mode, or the intention of their makers. In addition, some works may have been deliberately intended to be polyvalent. We simply lack a method of verifying this claim.[12]

A representative example of a painting about which various aspects can be explained, but whose ultimate meaning, tone and intention nevertheless remains elusive, is Vermeer's *Lady Standing at a Virginal* (FIG. 3).[13] A striking detail visible behind this musician is a depiction of a cupid holding a card or a rectangular piece of paper in his raised left hand, and leaning on a bow with his right hand. There are various readings of this detail, but for the time be-

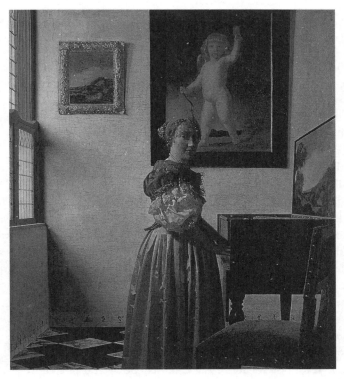

FIGURE 3 Johannes Vermeer, *A lady standing at the virginal.* National Gallery, London.

FIGURE 4 Otto Vaenius, *'Only One'*, emblem from Otto Vaenius, *Amorum emblemata*, Antwerp 1608.

ing I am assuming that Vermeer derived the god of love from an illustration in Otto Vaenius' extremely popular emblem book, the *Amorum emblemata* (FIG. 4).[14] The print in question shows the number 1 on the raised card (here actually a sign), while the cupid is standing on a board marked with the numbers 2 to 10. The accompanying motto and poem instruct us that it is allowed to love only one person. That is why Amor is demonstratively waving the number 1 and treading the higher numbers underfoot.

Although the card held up by Vermeer's cupid is blank and the board with the other numbers is missing, we can assume that in conceiving his painting Vermeer had the meaning expressed by Vaenius in mind. Now, this hypothesis does not get us very far. Even if it is correct, we are still ignorant as to Vermeer's exact intention. How, and this seems to me an important question, did the painter want the moral he had included to function?

There would appear to be more than one possible answer to this question. Perhaps Vermeer wanted to present the message conveyed by the cupid as a reflection of the life of the beguiling musician. But it could just as easily be that he is holding up the moral in question to her for imitation, because her conduct left something to be desired. A third possibility is that the moral is aimed at us, the viewers. However, perhaps (this is the fourth option) Vermeer was leaving all those possibilities open and the choice up to the beholder. This choice could then be either unambiguous and equivocal, the latter case combining all of these possible readings. Whatever the case may be, we do not know what Vermeer intended, any more than we can make a valid statement about the tone of his visual commu-

nications. How much seriousness, or humour or irony he may have woven into his representation, or even how lightly or seriously we should interpret the moral, about this too Vermeer leaves us in the dark. And we are not the only ones, probably. Another question is whether Vermeer's contemporaries recognised the degree of ambiguities in his intentions.

In its refusal to be frank with us and reveal the structure of its meaning, the *Lady Standing at a Virginal* is certainly no exception. That countless paintings are reticent about their intrinsic meaning could very well have something to do with the general fascination of the seventeenth century with the enigmatic, with ambiguities or partial disguise. Formulated as an aesthetic principle and partly based on much older rhetorical principles, we can detect this fascination in diverse literary writings, and occasionally in art theory.[15]

Unlike Svetlana Alpers who, as I said, regards Dutch culture of the seventeenth century as a visual culture *par exellence*, and looks for the essence of seventeenth-century painting in its surface, in this discourse I want to emphasise what I would like to call the 'taligheid', or, in German, the 'Sprachlichkeit' of the art and culture of that time. As far as I know there is no such term in English, but the adjective 'linguistic' or 'linguistical' comes closest.

My interest is in art which somehow incorporates elements of language, painted words or expressions. In principle, two patterns can be identified here: words which are illustrated through appropriation of the actual letters; and words, texts, which have been transformed and assimilated into the rest of the composition. I will give two examples: a *Still Life* by Jan Davidsz. de Heem from 1628 (FIG. 5), in which words are depicted in their literal form, and a *Self-Portrait* by Rembrandt[16] in which no letters appear but in which, if I am correct, a word is visualised which is meaningful for Rembrandt. We will return to that presently.

FIGURE 5 Jan Davidsz. de Heem, *Still life with books* (1628). Mauritshuis, The Hague.

However, we must not overlook the fact that there are two sides to every coin. We could easily regard manifestations of the linguistic in the light of the sisterhood of word and image, of poetry and painting, which was endlessly proclaimed in sixteenth and seventeenth-century Holland.[17] This affinity not only represented a humanistic cliché coined in Italy, it also reflected a real situation. In practice word and image were often very close to each other. Many an artist attempted to wield both pen and brush and many painters were members of a chamber of rhetoric.[18] And where seventeenth-century art is partly characterised by a high degree of the linguistic, prose and above all poetry on the other hand can sometimes be extremely 'pictorialist', a word that does appear in the English vocabulary.[19]

As far as the latter is concerned, with her emphasis on the visual in Dutch art and culture, Alpers has a point: the visual and the pictorial are after all closely related to each other. On the other hand, she prefers to remain blind to the reverse, namely the pronounced tendency to enrich visual images with the linguistic.

Pictorialism is particularly obvious in the work of a poet like Joost van den Vondel, whose *Introduction to Dutch Poetry* has already been referred to. In the course of his long career, Vondel repeatedly made use, with apparent pleasure, of technical painting terms in his descriptions of nature, for example.[20] He presented his first drama *Pascha* as a 'living-beautiful-fine painting'.[21] Later, he was inspired by a painting by Jan Pynas to write the tragedy *Joseph in Dothan* (FIG. 6), whose final act in particular can be called a successful example of his attempt to 'imitate with words the painter's paint, drawings and passions...'. Drawing to be understood here as design.[22]

FIGURE 6 Jan Pynas, *Joseph's blood-stained clothing, shown to Jacob*. Hermitage, St. Petersburg.

With regard to pictorialism, Vondel also wrote more than two hundred poems about paintings and he was certainly not the only one to practise this specific genre of poetry. In one of these poems Vondel mentioned the Frisian painter Wybrand de Geest, recalling that De Geest had also been lauded by a Frisian poet: 'It is his custom to marry your painting to his poetry.'[23] Such lines flowed with great regularity from seventeenth-century pens and belong to the countless testimonies legitimising and perpetuating the sisterhood of word and image.

Also of interest in this context is the fact that in 1641 the translation of a Spanish novel was dedicated to Wybrand de Geest, 'in which all the defects of the age, among people from all walks of life, were punished, for delight and for instruction; and nakedly displayed as in a painting.'[24] Equally as fascinating as the comparison with a picture, is the double definition of quality used here, namely that it be pleasurable and instructive. To be both enjoyable and elevating was the goal of all the arts in the seventeenth century and in so doing it was possible to call on the universally respected Horace. His statement: 'He has won every vote who mingles profit with pleasure' (*Omne tulit punctum qui miscuit utile dulci*) was repeated *ad infinitum* with and without variations.[25] It is therefore not surprising that it was usually on the level of the moral or the level of the deeper meaning – the 'nice meanings' Ridderus spoke of – that painting and literature came closest to each other.

The use of the family metaphor (sisterhood) was one way of indicating the intimate relationship between the literary and visual arts. The use of a second phrase from Horace, *ut pictura poesis*, lifted from its context and, since the Renaissance, translated as 'a painting is like a poem' was another effective expression of the same idea.[26] Yet it was no less usual to speak, after Plutarch, of painting as dumb poetry and of poetry as speaking painting.[27] The reader is undoubtedly familiar with all these clichés.

What is perhaps not so generally known is that rhetoric was also part of the game. A good piece of oratory, we read in manuals of rhetoric, was supposed to be 'painted' in variegated colours, with contrasts of light and dark. In rhetorical prescriptions, colour was particularly favoured as a qualitative designation well into the eighteenth century.[28] In 1776 Sir Joshua Reynolds, for example, was still proclaiming to his students that: 'Well-turned periods in eloquence, or harmony of numbers in poetry (...) are in those arts what colouring is in painting.'[29]

Intimacy between word and image was not always guaranteed. When the question arose as to which of the two could claim to be the leader, animosity might arise between the sisters. Competition between the arts, also that between painting and sculpture known in art history as 'paragone', was partially a realistic affair and part shadow-boxing cultivated by the theoreticians.[30] Leonardo da Vinci was already convinced of the superiority of painting to poetry on the basis of the fact that painting served the noblest sense.[31] In seventeenth-century Holland, the treatise writer Philips Angel, in his *Praise of painting* of 1642, forwarded the same opinion; although for him a deciding argument was the greater financial gain, the brush providing more than the pen.[32]

Such considerations do not occur in the *pictura-poesis* literature, simply because there visual and literary elements are strung together and there is no room for competition. Examples of this sort of literature are illustrated collections of proverbs, illustrated broad-

sheets, illustrated songbooks, iconologies and emblem books, all produced by the ton in the seventeenth century. The emblem book in particular, in which word and image are joined in the most pregnant manner, flourished enormously at the time.[33]

Although they were not usually published separately, this category also includes hundreds of poems about specific pictures, mainly portraits. I have already mentioned Vondel's two hundred works in this context.[34] Whereas these are texts about depictions, there are also many depictions of texts, such as proverb paintings for example. Famous is Pieter Bruegel's painting of 1559, in which eighty-five proverbs and sayings are literally, as it were, transformed into images (FIG. 7).[35] We can find such transformations in many other paint-

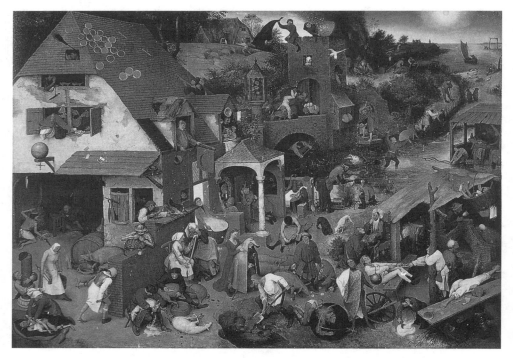

FIGURE 7 Pieter Bruegel, *Netherlands proverbs* (1559). Staatliche Museen, Gemäldegalerie, Berlin.

ings too, though on a less encyclopedic scale than in the Bruegel. Usually this is a single detail more or less emphatically incorporated into the composition, for example in a painting by Anthonie Croos from 1665, a *View of The Hague from the Northwest* (FIG. 8), in which the repoussoir at the right – a gnarled tree with a bird-nester – conceals a familiar seventeenth-century saying.[36] It is also illustrated in an etching by Claes Janszoon Visscher after a painting by David Vinckboons (FIG. 9), with rhyming caption: 'He who knows where the nest is, knows it/ but he who steals it, has it'.[37] Nowadays we would say 'Possession is nine tenths of the law', that is, it is not so easy to get your hands on something.[38]

FIGURE 8 Anthonie Croos, *Landscape with a view of The Hague* (1665). Musée des Augustins, Toulouse.

FIGURE 9 Claes Jansz. Visscher, etching after David Vinckboons, *The bird's-nester*.

Many seventeenth-century paintings include details which turn out to be no more than accurate visual translations of texts or words. The viewer was expected to distil the word from the image as it were, that is, to decode it: a mental activity which must have contributed to his aesthetic experience.

I suspect that Rembrandt indulged in this practice as well. In the 1656 inventory of his possessions is mentioned a work described as 'a bittern, after life, by Rembrandt'.[39] This is almost certainly the *Self-portrait with Bittern* (FIG. 10) of 1639, a portrait which in our time has been variously interpreted in terms of eroticism, social status, vanitas and natural ingenuity.[40] Traditionally, imagination was considered part of that ingenuity. The latter is in keeping with what I would like to add to this bouquet of interpretations, that is, the possibility of a Rembrandtian pun, which incidentally does not necessarily exclude other connotations.

FIGURE 10 Rembrandt van Rijn, *Self-portrait with a dead bittern* (1639). Gemäldegalerie, Dresden.

'A bittern, after life': in seventeenth-century Dutch, the bittern was called 'pitoor' (sometimes written with two t's).[41] The word 'pitoor' is very close to *pictor*, the Latin term for painter, and even more close to the Italian *pittore*. The words, especially pitoor and *pittore* are also quite simular in pronunciation. That for this unusual portrait Rembrandt chose this particular bird and emphasizes it through lighting and positioning, is probably less a coincidence than it would appear.

Naturally, this pitoor-pittore-pictor association is of trifling importance, but it would be incorrect to claim that an artist of Rembrandt's quality would feel himself above such things. It would be difficult to overestimate the status enjoyed by puns and visualisations of words in the seventeenth century. It was only in the twentieth century that punning came to be considered the lowest level of wit.

A consummate master in this respect was Jan Steen (FIG. 11, 12). Considering the nature of seventeenth-century humour, we can assume that Steen's saucy puns and expressions cast in visual motifs were highly appreciated. His visualisation of an obscene expression about the filling of a tobacco pipe as an allusion to coitus is a typical example of this genre. Steen repeated the joke a number of times, just as he more than once played visual games with the ambiguity of the word 'kous', which apart from a stocking can also refer to the female sexual organs.[42] Other artists amused the public in a similar way with stockings,

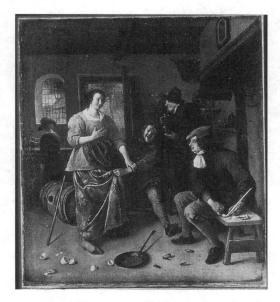

FIGURE 11 Jan Steen, *The interior of an inn*. National Gallery, London.

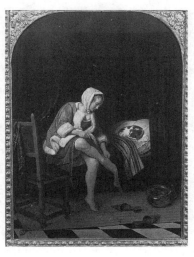

FIGURE 12 Jan Steen, *Woman at her toilet*. Rijksmuseum, Amsterdam.

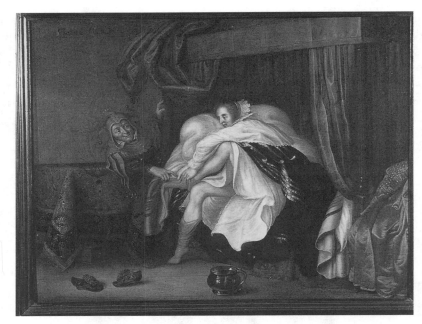

FIGURE 13 Adriaen van de Venne, *'Geckie met de kous'*, Muzeum Narodowe, Warsaw.

for example Adriaen van de Venne (FIG. 13) and, later in the century, Cornelis Dusart in a watercolour showing a *Lascivious couple* (FIG. 14), in which we see the woman demonstratively waving the garment in question.[43]

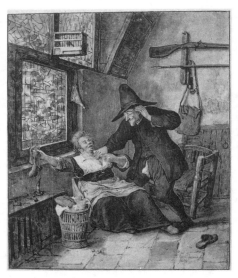

FIGURE 14 Cornelis Dusart, *Lascivious couple* (1687, watercolour). British Museum, London.

While this sort of titillating joking abounded in seventeenth-century art, virtue was preached incessantly and could also be translated from one medium to the other, from word to image. An example of visualised rectitude is found in a 1679 *Family portrait* of the children of a Leiden burgomaster by Daniel Mytens II (Fig. 15).[44] It is completely based on Ripa's *Iconologia*, the standard allegorical guide mentioned earlier, which included both texts and accompanying illustrations, which in themselves are already abstractions made concrete.

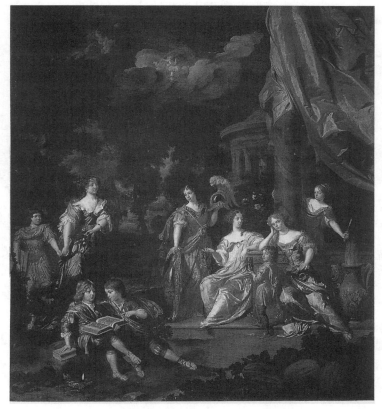

FIGURE 15 Daniel Mytens II, *Family portrait* (1679). Rijksmuseum, Amsterdam

Nine children are posed before a park-like background with a round temple and several free-standing columns, one of which is draped by a voluminous red curtain; a tenth child hovers as an angel above the group, indicating that it is dead. The scene's unrealistic character is accentuated by the children's colourful costumes, which bear little resemblance to contemporary fashion, as well as by some of their accoutrements. Each of the figures appears to represent a specific virtue, making this family portrait simultaneously an allegorical tableau. It is a matter of some conjecture whether the iconographic programme, which must have been developed by the patron – undoubtedly the Leiden burgomaster – in con-

junction with the painter, was intended as an exhortation for the children to adopt the relevant virtues, or if it was meant to suggest that the offspring already exemplified the combined ethic.

I will refrain from giving an inventory of all the concepts and motifs derived from Ripa: after all, the necessary liberties were sometimes taken. Everything which was too obviously unrealistic was left out. As *pars pro toto*, I will only show Temperance and Constancy (FIG. 16, 17): two of Ripa's personifications which are imitated by the sitting girl with the bridle (but without Ripa's elephant), and the standing girl to the far right, who grasps a pillar and holds a sword above a fire. She is taken over wholesale from the *Iconologia*.[45]

FIGURE 16 *Temperance*, illustration from Cesare Ripa, *Iconologia*, Amsterdam 1644.

FIGURE 17 *Constancy*, illustration from Cesare Ripa, *Iconologia*, Amsterdam 1644.

One could claim that the process of transformation in Mytens' picture is somewhat different since the people portrayed also had visual origins, starting in Ripa's woodcuts. On the other hand Ripa's text was also used and translated visually, a facet that would lead us too far astray to go into now. In any case, it does not seem exaggerated to me to characterise Mytens' painting as a particularly 'bookish' performance.

Still Lifes

I would like to emphasise that not everything was equally 'bookish' or linguistic in Dutch art of the seventeenth century. Just as there is enough seventeenth-century poetry in which the painterly element remained limited or was even completely absent, naturally the language content is not equally present in each painting. But whilst it can easily be shown that

throughout the seventeenth century there were artists who had little interest in producing images à la Steen or Mytens with visualised expressions or ideas, there were many painters who enjoyed accommodating linguistic details into their compositions, which often led to intriguing iconography, whether or not it was decodable.

As I have already briefly mentioned, two basic patterns can be identified in the use of linguistic expressions in the fine arts. First, expressions which have been transformed into a visual motif, such as proverbs, sayings, words, examples of which we have seen in Bruegel, Rembrandt, Steen and Mytens. And second, expressions which have been left in their 'natural form', thus words openly imitated in paint, written or printed. We saw an example of this category in the *Still Life* by Jan Davidsz. de Heem (Fig.5). Of the books displayed in this painting, two bear titles and the names of the authors, Bredero and Jacob Westerbaen.[46] In the Dutch Republic with its enormous book production and high degree of literacy, this sort of still life enjoyed an uninterrupted popularity.

According to Svetlana Alpers, words and texts in paintings, 'rather than supplying underlying meanings', above all give us more to look at.[47] In her view, they are eyecatchers which 'extend without deepening the reference of the work'. Indeed, the *mise-en-page* of a text, or the contrasts between a fragment with letters and the rest of a painting's configuration, can produce splendid artistic results, but that does not alter the fact that texts often have yet another function. On many occasions they are added to lend depth or nuance to the effect of a depiction, or to offer an amusing commentary on that depiction.

An ingenious painting by Gerard van Honthorst of 1625 (FIG. 18) is a typical representative of seventeenth-century humour.[48] It depicts a courtesan ostentatiously pointing

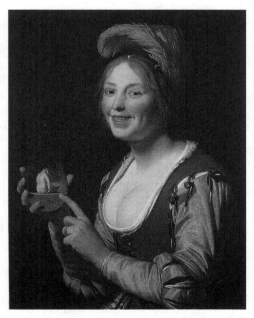

FIGURE 18 Gerard van Honthorst, *Young woman holding a medaillion* (1625). City Art Museum, St. Louis, Missouri.

to a medallion with a nude woman seen from the back, her head turned away, sitting on a folding table. We should probably regard the courtesan and the miniature nude as one and the same person. Written under the nude figure is: 'Wie kent mijn naeis van Afteren' – 'Who knows my nose from behind.' The Dutch word used here for 'nose' is 'naeis', which should probably be understood as a dialect form of the word for nose, 'neus', with perhaps a nod to the word 'naers', which means the same as 'arse'.[49]

Indeed, we cannot know her nose from behind and looking at her does not help because she teasingly holds a hand before her face. A mirror on the table elaborates the joke even further - her turned head also prevents her nose from being seen in the mirror. Seventeenth-century viewers must have found all this very amusing.

A less daring variant of this humour, where word and image are once again artfully combined and, moreover, supplemented with a moral, is an engraving by Hendrick Bary (FIG. 19) made much later in the seventeenth century. The standing man seen from behind bears the following rhymed comment:[50] 'Who looks upon me fain would know/ Who am I and what I wear;/ But friend I am like he who sees me;/ because I do not know my selves.'

A moment ago when I mentioned Jan Davidsz. de Heem for the second time, I spoke of several still lifes in which texts play a role, texts in what I have called their 'natural shape'. With these still lifes I will bring to a close my exposition about the painted word and it will hopefully become clear that texts-in-paint could and do provide, not only visual pleasures, but also intellectual information. This recalls Pastor Ridderus, whose standpoint to my mind reflects the consensus at the time, namely the idea that painting is about both artistry and meaning, which preferably should show some ingenuity.

FIGURE 19 Hendrick Bary, *Standing man* (engraving).

Still lifes with books, I have just said, remained popular throughout the seventeenth century. The last quarter of the century witnesses some painters, the most interesting being Edwaert Collier, who could not get enough of books and texts.[51] Characteristic of his style is a *Vanitas Still Life* (FIG. 20) including a songbook entitled *Cupidoos lusthof* (Cupid's pleasure garden), Flavius Josephus' *History of the Jewish War*, and a Dutch translation of a then-famous book by the sixteenth-century French Calvinist Du Bartas, *La Sepmaine ou la creation du monde*. The meticulous manner in which the painter has depicted the three title pages, or perhaps we should say, written them out, shows a certain mania with regard to the seductive sisterhood of word and image.

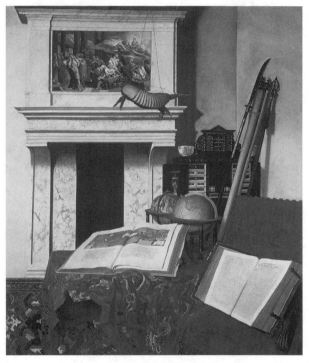

FIGURE 20 Edwaert Collier, *Vanitas still life*. Stedelijk Museum 'de Lakenhal', Leiden.

No less interesting in iconographic terms is a *Still Life* attributed to Collier (FIG. 21), which includes a sculpture of a cross-bearing Christ. This is not an invention of the painter, but a rather exact reproduction of Michelangelo's *Christ* in Santa Maria sopra Minerva in Rome. Books are also visible, including one that is particularly appropriate in our context, namely the 1644 Dutch edition of Ripa's *Iconologia* (FIG. 22). Here Ripa is not translated into other forms and material as in Jan Mytens' *Family Portrait* (FIG. 15), but faithfully imitated in its physical aspects. The book is opened, not at all randomly, to the section on *Glory, Fame, Honour*, page 441. The painter's meticulousness extends to the signature and *custos*, or catchword at the bottom of the page.[52]

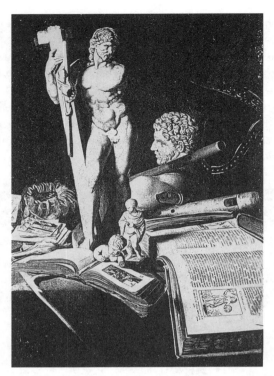

FIGURE 21 Edwaert Collier or Simon Renard de Saint-André, *Still life with sculpture.*
Whereabouts unknown.

FIGURE 22 Page from Cesare Ripa, *Iconologia*, Amsterdam 1644.

Collier and his followers were not the only ones to eagerly embrace significant books. Many other painters also incorporated printed matter with great refinement into canvas or panel. An exceptional picture was that by Jan van der Heyden, better known as the painter of urban views and the inventor of the fire engine, but here excelling as a painter of valuable collectible items and two opened folios (FIG. 23).[53] They are, on the chair to the right, the Dutch Authorized Version of the Bible, and on the table, an atlas by Blaeu, the *Toneel des Aerdrycks*. The texts have been included right down to the smallest typographical details with striking precision, just as the map in the atlas of fortifications at Bergen op Zoom are enormously accurate.

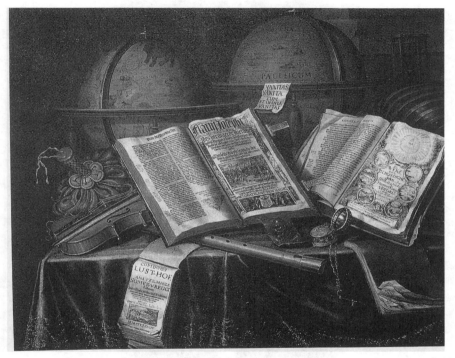

FIGURE 23 Jan van der Heyden, *Still life with books and curiosities.* Szépmüveszeti Múzeum, Budapest.

The Bible is open at the first page of the book of *Proverbs* which begins with the well-known saying 'Vanity of vanities, all is vanity', a text which was depicted separately in countless still lifes, usually, as in those by Bailly and Collier, in Latin. In the case of Jan van der Heyden, the choice of the book of *Proverbs* must be seen in relation to the unusual signature used here by the painter. It is 'old J.v.d.h. 75 years', which means that this masterpiece was painted in 1712, the year of Van der Heyden's death. The creation of such a still life by a seventy-five-year-old, with such a steady hand and such precision, is an achievement of the first order.

Conclusion

To conclude I would like to return to Holland's leading seventeenth-century poet, whose poetica, *An Introduction to Dutch Poetry* was briefly discussed, as was the fact that he wrote many poems about paintings: Joost van den Vondel. One of his poems figures concretely in a *Still life* by Cornelis Brisé (FIG. 24, 25).[54] The work is signed with a flourish on one of the depicted books, and dated 1665. Although it shows an untidy pile of odds and ends, the sisterhood of word and image is extravagantly celebrated in this piece where painting and poetry perform an unusually effective duet.

FIGURE 24 Cornelis Brisé, *Vaniats still life* (1665). Rijksmuseum Amsterdam

FIGURE 25 Cornelis Brisé, *Vanitas still life*, détail *Figure 24*.

Even more striking than the elegant signature is the sheet of paper or parchment with Vondel's verse, which in ten lines sings the praises of man's equality in the face of death:[55]

'Death equates both high and low
Middling and rich and poor just so
Dying is the common lot,
Bookish knowledge and marotte
Have equal wisdom in the grave.
The digger's spade and bishop's stave,
The bagpipes and the turban crown,
Are just as fair when life's laid down.
So let them bustle, those that will,
It all ends up by standing still.'

The last line of the poem, literally 'So staat het al ten lesten stil' (So stands it all, at long last, still), has a gratification of its own. Given the seventeenth-century infatuation with puns, allusions and double meanings, it is not inconceivable that there should be a play on words here. One is led to think of the word *stilleven*, still life, a new word at the time.[56]

With a few small changes, Brisé wrote out the lines from the poem entitled 'On a painting', which Vondel published in 1660 and to which he added the motto 'Sceptra ligonibus aequat': sceptre and spade by death are equal made.[57] We do not know which painting Vondel had in mind at the time, or at least there is no documentation, but we can imagine it, as his verse corresponds to a number of the objects depicted by Brisé in 1665: book, marotte (standard attribute of the jester), spade, crook, bagpipes and turban crown. In fact, the engaging text implies that Brisé's still life contains the same ingredients and possibly looks like the unknown painting that had inspired Vondel to write his poem five years earlier. It is highly probable that this unknown work was also by Brisé. His *Still Life* of 1665 could be a variant or a replica, to which that extremely relevant poem was added with appropriate pride.

One could argue that art history as a discipline is characterised by a high percentage of speculative statements and deductions. My elucidation of Brisé's still life and the place of Vondel's poem in it, is just such a speculation. We know absolutely nothing about the relationship between the great poet and the somewhat less great painter; if it is even possible to speak of a relationship. This is how the art historian is – I would almost say - led astray, but what I mean is, how he is driven to speculation.

Historical Semantics and Political Iconography: The Case of the Game of the French Revolution (1791/92)[1]

ROLF REICHARDT

Using pictures to convey important philosophical, moral and political concepts was a common cultural practice in early modern France. Indeed, from the perspective of historical semantics at least three major examples of these traditions can be distinguished. The first is that of the learned allegories, a form explained and socially institutionalised in a long series of emblematic treatises[2] beginning with Andrea Alciati's *Emblematum libellus* (1534; French translation, 1558) and continuing right up to the *Iconologie* of Gravelot and Cochin (1791).[3] In one such example, the *Liberté* of Cesare Ripa (FIG. 1) – adapted to the French cultural context by Jean Baudoin in 1643 – Liberty is depicted as the sovereign of the 'Empire of Liberty' (symbolised by the sceptre), while the cat at her feet and the Phrygian cap upon her head represent her love of personal freedom and role as a liberator of the slaves, respectively.[4] Ripa's *Egalité* (FIG. 2), in turn, carries the symbol of justice – the scales – and

FIGURE 1 Allegory of *Liberty*, copperplate, in Cesare Ripa, *Iconologie*, 2 vols., Paris 1643, I: p. 9

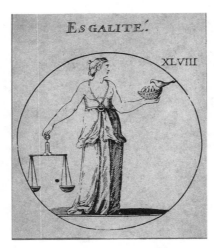

FIGURE 2 Allegory of Equality, copperplate, ibid., I: p. 54

the family of swallows supported by her other hand signifies the value of equal sharing.[5] In order to lend substance to the abstract key concepts to which they referred, the politicians of the French Revolution drew heavily on these – mostly female – allegories.[6] Their adaptations of such images could be very creative however, as is shown by a study for a monument to the Republic (FIG. 3) in which the figure of *Marianne* is portrayed as the republican embodiment of Liberty, Equality and Fraternity.[7]

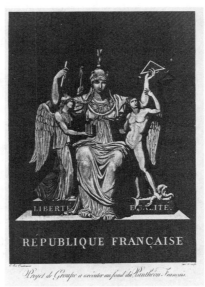

FIGURE 3 Study for a monument of the *French Republic* intended for the Pantheon. Aquatint by Antoine Quatremère de Quincy 1794/95, 39,5 x 27 cm, Bibliothèque Nationale Paris

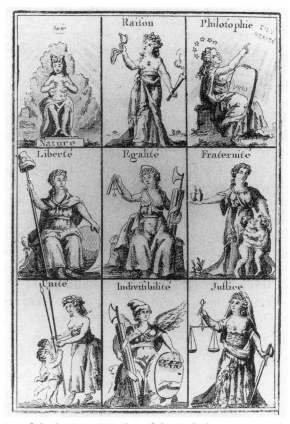

FIGURE 4 Allegories of the basic principles of the Enlightenment and republicanism, in François-Jean Dusausoir, *Livre indispensable aux enfans de la liberté*, 2nd ed., Paris 1793–94, frontispiece

Partly connected to that of the *Emblemata* was the more popular tradition of didactic pictures. Widely used by the Catholic reform movement in the 17th and 18th centuries,[8] this practice was taken up by the revolutionaries, who adapted it to their own purposes, for example in the form of republican primers and political catechisms.[9] The need for such publications was stressed by Lequinio on 27 November 1791, in the context of putting forward a proposal at the Parisian Jacobin club that the prize-winning *Almanach du Père Gérard* by Collot d'Herbois be illustrated:

> You are aware of the ills that fanaticism has brought about by spreading pictures throughout the countryside. I propose that the Society put all its efforts into working to the opposite effect and produce pictures in accordance with the Revolution.[10]

The Revolutionaries were as aware of the power wielded by pictures in the semi-literate society of their time as their opponents. One of them put it very succinctly when he de-

scribed pictures as a sort of 'spoken writing' (*écriture parlée*),[11] a comment which underlines their connection to a semi-oral, popular culture that had, with the Revolution, regained some of the importance it had lost through the combined effects of Absolutism and the Enlightenment.[12]

Examples of this politically motivated form of iconography can be seen in some elementary-school textbooks produced in the Year II (1793/94). Aimed at children of the *sans-culottes,* these textbooks contained either frontispieces summing up the main political virtues described in the text (FIG. 4) or illustrations accompanying each conceptually based dialogue. One example, the visual allegory of *Égalité* in the catechism of Chemin-Dupontès (FIG. 5), goes beyond the traditional image of the female figure with the scale-beam in also depicting the official axe used to kill the dragon of counter-revolution (an additional symbol of her power), the figure of Nature (the foundation of equality) and the former privileged orders fraternising with the Third Estate.[13]

The third pictorial tradition discussed here consists of social satires and political caricatures that were originally printed as broadsheets (FIG. 6). Although not generally used for this purpose during the *ancien régime,*[14] such illustrations became increasingly important vehicles for political imagery during the Revolution.[15] In the case of the complex concept of 'aristocratie', attempts were made to convey the content of contemporary pamphlets in concrete visual terms[16] by making use of the image of the 'aristocrate' as a hypocritical, two-

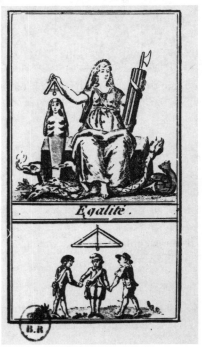

FIGURE 5 Allegory of *Equality.* Anonymous, etching, in Jean-Baptiste Chemin-Dupontès, *L'Ami des jeunes patriotes,* Paris 1793–94, p. 30

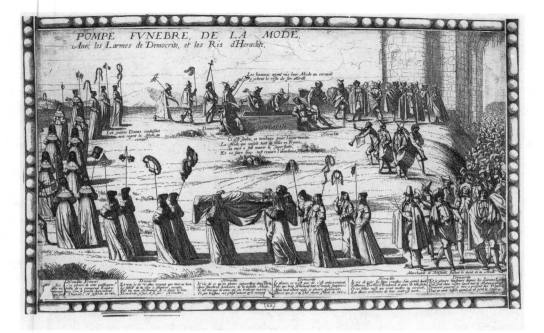

FIGURE 6 'The burial of fashion'. Anonymous, copperplate, 1633, Bibliothèque Nationale Paris

faced character (FIG. 7)[17], in one instance, and the idea of the aristocrat as the modern Judas ISCARIOTTE[18] (an anagram of 'aristocratie'), in another (FIG. 8). The latter image is a reference to the 'complot aristocratique' hatched by a group of aristocrats in early July 1789. The socially 'mixed' nature of the new polemical concept of *aristocratie* was expressed in the form of a three-headed monster (FIG. 9): guided by the clerical figures of Hypocrisy and Fanaticism. A prelate, a nobleman and a judge join forces in order to devour the people alive – a pictorial rendering[19] of the modern concept of 'feudal absolutism', *avant la lettre*. A definition of 'aristocratie' taken from a contemporary pamphlet reads like a commentary on this print:

> [She] has the claws of a harpy, the tongue of a blood-sucker, the soul of a procurator, the heart of a financier, the feet of a ram, the gluttony of a vulture, the cruelty of a tiger, the haughtiness of a lion, the randiness of a monk and the stupidity of a judge; we have experienced how she has sucked the blood of humanity for more than a century, how she has eaten away at the harvests and hopes of the peasant, how she has devoured the people and caused the greatest devastation in France.[20]

Although they were created independently of one another, this conceptually oriented text and the above-mentioned caricature converge to a remarkable degree. Taken together, they represent a crystallisation in demonised form of popular criticisms of state and social con-

FIGURE 7 The two-faced aristocrat – how he curses the Revolution and how he believes in the Counterrevolution. Anonymous, coloured etching, 1790–92, Bibliothèque Nationale Paris

ditions during the *ancien régime*. The fancifully exaggerated imagery lends substance to the critique while holding up the counter-image of the 'moral economy' of the common people. The loathsome portrayal of the clergy, the nobility and the representatives of the absolutist tax and judicial administration refers not only to the fact that they exploited the helpless citizenry but also – and particularly – to the ruthlessness and insatiability with which they did so; qualities that exposed the hypocrisy of the supposed ethics of their class (celibacy, honour and justice). These accusations are poignantly summarised in the nightmarish image of the multi-headed vampire gorging itself on the blood of the people – a literal interpretation of the expression 'les sangues du peuple' in current use from the time of the peasant revolts in the 17th century.[21]

Thus far, the different pictorial traditions described above seem to correspond closely to the modern practice of historical semantics, the primary objective of which is to study the structure and evolution of individual concepts.[22] Although the semantic fields[23] of concepts such as 'aristocratie' have occasionally been reconstructed,[24] no attempt has been made to seek out potential semantic dimensions beyond those in the immediate context. The impression one gets from reading important texts is that, like mushrooms, key concepts[25] tend to be found in clusters rather than alone. Is this impression misleading or does it suggest the existence of whole sign systems hidden within the context?

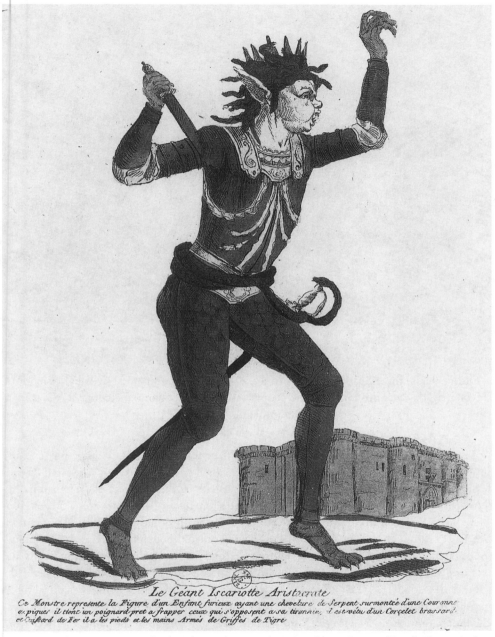

Le Géant Iscariotte Aristocrate

Ce Monstre represente la Figure d'un Enfant furieux ayant une chevelure de Serpent surmontée d'une Couronne
et piques il tient un poignard pret a frapper ceux qui s'opposent a sa tirannie, il est vetu d'un Corcelet brassard
et Gustard de Fer il a les pieds et les mains Armés de Griffes de Tigre

FIGURE 8 The *Aristocrat* as fanatical murderer and new Judas in front of his 'hide-out', the
Bastille. Anonymous, coloured etching, 1790–91, 29,1 x 20,5 cm, Bibliothèque Nationale
Paris

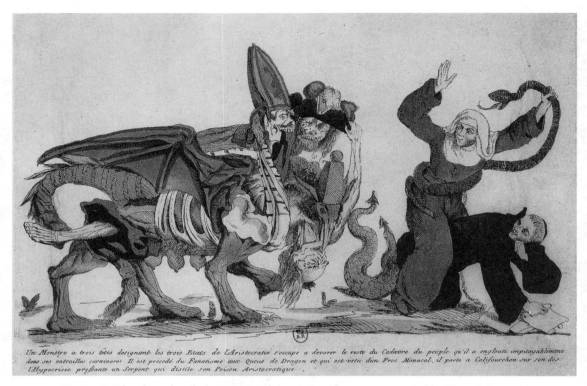

Un Monstre a trois têtes designant les trois Etats de l'Aristocratie s'occupe a devorer le reste du Cadavre du peuple qu'il a englouti impitoyablement dans ses entrailles carnivores. Il est precedé du Fanatisme aux Queus de Dragon et qui est vettu d'un Froc Monacal, il porte a Califourchon sur son dos l'Hypocrisie pressante un Serpent qui distile son Poison Aristocratique.

FIGURE 9 The three-headed monster of the *Aristocracy*, accompanied by Fanaticism and Hypocrisy, devours the corpse of the people. Anonymous, coloured etching, 1789, 22,7 x 35 cm, Bibliothèque Nationale Paris

Just as in the case of individual concepts and their semantic fields, iconography can also provide an answer to this question. A document which has been virtually neglected by professional historians (FIG. 10) offers particular insight in this connection. The source referred to is a printed parlour game which 'narrates' the history of France from the religious wars of the 16th century to the promulgation of the revolutionary constitution in September 1791. Although previously regarded as having only ethnographic interest,[26] this anonymous etching can shed considerable light on the problem at hand, as, by fusing words and pictures, it actually represents a kind of 'history of concepts'. As simplified versions of the game demonstrate (FIG. 11), it is based on a chain of key words representing the crucial forces in French history, the order and significance of which correspond surprisingly closely to the chain of definitions in a civic catechism.[27] In the enlarged version of the game, each key word additionally functions as the title of an appropriate picture. In this way, the latter document offers the historian an authentic system of signs that is firmly rooted in the social and cultural context of 18th century France. The historian does not have to reconstruct the system himself; to understand it he has only to 'read' it correctly. Nevertheless, before we do this – i.e. actually start playing the game – we need to ask and answer a few preliminary questions.[28]

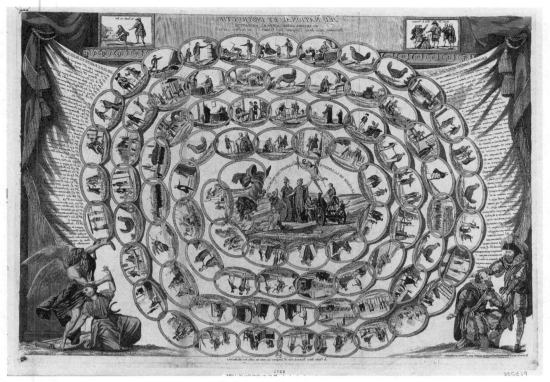

FIGURE 10 'Instructive national game, or the exemplary and entertaining instructions of Henry IV and Père Gérard for honest and decent citizens'. Anonymous, coloured etching, published by André Basset, 1791, 50,7 x 73,7 cm, Bibliothèque Nationale Paris

The Document and Its Background

The first question is whether this game might just be an isolated and unrepresentative case, and therefore of no value to the social historian. The game at hand is part of an old tradition of *jeux de l'oie* ('goose games'), which are spirally ordered, word-and-picture board games with geese drawn on some fields. Such games, which had existed since the Renaissance,[29] were in France particularly associated with the Jesuits, who used them for didactic purposes.[30] Originally dealing only with biblical and ethical themes, from the middle of the 17th century they began increasingly to concern secular ones, as well: literature, geography, French history and the topics of the day. Above all in the 18th and 19th centuries, such games proved an inexpensive way of combining learning with pleasure. They were popular with both the upper and middle classes, with children and adults. Even though they were a consumer item exposed to considerable wear and tear, more than 120 games produced between 1650 and 1820 have survived in the form of single printed sheets (FIG. 12). The production of such games doubled in the second half of the 18th century, and reached an all-time peak under the First Empire.

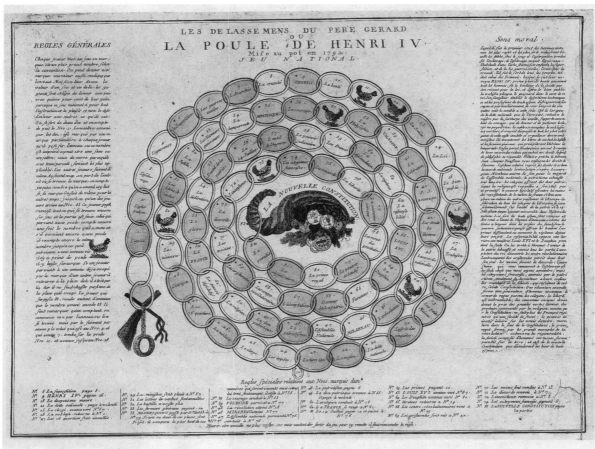

FIGURE 11 'Diverting National Game of Père Gérard, or In the Year 1792 the Chicken is put in the Pot'. Anonymous, coloured etching, 1791, 37,6 x 51 cm, Bibliothèque Nationale Paris

Thus, our revolutionary game is one of a series of products with a similar structure and function. Where it stands out is in its high degree of politicization and in the unusual symbolic power of its imagery. Before the Revolution, games dealing with French history did not go beyond the reproduction of stereotyped portraits of kings and the obligatory listing of their heroic exploits and military victories (FIG. 13). Our game, in contrast, concentrates on the political and social key-concepts and their pictorial-allegorical representation. These characteristics are shared with Revolutionary political prints in general.

Illustrated prints of this type were usually published in editions of about 1000–2000 copies. In Paris, they were displayed and sold in the streets, on the banks of the Seine and at the Palais-Royal. They were aimed particularly at the generally illiterate lower classes. Peddlers purchased them in bundles of 20 at a cost of five or six *livres*;[31] individual sheets were then sold at five *sous* a piece; a price within the means of the average Parisian artisan. Their

FIGURE 12 Long-term trends in the publication of French *jeux de l'oie* 1650–1829

purpose was to inform the masses and win them over to the Revolution. In this respect they can be seen as a central element of revolutionary culture and political communication.[32]

As with numerous other Revolutionary prints, the fact that the game was used as a model for various reproductions suggests that it enjoyed a high degree of public interest. In the cases of two other historical games (FIG. 14), both shorter and far less concerned with political concepts, only one version is known.[33] Our game, on the other hand, was sold in at least five simplified versions at reduced prices.[34] In these editions, not all of the coloured illustrations were reproduced, but the complete semantic structure of the original was preserved (see FIG. 11 above). If the number of such versions is a marker of success, then our game was the most successful of the ten Revolution-era *jeux de l'oie* of which copies have survived.

The game was published by none other than Paul-André Basset whose shop in the rue Saint-Jacques was the leading source of popular revolutionary prints in general and of *jeux de l'oie* in particular. He and his successor produced about twenty such games between 1780 and 1860.[35] Basset skilfully adapted his wares to suit public tastes and political trends – a talent which made him a rich man. This fact did not go unnoticed by his contemporaries: twisting the meaning of a contemporary anticlerical caricature (FIG. 15), an almanac mockingly observed that the Revolution had not made Basset lean like the dispossessed priest, but rather had made him fat like an *abbé* of the *ancien régime*.[36] However, Basset himself was capable of self-irony, and in a print he produced in 1790 (FIG. 16), showing his

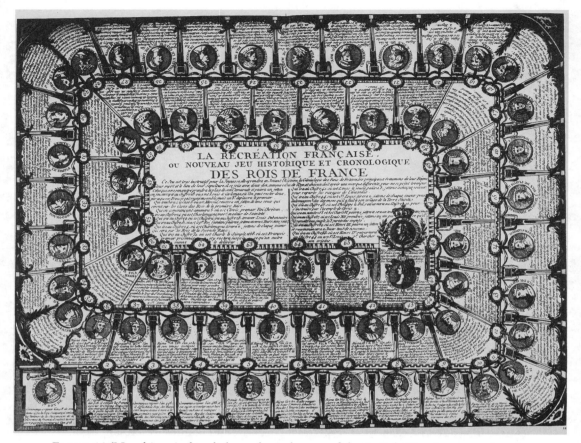

FIGURE 13 'New historical and chronological game of the French Kings', copperplate, by Louis Crêpy, 1745, Neudr. 1775, 43,5 x 55 cm

shop with its window display, one can observe the two main ways in which his prints were sold: while the lady behind the counter is waiting for customers, a *colporteur*, or salesman, is leaving the shop, heavily laden with prints to peddle in the streets.

To understand what made this game so popular, we should bear in mind that our game belongs not only to the genre of the *jeux de l'oie*, but also to that of the large-sized, pictorial broadsheet – coloured 'posters' which reproduced in simplified form varying combinations of the most popular caricatures of the day (FIG. 17), thus creating a kind of cheap miniature gallery of Revolutionary graphics. Furthermore, the game's stage-like setting makes use of two popular elements of French political culture. First, it is strongly influenced by the cult surrounding Henry IV, the 'good king' *par excellence*,[37] whose glory had been sung in Voltaire's highly successful epic poem *La Henriade* who was portrayed in numerous plays as a national hero and father-figure,[38] and whose anecdotes and 'golden words' continued to circulate in many regularly reprinted anthologies right up through the first years of the Revolution.[39] Two of the scenes depicted on the border of our game, along with their cap-

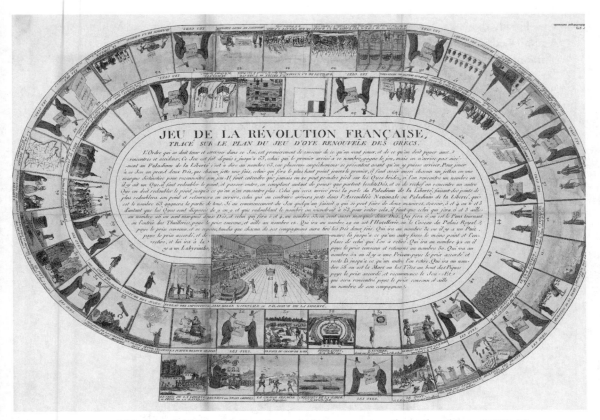

FIGURE 14 'Game of the French Revolution'. Anonymous, coloured etching, 1790, 35 x 50,5 cm, Bibliothèque Nationale Paris

tions, are taken directly from such anthologies: in the lower left-hand section, Henry is reconciled with his minister, Sully.[40] In the upper right-hand corner, he utters his famous promise to provide all his subjects with a 'chicken in the pot' every Sunday.[41] Another image towards the upper left shows the affable king returning from the hunt and stopping incognito at a peasant's hut – a scene taken from a play staged in Paris in 1791.[42] Henry appears once more in field 76 of the game and is generally portrayed as the leading figure of an important epoch in French history.

Like Henry IV, the second French cultural figure whose popularity the game put to use is also referred to in the subtitle of the original version: 'Père Gérard'. Three other versions even carry the name of the celebrated Breton in the main title (see FIG. 11, *Les Délassemens du Père Gérard*, above). Michel Gérard was the only peasant deputy in the National Assembly[43] and his pithy remarks in Parliament earned him such fame and popularity that he became a favourite subject of comtemporary prints (FIG. 18). The most widely read almanac of the Revolution, the *Almanach du Père Gérard* by Collot d'Herbois,[44] turned Gérard into a sort of father-figure whose task was to explain the Revolution, and especially the new constitution, to the peasantry of the provinces. Our game had the same function.

Finally there is the question of the the game's immediate historical context. When it was published in either October or November 1791, its purpose was to commemorate the extraordinary fact that, after two years of hard parliamentary work, the first written constitution of France had not only been completed but had also been accepted by Louis XVI. Like the political catechisms,[45] popular prints (FIG. 19) and songbooks[46] published at the same time, it was intended to popularise the Constitution, to contribute to the political education of the people and to propagate the Constitution as a quasi-religious symbol of national consensus and pride. After all, celebrating the new constitution meant finding a political consensus: at the time of its promulgation, the radicalisation of the Parisian *sans-culottes* was just beginning, the Jacobin club had split up and the republican movement had been

FIGURE 15 'The priests of yesterday and today'. Anonymous, coloured etching, 1789–90, 22,5 x 18 cm, Bibliothèque Nationale Paris

FIGURE 16 André Basset's shop for popular prints in Paris, corner of the rue Saint-Jacques and the rue des Mathurins. Anonymous, coloured etching, published by Basset, 1791, 18,5 x 24,8 cm, Bibliothèque Nationale Paris

stopped, if only temporarily, by the 'Massacre of the Champ de Mars' on 17 July 1791. By its moderate focus on the Constitution as a symbol of common consent, our game had the aim of bridging the gap between radical adherents and opponents of the Revolution, between monarchists and republicans.

A 'History of Concepts' of Social and Political Progress

Let us now put theory into practice, by playing a first round of the game. We shall start by moving along the fields in their given order. The 83 miniatures – 83 was also the number of French *départements* at that time – and their captions are ordered in a linear fashion that describes the course of French history. The structure of the whole is well considered and skilfully wrought. From the opening field it is clear that the past is to be seen through the lens of the Enlightenment and the Revolution: the beginning of history is portrayed as a mythical, uncorrupted state of nature in which all men were created equal, an image that recalls the opening line of Rousseau's *Contrat social* (1764): '*L'homme est né libre, et partout il est dans les fers.*'[47] Indeed, the image of chains being broken by the allegory of Time is repeated on the border of the game. A rather radical cure for the ills of the time is depicted in a revolutionary caricature from 1789 (FIG. 20), in which the old inequalities of the Estates of the Realm are levelled with the help of a scale-beam: while the oppressed are finally af-

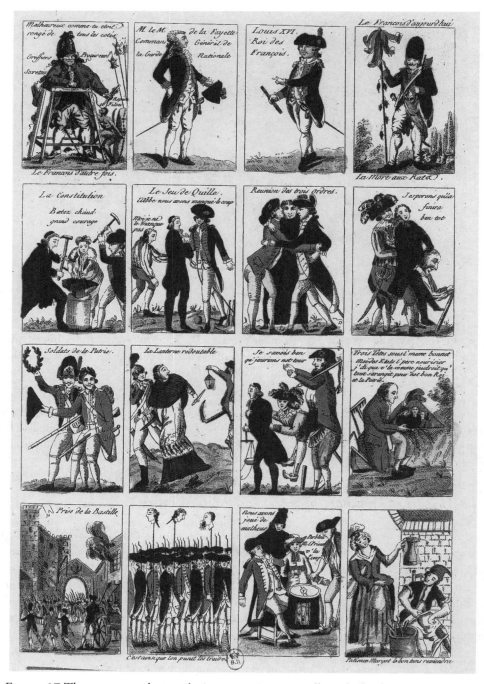

FIGURE 17 The most popular revolutionary caricatures collected together on a pictorial broadsheet. Anonymous, coloured etching, 1789–90, 81 x 72 cm, Bibliothèque Nationale Paris

RONDE.

Air : *Adieu donc, dame Françoise.*

CHANSON.

Air : *Aussitôt que la lumière vient redorer nos côteaux.*

PORTRAIT DU PÈRE GERARD,

Bas-Breton, Député à l'Assemblée Nationale en 1789.

AVIS A TOUS LES BONS CITOYENS.

A ORLÉANS, chez LETOURMY, place du Martroi.

FIGURE 18 'Portrait of Père Gérard from Lower Brittany, Deputy of the National Assembly of 1789'. Coloured woodcut with transfer printing, published by Letourmy in Orléans, 1790

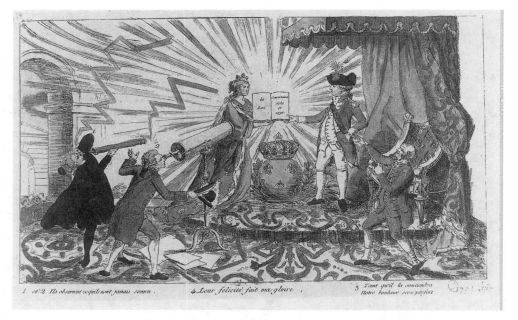

FIGURE 19 To the applause of the Third Estate, but mistrustfully observed by the clergy and nobility, Louis XVI accepts the *Constitution* from Francia. Anonymous, coloured etching, 1790–91, 20,3 x 34, 3 cm, Bibliothèque Nationale Paris

forded the liberty to grow back to their natural size, the noble and the prelate, having become too tall and fat with the privileges they enjoyed during the *ancien régime,* are cut down to size with a saw. Thus, as the caricature suggests, the state of Égalité is re-established by the Revolution.

This imagined Golden Age of French history is destroyed by *Usurpation, Esclavage, Ignorance, Guerres civiles* and *Anarchie.* Thus, fields 2–8 mark the transition to the dark Middle Ages and the Wars of Religion, while underlining the negative influence of the nobility and the clergy.

In fields 9–16, Henry IV appears as a kind of saviour. His *Bonté* leads to a period of just and solicitous rule in which the welfare of all is the guiding principle. Some of the miniatures illustrate scenes from the popular myth of the *bon roi.* It is no accident that the geese commonly used in such games are here replaced by chickens, for they recall the king's proverbial promise while symbolically redeeming it: a player who lands upon a field occupied by a chicken is allowed to double the number of steps indicated on the dice and can thereby progress more quickly towards his goal.

In 1610, Henry is traitorously murdered by Ravaillac. Consequently fields 17–33 form a long period of *Despotisme* and *Misère,* of arbitrary rule by ministers during which the Tiers État is exploited by the *Clergé,* the *Noblesse* and the *Fermiers généraux.* The illustrations accompanying these catchwords deprecatingly refer to concrete historical events and

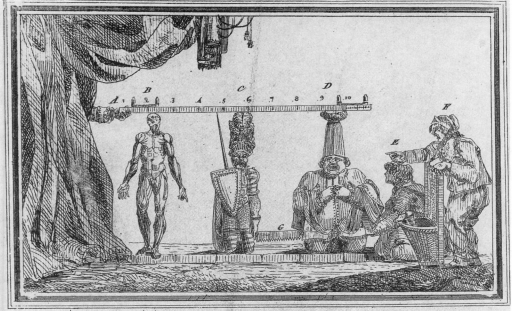

la Nouvelle Taille

A. Monsieur Necker derrière le rideau tient un Niveau sous lequel il fait passer les trois ordres. B. le Tier états représentés par un Écorché à la hauteur du quel ce Ministre force la Noblesse C et le Clergé D. a se ranger malgré le chagrin que causent cette nouvelle imposition E.F. sont des membres du peuple dont l'un armé d'une scie G. coupe l'excédant, et l'autre en a joyeusement le produit.

FIGURE 20 Society is measured anew. Anonymous, etching with contemporary inscription, 1789, 14,6 x 19 cm, Bibliothèque Nationale Paris

institutions associated with the *ancien régime,* including Louis XIV's wars of conquest (20), the imprisonments in the Bastille (30 and 31) and the John Law scandal of 1720 (33).

However, a new era is about to emerge – an event symbolised by its spiritual precursors and representatives, Montesquieu, Voltaire,[48] and Rousseau, the enlightened theorists of *Philosophie* and *Tolérance.* It is interesting to note that the history of France from the Enlightenment to the Revolution is conceptualised in the game as a unbroken continuum: in field number 41, a deputy of the National Assembly, resembling Mirabeau, carries the Mosaic tables of the Rights of Man of August 1789, which here appear as the direct realisation of Rousseau's *Contrat social.*

The subsequent pictorial and conceptual history of the Revolution concentrates on its parliamentary, constitutional and military dimensions, carefully avoiding all reference to the '*journées révolutionnaires*'. The only exception to this is the (delayed) representation of the storming of the Bastille (54). At this point, the game's central themes are the principle of the separation of political powers, the symbolic acts of patriotic harmony and the will-

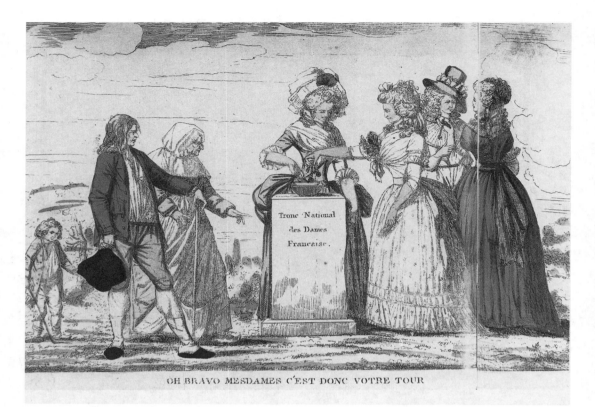

OH BRAVO MESDAMES C'EST DONC VOTRE TOUR

FIGURE 21 On 17 September 1789 the wives of Parisian artists sacrifice their jewellery on the Altar of the Fatherland in the National Assembly. Anonymous, coloured etching, 1789, 22,5 x 33,9 cm, Bibliothèque Nationale Paris

ingness to make sacrifices – witness the references to the festivities accompanying the 'pantheonisation' of Mirabeau (45); the first festival of the Federation (52); sacrifices at the altar of the fatherland (47 and 72), which refer to larger prints (FIG. 21); and the personification of Francia, clad in royal robes, carrying the Tablets of the Laws (49, 50 and 60).

However, the Revolution cannot proceed smoothly; the path to the Constitution is full of stumbling-blocks. Three forces are primarily blamed for these obstacles: the clergy, who object to the nationalisation of their property as well as to the oath of the Civil Constitution (58 and 68); the Aristocrates, who want their titles and privileges restored (67); and the king's brothers,[49] who refuse to recognise the Constitution (57). These three groups form the *Contre-révolutionnaires* (66), who emigrate to Coblence in order to set up an army for an invasion of France – yet another concrete reference to a contemporary print (FIG. 22). Louis XVI's secret alliance with the enemies of the Revolution is revealed in his unsuccessful attempt to escape from France on 20 June 1791 (63). Against this background, the king's acceptance of the Constitution three months later is looked upon as a victory for the Revolution (65).

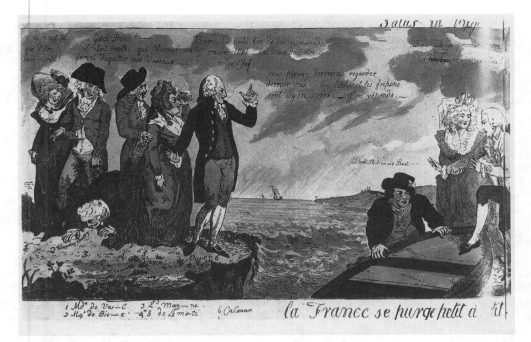

FIGURE 22 The flight of French emigrés across the Rhine. Anonymous, coloured etching, 'Pub^d. July 29 by S. Forges 83 Picadilly', 1791, 19,8 x 69,3 cm, detail, Bibliothèque Nationale Paris

Some other historical games on the Revolution also end with this event (see for example FIG. 14 above). In this one, however, it is followed by 18 more fields which serve to open up a perspective on the future. The message of this final part of the game is that the ideals of the Constitution cannot be realised until a number of pre-conditions have been met: re-actionary political forces must be crushed, a goal that can only be accomplished when *Inconstance* and *Discorde* are replaced by *Concorde* and *Amour du prochain* and when the Dauphin has become a true servant of the nation (67–78). This constitutional future (80) is portrayed as the Elysian Fields, where, according to the accompanying miniature as well as the print on which it was modelled (FIG. 23), Jean-Jacques Rousseau already resides.[50] This vision of paradisical France also leans on an allegory of freedom drawn by Moreau le Jeune for Rabaut Saint-Etienne's Almanac of the Revolution (FIG. 24).

The preceding explanation for the linear course which French history is made to pursue in the game has more claim to authenticity than may seem justified at first glance. It is not only determined by the hard historical facts to which a series of miniatures very obviously allude; it is also confirmed by a self-interpretation, written in both French and German, on a simplified copy of the game (see FIG. 11 above). The following is a translation of the German text:

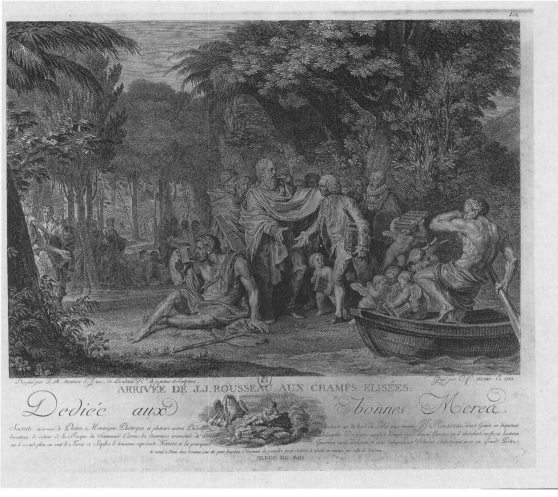

FIGURE 23 The classical philosophers and Diogenes greet Jean-Jacques Rousseau on his arrival in the Elysian Fields. Copperplate by C. F. Macret after Jean- Michel Moreau le Jeune, 1782, Bibliothèque Nationale Paris

THE MORAL

Equality was the natural state of man. But the stronger and more cunning soon brought the weaker under their yoke, and Usurpation brought forth Slavery; this begat Stupidity; the habit of Cowardly Submissiveness spawned Superstition, hence the Civil wars, Anarchy, [and] Cruelty. This was the fate of all nations, as 'twas the lot of the West Franks when Heaven sent them Henry IV. A most benevolent sovereign, he showed a great love for all mankind and this, together with his respect for the Law and his concern for the Welfare of all, led to a contented Society. Treachery plunged its dagger

Pl. I. Page 1.

Il vient après mille ans,
Changer nos loix grossieres.

Voltaire

I. M. Moreau le jeune, Del. J. B. Simonet Sculp. 1791

FIGURE 24 Francia welcomes Liberty as the new ruler of France. Etching by Jean-Baptiste Simonet after Jean-Michel Moreau le Jeune, 1791, 5,2 x 9,1 cm

into the heart of this noble prince. His successor introduced despotism (arbitrary power). Excesses and extravagances of all kinds were the hallmarks of his government and court. A despot's obsession with Conquest brought this folly to a peak. Here lies the source of the National debt which the Third Estate, impoverished by the great burden of Taxation, bore with steadfastness and equanimity. The Clergy paid nothing, the Nobility just as little. Those who could claim an Ancient lineage believed that they should be free from all toil and care. By way of Intrigue this haughty and useless lineage rose to Ministerial positions. They created the Lettre de cachet, the Bastille and the General tax farmers, who plunged the state into Bankruptcy. It was finally Montesquieu

HISTORICAL EPOCHS		THE GAME'S FIELDS. CONCEPTS
Natural state		*Égalité*
Wars of Religion 1559-1589		*Usurpation · Esclavage · Ignorance · Séduction · Guerres civiles · Anarchie · Cruauté*
1589-1610		*Henri IV · Bonté · Société · Loi · Bien Public*
Abso-lutism **1610 to 1748**	Principles	*Trahison · Despotisme · Esprit de Conquête · Intrigue*
	Guilty Parties	*Clergé · Noblesse · Ministres · Fermiers généraux*
	Means	*Petites Maisons · Impôts · Lettre de cachet · Bastille*
	Results Victims	*Dette Nationale · Misère · Tiers État · Banqueroute*
Enlightenment 1748 - 1789		*Montesquieu · Courage · Voltaire · Philosophie · Tolérance · Rousseau · Droits de l'homme*
Revo-lution **1789 to 1791**	Events Persons	*14 Juillet · Fédération · Acceptation Mirabeau · Louis XVI · Dauphin*
	Principles Virtues	*Révolution · Don patriotique · Religion · France · Gloire · Vigilance*
	Symbolism	*Autel de la patrie · Cocarde nationale · Autel de l'hymen · Citoyennes françaises*
	Insti-tutions	*Assemblée nationale · Pouvoir législatif · Pouvoir judiciaire · Responsabilité · Force armée · Nouvelle Constitution*
	Opposing forces	*Princes · Dissimulation · Varennes · Contre-révolutionnaires · Aristocrates · Moines · Discorde · Inconstance*

FIGURE 25 Chronological table portraying Basset's *Jeu national*, original headings for the game fields are in italics

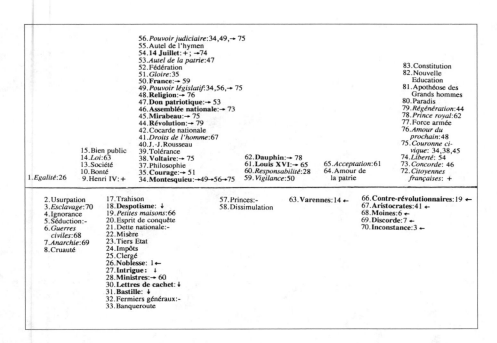

Figure 26 Schematic presentation of Basset's *Jeu national*: the valences of the game fields in their given order and with their cross-references

LEGEND (EXPLANATION OF LETTER TYPES AND SIGNS)

normal	=	field without special instructions
italic	=	field that a compulsory move leads to
bold	=	field from which a compulsory move starts
Æ	=	compulsory move ahead to numbered field
··	=	compulsory move back to numbered field
Ø	=	compulsory move back to start of game
+	=	The player receives payment
-	=	The player has to pay into kitty (cash-desk)

who had the Courage to pull at the curtain concealing our rights; the spirit of Philosophy spread over the land. Voltaire preached Tolerance, J.J. Rousseau taught us the Rights of man. The enlightened vassal recovered his rights and assumed the National cockade. The Revolution hath begun. The courageous Mirabeau rouses the majority of the National Assembly with his eloquence, the flame of patriotism warms the entire realm, the citizens offer up Patriotic gifts; Religion is returned to its original, uncorrupted state; Legislative power rests in the hands of the representatives of the nation. France rises courageously to take its place among the other European powers. The Federation of citizens of the realm is solemnly sworn in on the Altar of the fatherland.

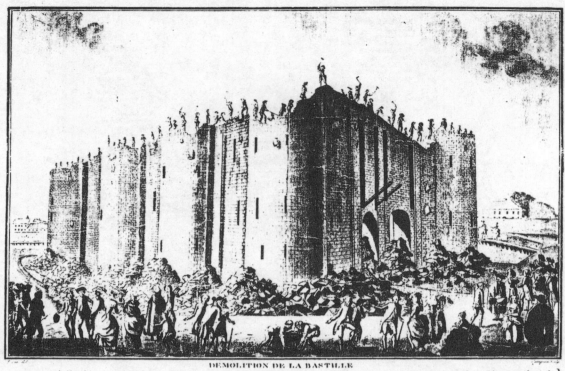

DEMOLITION DE LA BASTILLE

FIGURE 27 'Demolition of the Bastille'. Coloured aquatint by the brothers Le Campion and Joseph Alexandre fils after Tétar, published by André Basset, 1789, 19,7 x 28,5 cm, Bibliothèque Nationale Paris

The 14th of July is a date that will never be forgotten in the history of nations. All manner of chains are broken asunder and innocent victims who were destined to languish in the prisons of fanaticism are brought back to the Marriage altar. Judicial power, now organised, instils fear in the hearts of all traitors. The Princes either dissemble or utter threats. Vigilance thwarts their plots. Accountability holds the Ministers within bounds. Louis XVI and the Dauphin flee. They are seized in Varennes. Love of the fatherland reconciles all parties. The King's Acceptance frustrates the Counter-revolutionaries' plans. The rashness of the aristocrats is brought to light. Monks sow the seeds of Discord; Fickleness, which could return us to vassalage, is all we need fear. Yet the Citoyennes of France, filled with the spirit of Patriotism, will soon teach their children of the advantages, of the blissful happiness which flows forth from our Constitution. The New pedagogy will shape the man of tomorrow. Harmony will hold sway over all citizens; liberty will know no bounds; the Laurel wreath will be the reward for great virtue; Fraternal love, which is demanded by religion as well as by the Constitu-

Mr. Masers de Latude.

Vestier Pinx.t Canu Sculp.

Victime d'un pouvoir injuste et criminel,
Latude dans les Cachots eut terminé sa vie,
Si l'art du despotisme aussi fin que cruel,
Avoit pu dans ses fers enchainer son génie.

FIGURE 28 Latude, martyr for Liberty and former prisoner of the Bastille, also the popular hero of a spectacular escape from the state prison with the help of a self-made rope ladder, signifies the storming of the Bastille in a move against despotic repression. Etching and stipple by Jean-Dominique-Etienne Canu after Antoine Vestier, 1790, 13,8 x 10 cm

FIGURE 29 *Convulsionnaires* arrested at the cemetery of the Parisian municipality of Saint-Médard on the strength of *lettres de cachet* are incarcerated in the Bastille. Anonymous, etching, 1731, detail

SCENE DANS L'INTERIEUR DE LA BASTILLE
Pendant la Journée du 14 Juillet 1789

FIGURE 30 Imaginary liberation of an aged martyr of the Bastille from the legendary torture chambers of the state prison by the stormers of the Bastille on 14 July 1789. Etching and stipple by I. Hardener after Klooger, 1789, 51 x 63,2 cm, Bibliothèque Nationale Paris

tion, will turn the reborn Franks into a brotherhood; the executive power, enlightened as to its real duties, will follow the path of the Constitution; the Prince royal, shaped by the Revolution's great example, will complete the Rebirth of the nation; a society made up of virtuous people will be a Paradise on earth; this, and all possible welfare, arise from the New Constitution.

One may conclude from what has been said thus far that the fields of the game were arranged in a well-reasoned, consistent way. This becomes still more apparent if we examine the key concepts which caption the pictures, forming a chronological diagram of French history (FIG. 25). In this diagram the negative periods and their dominant forces have been

given a dark background, while the positive periods have been left white; this indicates a progression from *ténèbres* to *lumières*, from the 'dark Middle Ages' to the Enlightenment of the 18th century and to *Liberté*: an act of redemption brought about by man himself. Here was a popular, open-ended history of secular progress, produced two years before the famous *Esquisse* of Condorcet, which is regarded as the first modern conceptualisation of historical progress.

A Dichotomous Semantic Structure Intensified by Pictures

As we have seen, the chronological order of the fields of our game makes numerous semantic relationships apparent. The *Lettres de cachet*, for example, are attributed to the *Ministres* (28 and 30) and Mirabeau is presented as the leading protagonist of the Revolution (45 and 46). But the game is much more complex than this. On both sides of the board we find rules describing compulsory moves that require the player to skip a certain number of places, i.e. to leave the given order of the fields and to connect with more distant fields and their concepts. If we want to comprehend the importance of these instructions, we have to play a second round. This time our purpose is not simply to advance across the fields in their given order but rather to take the various cross-references into account.

The game's special instructions are, of course, typical of the genre of the *jeux de l'oie*: various obstacles, as well as moves which serve to accelerate the game, were built in so as to increase both the suspense and the number of possible moves. Thus, for technical reasons, there are both favourable and unfavourable fields of special importance. This structure was very skilfully used by the authors of our game to promote the dichotomous value system of the Revolution. This becomes more apparent if we turn the spiral order of the fields into a linear one and divide the fields into two groups (FIG. 26): those referring to positive forces and those referring to negative ones. The fields which are subject to special rules have been marked by bold letters. All fields retain their original numbers. The numbers after the titles of the fields indicate those from which the players have come or to which they must go; pluses and minuses indicate that the players are either to collect money from the cash desk or to pay some in.

The additional connections which the special rules provide between the key concepts of different fields are all significant. Let us take a closer look at some of these semantic relations. A player who reaches the fields *Lettre de cachet* or *Bastille*, for example, has to go back to the start (30 and 31). If he reaches Varennes (63) he is called back to the Law (14), where he learns that Louis' attempt to flee was utterly illegal. If he happens to get to Séduction or the National Debt (5, 21), he has to pay a fine. If, on the other hand, he is lucky enough to reach the field Voltaire, he is decorated with a Laurel wreath (38 and 75). On the field Montesquieu, he is even allowed to make three consecutive moves: first to the legislative power, then to the judiciary and finally to the executive – a whirlwind ride through the basics of constitutional law (34, 49, 56, 75). *Révolution*, for its part, clears the path to *Régénération* (44 and 79).

Although the above observations confirm the game's generally moderate character, it is not without some radical views. These are directed especially against the clergy and the no-

bility. The monks are held responsible for the Civil Wars (68 and 6) and the Aristocrats are warned to remember that they have renounced their privileges in the name of the *Droits de l'homme* (67 and 41). Dyed-in-the-wool *Contre-révolutionnaires* are relegated to a mad-house (66 and 19). This rapid alteration of positive and negative fields produces the impression of a world sharply divided into the forces of good and evil. This cannot fail to have a strong suggestive influence on the players: a player who has been thrown back to the starting-point for the third time after landing on the field *Despotisme* (18) will have learnt for good that he can only win if he sticks to the positive values: the forces and proponents of the Enlightenment and the Revolution.

Semantically these reticular connections are determined by the principal meaning of the respective words, which is to say that they are language oriented. By combining concepts with complementary or opposite pairs of words, their meaning is intensified and their position in a whole system of values is marked.

There are also semantic connections of another kind, however. These are not verbal but visual, and arise from the symbolic language of the pictures. The pictures not only illustrate individual key words (i.e. visually represent them) but also connect them to each other on the basis of common iconographic and thematic elements. Their function is to expand upon the meaning of the most essential key words through the use of pictorial allusions. Though self-evident to the contemporary observer, these allusions must be reconstructed by the modern student. In spite of their having no concrete effect on the course of the game itself, the suggestive influence of these implicit connections should not be over-looked.

Let us consider the three richest semantic fields constructed by this semantic iconography. Firstly, France. One would assume that in a document commemorating the constitution of a monarchy, the king would be given pride of place; quite the opposite is true in our game, however. Indeed, Louis XVI is twice humbled – through his unfavourable comparison with the idealised Henry IV[51] and again in connection with his arrest at Varennes – while *Francia*, liberated from her chains at the beginning of the game, figures as the actual sovereign. She, not the National Assembly, embodies Legislative Power (49). She, not the monarch, wears the crown and keeps watch over the officials of the state (60). She and she alone represents the welfare of the realm (50). Welcoming Liberty, *Francia* dominates the central picture and presides over the game's final station.

Let us now consider the semantic field of the Bastille[52]. It is true that there is only one field with that title (31), the image accompanying it is a reproduction of an illustration that appeared on several revolutionary handbills (FIG. 27) showing the triumphal demolition of the state prison. The neighbouring fields suggest that the Bastille was a product of the practice of the *Lettres de cachet* and an instrument of terror used by the General tax farmers (30 and 32). To contemporary observers, however, the symbolic presence of the Bastille would have been clearly recognisable in the miniatures of other fields as well: firstly in the figure of the self-proclaimed martyr of the Bastille, Latude,[53] who is depicted with the rope ladder he used when trying to escape from the prison (3 and FIG. 28); secondly as a state prison where innocent victims of despotism, like the 'convulsionnaires'[54] in 1730 (FIG. 29), are about to be incarcerated (18); thirdly as a locality where the first *journée* of the Revolution

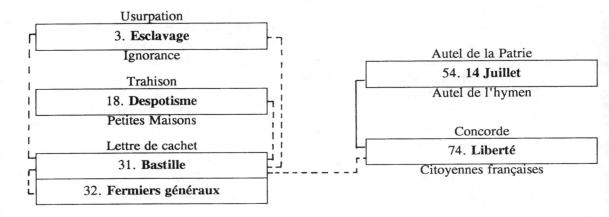

FIGURE 31 Semantic interrelationships of the key word *Bastille* in Basset's *Jeu national*

took place (54); and finally as a dungeon where a very old man resembling the fictitious 'Comte de Lorges'[55] is being liberated by the victorious revolutionaries (74 and FIG. 30). Thus, these visual representations link the word Bastille to the concepts of *Esclavage*, *Despotisme, Fermiers Généraux*, 14 *Juillet* 1789, and *Liberté*, thereby underlining its bipolar meaning for the Revolution.[56] If we now translate these findings into a diagram (FIG. 31). It becomes clear that it is not the explicit rules of the game (marked by unbroken lines) but rather its implicit visual connections (indicated by broken lines), that enable the Bastille to function as a directing concept – one that determines the meaning of the semantic system of the *jeu national*.

The most crucial semantic pivot, however, and the one distinguished by the most varied and numerous connections, is derived from the related concepts of the Law and the Rights of Man. These concepts serve not only explicitly to reprove the king for his flight to Varennes (14, 63) and the aristocrats for their counter-revolutionary plots (41, 67) but, linked together by the common symbol of the Tablets of the Law,[57] they also influence the visual representation of Intrigue (27), Regeneration (79) and the New Education (82). Thus, once again, we have a semantic field (FIG. 32) with a bipolar structure that typifies the self-perception the early Revolution, as well as its belief in having effected a major caesura. It shows the ideological mechanisms used by the protagonists of the Revolution to justify themselves and their work.

It is very significant that the three concepts of France, the Bastille and the Rights of Man are at the centre of our document in view of the integral role they have played in the political culture and national identity of modern France: the figure of Francia, as the vanguard and embodiment of the Republic;[58] the Bastille, as an almost mythological symbol of the defeat of 'despotic absolutism'[59] and the victory of Liberty on the *Quatorze Juillet*; and the Rights of Man, as the value that was recognised as enjoying the broadest base of consent during the bicentenary celebrations.[60]

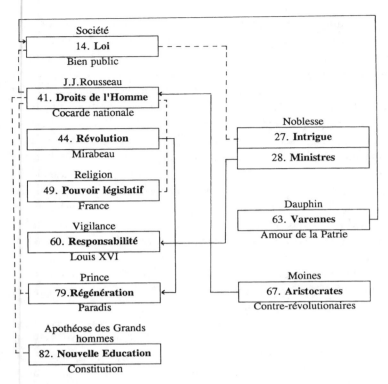

Société
14. **Loi**
Bien public

J.J.Rousseau
41. **Droits de l'Homme**
Cocarde nationale

44. **Révolution**
Mirabeau

Religion
49. **Pouvoir législatif**
France

Vigilance
60. **Responsabilité**
Louis XVI

Prince
79.**Régénération**
Paradis

Apothéose des Grands
hommes
82. **Nouvelle Education**
Constitution

Noblesse
27. **Intrigue**
28. **Ministres**

Dauphin
63. **Varennes**
Amour de la Patrie

Moines
67. **Aristocrates**
Contre-révolutionaires

FIGURE 32 Semantic interrelationships of the key word *Droits de l'Homme* in Basset's *Jeu national*

Conclusion

If one views this game of the Revolution from the perspective of the 'iconographic ancien régime', it may to a certain extent be considered as the fusion of the three pictorial traditions that were briefly discussed at the beginning of this analysis. Its sign language is drawn mainly from the rich reservoir of contemporary political caricature. These caricatures are either combined with emblematic figures (e.g. the allegories of *Anarchie* and *Gloire*, fields 7 and 5), didactic-theological elements (e.g. the Tablets of the Law, fields 79 and 82) or representations of clerical instructions whose meanings have been reversed in the spirit of the Revolution (4, 68).[61] The allegorical intensity of the pictorial language thus achieved, with its emblems and magical symbols, is characteristic of the graphic arts of the French Revolution as a whole.[62] In this way, the individual fields substantiate and broadly elucidate at least four points that are of basic importance for the history of concepts.

[1] Because the history of concepts, as it has thus far been generally practised, concentrates primarily on texts (usually by 'famous authors') rather than pictorial sources, a considerable portion of the potential research material has been neglected. This is regrettable, since such material would seem to be of some considerable importance for the study of socio-cultural

history. Indeed, in the few semi-literate societies of pre-industrial Europe, public communication and collective symbols united in a kind of multimedia process in which texts, pictures and songs frequently worked together. As was shown earlier with the concept of *Aristocratie*, as well as with the symbolic figures of Henry IV and Père Gérard, the texts and the pictures accompanying them did not operate as isolated, disconnected entities, nor did they function on completely different or sharply divided cultural levels. In functionally relating to the newly emerging public political life, the two were – quite often emphatically – interrelated and mutually supported each other. While the primary aim of the texts was to differentiate and theoretically substantiate concepts, the pictures often reduced the latter to their core meanings. In so doing, however, they increased the social effectiveness of the concepts by symbolising, emotionalising and popularising them.

[2] As we have seen, historically important key concepts do not only exist as abstract terms. A person, event or place loaded with symbolic meaning can also be seen as the concrete rendering of an abstract word. When illustrated visually, general principles and catchwords such as *Liberté* and *Aristocratie* are, so to speak, 'embodied'; given an easily recognisable, standardised shape, which makes their inherent potential for associating ideas and actions not only obvious but palpable. One could say that such iconographical qualities are an important prerequisite for the symbolic power and widespread appeal of fundamental historical ideas.

[3] When, contrary to the general rule, the 'fleshing out' of an abstract idea is carried out in such a way that, instead of remaining distanced and neutral, it signalises either emphatic rejection or enthusiastic approval, the emotional charge – and with it, the appellative potency – of the illustrated concept is increased. For example, the collective experience of 14 July 1789 and its immediate after-effects became so deeply imbued in the term Bastille that thenceforward the mere public denunciation of certain political and social conditions as *bastilles* was an effective way of mobilising mass demonstrations and militant activists.[63]

[4] Concepts that have been simplified and emotionalised through this process of visual representation are certainly more widely intelligible than are abstract principles. They can more easily be popularised and instilled in the minds of the common people. This is why graphic art has played such an outstanding role in times of great social change, such as the Reformation and the French Revolution. Both were periods when the ability to mobilise the 'masses' was of paramount importance.

But our *jeu de l'oie* not only sheds light on the history of individual terms. Innocent of any explicit notion of linguistic structuralism, the game already contains the foundations for a structural history of concepts – something which isolated visual representations of single terms do not and indeed cannot. This is an effect of the way in which it links more than seventy pictorialized political-historical concepts, termini and names into an ingenious web of meaning. This is accomplished in a threefold manner: firstly, in a general way, by means of the chronological-causal interlocking of the game fields; secondly, and more specifically, by prescribing further connections beyond those of the simple linear ordering of the game fields (see above FIG. 26) in the cases of some particularly important and disputed terms; and thirdly through the iconographic and thematic relationships among the accompanying pictures. If one understands all the connections governed by the rules of the game as semantic relationships – and with respect to this document, this is by no means an

anachronistic view -, then a tightly meshed net of terms becomes visible. Within this construct, certain highly allusive key concepts form especially important nodes. Furthermore, within the immediate area of influence of single terms, associations often overlap (e.g. Tolérance suggests both Rousseau and Voltaire; fields 38, 39 and 40). Such a synthetic viewpoint probably more closely approximates the structure and functioning of historical semantics than do lexical or emblematic attempts at standardization, which imply a semantic autarchy and virtually static unequivocality of artificially isolated concepts. In opposition to this, our game teaches at least the following:

[a] That semantic formations and networks of historical terms and pictures are not a construct of modern linguists and semiologists, but rather something that was inherent in the way in which late 18th century France viewed itself. It was above all within the frameworks of these structures, and to a lesser degree in the form of single concepts and emblems, that verbal and iconic elements were able to develop and become a part of the collective consciousness.

[b] That such semantic networks of meaning comprised of words and pictures are not 'democratically' structured: the symbols involved do in fact differ quite decidedly in value. To put it more simply, one has to differentiate between richly allusive and influential key concepts, on the one hand, and the secondary concepts with which they are reciprocally connected, on the other.

[c] That historical concepts do not develop their suggestive potential and public appeal in isolation but rather together with concepts – both complementary and antithetical – with which they form common semantic fields. So it is that in our game, the *Aristocrates* are characterised by their immediate 'neighbours', the *Contre-révolutionnaires* and the *Moines*, on the one hand, and, on the other, by the antithesis of their privileges and elitist claims, the *Droits de l'homme* (66–68 and 41).

[d] That semantic sign systems are by no means fixed, virtually static constructs, but contain an inner dynamic owing to the reciprocity of key, complementary and antithetical concepts. This applies to single semantic fields as well as to relationships among several such fields.

[e] That, from the perspective of the history of concepts, key concepts of a general nature are anything but precise and unequivocal. They are distinguished instead rather by their wide range of meaning and by a certain ambiguity which can make them attractive even to completely opposed political and social groupings. For example, in 18th century France, the term Bastille initially signified *Despotisme* alone; only when it received its additional meaning of *Liberté* on 14 July 1794 (see FIG. 31 above) did it assume the character of a semantically bipolar catchword. Bastille was now a word that both followers and opponents of the Revolution could use against each other.

[f] That semantic dynamics and ambiguity are at once a prerequisite for and an expression of the logomachy and pictorial struggle which different socio-political groups waged around these concepts and symbols. It was the aim of each party to establish and fix their content to suit their respective purposes.

Our *jeu de l'oie* is therefore instructive in a way that goes beyond the cultural history of early modern and revolutionary France. With its network of words and pictures, it makes basic structural features of historical semantics visible. Admittedly, they are features which historians of concepts may sometimes intuit but often cannot support directly with documentary evidence. The analysis of this unique document could provide a starting point for the recognition of pictures as an integral part of the history of concepts. It might also serve to encourage what have until now been rather cautious attempts at a historical, structurally oriented, semantic analysis of whole fields and networks of concepts.

Between Cambridge and Heidelberg. Concepts, Languages and Images in Intellectual History

MARTIN VAN GELDEREN

In November 1595, the States of Holland contributed a subsidy for the commission of a new stained glass window for the church in Wassenaar. The States decided that the Wassenaar window, to be placed in the top position of the church, should represent 'the garden of Holland'.[1] The motif was popular, featured on coins, in engravings, paintings and stained glass. It became part of a series of standard images which formed the patriotic iconology of the new Dutch Republic. In 1596 Holland's senior town, Dordrecht, honoured the St. Janschurch in Gouda with a window featuring all the conventional elements of the representation of the 'garden of Holland'.[2] The window shows the virgin of Dordrecht, seated in a garden, holding a palm branch. The flourishing garden, full of flowers, is enclosed by a carefully plashed fence. Garden and fence are situated in a classical triumphal arch, which is surrounded by the cardinal virtues Wisdom (top left), Justice (bottom left), Fortitude (bottom right) and Moderation (top right).

As elsewhere, the image of the 'garden of Holland' was used in Gouda to represent the triumph of the flourishing, free and united commonwealth of Holland, ruled by the classical virtues of good government. The symbols of garden, fence, flowers and palm branch can be seen as visual representations of the political concepts of liberty, concord and prosperity which dominated the political literature of the Dutch Revolt. Thus the windows of Wassenaar or Gouda can be interpreted as fine representations of concepts which were of central importance to the intellectual history of the Dutch Revolt and the Dutch Republic; illustrating that in the political culture of the Low Countries visual and textual representation were markedly intertwined.

The windows of Wassenaar and Gouda also indicate the intimate connection between the concepts of liberty, concord and prosperity in late sixteenth-century Holland. Liberty, concord and prosperity were, together with concepts such as sovereignty, representation, privileges and civic virtue, constitutive of a political language which formed the intellectual foundation of the Dutch Revolt and the early Dutch Republic.[3] In this language liberty was presented as the political value par excellence, the 'daughter of the Netherlands', the source

of prosperity and justice. The Dutch Revolt itself was essentially interpreted as the defence of liberty, threatened by the lust for power and the tyrannical ambitions of Philip II's government. Fortunately the political order of the Low Countries was the deliberate creation of wise classical and medieval ancestors with the explicit purpose of safe-guarding liberty. It tried to achieve this goal by means of a constitutional framework consisting of a set of fundamental laws, the privileges, charters and customs of the Dutch provinces and a number of crucial institutions such as the States. The functioning and flourishing of the ancient constitution required civic virtue, including concord, from all levels of society. The shrubs in the garden of Holland could only blossom if they were cultivated with virtuous assiduity.

This interpretation of the church windows in Wassenaar and Gouda raises questions which have been central to the development of a Dutch approach to conceptual history. Between Cambridge and Heidelberg, students of intellectual history are wavering between German *Begriffsgeschichte* and the history of political languages as it is practised between Cambridge, England and Cambridge, Massachusettes. The issues are manifold and complex, touching ontology, epistemology and methodology in one stroke. As exemplified in the contributions of Terence Ball, Iain Hampsher-Monk, Hans-Erich Bödeker and Reinhart Koselleck, at the highest level of abstraction the very nature of 'being' of concepts and languages is at issue. This leads to a labyrinth of questions about the relationship between language and material reality, and, by consequence, about the relationship between political thought and action. In addition the interrelationship between concept and political language, at times verging on the chicken-egg banality, is a recurrent theme, entailing doubts about the methodological clarity and validity of both *Begriffsgeschichte* and the history of political languages. Finally, as exemplified in the contributions and of Eddy De Jongh, Bram Kempers and Rolf Reichardt, the interpretation of visual sources challenges conceptual history, the history of political languages and art history alike. Reflection on art in history and history in art must start with the epistemology of visual imagery as a source of historical knowledge and with wondering whether seeing images and reading texts are similar and/or dissimilar hermeneutic experiences.

The Linguistic Turn and the Art of Interpretation

Friedrich Schleiermacher and Wilhelm Dilthey, the founding fathers of Romantic Hermeneutics, built their theories of interpretation on the foundation of "humanistic historicism".[4] The principal aim of hermeneutics was to recapture the genesis, the *Konzeptionsentschluss*, and development of a human act in order to arrive at its true understanding. This process of interpretation entailed an understanding of language. Schleiermacher did not see texts as mere mechanical applications of given socio-linguistic rules. Moreover, he recognized the importance of linguistic singularity and of individualistic innovation. Schleiermacher therefore urged scholars to move beyond "grammatical interpretation" to psychological understanding. Language was regarded as the externalization of ideas, as the medium of a "*vorsprachlichen Idee*", of an idea existing before language. To understand a text was to understand "the spirit which initiated and controlled (this) writing, and for whose representation the writing exists".[5] Empathy was the traditional key

hermeneutic concept. For Schleiermacher and Dilthey a text was 'the "expression", *Ausdruck*, of the thoughts and intentions of its author; the interpreter must transpose himself into the author's horizon so as to relive the creative act'[6] in order to understand the text.

Modern *Begriffsgeschichte* and the history of political language have moved a long way from the legacy of traditional hermeneutics. The linguistic turn, which has marked philosophy throughout this century, has pervaded the humanities and social sciences for the past few decades. From being a tool that we use to express ideas or to mirror reality, language has been elevated to the 'medium in which we live'.[7] The ontological understanding of language as the house of being, *das Haus des Seins*, to put it in Heideggerean terms, has led to profound epistemological and methodological debates in intellectual history. As Donald Kelly has put it, 'even the history of "ideas", though it reaches out for the enduring, must in practical terms trade in the currency of the transient- must start from and finally return to the cave of human discourse'.[8]

Within their own historical and intellectual context *Begriffsgeschichte* and the history of political languages have been immersed in the linguistic turn. *Begriffsgeschichte* endorses and criticizes principal parts of Hans-Georg Gadamer's Philosophical Hermeneutics.[9] With Heidegger and Gadamer themselves being involved in a philosophical *Begriffsgeschichte*, as exemplified in the *Archiv für Begriffsgeschichte*, the project of the *Geschichtliche Grundbegriffe* 'originated in a style of historical inquiry that stressed hermeneutics and hence the importance of the conceptual apparatus, horizons, and self-understanding of historical actors'.[10] In many ways, Koselleck's theory of *Begriffsgeschichte* is a deliberate attempt to take Gadamer's Philosophical Hermeneutics from its ontological and epistemological heights to make it relevant for the practice of history.

Starting from the classical Aristotelian position that human beings are primordially social and communicative, Koselleck argues that society and language are meta-historical *a priori* without which history is inconceivable. Conceptual and social history have therefore an interdependent claim to universality which subsumes historical sub-disciplines such as cultural, economic and intellectual history.[11] However, in the conception of German *Begriffsgeschichte*, the interdependence of conceptual and social history does not lead to unification, as Koselleck insists 'that language and history be kept separate analytically, because neither one can be related in its entirety to the other'. While acknowledging the ontological importance of language, Koselleck claims, using Gadamerean language, that there is more to the house of being than language: 'history in the actual course of its occurrence has a different mode of being from that of the language spoken about it (whether before, after, or concomitant with the events)'.[12] Love is a sympathetic case in point, as Koselleck argues in his contribution to this volume that figures of speech between two lovers need not mirror the love between two individuals.[13] Just as love can not be reduced to the language of lovers, so society can not be reduced to the language of its members. Conceptual history must start from the ontological recognition of language and society as the two floors of the house of being.

Intertwined with social history, conceptual history 'is concerned with the reciprocal relationships between continuities, changes, and innovations in the meanings and applications of political and social concepts on the one side, and large-scale structural transformation in

government, society and the economy on the other'.[14] The creative tension between social reality and language lies at the heart of *Begriffsgeschichte*. As Koselleck explains this tension in his contribution to this volume, 'the reality may well change before its conceptualization. Likewise, emerging concepts can instigate new realities'.[15] The focus therefore is on the diachronic study of processes such as *Demokratisierung* (democratization), *Ideologiesierbarkeit* (the incorporation into ideologies) and *Politisierung* (politicization) of concepts. The conflicts over the applications of concepts indicate structural changes in politics and society. As language is constitutive of our 'horizon', of our 'range of vision that includes everything that can be seen from a particular vantage point',[16] concepts also shape political and social change.[17] The study of language as agent and indicator of structural change is the defining moment of *Begriffsgeschichte*.

On the basis of the primordial linguisticality and sociability of human beings *Begriffsgeschichte* has performed a major innovation in German study of history. Taken from its Heideggerean heights, *Begriffsgeschichte* was connected with social history. This implied a grand departure from the traditional history of ideas as propounded by Friedrich Meinecke whose *Geistesgeschichte* focused on the eternal wisdom of dateless ideas. At the same time *Begriffsgeschichte* salvaged intellectual history, almost overrun by social historians from Bielefeld and elsewhere who rushed towards a hard core historical social science, a *historische Sozialwissenschaft*.

The formative decades of *Begriffsgeschichte* coincided with the rise of the new 'Cambridge' approach to the history of political thought as epitomized in the work of John Pocock and Quentin Skinner. Like *Begriffsgeschichte,* the development of the history of political languages started with the rejection of prevailing 'orthodoxies' in the history of ideas. In his classic article *Meaning and Understanding in the history of ideas* Skinner rejects both 'textualism', with its claim that the text itself forms 'the sole necessary key to its own meaning', and 'contextualism', insisting that it is the *context* of religious, political and economic factors which determines the meaning of any given text.[18] Although sharing the need for departure from the old history of ideas as practised by Meinecke and Lovejoy, the philosophical foundations of *Begriffsgeschichte* and the new Cambridge approach are very different. Whilst *Begriffsgeschichte* was developed within the horizons of German traditions of historiography and hermeneutics, the history of political languages originated in the Anglo-Saxon traditions of Collingwood, the philosophy of language and J.L. Austin's theory of speech acts. Thus Skinner rejects textualism because it fails to recognize the historical linguisticality of texts. Inspired by Austin and Wittgenstein Skinner argues that a text is the embodiment of a particular usage of language by a particular agent at a particular time.

For its part, 'contextualism' fails to see that explaining why an author has written a text, is not the same thing as understanding the text itself.[19] Thus, whereas textualism ignored the historicity of human action, contextualism misconceives or has misconceptions of the relationship between text and context. If the aim is to 'recover the historical identity' of texts, the 'hermeneutic enterprise' of intellectual history should be guided by what Skinner has labelled an 'historical and intertextual approach'.[20]

In attempting to construct such an approach which acknowledges both the importance of the historicity of texts and of the relationship between text and context, Pocock and Skinner have both underlined the importance of linguistic and intellectual contexts. A principal starting point for their approaches is the recognition that each political author has to be seen, as Pocock has put it in Saussurean language, 'as inhabiting a universe of *langues* that give meaning to the *paroles* he performs in them'.[21] It is essential to recognize the normative character of *langues*, of 'languages' used in political discourse. According to Pocock *langues* 'will exert the kind of force that has been called paradigmatic (..). That is to say, each will present information selectively as relevant to the conduct and character of politics, and it will encourage the definition of political problems and values in certain ways and not in others'.[22] Political theorists – and other likeable human beings – live in a normative vocabulary of political languages. Political actors perform speech acts within the linguistic and intellectual context of their normative vocabulary. The relationship between language and speech act, between *langue* and *parole* should be seen in terms of a duality. On the one hand the normative vocabulary enables individuals to structure and interpret the world they live in, both in an empirical and normative sense; it allows them to make sense and to evaluate the changing world around them. Thus individual speech acts are generated, which on the other hand reproduce or transform the normative vocabulary in general and one or more political languages in particular. The study of political ideas very much becomes focused on the 'moves' agents make within political languages, on how they endorse, refute, elaborate or ignore 'the prevailing assumptions and conventions of political debate'[23] or, in other words, on how agents accept, modify and innovate political languages. The history of political thought becomes the history of *continua* of political discourse.[24]

As Iain Hampsher-Monk points out in his contribution to this volume, one of the great virtues of the new history of political languages is to emphasize human agency as the prime mover of history, instead of the structures and processes floating through *Begriffsgeschichte*. History is the history of creative individuals who transform political language and thereby politics, whose linguisticality is emphasized throughout the anglophone approach. However, in focussing on 'how to do things with words', in emphasizing Wittgensteinean language-games as the house of human being, English language theorists are in danger of fitting Folly's description of philosophers in Erasmus's *The Praise of Folly*. To paraphrase Folly, being caught up in the 'quiddities' and 'ecceities' of language-games, language theorists may not be 'able to see the ditch or stone lying in their path'.[25] In this respect attention to the creative tension between language and society, as conceived of by Koselleck and as emphasised by Hans Bödeker in his contribtion, is necessary for those who want to study 'ideas in context'.

At the same time, the ontological distinction between language and society, which forms the foundation of *Begriffsgeschichte* is deeply problematic. According to Koselleck, 'language and history cannot be related to each other in their entirety' because of the 'prelingusitic, metahistorical conditions of human history, such as time, the inner and outer delimitation and hierarchy. When the 'fluctuating distinction between "inner" and "outer" hardens into passionate conflicts between friend and foe', when hierarchy 'leads to enslavement and permanent subjugation', then, as Koselleck puts it, 'there will occur events, or

chains of events, or even cataracts of events, which are beyond the pale of language'. As the Holocaust looms large over German history, Koselleck argues that 'there are events for which words fail us, which leave us dumb, and to which, perhaps, we can only react in silence'.[26]

Koselleck's conception of history finds its classical inspiration in the works of Herodotus and Thucydides. Its *Leitmotiv* is derived from Herodotus: 'There are some things which cannot be explained in words, but only in actions. Other things can be explained in words, but no exemplary deed emerges from them'.[27] And Koselleck follows Thucydides in elevating 'the tension between speech and action to the central methodological axis' of the study of history.[28] At the same time Kosselleck recognizes that pre-linguistic conditions of human history and the conflicts they generate are not only 'grasped by man linguistically', but are also 'reshaped socially or regulated politically' through language.[29] Thus, as Iain Hampsher-Monk argues in his contribution, the extra- or pre-linguisticality of politics and society is in need of serious qualification. Social structures are linguistic structures; political action is linguistic action. To recognize man as a social and communicative being is to recognize man as a linguistic being. The history of language subsumes social and political history.

In this regard it is mystifying why the ontological distinction between language and society entails separate disciplines of the study of history. It is mystifying how the epistemology and methodology of social history differs from conceptual history; it is mystifying how the social-historical study of love is epistemologically and methodologically distinct from the conceptual-historical study of the same phenomenon. Love might be more than the discourse of lovers, and it may have pre-linguistic conditions, but for the loving historian language is all that has been left. For the study of history language is the epistemological house of being, because, as Kosselleck argues in this volume, 'everything that belonged together *in eventu* may be conveyed solely through verbal testimony *post eventum*'.[30] As the world presents itself through language, to quote Gadamer,[31] the initial methodological and epistemological puzzles seem to be the same for all brands of historical study. The ontological relationship between language and reality is not just a puzzle for Folly's philosophers. It is also deeply relevant to the practice of all historians.

Practice

For the study of political and social concepts *Begriffsgeschichte* proposes to employ methods developed in fields such as historical semantics, linguistics and philology in creative interaction and tension with methods of social history. It proclaims an interplay between semasiology, onomosiology and many other 'ologies'. As a result, *Begriffsgeschichte* has become a methodological hotch-potch which is in serious need of clarification. With notable exceptions, which include Koselleck, Hans-Ulrich Gumbrecht and some other authors *Begriffsgeschichte* as practised in the *Geschichtliche Grundbegriffe* is an old fashioned 'walk across the summits of the history of ideas', to quote Hans Erich Bödeker.[32] In response conceptual historians have sought to formulate a more methodical approach. One of the most notable attempts in this direction is found in the work of Rolf Reichardt, who has set up a list of guidelines, *Arbeitsregeln*, for the practice of *Begriffsgeschichte*. Reichardt's guidelines

concern the selection and social characterization of primary sources and the reconstruction of conceptual fields, *Begriffsfelder*. Emphasizing the social nature of language and the interplay between history of ideas and social-historical semantics Reichardt urges *Begriffsgeschichte* to differentiate its sources along grades of social representation (*soziale Repräsentativitatätsgrad*), areas of practical use (*Praxisbereiche*) and textual genres such as dictionaries, newspapers and pamphlets. To reconstruct the historical meaning of concepts within their social, political and intertextual context Reichardt proposes to look at words and sentences which define a concept, at aligned words which add to, explain or differentiate a concept, and at contrasting concepts (*funktionale Antonyme*).[33]

Reichardt's *Handbuch* of fundamental political and social concepts in France seeks to understand concepts as social norms reflecting and constituting everyday life in society – from coffee-house to grand theory. The guidelines are focused on the recovery of the social dimension of the usage of concepts. Reichardt's 'method', however, does not address, let alone resolve some of the more fundamental issues concerning the methodological clarity of 'practising *Begriffsgeschichte*'. It does not address serious doubts which have been raised concerning the discipline's conception of its very subject matter, concepts. Concepts are more than words, but how they fit between words, discourses, languages and vocabulary is an unresolved issue.

As Hans Erich Bödeker emphasizes, in 'practising *Begriffsgeschichte*' the focus has traditionally been on certain key-words, on title words with a costly neglect of semantics. By consequence, as Bödeker argues, within the practice of *Begriffsgeschichte* 'the discursive interconnection of the individual keywords remains, by and large, without analysis'.[34] In narrowing down the study of language to the study of concepts, *Begriffsgeschichte* loses sight of rhetorics, of strategies of communication and persuasion, which are essential to the understanding of communication as a social – and political – process.

The recognition that concepts need to be interpreted within the framework of discourses lies at the heart of the project of 'critical conceptual history', which has found its most eloquent pleas in publications of James Farr and Terence Ball.[35] As Ball puts it in this volume, the task of critical conceptual history 'is to chart changes in the concepts constituting the discourses of political agents living and dead'.[36] Thus conceptual history highlights 'the language – the concepts and categories, the metaphors and rhetorical strategems – in which political problems are framed, discussed, debated and sometimes even resolved by partisans of various stripes'.[37]

Begriffsgeschichte and history of political languages meet each other in the aims of critical conceptual history. Noble objectives, however, do not necessarily entail methodological clarity. It is as yet unclear how the methodological and epistemological horizons of conceptual history and the history of political languages can fuse. For his part, Quentin Skinner has dismissed the very possibility of a history of concepts as such. In Skinner's view concepts are Wittgentsteinean tools, which means that 'to understand a concept, it is necessary to grasp not merely the meaning of the terms used to express it, but also the range of things that can be done with it'.[38] To understand concepts, according to Skinner, is to understand their 'uses in argument'. The historical understanding of concepts requires an understanding of their usage within a political language. For example the interpretation of the mean-

ing of the concepts of concord and harmony as used in the representation of the windows in Wassenaar and Gouda requires an understanding of the usage of the terms which constitute these concepts within the political language of the Dutch Revolt. To understand conceptual change is to relate their usage within a normative vocabulary.[39]

Recapturing the normative vocabulary is for Skinner one of the basic steps in the process of interpretation.[40] The recovery of the normative vocabulary of political languages, is a precondition for understanding what an author historically 'was doing' with a certain concept in certain utterance, in a certain text at a certain time. The understanding of the illocutionary force of a speech act, to use Austinean language, requires a complex process of interpretation which includes recovering the conventional range and reference of terms, relating the speech act to its social context and to the mental beliefs of its agent.

There can be little doubt about the success of the Cambridge approach as exemplified in the series *Ideas in Context* and the *Cambridge Texts in the History of Political Thought*. Nevertheless there is ongoing debate over the clarity of its methodological devices.[41] One of the issues is how to recover past normative vocabularies, past political languages. At this point, conceptual history and the history of political language are involved in a language-game of chicken or egg. Where the understanding of concepts requires the reconstruction of the discursive settings of their usage, the recovery of political language and political vocabulary must be based on an understanding of constitutive components, such as concepts. Conceptual history and history of political language may meet each other at a methodological middle-ground, conveniently described as the semantic field. To grasp the historical meaning of concepts, it is necessary to study their usage in sentences and passages of texts, to study how words, phrases, metaphors and rhetorical topoi denoting the concept are used in argument, to study aligned and contrasting concepts and to study structures of argumentation. For example, to understand the historical meaning of the concept of concord in the Dutch Revolt it is necessary to study the use of the words and phrases denoting this concept in relation to concepts such as liberty and virtue and in relation to rhetorical devices mainly derived from classical sources, in particular from the works of Sallust and Cicero. Likewise the reconstruction of the political language of the Dutch Revolt requires the study the interrelated meaning of constitutive phrases, concepts and key-words including liberty, concord and virtue. Conceptual history and history of political language are intertwined in a hermeneutical circle around semantic fields.

Images, Concepts and Languages

As the church windows in Wassenaar and Gouda illustrate, the representation and formulation of the concept of concord was not confined to textual material during the Dutch Revolt. A full understanding of the historical meaning of concord must move beyond texts to include the political imagery of the Revolt.

As Pim den Boer argues in his contribution, the history of Dutch concepts must start in the sixteenth century when scholars such as Simon Stevin and humanists such as Dirck Volckertsz Coornhert set up grand projects to establish, purify and glorify the Dutch language on the classical models of Cicero and Seneca.[42] The rise of the Dutch language coin-

cided with 'the dawn of the Golden Age' in Dutch painting, to which Coornhert contributed as engraver.[43]

Ever since Johan Huizinga wrote his classic works on the culture of the Burgundian Netherlands and the Dutch Republic, historians have esteemed Dutch painting in the Golden Age as the hallmark of the Dutch nation, as the most glorious Dutch contribution to European civilization.[44] The importance of Dutch painting is confirmed by its tremendous popularity in the Golden Age itself. According to recent estimates, between 1580 and 1700, about 6 million paintings were produced in the Dutch Republic. This implies a weekly production of 1.6 painting per artist, on average. The wealthiest stratum of Dutch society decorated its houses with no fewer than 53 paintings on average; the smallest property owner still had 7 paintings, on average.[45]

The interpretation of Dutch painting is an issue of great controversy. The past few decades have seen the rise of the iconological approach to Dutch art under the inspiration and leadership of Eddy de Jongh.[46] As De Jongh puts it, the 'iconologists' 'look for the quintessence of the work of art in the underlying ideas in iconographic and cultural definitions'.[47] The iconological approach tries to 'decipher layers of meaning and literary allusions hidden in painting and to relate the siginificance of genre painting to the classical concept of *docere et delectare* (to teach and delight)'.[48] Emphasizing the *Sprachlichkeit*, the linguisticality of Dutch painting, the iconological approach tries to decode the moral or humourous meaning of images by relating them to textual material including emblem books, poetry and ethical and political literature such as the works of Jacob Cats and Joost van den Vondel. The results of the iconological approach have been illuminating and amusing. Its most recent highlight is Simon Schama's *The Embarassment of Riches* which makes ingenious and eclectic use of iconological devices to develop the thesis that in the face of the rise of commercial society Dutch culture was characterized by moral anxiety.[49]

The iconological approach is criticized from a variety of angles. The most strenuous attack comes from Svetlana Alpers who rejects Dutch iconology for its 'reductive view' that subject matter, messages and meaning were paramount in Dutch art and that paintings were merely means by which meaning and message are made visible.[50] In *The Art of Describing* Alpers argues that Dutch art did not want to make jokes or teach morals, but that it wanted to grasp and communicate knowledge through observation and visual description of the world in the greatest possible detail. Through a new sort of 'experiential observation' Dutch painting tried to vex nature. Alpers seeks to link the rise of Dutch painting as the craft of observation with main developments in science and philosophy. *The Art of Describing* contains a lengthy and unfortunate attempt to connect Dutch painting with the philosophy of Comenius and the empiricism of Francis Bacon. As David Freedberg has pointed out, Alpers largely neglects stunning developments in Dutch science, such as the publications by Rachel Ruysch's, Judith Leyster and Maria Sybilla Merian which marked the splendid rise of natural history through highly realistic illustrations of flowers and insects. Merian's, Leyster's and Ruysch works of art are in fact key examples of the links between artistic and scientific activity in the Dutch Republic, giving credence to Alpers' thesis that the Dutch Golden Age was a grand visual culture whose motto was 'seeing is believing'.[51]

The clash between the iconological approach and Alpers' naturalistic understanding of Dutch art is nicely illustrated by the widely diverging interpretations of David Bailly's *Still life* from 1651. Alpers celebrates this work as a fine example of 'experiential observation'. The table displays 'an assemblage of materials made by nature and worked by man' to reveal their nature: 'wood is shaped, paper curled, stone is carved, pearls polished and strung'. In a Baconian way, nature is molded and squeezed 'in order to reveal her'.[52] For De Jongh, Bailly's painting is a typical example of the vanitas still life. Objects such as the skull, the hour-glass, the air bubbles, and the text from *Ecclesiastes* (*Vanitas vanitatum et omnia Vanitas*) are abundant symbols of the moral statement that man is a mortal being who should beware of vanity.[53]

De Jongh's iconological interpretations and Alpers' naturalist approach have major implications for the intellectual history of the Dutch Republic and the history of Dutch concepts. Both approaches entail ambitious yet widely diverging interpretations of the culture and intellectual heritage of the Dutch Golden Age. Alpers presents the Dutch Golden Age as the pioneering example of a visual culture. De Jongh's emphasizes the plurality of symbolism in Dutch painting and its moral ambivalence. In both cases, the history of art is connected haphazardly with an analysis of philosophical and literary texts. Thus in both cases the problems of relating the history of art to the intellectual history of Dutch literature and philosophy are apparent.

Questions concerning the position of the history of art in the wider framework of history as discipline are haunting cultural and intellectual historians, treading in the footsteps of Johan Huizinga.

Huizinga's reflections on art and history between 1905 and 1935 were initially deeply inspired by the attempts of Dilthey and other German philosophers and historians to vindicate history as a distinct discipline between the arts and sciences.[54] Inspired by the studies of Dilthey, Simmel and later also Rothacker, Huizinga argued that historical understanding was essentially different from the causal explanation dominating the natural sciences. In Huizinga's view the primary aim of the historian is to understand individual acts, thus laying the foundations for more comprehensive representations of the past. Departing from the German analysis of empathy, Huizinga emphasized the constitutive role of art for the discipline of history. Developing a 'small phenomenology'[55] of the historian's practice, he argued that the interaction between art and historical imagination is constitutive to history as a discipline.[56] In Huizinga's view, both art and history consist principally of the evocation of images. Images are incipient in historical research, providing the initial stimulus to further study.

Huizinga's own masterpiece of cultural and intellectual history, *The Waning of the Middle Ages*, started quite literally 'in the mirror of Van Eyck', and initially Huizinga wanted to give his study of the culture of the Burgundian Netherlands this title. Aesthetic intuition made Huizinga wonder about the lack of harmony in Van Eyck's works, the passion for detail and the appearance of flawless naturalism. This aesthetic appreciation of Van Eyck raised fundamental issues concerning the medieval mind and suggested the image of a culture in decline. Likewise, the appreciation of Vermeer and Rembrandt formed the images which underlie Huizinga's major study of Dutch culture, *Dutch Civilization in the Seven-*

teenth Century. Departing from Van Eyck, Vermeer and Rembrandt, Huizinga embarked on a journey of historical imagination and scrupulous research of an impressive array of primary sources. The objective was not to achieve a mimetic representation of the past reality of Burgundian and Dutch culture; Huizinga stated that the task of cultural history was the creative reconstruction of images opening up horizons of historical understanding. As Huizinga put it, if history wants to achieve its objective 'of reviving the past...it must consciously transcend the borders of what can be known through concepts'. Whilst the natural scientist tries to capture the knowledge of nature in 'rigorous concepts', the historian moves beyond the realm of concepts to 'envisage' and create images of the past.[57]

The preponderance of optical metaphors in Huizinga's reflections and his eye for the constitutive role of art in history, did not mean that art subsumed history. On the contrary, Huizinga was acutely aware of the methodological problems involving the use of visual sources in cultural history.[58] In the course of the decades, as enthusiastic historians indulged themselves in the use of visual sources, Huizinga's own caution and suspicion grew. He argued that the study of works of art opened only limited perspectives to the historian of culture. According to Huizinga, 'the idea which works of art give us of an epoch is far more serene and happy than that which we gain in reading its chronicles, documents, or even literature'.[59] In his view the 'vision of an epoch resulting from the contemplation of works of art is always incomplete, always too favourable, and therefore fallacious'. Thus, as David Freedberg has noted, historians using Dutch works of art as historical sources 'need to know more about the *kinds* of knowledge embodied in Dutch pictures, prints, and book illustrations'. There is, to quote Freedberg again, a need to identify 'the relationship that may or not exist between particular kinds of knowledge on the one hand and individual representational genres on the other'. Historians are required to study works of art within the appropriate artistic and also epistemological traditions, with a keen eye for both artistic and socio-economic pressures and settings.[60]

In addition, Huizinga's own use of works of art raises the grand question of whether images can be read as texts or whether imagery requires a new hermeneutics, distinct from textual hermeneutics. As Frank Ankersmit has noted, 'anyone who studies the current literature on the relation in the hope of finding an intuitive confidence in the differences between the two confirmed is in for a disappointment'.[61] From Gombrich's *Meditations on a Hobby Horse* to Goodman's *Languages of Art* theorists and historians have moved towards a semiotic approach of images, thus qualifying, if not breaking down, the differences in the interpretation of visual and textual sources.[62] Huizinga himself seemed to favour a hermeneutic circular approach in relating visual to textual sources.[63] Thus *The Waning of the Middle Ages* circles around Van Eyck. As Van Eyck's works raise fundamental questions concerning the medieval mind and culture, Huizinga moves to the analysis of textual sources and returns to Van Eyck in the culmination of his attempt to understand the culture of the Burgundian Netherlands. However, Huizinga insisted on the essential differences between texts and images as historical sources. In spite of the preponderance of Van Eyck, Vermeer and Rembrandt in his work, Huizinga argued that 'literary products offer one criterion more than the visual arts: they make it possible for us to appraise the spirit as well as the form'.[64]

With some notable exceptions, including studies by Reichardt and Skinner,[65] *Begriffsgeschichte* and the history of political language have refrained from studying visual material systematically. In the face of the visual glory and abundance of the Golden Age, historians of Dutch concepts must take up the formidable challenge to link the study of visual and textual material and to follow in the hermeneutic footsteps of Johan Huizinga. Hermes, however, is 'wily and deceptive', in the words of Plato.[66] The virgin of Holland waits in the garden.

On the Contributors

Terence Ball is Professor of Political Science at the University of Minnesota. He received his PhD from the University of California at Berkeley in 1973. He has held visiting appointments at Nuffield College, Oxford (1978-79); U.C. San Diego (1984); Christ Church, Oxford (1993); Corpus Christi College, Oxford (1995). He has held fellowships from the Center for Advanced Study in the Behavioral Sciences at Stanford, the National Endowment for the Humanities, and the Woodrow Wilson International Center for Scholars in Washington, D.C., among others. His books include, most recently, *Transforming Political Discourse* (Oxford 1988), *Political Innovation and Conceptual Change* (Cambridge 1989), *Political Ideologies and the Democratic Ideal* (New York 1995), and *Reappraising Political Theory* (Oxford 1995). He is co-editor of the forthcoming *Cambridge History of Political Thought: Twentieth Century* and a member of the Editorial Board of *The Journal of Political Ideologies*.

Hans Erich Bödeker is research fellow at the Max-Planck-Institut für Geschichte in Göttingen. He has been visiting professor at George Mason University, Fairfax, Virginia (1987), at UCLA (1992), and at the EHESS, Paris (1997). He has co-edited *Aufklärung als Politisierung - Politisierung der Aufklärung* (Hamburg 1987), *Alteuropa oder Frühe Neuzeit? Probleme und Methoden der Forschung* (Stuttgart 1991), *Le livre religieux et ses pratiques: études sur l'histoire de livre religieux en Allemagne et en France a l'époque moderne* (Göttingen 1991), *Aufklärung/Lumières und Poliktik. Zur politischen Kultur der deutschen und französischen Aufklärung* (1996) and edited *Lesekulturen im 18. Jahrhundert* (Hamburg 1992) and *Histoires du Livre: nouvelles orientations* (Paris 1995). He has published extensively on German early modern period.

Pim den Boer is Professor of History of European Culture at the University of Amsterdam. In 1994-1995 he was (together with Wyger Velema) co-ordinator of the theme-group on Dutch Conceptual History at the Netherlands Institute for Advanced Study (NIAS). His publications include *History as a profession. The study of history in France 1818-1914* (Princeton 1998). He his co-author of *The history of the idea of Europe* (eds. K. Wilson and J. van der Dussen, London 1993), and co-editor of *Lieux de mémoire et identités nationales. La France et les Pays-Bas* (Amsterdam 1993).

Willem Frijhoff obtained his PhD with a study on the social history of the early modern Dutch university system (*La société néerlandaise et ses gradués: une recherche sérielle sur le statut des intellectuales 1575-1814*, Amsterdam/Maarssen 1981). Before moving to the Free University of Amsterdam, in 1997, he has been Professor of Cultural History at the Erasmus University of Rotterdam. He is also a member of the Royal Netherlands Academy

of Sciences. His publications deal mainly with the history of mentalities and historical anthropology. Among his publications are (co-)edited volumes on *Witchcraft in the Netherlands from the fourteenth to the twentieth century* (Rotterdam 1991), *Cultuur en maatschappij in Nederland 1500-1850: Een historisch-antropologisch perspectief* (Meppel-Amterdam/Heerlen 1992), and *Lieux de mémoire et identités nationales* (Amsterdam 1993), and a contextual biography of a seventeenth-century orphan, centred on religious experience and the construction of the self, *Wegen van Evert Willemsz. Een Hollands weeskind op zoek naar zichzelf (1607-1647)* (Nijmegen 1995).

Martin van Gelderen is Professor of Intellectual History at the University of Sussex. In the academic year 1994-1995 he was a fellow at the Netherlands Institute of Advanced Studies. His main publications include *The political thought of the Dutch Revolt (1555-1590)*, in the series *Ideas in Context* (Cambridge 1992) and *The Dutch Revolt*, in the series *Cambridge Texts in the History of Political Thought* (Cambridge 1993).

Iain Hampsher-Monk is Professor of Political Theory at the University of Exeter, UK. He is a founder and editor of the journal *History of Political Thought* and author of *A History of Modern Political Thought - major political thinkers from Hobbes to Marx* (Oxford 1992) which won the UK Political Studies Association McKenzie Book Prize. His main research publications have been in seventeenth- and eighteenth-century radical political thought, the methodology of the history of political thought, and in aspects of contemporary political theory. He was a NIAS fellow 1994-1995. He is currently working on a study of the political ideas of Edmund Burke.

Eddy de Jongh is a former Professor of Art History at the State University of Utrecht. As an outstanding scholar of Dutch art he has made a substantial contribution to the iconological re-evaluation of seventeenth-century painting over the last thirty years. His books include *Still-life in the age of Rembrandt* (Auckland 1982), *Portretten van echt en trouw: huwelijk en gezin in de Nederlandse kunst van de zeventiende eeuw* (Zwolle 1986) and *Zinne- en minnebeelden in de schilderkunst van de zeventiende eeuw* (Amsterdam 1967). A collection of his articles appeared under the title *Kwesties van betekenis. Thema en motief in de Nederlandse schilderkuns van de zeventiende eeuw* (1995). Together with Ger Luijten he authored *Mirror of Everyday Life: Genre Prints in the Netherlands 1550-1700*, the catalogue of an exhibition held in the Rijksprentenkabinet of the Rijksmuseum (1997).

Bram Kempers is Professor of Cultural Studies and Sociology at the University of Amsterdam. He works mainly in the field of art-patronage and society in Renaissance Italy. He is the author of *Painting, power and patronage: the rise of the professional artist in the Italian Renaissance* (Allen Lane, The Penguin Press 1992), an English translation of his PhD *Kunst, macht en mecenaat: het beroep van schilder in sociale verhoudingen, 1250-1600* (Amsterdam 1987, also in German). He is co-editor of *In opdracht van de staat: opstellen over mecenaat en kunst van de Griekse polis tot de Nederlandse natie* (Groningen 1994) and *Openbaring en bedrog. De afbeelding als historische bron in de lage landen* (Amsterdam 1995).

Reinhart Koselleck, educated at the University of Heidelberg and being one of the initiators of the German project, can be called the Nestor of the *Begriffsgeschichte*. Koselleck was Professor of Modern History and Theory of History at the Universities of Heidelberg, Bochum and Bielefeld. He is the author of many books and articles on the history of concepts, social history and theory of history, and the editor of many volumes, some of which have to be mentioned, such as his famous Ph.D. thesis *Kritik und Krise. Eine Studie zur Pathogenese der bürgerlichen Welt* (1954), his Habilitations-work, *Preußen zwischen Reform und Revolution. Allgemeines Landrecht, Verwaltung und soziale Bewegung van 1791 bis 1848* (1965) and *Vergangene Zukunft. Zur Semantik geschichtlicher Zeiten* (1979).

Hans-Jürgen Lüsebrink is Professor of Romance Literature and Cultures and Intercultural Communication at the University of Saarbrücken. He has held several visiting appointments, amongst others at the Ecole des Hautes Etudes en Sciences Sociales in Paris, the Université Laval in Québec and the Universities of Innsbruck, Rouen and Tours. He is the author of *Literatur und Kriminalität im Frankreich des 18. Jahrhunderts* (Munich-Vienna 1983) and *Schrift, Buch und Lektüre in der französischsprachigen Literatur Afrikas* (Tübingen 1990). With Rolf Reichardt he is the editor of the *Handbuch der politisch-sozialen Grundbegriffe in Frankreich, 1680-1820* Vol. I-XIII (Munich 1990-). Together they wrote *Die* Bastille. *Zur Symbolgeschichte von Herrschaft und Freiheit* (Frankfurt/M 1990). The books he has edited include, most recently, *African Literature and Literary Theory* (Hamburg-Münster 1994) and *Nationalismus im Mittelmeerraum* (Passau 1994).

Rolf Reichardt is honorary Professor of Modern History at the University of Gießen. Since 1991 he has been Director of the 'Section Collecting Works on French Research: Culture, Society, Regions'. He is the co-editor of the *Handbuch politisch-sozialer Grundbegriffe in Frankreich 1680-1820* (Munich 1985-). Among his publications are *Reform und Revolution bei Condorcet* (Bonn 1973), *Das Revolutionsspiel von 1791* (1989), *Die Bildpublizistik der Französischen Revolution* (with Klaus Herding, Frankfurt/M 1989), *The 'Bastille'. A History of a Symbol of Dispotism and Freedom* (with Hans-Jürgen Lüsebrink, Durham N.C. 1997). He is the editor, co-editor and co-author of numerous other publications, including *Sieyès, Politische Schriften 1788-1790* (Munich 1975-1980), *Ancien Régime, Aufklärung und Revolution* (Munich 1979-), *Sozialgeschichte der Aufklärung in Frankreich* (Munich 1981), *Die Französische Revolution als Bruch des gesellschaftlichen Bewußtseins* (Munich 1988), *Die Bastille: Symbol und Mythos in der Revolutionsgraphik* (Munich 1989), *Französische Presse und Pressekarikaturen 1789-1992* (Mainz 1992); *Weltbürger, Europäer, Deutscher, Franke: Georg Forster zum 200. Todestag* (Mainz 1994).

Bernhard F. Scholz is Professor of General and Comparative Literature at Groningen University. He studied English and German literature and Philosophy at the universities of Freiburg, Würzburg and Hamburg, and Comparative Literature at Indiana University, Bloomington, USA. His fields of interest are the history of criticism, literary semantics and word-and-image studies. Articles of related interest: 'Literarischer Kanon und literarisches System: Überlegungen zur Komplementarität zweier literaturwissenschaftlicher Begriffe

anhand der Kanonisierung von Andrea Alciatos *Emblematum liber* (1531)' (1987); 'Das Emblem als Textsorte und als Genre: Überlegungen zur Gattungsdefinition des Emblem'(1986); 'The Res Picta and the Res Significans of an Emblem, and the Indexer's Eye: Notes on the Basis of an Index of Emblem Art' (1990); 'Emblematik: Entstehung und Erscheinungsweisen' (1992); 'El concepto de cronotopo en Bajtín: notas sobre la conexión kantiana' (1993); 'From Illustrated Epigram to Emblem: The Canonization of a Typographical Arrangement' (1993); 'The Brevity of Pictures. Notes on a Topic of Sixteenth and Seventeenth Century Treatises on the Impresa and the Emblem' (1994); 'Der Mensch - eine Proportionsfigur. Leonardo da Vincis Illustration zu Vitruvs *De Architectura* als Bildtopos' (1994).

Karin Tilmans is currently Research Fellow of the Huizinga Institute and Lecturer of mediaeval and Early-Modern History, University of Amsterdam. She works currently on a project on conceptual history entitled 'Political discourse in the Habsburg Netherlands: the changing concepts of *republic* and *citizen*'. Her publications include *Historiography and Humanism in Holland at the time of Erasmus* (Bibliotheca Humanistica et Reformatorica LI, Nieuwkoop 1992) and articles on late-medieval and early-modern historiography and political thought in the Netherlands. In the Dutch project on conceptual history, she was NIAS-fellow 1994-1995 and published on the development of the concept of fatherland (1400-1600) and she coordinates a research group on the concept of citizen(ship).

Maurizio Viroli did his PhD research at the European University Institute in Florence. He was a Jean-Monnet Fellow at the same institute in 1978-88. He has been Assistant Professor of Politics at Princeton University, where he is now Professor of Politics. His major publications include *Jean Jacques Rousseau and the well-ordered Society* (Cambridge 1988) a revised version of his dissertation *From Politics to Reason of State. The Acquisition and Transformation of the Language of Politics 1250-1600*, Ideas in Context 22 (Cambridge 1992), *For Love of Country* (Oxford 1995) and *Machiavelli* (Oxford 1998). Maurizio Viroli was co-editor, with Gisela Bock and Quentin Skinner, of *Machiavelli and Republicanism*, Ideas in Context 18 (Cambridge 1990).

Frank van Vree is Senior Lecturer Cultural History and Media Studies at the University of Amsterdam. His publications include a study on the formation of Dutch public opinion in the interwar period, *De Nederlandse Pers en Duitsland* (Groningen 1989), a history of the memory of the Second World War, *In de schaduw van Auschwitz. Herinneringen, beelden, geschiedenis* (Groningen 1995) and a history of *de Volkskrant*, a leading newspaper in the Netherlands (*De metamorfose van een dagblad*, Amsterdam 1996). He was co-editor of a volume on communication history since the late middle ages, *Tekens en Teksten* (Amsterdam 1992) and is editor of *Feit & Fictie*, a journal on the history of representation.

Notes

INTRODUCTION

1. R. Koselleck, 'Introduction', *Geschichtliche Grundbegriffe* Vol. I. Cf. *Geschichtliche Grundbegriffe* Vol. VII, Stuttgart 1992.
2. Melvin Richter, *The History of Political and Social Concepts*, Oxford 1995.
3. Wyger Velema, 'Over de noodzakelijkheid van een Nederlandse Begripsgeschiedenis', in *Bulletin. Geschiedenis, Kunst, Cultuur*, II/1 (1993) 27-40; Pim den Boer, 'Naar een geschiedenis van begrippen in het Nederlands' in: S. Dik and G. Muller (eds.), *Het hemd is nader dan de rok. Zes voordrachten over het eigene van de Nederlandse cultuur*, Assen/Maastricht 1992, 47-60.
4. Andrea Alciatus, also known as Andrea Alciati, Andreas Alciat or Andrea Alciato.
5. Provisional titles of forthcoming publications: N. van Sas (ed.) *De ontwikkeling van het begrip Vaderland in Nederland van de late Middeleeuwen tot de twintigste eeuw* (The Development of the Concept of the Fatherland in the Netherlands from the Late Middle Ages to the Twentieth Century). E. Haitsma Mulier and W. Velema (eds.), *De ontwikkeling van het Nederlandse Vrijheidsbegrip van de Late Middeleeuwen tot de twintigste eeuw* (The Development of the Dutch Concept of Freedom from the Late Middle Ages to the Twentieth Century). P. den Boer (ed.). *Omtrent hoofsheid en beschaving. Aanzet tot begripshistorisch onderzoek* (On Courtliness and Civilization. A First Step toward Conceptual History Research).

CHAPTER 1

1. A more extensive version of this article has been published in *Theoretische Geschiedenis* 23/3 (1996) 290-310. The history and background of the *Geschichtliche Grundbegriffe* are extensively dealt with by Melvin Richter, *The History of Political and Social Concepts. A Critical Introduction*, New York 1995.
2. J. Ritter (ed.), *Historisches Wörterbuch der Philosophie* Vol. I, Darmstadt 1971, 799-808.
3. E. Rothacker, 'Preface', *Archiv für Begriffsgeschichte* Vol. I (1955).
4. M. Richter, 'Reconstructing the History of Political Languages: Pocock, Skinner and the Geschichtliche Grundbegriffe', *History and Theory* XXIX (1990) 44.
5. B. Rüthers, *Carl Schmitt im Dritten Reich. Wissenschaft als Zeitgeistverstärkung?*, Munich 1989.
6. R. Koselleck, *Begriffsgeschichtliche Probleme*, 33.
7. C. Schmitt, 'Der Begriff des Politischen' (1932), quoted by H. Quarits, *Positionen und Begriffe Carl Schmitts*, Berlin 1989, 17.
8. O. Brunner, *Land und Herrschaft*, Vienna 1942, 124.
9. In the introduction to the article on 'Staat' in the *Geschichtliche Grundbegriffe*, in fact a very clear reference is made to the work of Carl Schmitt. W. Conze in his introduction in *Geschichtliche Grundbegriffe* Vol. VI, 5.
10. 'Bund', 'Demokratie', 'Emanzipation', 'Fortschritt', 'Geschichte', 'Herrschaft', 'Interesse', 'Krise', 'Revolution' and parts of 'Staat/Souveränität', 'Verwaltung' and 'Volk/Nation'.
11. *Geschichtliche Grundbegriffe* III, 617.

12. *Geschichtliche Grundbegriffe* III, 649-650.
13. W. Schulze, 'Deutsche Geschichtswissenschaft nach 1945', Supplement 10 (1989), *Historische Zeitschrift*, Munich 1993, 261.
14. Conze edited volumes II (1975), IV (1978) and V (1984) and completely or partially wrote the entries on 'Adel', 'Arbeit', 'Arbeiter', 'Bauer', 'Beruf', 'Demokratie', 'Fanatismus', 'Freiheit', 'Militarismus', 'Mittelstand', 'Monarchie', 'Proletariat', 'Rasse', 'Reich', 'Säkularisation', 'Sicherheit' and 'Schutz'. His entries on 'Staat/Souveränität' and 'Stand/Klasse' were published posthumously.
15. R. Koselleck, 'Werner Conze, Tradition und Innovation', *Historische Zeitschrift* 245 (1987) 529-543.
16. For a detailed description of the atmosphere at Königsberg and Rothfels' position, see the semi-auto-biographical passages in W. Conze, 'Hans Rothfels', *Historische Zeitschrift* 237 (1983) 311-360.
17. *Die deutsche Kolonie Hirschenhof. Das Werden einer deutschen Sprachinsel in Livland* (1934), see W. Weber, *Biographisches Lexikon zur Geschichtswissenschaft in Deutschland, Österreich und der Schweiz,* Frankfurt on Main 1987, 92.
18. According to Koselleck, there were definitely two or three sentences with an anti-Semitic drift in an article Conze wrote in 1938. Koselleck, 'Werner Conze', *Historische Zeitschrift* (1987) 536.
19. *Ibidem* 537.
20. In an otherwise favourable review of *La Méditerranée* in *Historische Zeitschrift* 172 (1951) 358-362, Conze completely misjudged the meaning of Braudel's work. He was of the opinion that there was a resemblance between Braudel's ideas and Otto Brunner's conceptions of social history defended in the *Anzeiger der phil.-hist. Klasse* 1948, 335 ff.
21. After completing his studies, Brunner initially worked in the archives. In 1929, his professorial dissertation was about the financial situation in Vienna in the Middle Ages. Literature about Brunner includes Weber, *Biographisches Lexicon*, 72; L. Buisson, *Zum Gedenken an Otto Brunner 1898-1982,* Hamburg 1983, 13-31; J. Van Horn Melton, 'Otto Brunner and the Ideological Origins of Begriffsgeschichte' in *The Meaning of Historical Terms and Concepts*, 21-33; O. Brunner, 'Alphonse Dopsch', *Zeitschrift der Savigny-Stiftung für Rechtsgeschichte* 72 (1952) 455-458.
22. W. Conze in his Introduction on 'Staat', *Geschichtliche Grundbegriffe*, VI 5.
23. R. Koselleck, 'Begriffsgeschichtliche Probleme der Verfassungsgeschichtsschreibung', *Gegenstand und Begriffe der Verfassungsgeschichte*, Berlin 1983; 'Der Staat', *Zeitschrift für Staatslehre, Offentliches Recht und Verfassungsgeschichte*, Supplement VI, 12-16.
24. O. Brunner, *Land und Herrschaft*, Vienna 1942, 501.
25. He was successor to the influential Hermann Aubin, who also published the famous *Vierteljahresschrift für Wirtschafts- und Sozialgeschichte* from 1925 to 1967.
26. R. Koselleck, 'Begriffsgeschichtliche Probleme', 16, see also W. Schulze, *Deutsche Geschichtswissenschaft nach 1945*, 281-301: 'Von der "politischen Volksgeschichte"' zur "neuen Sozialgeschichte"'.
27. O. Brunner, *Adeliges Landleben und Europäischer Geist*, reprint Salzburg 1954, 12.
28. See for example *Alteuropa und die moderne Gesellschaft. Festschrift für Otto Brunner*, Historical Seminar of the University of Hamburg, Göttingen 1963.
29. The same passage from Land und Herrschaft quoted by R. Koselleck, 'Begriffsgeschichtliche Probleme der Verfassungsgeschichte' 16, and by W. Conze, *Geschichte Grundbegriffe*, VI 5.
30. In essence, this was a reprint of an earlier article, *'Feudalismus'. Ein Beitrag zur Begriffsgeschichte*, Akademie der Wissenschaften und der Literatuur in Mainz, 1958, 591-627.
31. R. Reichardt, Introduction, *Handbuch*, vol. I/II, Munich 1985, 63-64.
32. 'Ein Grundbegriff ligt also gerade dann vor, wenn er perspektivisch verschieden ausgelegt werden muss, um Einsicht zu finden oder Handlungsfähigkeit zu stiften', *Geschichtliche Grundbegriffe* VII, VII. Cf. Koselleck, Foreword, *Geschichtliche Grundbegriffe* VII, VI.
33. R. Reichardt, Introduction, *Handbuch*, 78-82.
34. H.U. Gumbrecht and R. Reichardt, 'Philosophe, Philosophie', *Handbuch* III (1985) 3.
35. Some of the terms Koselleck specifies are Kirche, 'Sekte', 'Kunst', 'Wissenschaft' and 'Technik'. The groups include 'Barbaren', 'Wilde', 'Heiden', 'Knecht', 'Diener' and 'Sklave'.

36. *Geschichtliche Grundbegriffe* VII, p. VII. Other older terms that Koselleck specified include 'Heiligkeit', 'Trauer', 'Martyrer', 'Gedachtnis', 'Nachwelt', 'Dieseits', 'Raum', and 'Zeit/Zeitalter'. Some of the terms from the field of ecology are 'Land', 'Landschaft', 'Erde', 'Feuer', 'Luft', 'Wasser' and 'Meer'.

37. L. van den Branden, *Het streven naar verheerlijking, zuivering en opbouw van het Nederlands in de 16de eeuw* (The Pursuit of the Glorification, Purification and Advancement of the Dutch Language in the Sixteenth Century), Ghent 1956.

38. Stevin hoped that the introduction of Dutch in science would make it more accessible for both adults and children. For a reprint of the original edition, see *The Principal Works of Simon Stevin*, vol. V, Amsterdam 1966, 465-581.

39. S. Stevin, *Het burgerlijk leven* (Bourgeois Life), printed by Nicolaes van Ravensteijn, Amsterdam 1646. For an impressive list of neologisms attributed to Stevin and compared, see K.W. de Groot, 'Het purisme van Simon Stevin' (The Purism of Simon Stevin), in *De Nieuwe Taalgids* 13 (1919) 161-182.

40. Important work in this field has been done by Martin van Gelderen, *The political thought of the Dutch Revolt (1555-1590)*, Cambridge 1992, and *The Dutch Revolt*, Cambridge 1993.

41. The results produced by these work groups are to be published in the near future. N. van Sas (ed.) *De ontwikkeling van het begrip Vaderland in Nederland van de late Middeleeuwen tot de twintigste eeuw* (The Development of the Concept of the Fatherland in the Netherlands from the Late Middle Ages to the Twentieth Century). E. Haitsma Mulier and W. Velema (eds.), *De ontwikkeling van het Nederlandse Vrijheidsbegrip van de Late Middeleeuwen tot de twintigste eeuw* (The Development of the Dutch Concept of Freedom from the Late Middle Ages to the Twentieth Century). P. den Boer (ed.). *Omtrent hoofsheid en beschaving. Aanzet tot begripshistorisch onderzoek* (On Courtliness and Civilization. A First Step toward Conceptual History Research).

42. J. Huizinga, 'Nederland's geestesmerk' (The Mark of the Dutch Mind), *Verzamelde Werken* (Collected Works), Haarlem 1948-1953, VII 291.

CHAPTER 2

1. Originally published under the title 'Sozialgeschichte und Begriffsgeschichte' in W. Schieder and V. Sellin, *Sozialgeschichte in Deutschland*, Vol. I, Göttingen 1986, 89-109. Apart from the books and articles mentioned in the notes and in other contributions to this volume, the following titles may be recommended: Eugenio Coseriu, *Synchronie, Diachonie und Geschichte*, Munich 1974; Hans-Georg Gadamer, *Die Begriffsgeschichte und die Sprache der Philosophie*, Opladen 1971; Reinhart Koselleck (ed.), *Historische Semantik und Begriffsgeschichte*, Stuttgart 1978; Régine Robin, *Histoire et linguistique*, Paris 1973; Irmline Veit-Brause, 'A Note on Begriffsgeschichte', *History and Theory* 20 (1981) 61-67.

2. H. G. Meier, Article 'Begriffsgeschichte', in *Historisches Wörterbuch der Philosophie* Vol. 1, Basel/ Stuttgart 1971, cols. 788-808.

3. R. Eucken, *Geschichte der philosophischen Terminologie*, Leipzig 1879 (reprint 1964).

4. O. Brunner, *Land und Herrschaft*, 2nd ed., Brno/Munich/Vienna 1942, xi.; *Land and Lordship: Structures of Governance in Medieval Austria*, trans. Howard Kaminsky and James Van Horn Melton, Philadelphia, 1992.

5. See W. Conze, 'Zur Gründung des Arbeitskreises für moderne Sozialgeschichte', *Hamburger Jahrbuch für Wirtschafts- und Gesellschaftspolitik* 24 (1979) 23-32. Conze himself preferred the term 'structural history', in order to avoid the restriction to 'social questions' that the word 'social' often brought with it. Otto Brunner took up the term 'structural history' in order to avoid the restriction – dictated by the times in which he was writing – to a 'history of the German people' [*Volksgeschichte*], which, following his theoretical premises, was, even in 1939, directed towards structures. On this, compare the second edition of *Land und Herrschaft* (1942), 194, with the fourth revised edition (Vienna/

Wiesbaden 1959) 164. This is a good example of how even politically dictated cognitive interests can produce new theoretical and methodological insights which outlast the situation in which they arose.

6. See Hayden White, *Tropics of Discourse*, Baltimore and London, 1982².

7. On this see the D. Schwab's article 'Familie' in *Geschichtliche Grundbegriffe* Vol. 2, Stuttgart 1975, 271-301; E. Kapl-Blume, *Liebe im Lexikon*, MA thesis, Bielefeld 1986.

CHAPTER 3

1. Whilst writing this essay, I have benefitted greatly from discussions with Martin van Gelderen, Hans Bödeker, Dario Castiglione and my two co-editors, and from the comments of audiences at the Netherlands Institute for Advanced Study, Wassenaar and at the Universities of Amsterdam and Leiden.

2. The major substantive works are Quentin Skinner, *Foundations of Modern Political Thought*, 2 vols., Cambridge 1978; and J.G.A. Pocock, *The Machiavellian Moment. Florentine Political Thought and the Atlantic Republican Tradition*, Princeton 1975. Methodological works are cited in the body of this chapter as appropriate. Major representative methodological statements of each author are: Quentin Skinner 'Meaning and Understanding in the History of Ideas' reprinted in James Tully (ed.), *Meaning and Context: Quentin Skinner and his Critics*, Cambridge 1988; and J.G.A.Pocock, 'The State of the Art' in Pocock, *Virtue Commerce and History* (itself one of the 'Ideas in Context' series), Cambridge 1985. Assessments and bibliographies can be found for Skinner in J.Tully, *Meaning and Context*, Cambridge 1988, and for Pocock in I.W.Hampsher-Monk, 'Political Languages in Time: The work of J.G.A.Pocock' in *The British Journal of Political Science* XIV no.1 (1984) 89-116.

3. Quotations are drawn from the series description found in all volumes, facing the title page, e.g. Peter N. Miller, *Defining the Common Good, Empire, religion and philosophy in eighteenth century Britain*, Cambridge 1994, ii.

4. The origins of the Centre are described in 'The History of British Political Thought: the Creation of a Centre', J.G.A.Pocock, *Journal of British Studies*, 24 3(1985) 283-310; *Proceedings of the Center for the Study of the History of British Political Thought*, Gen. ed. Gordon Schochet, 5 vols., Washington D.C. 1990-1993; and J.G.A.Pocock with Gordon J.Schochet and Lois G.Schwoerer (ed.), *Varieties of British Political Thought 1500-1800*, Cambridge 1991. Other more specialist works relate intimately to particular portions of that seminar. Amongst those which are closest to the interests of conceptual history are Terence Ball and J.G.A. Pocock (eds.), *Conceptual Change and the Constitution*, Lawrence Kansas 1988, Linda Levy Peck, *The Mental World of the Jacobean Court*, Cambridge 1991, R.A. Mason (ed.), *Scots and Britons: Scottish Political Thought and the Union of 1603*, Cambridge, and J.C. Robertson (ed.) *A Union for Empire: the Union of 1707 in the Context of British Political Thought*, Cambridge.

5. Few such comparisons have come to my notice. The major exception and persistent anglophone champion of *Begriffsgeschichte*, in a number of articles published between 1986 and the present, has been Melvin Richter. His 'Pocock, Skinner and the *Geschichtliche Grundbegriffe*' appeared in *History and Theory* 19(1990) 38-70 and is now superseded by his critical introduction *The History of Political and Social Concepts*, Oxford 1995, which appeared after the writing of the conference paper on which this chapter was based. Chapter 6 contains an extended comparison of *Begriffsgeschichte*, Pocock and Skinner, however even Richter's comparison focuses on their methodological prescriptions rather their intellectual entrepreneurship. See also 'Editorial' by Michael Freeden, *Journal of Political Ideologies* 2/1 (1997) 3-11.

6. For example the contributions to the volume by Pim den Boer and Hans Bödeker.

7. J.G.A. Pocock 'The History of Political Thought: a methodological enquiry' in *Politics, Philosophy and Society*, ser. 2, Oxford 1962, and Quentin Skinner's 'Meaning and Understanding in the History of Ideas', *History and Theory* 8 (1969), reprinted in James Tully (ed.) *Meaning and Context: Quentin Skinner and his Critics*, Cambridge 1988.

8. When I was an undergraduate my notoriously controversial Professor of Philosophy Anthony Flew, began his first year lectures with the following announcement: 'Today I begin our Introduction to Philosophy course. I shall be lecturing on Plato for the first term, and I don't want to hear anyone complaining that we aren't doing contemporary philosophy because we are!'.

9. Thus Pocock remarked in 1969: 'the history of political thought has a constant tendency to become philosophy.' Curiously, Pocock sees this as driven not only by misplaced philosophical standards, but also by historical demands of narrative coherence. Pocock, 'History of political thought', *Politics, Philosophy and Society*, 187. Cf. the not entirely dissimilar position of Koselleck in 'Terror and Dream: Methodological Remarks on the Experience of Time during the Third Reich' in Reinhart Koselleck (tr. Keith Tribe), *Futures Past: on the semantics of historical time*, Cambrige Mass. 1985, 215; original *Vergangene Zukunft. Zur Semantik geschichtlicher Zeiten*, Frankfurt am Main 1979. A provoking and sensitive discussion on the relationship between this kind of political theory and various strands within the 'historical revolution' is provided by Dario Castiglione 'Historical Arguments in Political Theory' *Political Theory Newsletter* 5 (1993) 89-109.

10. This is not to say that these claims were not often advanced with considerable erudition and scholarship. On Marsilius and Hobbes as liberals see A.Gewirth *Marsilius of Padua - the Defender of the Peace*, 2 vols, London and New York 1961, and Leo Strauss *The Political Philosophy of Hobbes, its basis and genesis*, Oxford 1936, Plato's totalitarianism is famously unmasked in Karl Popper: *The Open Society and its Enemies,* 2 vols., volume I: *The Spell of Plato*, London 1945; and the locus classicus for Rousseau is the surprisingly short chapter by J.L.Talmon in his *Origins of Totalitarian Democracy*, London 1952. See my 'Rousseau and Totalitarianism - with hindsight?' in Robert Wokler (ed.), *Rousseau and Liberty*, Manchester 1995, 267-88.

11. Amongst the works cited by Skinner as engaging in this and related practices which involve 'reifying' doctrines, many but by no means all, emerging from Political Science Departments, are the following: Ernst Cassirer, *The Philosophy of the Enlightenment*, Boston 1955; G.E.G.Catlin, *A History of Political Philosophy*, London 1950; J.W. Gough, *John Locke's Political Philolosophy*, Oxford 1950; Andrew Hacker, *Political Theory: Philosophy Ideology, Science*, New York 1961; Peter H. Merkl, *Political Continuity and Change*, New York 1967; Christopher Morris, *Political Thought in England from Tyndale to Hooker*, Oxford 1953; Hans J. Morgenthau, *Dilemmas of Politics*, Chicago 1958; John Plamenatz, *Man and Society* 2 vols, London 1963; Bertrand Russell *History of Western Philosophy*, New York 1946; G.H. Sabine, *A History of Political Theory*, London 1951; Leo Strauss, *History of Political Philosophy*, Chicago 1963; T.D. Weldon, *States and Morals*, London 1946.

12. This paragraph summarizes the structure of Skinner's argument in sections I and II of 'Meaning and Understanding', *Meaning and Context*, 30-50. A number of these points – particularly the tendency to reorganize thought to a higher level are also to be found in Pocock's 1969 article.

13. The most salutary example of this was the virtual ignoring of the English Civil War thinker James Harrington, whose work was neither philosophical, in the sense of engaging in metaphysical or epistemological preliminaries, nor it must be said a model of clarity. As Pocock has shown, however, he is the pivotal figure both for the transmission of civic republican thought and for English historiographical self-understanding in the later seventeenth and eighteenth centuries. See the seminal 'Machiavelli, Harrington and English Political Ideologies in the Eighteenth Century', *William & Mary Quarterly* 3rd ser. vol. XXII/4 (1965) reprinted in Pocock *Politics Language and Time*, Chicago and London, Chicago 1971, as well as Chapters 11 and 12 in *The Machiavellian Moment*. Pocock's edition of *The Political Works of James Harrington*, Cambridge 1977, contains a 150 page introduction which includes a substantial chapter on 'Harrington's ideas after his lifetime'.

14. The classic case here was the assumption that Locke, simply because he came after Hobbes, was in some sense 'responding' to him. That Locke was virtually oblivious of Hobbes, and the vital importance of recognising Filmer as the adversary in order to understand Locke's argument was demonstrated by Peter Laslett in his crucial edition of Locke's *Two Treatises of Government*, Cambridge, Cambridge University Press, 1960 – a work which exerted a seminal influence on Skinner's early understanding of context, Skinner, 'Reply to my Critics', *Meaning and Context*, 327 fn.12.

15. Although this essay focusses on only the first two, John Dunn's early methodological essay 'The Identity of the History of Ideas' in *Philosophy*, XLIII (April 1968), reprinted *Politics, Philosophy and Society IV*, ed. by P. Laslett, W.G. Runciman and Quentin Skinner, Oxford 1972, and in John Dunn, *Political Obligation in its Historical Context*, Cambridge 1980, was one of the trio of works invariably cited as initiating the historical revolution. The other two were Pocock's 'History of Political Thought a Methodological Enquiry' in *Politics Philosophy and Society II*, Oxford 1962, and Skinner's own 'Meaning and Understanding in the History of Ideas', first published in *History and Theory* 8 (1969) and reprinted in J. Tully (ed.), *Meaning and Context*, Cambridge 1988. Skinner generously credits Dunn with the insight that Austin's theory of speech-acts might be relevant to the interpretation of texts in the history of political thought. 'A Reply to my Critics', *Meaning and Context*, 327 fn 12.
16. '...A methodological enquiry', 187.
17. Thus Locke turns out not to be related to Hobbes at all, but, antithetically to Filmer (as shown by Laslett), and by way of his construal of the language of sovereignty to George Lawson (Julian Franklin), possibly the Levellers and ultimately Calvinist resistance theorists (Quentin Skinner).
18. 'When we speak of 'languages', therefore, we mean for the most part sub-languages: idioms, rhetorics, ways of talking about politics, distinguishable games of which each may have its own vocabulary, rules, preconditions and implications, tone and style.' 'The Concept of a Language and the *Metier d'Historien*: some considerations on practice' in Anthony Pagden (ed.), *The Languages of Political Theory in Early-Modern Europe*, Cambridge 1987.
19. This was particularly true in Pocock's first work, *The Ancient Constitution and the Feudal Law*, Cambridge 1957, reissued 1987, where Common Lawyers, Royalists and Antiquarians formed different and eventually ideologically conflicting conceptions of the past.
20. Pocock: 'The Owl Reviews his Feathers: a valedictory lecture', xerox, Johns Hopkins University, May 11th 1994: the history of political thought 'has been becoming all my life less a history of thought than of language, discourse, literature' (18).
21. See most enthusiastically, *Politics Language and Time*, preface to reprint, Chicago and London 1989, x, and the first and last essays therein 'Languages and their Implications' and 'On the Non-revolutionary Character of Paradigms', but note in 'The Concept of a Language'(21): 'we may think of them as having the character of paradigms, in that they operate so as to structure thought and speech in certain ways and to preclude their being structured in others, we may not describe them as paradigms if the term implies that preclusion has been successfully effected'.
22. 'Languages and their Implications', 25; 'The Concept of a Language', 23; 'The state of the art', 7.
23. 'Burke and the Ancient Constitution', in *Historical Journal* III/2 (1960) and in *Politics Language and Time*.
24. This is not quite the idiom in which Pocock puts the point see 'The Concept of a Language', 26-7, but it seems concisely appropriate.
25. 'State of the art', *Virtue Commerce and History*, 10.
26. 'The concept of a language', 26-27; and less formally 'State of the art', 10.
27. There *were* such thinkers as Sheldon Wolin's 'Epic Theorists': the 'fully self-conscious linguistic performer', Hobbes was one such, but their identification was a matter of empirical historical research. Pocock, *Virtue Commerce and History*, 'Introduction: the state of the art', 16-17.
28. See Hobbes, *Leviathan*, ed. R. Tuck, Cambridge 1991, 395-396 (protection and obedience); Chapter 42 *passim*, esp. 271 ('profession with the tongue is but an externall thing'; 285 ('internall faith is in its own nature invisible, and consequently exempted from all humane jurisdiction') page numbers cited from original.
29. 'State of the art', 21; the reference is to Stanley Fish, *Is There a Text in This Class? The Authority of Interpretive Communities*, Cambridge, Mass. 1980.
30. 'Languages and their Implications', *Politics, Language and Time*, 6.
31. A. Lockyer, 'Pocock's Harrington', *Political Studies*, XXVIII/3 (1980).
32. See 'Languages and their Implications' *Politics, Language and Time*, 23-4. 'It is true that [a user of language] could not have meant to convey any message which the resources of language in his lifetime

did not render it possible for him to have meant; ... but within these limits there is room for it to have happened to him (as it happens to all of us) to mean more than he said or to say more than he meant.' Also 'State of the art', 20-1. Pocock's emphasis seems to have shifted here. The early works, and the flirtation with the 'paradigm', suggest logic or grammar as the primary quality of the 'language', the later offers a less formalistic characterisation as 'idiom' or rhetoric. 'It is a history of rhetoric rather than grammar, of the affective and effective content of speech rather than its structure.' 'The concept of a language', 22

33. For example: 'The Concept of a Language and the *Métier d'historien*' where he proposes 'to let them [metatheory, a general theory of language] arise, if they arise at all, out of the implications of what I shall be saying we as historians do. The *Métier d'historien* ... is primarily his craft or practice' (19).

34. J.L. Austin, *How to do things with Words*, edited by J.O. Urmson, Oxford Oxford University Press 1962 [delivered as the William James Lectures, Harvard, 1955]; John R. Searle, *Speech Acts, an essay in the Philosophy of Language*, Cambridge 1969.

35. British Rail once took to issuing 'pre-warnings'. Thus if the Buffet on the train was going to close down – characteristically just before supper time on long journeys – the passengers would be warned, but before being warned, there would be a pre-warning – that there was going to be a warning. But a pre-warning, as I pointed out in what I believe to be the only letter the *Guardian* has ever published on the subject of speech acts, is a logical impossibility. By uttering the word 'warning' you do in fact and irresistibly warn and no pre-warning can soften the blow.

36. Austin, *How to do things with Words*, 98 ff. For the formal elaboration of the rules see John Searle, *Speech Acts*, Cambridge 1969, Chapter 3, 'The Structure of Illocutionary Acts'.

37. William Shakespeare, *Henry IV* pt.1, Act III, 1, ll.53-5.

38. Here Skinner drew on another topic from contemporary philosophy of action, the relationship between action, intention and convention. G.E.M. Anscombe, *Intention*, Oxford 1957; A.I. Meldon, *Free Action*, New York, Humanities; Peter Geach, *Mental Acts*, London.

39. See the classic article by John Searle 'How to derive "ought" from "is"', *The Philosophcal Review*, January 1964.

40. 'Meaning and Understanding', in Tully (ed.), *Meaning and Context*, 55.

41. As may have happened during the attainder of Strafford in 1641 when Edmund Waller asked in the English Parliament – as if for a specific list of statutes – what the fundamental laws of the Kingdom were, and was told by speaker Maynard, that if he didn't know he had no business sitting in the House!

42. 'Meaning and Understanding', in Tully (ed.), *Meaning and Context*, 63-64.

43. The theory of speech acts may be approached most easily in J.L. Austin's *How to do things with words*. A more developed account is John R.Searle's *Speech Acts: an essay in the philosophy of language*, Cambridge 1969; Skinner's major statement was 'Meaning and Understanding in the History of Ideas', *History and Theory* 8 (1969), reprinted with other essays by him, criticisms of his position and his 'Reply to My Critics'.

44. Especially: 'Meaning and Understanding', in Tully (ed.), *Meaning and Context*, 48, 55, 64; 'Motives, intentions and Interpretation', in *Ibidem* 76-7. On *The Prince* as subversive see Skinner, *Foundations of Modern Political Thought*, vol.I, 128 ff., and less extensively in 'Introduction' to *The Prince*, ed. Quentin Skinner and Russell Price, Cambridge 1988.

45. For example in 'Some Problems in the Analysis of Political Thought and Action', 114 ff. Pocock broadly endorses this account, 'The Concept of a Language', 34.

46. That illocutionary verbs are vulnerable to this kind of subversion follows logically from the fact that they are definable in terms of rules, the criterion for the application of which cannot be exhaustively specified. This is hinted at by Searle, *Speech Acts*, 71.

47. For examples of Pocock's approach and anglophone conceptual history applied here see J.G.A.Pocock, 'The Americanization of Virtue', ch. 5 of *Machiavellian Moment*; Ball and Pocock (eds.), *Conceptual Change and the Constitution*.

48. Paul Adams, 'Republicanism in Political Rhetoric before 1776', in *Political Science Quarterly* LXXXV (1970).

49. For a fuller account see T. Ball '*A Republic – if you can keep it*' in: Ball and Pocock (eds.), *Conceptual Change*; and Hampsher-Monk, 'Publius, *The Federalist*', in *A History of Modern Political Thought*, Oxford 1992, 227-231.

50. Dario Castiglione, *Political Theory Newsletter*, 5/2 (1993) 89-109, esp, 92-4. Pocock considers the interplay between language and speech act in 'The State of the Art' in *Virtue Commerce and History*, esp. 4-7 and ff.; Skinner indicates the inadequacy of 'language' itself as the unit of analysis in 'Some Problems in the Analysis of Political Thought and Action' in Tully (ed.), *Meaning and Context*, 106.

51. Skinner advances the view that 'One way of describing my original [methodological] essays would be to say that I merely tried to identify and restate in more abstract terms the assumptions on which Pocock's and especially Laslett's scholarship seemed to me to be based.' 'Reply to my Critics' in Tully, *Meaning and Context*, 233.

52. 'Concepts and Discourses: a Difference in Culture?' conference paper, in *The Meaning of Historical Terms and Concepts - new studies on Begriffsgeschichte* ed. Hartmut Lehmann and Melvin Richter, German Historical Institute Occasional Papers no. 15 (German Historical Institute, Washington DC. 1992), 48.

53. 'Problems in the Analysis of Political Thought and Action', *Meaning and Context*, 106

54. 'The Concept of a Language' in Pagden (ed.) *Languages of Political Theory*, 29ff.

55. Skinner, *Foundations of Modern Political Thought* I xi.

56. Pocock responds to Melvin Richter's characterisation of *Begriffsgeschichte* in the German Historical Institute of Washington's Occasional Paper, 15 'The Meaning of Historical Terms and concepts, new studies on *Begriffsgeschichte*', ed. Hartmut Lehmann and Melvin Richter, Washington DC, German Historical Institute, 1996.

57. Skinner, for example in an extended discussion of Raymond Williams's *Keywords* which might be described as essays in conceptual or at least lexical history, 'Language and Social Change', in *Meaning and Context*. The concerns of Pocock's 'Modes of Political and Historical Time' in *Virtue Commerce and History*, bear a striking resemblance to those of Koselleck's essays (especially 'Modernity and the Planes of Historicity' and 'History, Histories and Formal Structures of Time') in *Futures Past*.

58. 'Reply to my critics', 283.

59. His *The History of Political and Social Concepts, a critical introduction*, Oxford 1995, includes material from a number of previously published essays. One should also mention Keith Tribe's path-breaking and prescient effort in translating *Futures Past* as long ago as 1979, Cambridge, Mass.

60. In a critical response to one of Richter's earlier articles, Jeremy Rayner claims that Richter is wrong to present it as an end in itself, and so a direct alternative to the 'Cambridge School', when Koselleck et. al. themselves present it as an aid to the understanding of history more broadly understood. Rayner, 'On *Begriffsgeschichte*', *Political Theory* 16/3 (1988).

61. Translator's introduction, to Koselleck *Futures Past*, xiii.

62. Koselleck, '*Begriffsgeschiche* and Social History', *Futures Past*, 80.

63. *Ibidem* 79.

64. *Ibidem* 80.

65. '*Begriffsgeschiche* & Social History', *Futures Past*, 85, 88.

66. '"Neuzeit"', *Futures Past*, 231.

67. Whilst Pocock tends to the former ('it is not my business to say that language is the only ultimate reality' – 'Concepts and Discourses' 9); Skinner tends to the latter (See his approving summative quotation of Charles Taylor's stress on the 'artificiality of the distinction between social reality and the language of description of that social reality.' 'Language and Social Change' in Tully (ed.), *Meaning and Context*, 132. However, see also Pocock, 'Political Ideas as historical events: Political Philosophers as Historical Actors', in M. Richter (ed.), *Political Theory and Political Education*, Princeton 1980.

68. James Farr, 'Understanding Conceptual Change Politically', in Terence Ball, James Farr and Russell Hanson (eds.), *Political Innovation and Conceptual Change*, Cambridge 1989, 31.

69. For example, on the linguistic problem of founding as a speech act see Bonnie Honig, 'Declarations of Independence: Arendt and Derrida on the problem of founding a republic.' *American Political Science Review* 85/1 (1991).
70. Keith Baker, *Inventing the French Revolution*, Cambridge, 1990, 9.
71. *Ibidem* 204.
72. Iain Hampsher-Monk, 'On not performing the British Revolution', paper presented to the Anglo American Conference, Historical Institute, London 1990.
73. '*Begriffsgeschiche* and Social History', *Ibidem* 82.
74. *Ibidem* 81, 82.
75. *Ibidem* 80.
76. James Farr, 'Understanding Conceptual Change Politically', in Terence Ball, James Farr and Russell L.Hanson (eds.), *Political Innovation and Conceptual Change*, Cambridge 1989.
77. The essays in *Political Innovation and Conceptual Change* come as close to contradicting this assertion as any, but notice how the most successful of them – that by Quentin Skinner on the State, is actually an exploration of the different ways in which the word state and its cognates changed its meaning within a number of different renaissance and early modern political languages, it is thus more the story of range of languages than the story of a single concept. The least successful, in my view – that of Hanson on Democracy– is so because if fails to locate the discussion of the word within any identifiable discrete language(s).
78. *Futures Past*, '*Begriffsgeschiche* and Social History, 90, 86, 79; 'Representation Event Structure', *passim* esp. 115.
79. Cf. Richter, *History of Political and Social Concepts*, 10.
80. 'Meaning and Understanding', *Meaning and Context*, 55-6.

CHAPTER 4

1. Cf. Reinhart Koselleck, 'Begriffsgeschichtliche Probleme der Verfassungsgeschichtsschreibung', in *Gegenstand und Begriffe der Verfassungsgeschichtsschreibung*, supplement to *Der Staat* VI, Berlin 1983, 15.
2. R. Koselleck, 'Einleitung' [Introduction] in: Otto Brunner, Werner Conze, Reinhart Koselleck (eds.), *Geschichtliche Grundbegriffe. Historisches Lexikon zur politisch-sozialen Sprache in Deutschland*, Vol. I, Stuttgart 1972, xiii-xxviii.
3. *Ibidem* xiiif.
4. *Ibidem passim.*
5. Cf. Reinhart Koselleck, 'Begriffsgeschichte und Sozialgeschichte', in Peter-Christian Ludz (ed.), *Soziologie und Sozialgeschichte. Aspekte und Probleme*, Opladen 1972, 117; cf. also the contribution of Koselleck to this volume; see also Helmut Berding, *Begriffsgeschichte und Sozialgeschichte*, in *HZ* 223 (1976) 98-110.
6. Koselleck, *Ibidem.*
7. Cf. Koselleck, 'Einleitung' in *Geschichtliche Grundbegriffe* XXI. On semasiology and anomasiology see Introduction, 2.
8. Koselleck, 'Begriffsgeschichte und Sozialgeschichte', *Soziologie und Sozialgeschichte*, 121.
9. Koselleck refers to this again and again in all of his theoretical drafts.
10. Cf. Koselleck, 'Einleitung' in *Geschichtliche Grundbegriffe*, p. xvi-xix.
11. On 'context' see Melvin Richter, *The History of Political and Social Concepts. A Critical Introduction*, New York/Oxford 1995.
12. Reinhart Koselleck, 'Richtlinien für das Lexikon politisch-sozialer Begriffe der Neuzeit', in *Archiv für Begriffsgeschichte* XI (1967) 81.
13. Reinhart Koselleck, 'A Response to Comments on the Geschichtliche Grundbegriffe', in Hartmut Lehmann, Melvin Richter (eds.), *The Meaning of Historical Terms and Concepts. New Studies on*

Begriffsgeschichte, Washington D.C., German Historical Institute, Washington D.C., Occasional Paper No 15 (1996) 69.

14. On criticism of *Grundbegriffe*, cf. especially: Peter von Polenz, 'Rezension der *Geschichtlichen Grundbegriffe Vol. I*', in *Zeitschrift für germanistische Linguistik 1* (1973) 235-241; Reinhart Koselleck (ed..), *Historische Semantik und Begriffsgeschichte*, Stuttgart 1978; Joachim Busse, *Historische Semantik. Analyse Programms*, Stuttgart 1987; as well as the recent work, Lehmann and Richter (eds.), *The Meaning of Historical Terms and Concepts*.

15. This is commented on several times in reviews of the *Lexikon*, e.g. Polenz, 'Rezension', *Zeitschrift für germanistische Linguistik* (1973) 239; and also Busse, *Historische Semantik, passim*.

16. Rolf Reichardt, 'Einleitung' in: Rolf Reichardt and Eberhardt Schmitt in collaboration with Gerd van den Heuvel and Anette Höfer (eds.), *Handbuch politisch-sozialer Grundbegriffe in Frankreich*, Munich 1985, pp. 39-148, p. 25f.

17. Cf. Rolf Reichardt, 'Zur Geschichte politisch-sozialer Begriffe in Frankreich zwischen Absolutismus und Restauration. Vorstellung eines Forschungsvorhabens' in: Brigitte Schlieben-Lange and Joachim Gessinger (eds.), *Sprachgeschichte und Sozialgeschichte. Zeitschrift für Literaturwissenschaft und Linguistik* 12/47 (1982) 49-74; Reichardt, 'Einleitung', *Ibidem*.

18. This is the thrust of the criticism in, especially, Dietrich Busse, *Historische Semantik*, 77ff. See also the contributions of Hampsher-Monk and Van Gelderen in this volume.

19. Koselleck uses 'concept' (*Begriff*) as a hyponym for 'word'; cf. Koselleck, 'Begriffsgeschichte und Sozialgeschichte', *Soziologie und Sozialgeschichte*, 119; however, this is not always the case; on this, see Peter von Polenz, Rezension, 237: 'Here, concepts, as units of the expressive side of language, are very much a special class of words (..). On the other hand, concept is also defined as a unit of the content side of language.'

20. Cf. Koselleck, 'Richtlinien', *Archiv für Begriffsgeschichte* (1967) 86.

21. Cf. Koselleck, 'Einleitung' in *Geschichtliche Grundbegriffe*, xx, xxiif.

22. On the reconstruction of abstraction in terms of logic and language use theory, cf. Wilhelm Kamlah, Paul Lorenzen, *Logische Propädeutik. Vorschule des verünnftigen Redens*, Mannheim 1967, 99ff.

23. Cf. Koselleck, 'Einleitung' in *Geschichtliche Grundbegriffe*, xx, xxiiff.; and Koselleck, 'Begriffsgeschichte und Sozialgeschichte', *Soziologie und Sozialgeschichte*, 123; see, on the other hand, 'Einleitung', xxiii: 'the meaning of words can be defined more exactly, concepts can only be interpreted.'

24. Koselleck, 'Richtlinien', *Archiv für Begriffsgeschichte* (1967) 86.

25. Cf. for example Koselleck in 'Richtlinien', *Archiv für Begriffsgeschichte* (1967) 86; and in 'Begriffsgeschichte und Sozialgeschichte', *Soziologie und Sozialgeschichte*, 124; as well as 'Einleitung' in *Geschichtliche Grundbegriffe*, xxiif.

26. On linguistic criticism of the general concept of *Begriffsgeschichte*, cf. especially, Dietrich Busse, *Historische Semantik*.

27. Koselleck drew attention to this again and again, for the first time in 'Richtlinien', *Archiv für Begriffsgeschichte* (1967) *passim*.

28. Koselleck, 'Begriffsgeschichte and Social History' in *Economy and Society* 11 (1982) 420.

29. Cf. Jürgen Kocka, Artikel 'Angestellter', in Brunner e.a. (eds.), *Geschichtliche Grundbegriffe*, Vol. I, 110-128, here p. 122.

30. Cf. Koselleck, 'Einleitung' in *Geschichtliche Grundbegriffe, passim*.

31. Cf. Koselleck, 'Begriffsgeschichte und Sozialgeschichte', *Soziologie und Sozialgeschichte*, 118ff., 124f.

32. Koselleck, 'Begriffsgeschichte und Sozialgeschichte', *Soziologie und Sozialgeschichte*, 118ff.

33. Cf., for example, Koselleck, 'Begriffsgeschichte und Sozialgeschichte', *Soziologie und Sozialgeschichte*, 118.

34. *Ibidem*.

35. *Ibidem* 123.

36. *Ibidem* 118.

37. Cf. Koselleck, 'Begriffsgeschichte und Sozialgeschichte', *Soziologie und Sozialgeschichte*, 118f.

38. Koselleck, 'Richtlinien', *Archiv für Begriffsgeschichte* (1967) 89.

39. Rolf Reichardt, 'Zur Geschichte politisch-sozialer Begriffe' in Schlieben-Lange and Gessinger (eds.), *Zeitschrift für Literaturwissenschaft und Linguistik* (1982) 58. See Chapter 12.

40. Clemens Knobloch, 'Überlegungen zur Theorie der Begriffgeschichte aus sprach- und kommunikationswissenschaftlicher Sicht' in: *Archiv für Begriffsgeschichte* 24 (1994) 7-24, here 22.

41. On the theoretical context, cf. Busse, *Historische Semantik*, 39ff.

42. Koselleck, 'Einleitung' in *Geschichtliche Grundbegriffe*, xxii, xiiii.

43. Cf. Koselleck, 'Einleitung' in *Geschichtliche Grundbegriffe*, xxii.

44. This was already emphasized in Koselleck, 'Richtlinien', *Archiv für Begriffsgeschichte* (1967) 84f; and in 'Begriffsgeschichte und Sozialgeschichte', *Soziologie und Sozialgeschichte*, 125. See also Melvin Richter, *The History of Political and Social Concepts*, 47ff.

45. Cf. earlier, Koselleck, 'Richtlinien', *Archiv für Begriffsgeschichte* (1967) 83ff. The danger here of reducing the framework to a mere history of ideas or history of things was explained most concisely by Busse, *Historische Semantik, passim*.

46. Koselleck, 'Einleitung' in *Geschichtliche Grundbegriffe*, xxiif.

47. Cf Koselleck, 'Richtlinien', *Archiv für Begriffsgeschichte* (1967) 87.

48. Rolf Reichardt, 'Zur Geschichte politsch-sozialer Begriffe' in: Schlieben-Lange and Gessinger (eds.), *Zeitschrift für Literaturwissenschaft und Linguistik* (1982) 52.

49. *Ibidem* 53.

50. On such approaches, Hans-Ulrich Gumbrecht, 'Für eine phänomenologische Fundierung der sozialhistorischen Begriffshistorie', in: Reinhart Koselleck (eds.), *Historische Semantik*, 75-101.

51. Clemens Knobloch, 'Überlegungen zur Theorie der Begriffgeschichte', *Archiv für Begriffsgeschichte* (1994) 10.

52. On the discussion of 'meaning' as 'use', cf. Busse, *Historische Semantik*, 115-122.

53. *Ibidem* 117.

54. Koselleck, 'Einleitung' in *Geschichtliche Grundbegriffe*, xxiii.

55. *Ibidem* xxi.

56. Koselleck, 'Response' in Lehmann and Richter (eds.), *The Meaning of Historical Terms and Concepts*, Occasional Paper No 15 (1996) 61.

57. Koselleck, 'Einleitung' in *Geschichtliche Grundbegriffe*, xiii.

58. Cf. Koselleck, 'Einleitung' in *Geschichtliche Grundbegriffe*, xxvif.

59. Koselleck, 'Einleitung' in *Geschichtliche Grundbegriffe*, xxi.

60. Koselleck, 'Begriffsgeschichte und Sozialgeschichte', *Soziologie und Sozialgeschichte*, 125.

61. Koselleck, 'Sozialgeschichte und Begriffsgeschichte', in Wolfgang Schieder and Volker Sellin (eds.), *Sozialgeschichte in Deutschland. Vol. 1: Die Sozialgeschichte innerhalb der Geschichtswissenschaft*, Göttingen 1986, 86-107, here 95.

62. Koselleck, 'Probleme der Relationsbestimmung der Texte zur revolutionären Wirklichkeit' in: Reinhart Koselleck and Rolf Reichardt (eds.), *Die Französische Revolution als Bruch des gesellschaftlichen Bewußtseins*, Munich 1988, 664-666; on Koselleck's theoretical approaches, see also Reinhart Koselleck, Hans-Georg Gadamer, *Hermeneutik und Historik*, Heidelberg 1987; and Reinhart Koselleck, 'Linguistic Change and the History of Events', in *Journal of Modern History* 61 (1989) 649-666.

63. Koselleck, 'Einleitung' in *Geschichtliche Grundbegriffe*, xxi .

64. Koselleck, 'Sozialgeschichte und Begriffsgeschichte', *Soziologie und Sozialgeschichte*, 94.

65. Koselleck, 'Feindbegriffe', in *Deutsche Akademie für Sprache und Dichtung*, 1993 Yearbook, 83-90, here 84.

66. Dietrich Hilger, '12 Thesen zur Begriffsgeschichte', in *Protokoll der Tagung über Methodenfragen der politisch-historischen Semantik*, MS Bielefeld 1975, cited in Hans-Kurt Schulze, 'Mediävistik und Begriffsgeschichte', in Koselleck (ed.), *Historische Semantik*, 243f.

67. Rolf Reichardt, 'Zur Geschichte politisch-sozialer Begriffe', in Schlieben-Lange and Gessinger (eds.), *Zeitschrift für Literaturwissenschaft und Linguistik* (1982) 53.

68. Koselleck, 'Response' in Lehmann and Richter (eds.), *The Meaning of Historical Terms and Concepts*, Occasional Paper No 15 (1996) 62.

69. Cf. Busse, *Historische Semantik*, 95f.

70. Kurt Röttgers, 'Philosophische Begriffsgeschichte', in *Dialektik* 16 (1988), 158-176, here 161.

71. Werner Bahner, 'Sprache und Geschichtswissenschaft', in Hans Bleibtreu and Werner Schmidt (eds.), *Demokratie, Antifaschismus und Sozialismus in der deutschen Geschichte*, Berlin 1988, 322.

72. Koselleck, 'Einleitung' in *Geschichtliche Grundbegriffe*, xxiii; cf. also 'Richtlinien', *Archiv für Begriffsgeschichte* (1967) 88.

73. For the first concise overview from a historian's perspective that is critical of *Begriffsgeschichte*, cf. Peter Schöttler, 'Historians and Discourse Analysis', in *History Workshop* 27 (1989) 37-65.

74. Koselleck, 'Response' in Lehmann and Richter (eds.), *The Meaning of Historical Terms and Concepts*, Occasional Paper No 15 (1996) 65.

CHAPTER 5

1. See, to mention only a few recent works, Michael Stolleis, *Staat und Staatsräson in der Neuzeit*, Frankfurt am Main 1990; Enzo Baldini (ed.), *Botero e la 'Ragion di Stato'*, Firenze 1992; Maurizio Viroli, *From Politics to Reason of State*, Cambridge 1992; Gianfranco Borrelli, *Ragion di Stato e Leviatano*, Bologna 1993; Hans Blom, *Morality and Causality in Politics. The Rise of Naturalism in Dutch Seventeenth Century Political Thought*, Utrecht 1995.

2. See M. Viroli, 'The Revolution in the Concept of Politics', *Political Theory*, and Id., *From Politics to Reason of State*, Cambridge 1992.

3. See Maurizio Viroli, *From Politics to Reason of State*, 11-70.

4. *The Digest of Justinian*, 50, 13,1.5; I am quoting from *The Digest of Justinian*, Th. Mommsen, P. Krüger, A. Watson (eds.), Philadelphia 1985, vol. IV 929.

5. Cicero, *De Finibus Bonorum et Malorum*, H. Rackham (ed.), London-New York 1914, 304-5; Seneca also, referring again to the Peripatetic school, mentions 'civil philosophy' (*civilis philosophia*) as a particular type of activity along with natural, moral and rational philosophy. *Epistle 89*; I am quoting from Seneca, *Seneca ad Lucilium Epistulae Morales*, R. M. Gummere (ed.), Cambridge Mass.-London 1958, vol. II 384-5.

6. C. Salutati, *De nobilitate legum et medicinae*, E. Garin (ed.), Florence 1947, 168.

7. *Ibidem* 170.

8. *Ibidem* 18.

9. *Ibidem* 198.

10. Francesco Guicciardini, *Dialogo del Reggimento di Firenze*, in E.L. Scarano (ed.), *Opere*, Turin 1974, 464-5.

11. Translation: 'And because some, engrossed in greed and longing, state that your majesty should never consent to return Piacenza, which goes against civil reason, recognisisng only reason of state in behaviour, I say that that uttering is not only little christian but also and even more, little human'. R. De Mattei, *Il problema della 'Ragion di Stato' nell'età della Controriforma*, Milan 1979, 13 n.34. The *Oratione* was written in 1547.

12. See Alberto Tenenti, 'Dalla "ragion di stato" di Machiavelli a quella di Botero', in A. Enzo Baldini (ed.), *Botero e la 'Ragion di Stato'*, Florence 1992, 11-21.

13. Translation: 'the situation discussed in this argument, one which can take place between us, should never be used with others, or when more persons are present'.

14. Among the first to point to the importance of the *Consulte* and *Pratiche* was Felix Gilbert in his seminal essay 'Florentine Political Assumptions in the Period of Savonarola and Soderini', *Journal of the Warburg and Courtauld Institutes* 20 (1957) 187-214.

15. See F. Gilbert, *Florentine Political Assumptions*, 208.

16. See F. Gilbert, *Florentine Political Assumptions*, 208.

17. On the enobling power of the locution 'reason of state' see Ludovico Zuccolo, 'Della ragion di stato', in B. Croce (ed.), *Politici e moralisti del Seicento*, Bari 1930, 33.

18. Translation: 'and this applies to all the others, because all the states, for whom considers their origin, are violent, except republics, in their own country and not on the outside of it, there is no power whatsoever which is legitimate, and neither the power of the emperor who is in such great authority that he gives reason to the others; and I make no exception from this rule for the priests, whose violence is double because to keep us under they use spiritual and worldy weapons.'

19. Translation: 'Reason of state is the concept of ways to found, conserve and enlarge a dominion made like this'.

20. Tommaso Campanella, *Quod reminiscentur*, Padua 1939, 62.

21. T.Campanella, *Aforismi politici*, L.Firpo ed., Turin 1941, 163

22. Ludovico Zuccolo, *Considerazioni Politiche e Morali sopra cento oracoli d'illustri personaggi antichi*, Venice 1621, 55.

23. Ludovico Zuccolo, *Della Ragion di Stato* in Croce, *Politici e moralisti*, 26.

24. 'La Politica è figlia della ragione e madre delle leggi, la Ragion di Stato è maestra delle tirannidi e germana dell'ateismo. La Politica, infine, è una pratica cognizione di tutti que' precetti che insegnano a' Principi il vero modo di rettamente governare, reggere e difendere così in pace come in guerra i suoi popoli. La Ragion di Stato è una intelligenza e cognizione di tutti quei mezzi che in qualsivoglia modo, o siano giusti o ingiusti, sono istrumenti a conservare e mantenere chi regna nello stato presente. Per questo la politica è propria de' principi, la Ragion di Stato de' tiranni', F.M. Bonini, *Ciro Politico*, Genua, 1647, Proem. The distinction between politics and reason of state was taken up also by Tommaso Tommasi, to stress that the latter is much more apt than the former to satisfy princes' curiosity. A prince, he wrote, may find the maxims of politics ('massime politiche') in S. Thomas, *De regimine principum* and in Aegidius Romanus' works. However, he would surely find these books boring and too ordinary. Instead, the books of Machiavelli, Nua and Bodin, where the maxims of reason of state are properly laid down, will surely provide him with the intellectual nourishment he is eager for. D.Tommaso Tommasi, *Il principe studioso nato ai servigi del serenissimo Cosimo gran principe di Toscana*, Venice 1642, 106-7.

25. Filippo Maria Bonini, *Il Ciro Politico*, Venice 1668, 142.

26. Giovanni Leti, *Dialoghi politici, o vero la politica che usano in questi tempi, i Prencipi, e le Repubbliche Italiane, per conservare i loro Stati, e Signorie*, Genoa 1966, vol. I 72.

27. 'Se s'uccidono gl'innocenti, i Prencipi, o vero i loro Ministri, coprono la crudeltà col dire *la Politica lo vuole*, Se si bandiscono gli Huomini più necessari al Regno, quelli che regnano dicono subito, la *Politica lo vuole*, Se si mandano de' Capitani men valorosi, all'imprese più difficili, non per altro che per farli perdere la vita, acciò non portassero ostacolo alcuno alla nascente fortuna del Privato, si dirà incontinente, la *Politica lo vuole*, se s'impoveriscono i più ricchi, *la Politica lo vuole*, se si demoliscono le Chiese, e si distruggono gli Altari, *la Politica lo vuole*, se s'imprigionano senza causa e senza autorità da poterlo fare gli Ecclesiastici maggiori, *la Politica lo vuole*, Se s'aggravano i Popoli di gravezze insopportabili, *la Politica lo vuole*, Se si ruinano l'intere Famiglie, *la Politica lo vuole*, se si lascia di trattar la pace, *la Politica lo vuole*, e in somma non si fa alcun male nel Principato, che la Politica non lo canonizi per un bene, e necessario di più', *Dialoghi politici*, vol. II 74-5.

28. G.Leti, *Dialoghi politici*, vol. I 69-70.

29. *Ibidem* 76-7.

30. Giovan Battista De Luca, *Il principe cristiano pratico*, Rome 1680, 44.

31. See Croce (ed.), *Politici e Moralisti*, 273. See also De Mattei, *Il pensiero politico italiano nell'età della Controriforma*, vol. I 164-187.

32. For a general discussion on the historic and intellectual significance of reason of state see: Norberto Bobbio, 'Ragion di stato e modernità', *L'Indice* (May 1994) 7.

1. Søren Kierkegaard, *The Concept of Irony*, transl. L.M. Capel, London 1966, 47.
2. See, *inter alia*, R.G. Collingwood, *An Autobiography*, Oxford 1939, esp. 61 ff.; Hannah Arendt, *Between Past and Future*, expanded edition New York 1968, esp. the essays on 'freedom' and 'authority'; Alasdair MacIntyre, *A Short History of Ethics*, London 1966 and *After Virtue*, Notre Dame 1981.
3. The phrase was coined by Gustav Bergmann. Cf. Richard Rorty (ed.), *The Linguistic Turn*, Chicago 1967.
4. Ludwig Wittgenstein, *Culture and Value*, transl. Peter Winch, Oxford 1980, 78e.
5. J.L. Austin, *Philosophical Papers*, 2nd edn. Oxford 1970, 201.
6. See my *Transforming Political Discourse: Political Theory and Critical Conceptual History*, Oxford 1988.
7. Reinhart Koselleck, *Futures Past: On the Semantics of Historical Time*, trans. Keith Tribe, Cambridge Mass. 1985, 74, 77.
8. Otto Brunner, Werner Conze and Reinhart Koselleck, *Geschichtliche Grunbegriffe. Historisches Lexikon zur Politisch-Sozialer Sprache in Deutschland*, Stuttgart 1972 - ; Rolf Reichardt and Eberhard Schmitt, *Handbuch politisch-sozialer Grundbegriffe in Frankreich*, Munich 1985 - . See also the useful introductions and overviews by Melvin Richter, 'Conceptual History [*Begriffsgeschichte*] and Political Theory', *Political Theory*, 14 (1986) 604-37, and 'The History of Concepts and the History of Ideas', *Journal of the History of Ideas* 48 (1987) 247-63.
9. See my *Transforming Political Discourse*, ch's 2 and 3.
10. Terence Ball, James Farr and Russell L. Hanson (eds.), *Political Innovation and Conceptual Change*, Cambridge 1989; Ball and J.G.A. Pocock, *Conceptual Change and the Constitution*, Lawrence Kans. 1988.
11. Bertrand de Jouvenel, *Sovereignty*, transl. J.F. Huntinton, Chicago 1957, 304.
12. The political theorists who had, I believe, the most acute appreciation of this aspect of political discourse are Thucydides and Hobbes (who, incidentally, was Thucydides's first English translator). For Thucydides, see James Boyd White, *When Words Lose Their Meaning*, Chicago 1984, and my review-essay, 'When Words Lose Their Meaning', *Ethics* 97 (1986) 620-31; J. Peter Euben, *The Tragedy of Political Theory*, Princeton 1990, ch. 6. On Hobbes, see my *Reappraising Political Theory*, Oxford 1995, ch. 4.
13. W.B. Gallie, 'Essentially Contested Concepts', *Proceedings of the Aristotelian Society*, 56 (1955-1956); Alasdair MacIntyre, 'The Essential Contestability of Some Social Concepts', *Ethics* 84 (1973) 1-8; W.E. Connolly, *The Terms of Political Discourse*, 2nd rev. edn. Princeton 1983, ch. 1.
14. See my 'Power', in Robert E. Goodin and Philip Pettit (eds.), *A Companion to Contemporary Political Philosophy*, Oxford 1993, 548-57, esp. 553-6.
15. For a survey and assessment of the disputes over 'republican' political thought, see my *Transforming Political Discourse*, ch. 3.
16. This is not, of course, to deny that 'tradition' is itself a hotly contested concept. See e.g. Edward Shils, *Tradition*, Chicago 1981, and Jaroslav Pelikan, *The Vindication of Tradition*, New Haven 1984.
17. This objection is raised by James Boyd White in 'Thinking About Our Language', *Yale Law Journal* 96 (1987) 1965-66.
18. I borrow the example from Quentin Skinner, 'Language and Political Change', in Ball *et al.*, *Political Innovation and Conceptual Change*, ch. 1.
19. Richard Dagger, 'Rights', *Political Innovation*, ch. 14.
20. Quentin Skinner, 'The State', *Political Innovation*, ch. 5.
21. John Dunn, 'Revolution', *Political Innovation*, ch. 16.
22. J. Peter Euben, 'Corruption', *Political Innovation*, ch. 11.
23. Mark Goldie, 'Ideology', *Political Innovation*, ch. 13.
24. Mary G. Dietz, 'Patriotism', *Political Innovation*, ch. 8.

25. This has been emphasized especially by the so-called 'new historians' of the 'Cambridge school', particularly Peter Laslett, Quentin Skinner, and John Dunn, as well as fellow-travellers such as J.G.A. Pocock.

26. See James Farr, 'Understanding Conceptual Change Politically', in *Political Innovation*, ch. 2.

27. MacIntyre, *Short History*, 2-3.

28. *Contra* 'realist' claims regarding the irrelevance of authorial intention, see my *Reappraising Political Theory*, 13-14; against assorted 'discourse theorists' of the 'postmodern' persuasion, see my *Transforming Political Discourse*, ch. 1, esp. 7-9.

29. See Arthur Danto, 'Basic Actions', *American Philosophical Quarterly* 2 (1965) 141-48.

30. Margaret Leslie, 'In Defence of Anachronism', *Political Studies* 18 (1970) 433-47; Joseph V. Femia, 'An Historicist Critique of "Revisionist" Methods for Studying the History of Ideas' repr. in James Tully (ed.), *Meaning and Context: Quentin Skinner and His Critics*, Princeton 1988, ch. 9.

31. Antonio Gramsci, *The Modern Prince*, in *Prison Writings*.

32. See my 'Party' in *Political Innovation*, ch. 7.

33. Skinner, 'Some Problems in the Analysis of Political Thought and Action', *Meaning and Context*, ch. 5, 112.

34. Jurgen Habermas, 'Wahreitstheorien' in *Wirklichkeit un Reflexion,* Pfullingen 1973, 239.

35. See Ball and Pocock, 'Introduction', *Conceptual Change and the Constitution*.

36. Skinner, *Foundations of Modern Political Thought*, Cambridge 1978, Vol I xii-xiii.

37. Skinner, 'Some Problems', *Meaning and Context*, 112.

38. Karl Marx, 'Eighteenth Brumaire' in *Political Writings*, transl. and ed. David Fernbach, New York 1974, Vol. II 146.

CHAPTER 7

1. Michael Oakeshott, 'The Voice of Poetry in the Conversation of Mankind' in Michael Oakeshott, *Rationalism in Politics and Other Essays*, London 1967 [1962] 197-247.

2. On the 'unrealistic' nature of this demand see Rüdiger Bittner, 'One Action' in Amélie Oksenberg (ed.), *Essays on Aristotle's Poetics*, Princeton 1992, 97-110.

3. On the 'differentiation of experience' in connection with the introduction of terms see e.g. Stephan Körner, *Experience and Theory*, London 1966, 3-80.

4. This claim I take it, is in keeping with the position put forward by Alfred Schutz and his school. I am obviously not denying that language as used in the life-world is not in itself functionally differentiated too. The point I want to make is that the differentiation which leads to the terminologies of the various sciences takes the linguistic situation of the life-world as its point of departure. See e.g. Alfred Schutz, *The Problem of Social Reality* in Alfred Schutz, *Collected Papers*, Vol. I., The Hague 1973; Alfred Schütz / Thomas Luckmann, *Strukturen der Lebenswelt*, Neuwied / Darmstadt 1975.

5. See Thomas Sprat, *History of the Royal Society*, London 1667. Facsimile edition London 1959, ed. J.I. Cope and H.W. Jones, 162: '...to separate the knowledge of *Nature*, from the colours of *Rhetorick*, the devices of *Fancy*, or the delightful deceit of *Fables*'; 112: 'this vicious abundance of *Phrase*, this trick of *Metaphor*, this volubility of *Tongue...*'

6. Reinhart Koselleck, 'Begriffsgeschichte und Sozialgeschichte' in Reinhart Koselleck, *Vergangene Zukunft*, Frankfurt 1984, 107-143, quotations on 113. With a disregard for terminological precision which, ironically enough, seems a trademark of some representatives of *Begriffsgeschichte*, he speaks of the 'Erfahrungsraum' (experiential space) and 'Erwartungshorizont' (expectational horizon) of concepts two pages later.

7. Koselleck, *op.cit.*, 119 f. Transl.: Now a word can become unambiguous in use. A concept, by contrast, must remain polysemic in order to remain a concept. True, the concept, too, attaches to a word, but at the same time it is more than a word: a word becomes a concept once the plenitude of a political-social context of meaning and experience, in which a word is used, enters into that one word. [...]

A word contains possibilities of meanings, a concept, by contrast, unites in itself a plenitude of meaning. Therefore a concept may be clear, but it must remain polysemous.

8. See Paul Ricoeur, *Freud and Philosophy. An Essay on Interpretation*, Tr. Denis Savage, New Haven/London 1970, 20-36.
9. See the analysis of the use of language in Peter L. Berger and Thomas Luckmann, *The Social Construction of Reality*, Harmondsworth 1971.
10. Koselleck refers to his discipline as a 'notwendige Hilfe für die Sozialgeschichte' (a necessary aid of social history).
11. I am here adapting the Kantian notion of an 'Architektonik' of the sciences: '...um nach einem ... wohlgeordneten und zweckmäßigen Plane bei der Erweiterung seiner Erkenntnisse zu Werke zu gehen, muß man also jenen Zusammenhang der Erkenntnise unter einander kennen zu lernen suchen. Dazu gibt die Architektonik der Wissenschaft Anleitung, die ein System nach Ideen ist, in welchem die Wissenschaften in Ansehung ihrer Verwandtschaft und systematischen Verbindung in einem Ganzen der die Menschheit interessierenden Erkenntnis betrachtet werden.' Immanuel Kant. *Logik*, Einleitung VI. A 68, in Kant, *Werke in zehn Bänden*, Ed. W. Weischedel, Darmstadt 1958, 475.
12. See e.g. Rolf P. Horstmann, 'Kriterien für Grundbegriffe' in Reinhart Koselleck, *Historische Semantik und Begriffsgeschichte*, Stuttgart 1978, 37-42.
13. H.G. Gadamer, *Wahrheit und Methode*, 2nd ed. Tübingen 1965, 284 ff.
14. Gadamer, *op. cit.*, 285.
15. Erich Rothacker, 'Geleitwort', *Archiv für Begriffsgeschichte* 1 (1955) 5.
16. Reiner Wiehl, 'Begriffsbestimmung und Begriffsgeschichte' in Rüdiger Bubner et al. (eds.), *Hermeneutik und Dialektik* vol. 2, Tübingen 1970, 167-213; quotation on 181.
17. There obviously would be little need for a history of concepts if Kuhnian 'normal science' were to prevail forever.
18. For an overview of recent narrative theory see Shlomith Rimmon-Kenan, *Narrative Fiction: Contemporary Poetics*, London 1983.
19. For the paired concepts of *récit* and *histoire* of narrative theory see Rimmon-Kenan, *Narrative Fiction*.
20. See Gadamer, *Wahrheit und Methode*, 283ff. *et passim*.
21. With the distinction between 'causally based' and 'semiotically' and thus 'conventionally based' I am adapting for my purposes the distinction between 'causal generation' and 'conventional generation' which Alvin I. Goldman developed in his *A Theory of Human Action*, Princeton 1970, 22-25.
22. See e.g. John Lyons, *Semantics* Vol. I, Cambridge 1977, 94-99.
23. For a detailed discussion the procedures which are used in turning everyday language predicates into terms see e.g. Wilhelm Kamlah / Paul Lorenzen, *Logische Propädeutik. Vorschule des vernünftigen Redens*, 2nd ed. Mannheim 1972, 64-78.
24. It should be noted, however, that in the process of de-contextualizing the terms of a disciplinary repertoire they are *de facto* being re-contextualizing. Only this time the contexts are not the 'contingent' ones of the life-world but the planned ones of the various terminological systems into which these terms enter in the process of definition and explication. Raising problem-historical and 'wirkungsgeschichtliche' questions with regard to the terminological repertoire of a particular discipline therefore characteristically takes on the form of enquiring into the 'paradigm' (Kuhn) or the 'episteme' (Foucault) underlying or informing the terminological system as a whole.
25. For the following discussion of the difference between the 'nomenclature' and the 'terminology proper' of literary scholarship I am indebted to Janusz Slawinski, 'Probleme der literaturwissenschaftlichen Terminologie' in Janusz Slawinski, *Literatur als system und Prozeß*, Tr. from Polish by Rolf Figuth, München 1975, 65-80.
26. Aristotle, *Poetics*, ch. 8.
27. The third edition of the *Reallexikon der Deutschen Literaturwissenschaft* of which the first volume has been published, edited by Harald Fricke et al., Berlin 1997- . This lexicon was first published in four volumes between 1925 and 1931 under the title *Reallexikon der Deutschen Literaturgeschichte* with

Paul Merker and Wolfgang Stammler as editors. A second edition with the same title was published in five volumes between 1955 and 1988 under the editorship of Werner Kohlschmidt and Wolfang Mohr. With the third edition which is being edited by Harald Fricke, Klaus Grubmüller, Jan-Dirk Müller and Klaus Weimar, the title has been changed from *Reallexikon der Deutschen Literaturgeschichte* to *Reallexikon der Deutschen Literaturwissenschaft*. This change in title undoubtedly reflects the greater degree of methodological rigour which entered literary scholarship in the wake of the 'linguistic turn' of the early seventies.

28. See e.g. Victor Erlich, *Russian Formalism: History – Doctrine*, The Hague 1955.
29. See e.g. Robert Weimann, *'New Criticism' und die Entwicklung bürgerlicher Literaturwissenschaft*, Munich 1974 2nd. ed.
30. Karl R. Popper, *The Logic of Scientific Discovery*, New York/Evanston 1965, 31.
31. I am leaving aside the further distinction between the 'factual' and the 'normative' justification of a concept.
32. It should be noted that the three disciplinary architectonics we have identified are not to be understood as meta-level affairs only.
33. R. Carnap and W. Stegmüller, *Induktive Logik und Wahrscheinlichkeit*, Vienna 1965, 15; J. F. Hanna, 'An Explication of "Explication"', in *Philosophy of Science* 35 (1968) 28-44.
34. See Jörg Zimmermann, 'Ästhetische Erfahrung und die 'Sprache der Natur", in J. Zimmermann (ed.), *Sprache und Welterfahrung*, München 1979, 234-256, esp. 235 f.
35. See my 'Forschungsbericht' on the publication history of the *Emblematum liber*: 'The 1531 Augsburg Edition of Alciato's *Emblemata*: A Survey of Research' in *Emblematica. An Interdisciplinary Journal for Emblem Studies* 5 (1991) 213-254.

CHAPTER 8

1. Rolf Reichardt, 'Einleitung' in *Handbuch* I, München 1985, 64. See also my reviews of the volumes I to VI and VIII to X in *Tijdschrift voor Geschiedenis* 100/1 (1987) 100-101; 100/4 (1987) 597-598; 102/4 (1989) 587-588.
2. Cf. the special issue 'Histoire et sciences sociales: un tournant critique', *Annales ESC* 44/6 (1989) 1317-1520, and several articles on the similar themes in later issues.
3. Cf. Peter Burke, *History and Social Theory*, Cambridge 1992.
4. This ambiguity is clearly reflected in the conception of Peter Dinzelbacher's dictionary *Europäische Mentalitätsgeschichte. Hauptthemen in Einzeldarstellungen*, Stuttgart 1993. See his definitions on IX-X and XXI.
5. In Peter Burke (ed.), *New Perspectives on Historical Writing*, Cambridge 1991, the term 'new history' is, e.g., consistently used for what others may call the '(new) cultural history', almost all the chapters are concerned with cultural themes or methods: microhistory, oral history, reading, images, the body, political thought, narrative. See for the 'new cultural history' Lynn Hunt, 'History, Culture and Text' in *eadem* (ed.), *The New Cultural History*, Berkeley/Los Angeles 1989, 1-22.
6. Hans Ulrich Gumbrecht, Rolf Reichardt and Thomas Schleich, 'Für eine Sozialgeschichte der Französischen Aufklärung' in *Sozialgeschichte der Aufklärung in Frankreich*, 2 vol., Munich/Vienna 1981, vol. I 3-51.
7. Reinhart Koselleck, 'Sozialgeschichte und Begriffsgeschichte' in Wolfgang Schieder and Volker Sellin (eds.), *Sozialgeschichte in Deutschland. Entwicklungen und Perspektiven im internationalen Zusammenhang*, vol. I, Göttingen 1986, 89-109. See Chapter 2, *passim*.
8. Cf. Reichardt, 'Einleitung' in *Handbuch*, I 51-64. For the evolution of historical semantics, see also Robert Jütte, *Abbild und soziale Wirklichkeit des Bettler- und Gaunertums zu Beginn der Neuzeit. Sozial-, mentalitäts- und sprachgeschichtliche Studien zum Liber Vagatorum (1510)*, Cologne/Vienna 1988, 1-25. Further the discussion in Melvin Richter, 'Conceptual history (Begriffsgeschichte) and political theory', *Political Theory* 14/4 (1986) 604-637; Jeremy Rayner, 'On Begriffsgeschichte', *ibid.* 16/3 (1988) 496-501; and Richter's rejoinder, *ibid.* 17/2 (1989) 296-301.

9. Antoine de Baecque, *Le corps de l'histoire. Métaphores et politique (1770-1800)*, Paris 1993.

10. For American scholarship, see the contribution of Terence Ball on 'Conceptual history and the history of political thought' in this volume.

11. The second volume bears a different, but equally programmatic title: P. Burke and R. Porter (eds.), *Language, Self and Society*, Cambridge 1991.

12. Gerd van den Heuvel, 'Cosmopolite, Cosmopoli(ti)sme' in *Handbuch*, VI, München 1986, 41-55.

13. For a critical appraisal of Erasmus's position, see A. Wesseling, 'Are the Dutch uncivilized? Erasmus on Batavians and his national identity', *Erasmus of Rotterdam Society Yearbook* 13 (1993) 68-102.

14. The opposition meant here is, of course, between 'ecclesiastical' and 'lay', thus between two institutional concepts, not between 'religious' and 'agnostic' (or similar terms), i.e. between two cognitive concepts. Erasmus of Rotterdam certainly was a true believer with a profoundly Christian worldview, but his position towards church organisation was rather skeptical, and in his view the authority of learning was beyond mere institutional motivation.

15. Cf. M. Grossmann, *Humanism at Wittenberg 1485-1517*, Nieuwkoop 1975.

16. Cf. my chapter 'Patterns' in Walter Rüegg (general ed.) and Hilde de Ridder-Symoens (ed.), *A History of the University in Europe. Vol. II Universities in Early Modern Europe (1500-1800)*, Cambridge 1996.

17. For the French references, I refer to the footnotes of the *Handbuch* entry.

18. E.g. [Michael Sendivogius], *Cosmopolite, dat is Borgher der Werelt, ofte het nieuwe licht van de wetenschap van natuurlycke dinghen*, transl. by Alba Starkse in Hem, Amsterdam, N. Biestkens 1627; *Cosmopolite, ou Nouvelle lumière de la physique naturelle*, transl. from Latin into French by Le Sr. de Bosnay, The Hague, Théodore Maire, 1640; *Le Cosmopolite, ou Nouvelle lumière chymique*, introd. by Bernard Roger, Paris 1976; *Cosmopolitae historia naturalis, comprehendens humani corporis atomiam et anatomicam delineationem*, Leiden 1686; Jacques de Nuysement, *Tractatus de vero philosophorum sale secreto et universali mundi spiritu, in supplementum diu desiderati Cosmopolitae*, Frankfurt am Main 1716. This alchemical meaning is not mentioned in the *Handbuch*.

19. Cf. Piero Pierotti, '"Cosmopolis"': un trattato mai scritto', *Rivista italiana di studi napoleonici* 17/2 (1980) 99-102, review of Giuseppe M. Battaglini, *Cosmopolis: Portoferraio medicea. Storia urbana 1548-1737* (1978).

20. A century later, e.g., the editor of the Dutch spectatorial periodical *De Kosmopoliet, of waereldburger*, which appeared for two whole years (Amsterdam, 1776-1777), proclaimed his universal patriotism in these terms: 'Hence I consider the world as my fatherland, hence I am a world citizen, a cosmopolitan' (Vol. I nr. 3, 1776). Cf. *Woordenboek der Nederlandsche Taal* VII 2, The Hague/Leiden 1941, col. 5755-5756.

21. This periodization and this negative image of France, traditional among eighteenth-century specialists, may well be challenged. Firstly, both in idea and in reality, the Republic of Letters is much older than Enlightenment scholarship tends to believe. Cf. the contributions to Hans Bots and Françoise Waquet (eds.), *Commercium litterarium. Forms of communication in the Republic of Letters 1600-1750*, Amsterdam/Maarssen 1994. Secondly, in her contribution 'L'espace de la République des Lettres' (ibid., 175-190), F. Waquet points out that one has to distinguish between Paris, the true capital of the Republic of Letters ever since the early seventeenth century, and the French province, but this distinction is more a case of representation than of reality.

22. Cf. the social and geographical analysis by L. Voet, 'Erasmus and his correspondents', in J. Sperna Weiland and W.Th.M. Frijhoff (eds.), *Erasmus of Rotterdam: The man and the scholar*, Leiden 1988, 195-202.

23. Anthony Grafton, *Joseph Scaliger. A Study in the History of Classical Scholarship*, 2 vol., Oxford 1983-1993; idem, *Defenders of the Text. Traditions of Scholarship in an Age of Science, 1450-1800*, Cambridge Mass./London 1991.

24. Otto S. Lankhorst, *Reinier Leers (1654-1714), uitgever en boekverkoper te Rotterdam*, Amsterdam/Maarssen 1983.

25. Cf. W. Frijhoff, 'L'usage du français en Hollande, XVIIe-XIXe siècles: propositions pour un modèle d'interprétation', *Études de linguistique appliquée*, nouv. série, 78 (avril-juin 1990) 17-26; same author, 'Le plurilinguisme des élites en Europe de l'Ancien Régime au début du XXe siècle', *Le Français dans le Monde. Recherches et applications*, a special issue edited by D. Coste and J. Hébrard, 'Vers le plurilinguisme des élites' (Feb.-March 1991) 120-129. Reversely, *anglomania* served in France in the second half of the eighteenth century as an anti-cosmopolitan catalyst in the creation of national identity. Cf. Josephine Grieder, *Anglomania in France 1740-1789: Fact, fiction, and political discourse*, Genève 1985.

26. Cf. Paul Hazard, 'Cosmopolite' in *Mélanges d'histoire générale et comparée offerts à Ferdinand Baldensperger* I, Paris 1930, 354-364; René Pomeau, *L'Europe des Lumières: cosmopolitisme et unité européenne au XVIIIe siècle*, Paris/Genève 1981.

27. Th.J. Schlereth, *The cosmopolitan ideal in Enlightenment thought. Its form and function in the ideas of Franklin, Hume and Voltaire, 1694-1790*, London 1977. For the Germans, see Hans-Wolf Jäger, 'Weltbürgertum in der deutschen Lehrdichtung', *Revue d'Allemagne* 18/4 (1986) 600-611, and other articles in this thematic issue on Cosmopolitism.

28. Published in The Hague, 1750. Others have London 1753 as the first edition. New ed. introd. by R. Trousson, Bordeaux 1970.

29. Cf. J.-P. de Beaumarchais, 'Fougeret de Montbron, Louis Charles', in J.-P. de Beaumarchais, D. Couty and A. Rey (eds.), *Dictionnaire des littératures de langue française* I, Paris s.a., 836-837.

30. On Rousseau and cosmopolitism, see Joseph Texte, *Jean-Jacques Rousseau et les origines du cosmopolitisme littéraire: étude sur les relations littéraires de la France et de l'Angleterre au XVIIIe siècle*, Paris 1895, 2e éd. 1909; repr. Genève 1970.

31. J.W. Oerlemans, *Rousseau en de privatisering van het bewustzijn. Carriérisme en cultuur in de achttiende eeuw*, Groningen 1988.

32. Rousseau, *Oeuvres*, éd. Launay, III 21; quoted from Van den Heuvel, 'Cosmopolite', 47.

33. Cf. Frederick M. Barnard, 'National culture and political legitimacy: Herder and Rousseau', *Journal of the History of Ideas* 44 (1983) 231-253.

34. Robert Darnton, 'The high Enlightenment and the low-life of literature in pre-revolutionary France', *Past & Present* 51 (1971) 81-115; French transl. in *Bohème littéraire et Révolution. Le monde des livres au XVIIIe siècle*, Paris 1983; Roger Chartier, 'Espace social et imaginaire social: les intellectuels frustrés au XVIIIe siècle', *Annales ESC* 37 (1982) 389-400; Elizabeth L. Eisenstein, *Grub Street abroad. Aspects of the French cosmopolitan press from the Age of Louis XIV to the French Revolution*, Oxford and New York 1992; and my chapter 'Graduation and Careers' in Rüegg, *History of the University*, Vol. II.

35. The author is said to be Charles Elie Denis Roonptsy, *maître du caffé*. The text was published in Amsterdam, s.n. 1778 (2d printing 1778).

36. Anacharsis Cloots, *Voeux d'un Gallophile*, Amsterdam 1786; *La République universelle, ou Adresse aux tyrannicides*, Paris 1792; *Étrennes aux cosmopolites*, Paris 1793. On Cloots: Albert Mathiez, *La Révolution et les étrangers: cosmopolitisme et défense nationale*, Paris 1918, 48-57; Albert Soboul, 'Anacharsis Cloots', *Annales historiques de la Révolution française* 52 (1980) 29-58.

37. On this problem, see: Jean-René Suratteau, 'Cosmopolitisme et patriotisme au Siècle des Lumières', *Annales historiques de la Révolution française* 55 (1983) 364-389; Jean Moes, 'Justus Möser: patriote cosmopolite ou nationaliste xénophobe?', *Revue d'Allemagne* 18/4 (1986) 637-649; Marita Gilli, 'Cosmopolitisme et xénophobie pendant la République de Mayence', *ibidem* 705-715. Cf. Grieder, *Anglomania*, 117-146.

38. Virginie Guiraudon, 'Cosmopolitism and national priority: attitudes towards foreigners in France between 1789 and 1794', *History of European Ideas* 13/5 (1991) 591-604.

39. Cf. my Rotterdam inaugural lecture *Cultuur, mentaliteit: illusies van elites?*, Nijmegen 1984. [also published as 'Kultur und Mentalität: Illusionen von Eliten?', transl. by Gerhard Jaritz, *Österreichische Zeitschrift für Geschichtwissenschaften* 2/2 (1991) 7-33].

40. Cf. Harry Senn, 'Folklore beginnings in France: the Académie celtique, 1804-1813', *Journal of the Folklore Institute* 18 (1981) 23-33; Mona Ozouf, 'L'invention de l'ethnographie française: le questionnaire de l'Académie celtique', *Annales ESC* 36 (1981) 210-230. And for the context in a broader perspective: W. Frijhoff, 'Volkskundigen vóór de volkskunde?', *Volkskundig Bulletin. Tijdschrift voor Nederlandse cultuurwetenschap* 20/3 (1994) 245-267.

41. Cf. e.g., Friedrich Wolfzettel, *Ce désir de vagabondage cosmopolite. Wege und Entwicklung des französischen Reiseberichts im 19. Jahrhundert*, Tübingen 1986; Martina Lauster (ed.), *Deutschland und der europäische Zeitgeist. Kosmopolitische Dimensionen in der Literatur des Vormärz*, Bielefeld 1994.

CHAPTER 9

1. See the study of Georg Bollenbeck, *Bildung und Kultur. Glanz und Elend eines deutschen Deutungsmusters,* Frankfurt/Leipzig 1994.

2. (Bertrand) Barère, *Rapport au Comité de Salut Public sur les idiômes. 8 pluviôse an II,* reedited in Michel De Certeau, Dominique Julia, Jacques Revel, *Une Politique de la langue. La Révolution française et les patois,* Paris 1975 (Bibliothèque des Histoires) 291-299, here 294, where the Italian dialect spoken on the island of Corsica is called a 'foreign language'.

3. Aleida Assmann, *Arbeit am nationalen Mythos. Eine kurze Geschichte der deutschen Bildungsidee,* Frankfurt/M 1994, 33.

4. Ernst Troeltsch, *Humanismus und Nationalismus in unserem Bildungswesen,* Berlin 1917, 42; quoted by Assmann, *Arbeit,* 85.

5. This results from the exploration of almost 50 French-German dictionaries of the period 1770-1820 in the context of the research project 'Wissens-, Begriffs- und Symboltransfer von Frankreich nach Deutschland, 1770-1820' sponsored by the Volkswagen Foundation and directed by H.-J. Lüsebrink and R. Reichardt.

6. Ahcène Abdellfettah, *Die Rezeption der Französischen Revolution durch den politischen öffentlichen Sprachgebrauch. Untersucht an ausgewählten historisch-politischen Zeitschriften (1789-1802),* Heidelberg 1989, 205-213.

7. *Neues deutsch-französisches Wörterbuch. Ein Hülfsmittel zur bequemen Anwendung der neuern französischen Wörter und Redensarten. Nach D. Leonard Snetlage, 'Nouveau Dictionnaire Français contenant les expressions de nouvelle création du Peuple Français', mit Abkürzungen, Zusätzen und einem französischen Register von Friedrich Lacoste,* Leipzig 1796, 114: 'Nationalmörder', 'Nationicide', 'Einer, der der Nation nachtheilig ist (Ludwig der Nationmörder, "Louis le Nationicide")'.

8. *Ibidem* 136.

9. 'Verschiedenheiten [...] die Aufmerksamkeit des Gesetzgebers auf sich ziehen mußte', *Ibidem* 137.

10. [Anon.], 'Das große National-Fest in Paris. Von einem Staatsmann, der in Einsamkeit lebt', *Minerva* 7 (15-3-1806) 166-175, here 167: 'Ein solches National-Fest wie jetzt der Kayser Napoleon veranstaltet, war bey der ehemaligen Römischen Nation sehr gebräuchlich.: es diente sowohl um ihre Größe den Völkern sehen zu lassen, als um ihre Armeen und Feldherren noch mehr mit Ruhm und Ehrbegier zu beleben.'

11. [Anon.], 'Ueber die französischen Nationalfeste', *Journal der neuesten Weltbegebenheiten* 6.1 (1800) 193-199, here 193.

12. Translation: 'The author doesn't mention the military celebrations, which always impressed most. The military music, the national hymns, the trophies won, the onlook of wounded soldiers and the urns, dedicated to the deceased heroes, filled the onlookers with holy veneration and high esteem. Buonaparte would not neglect these parades *during the war*'. *Ibidem* 199, footnote.

13. See Schubart, 'National-Verlust', *Oberdeutsche Allgemeine Literaturzeitung* (5-4-1803) col. 455-456.

14. The translated work of L.M. Réveillière-Lépeaux' *Réflexions sur le culte, sur les cérémonies civiles et sur les fêtes nationales* appeared in 1797, the same year as the original. Maximilien Robespierre, 'Rapport

des Präsidenten Robespierre über die National- und Dekadenfeste' in *Argos* IV (1794) 513-570; M. Robespierre, *Über die Nationalfeste der Franzosen. Eine Rede von Robespierre, gehalten in der Sitzung des Convents am 7. May 1794*, Altona 1794, 62; see also on this point Heinz Schuffenhauer, *Die Pädagogik Johann Gottlieb Fichtes*, Berlin 1963, 88; Manfred Buhr, *Revolution und Philosophie*, Berlin 1965, 78. For Mercier see for example his publication 'Über den Nationalmuth. Geschrieben im Januar 1792', *Minerva* 3.1. (1792) 482-494; Louis-Marie Jacques Amalric Comte de Narbonne-Lara, *National-Bündnis. Zuschrift der Pariser Bürger an alle Franzosen*, Straßburg 1790, 12; Amalric, 'Die Nation der Franken an die Teutschen (ein Flugblatt)', *Strasburgisches politisches Journal* 1 H. 10 (May 1792) 508-509; Amalric, 'Ueber den National-Charakter der Franzosen in Hinsicht auf ihre Constitution', *Minerva* 5.2 H. 6 (1792) 523-528; Amalric, 'Ueber National-Würde und National-Glück', *Minerva* 6.1 (1797) 26-31; L. M. Réveillière-Lépeaux, *Betrachtungen über den Gottesdienst, bürgerliche Gebräuche und National-Feste. Aus dem Französischen übersetzt von C. Fabricius*, Hamburg 1797, 45-47.

15. See on this point Hans-Jürgen Lüsebrink, '"Hommage à l'écriture" et "Eloge de l'imprimerie". Traces de la perception sociale du livre, de l'écriture et de l'imprimerie à l'époque révolutionnaire' in Frédéric Barbier, Claude Joly, Sabine Juratic (eds.), *Livre et Révolution*. Colloque organisé par l'Institut d'Histoire Moderne et Contemporaine (CNRS), Paris, Bibliothèque Nationale, 20-22 mai 1987, Mélanges de la Bibliothèque de la Sorbonne 9 (Paris 1989) 133-144.

16. See on this point the article of [Christoph Martin Wieland], 'Über deutschen Patriotismus, Betrachtungen, Fragen und Zweifel', *Der neue Teutsche Merkur* 5 (May 1793) 17-18, which distinguishes sharply between the French 'Nazional-Patriotismus' and the German 'teutscher Patriotismus' defined as 'Gemeingeist' (common spirit).

17. Ernst Moritz Arndt, 'Über deutsche Art und das Welschtum bei uns' in E.M. Arndt, *Geist der Zeit*, Altona, 1806. Reprinted in: *Arndts Werke. Auswahl in 12 Teilen mit Einleitung und Anmerkungen versehen*, A. Leffson and W. Steffens eds., Berlin 1912, 9th part, 151: 'Wer sie [*die Fremdsprache*] von Jugend an übt und treibt, der muß seine Anschauungen und Gedanken und Gefühle notwendig gegen den Spiegel stellen, der muß das angeborene Deustche endlich verkehrt erblicken und das eigentümlich Eigene muß ihm auf immer ein verschlossenes Rätsel bleiben.'

18. Ernst Moritz Arndt, *Ueber Volkshaß und den Gebrauch einer fremden Sprache*, Leipzig 1813, 35, 39: 'Das heißt die Sprache ist ein Spiegel des Volkes, das sie spricht; aus der Sprache eines Volkes erscheint mir hell, was es will, wohin es strebt, wohin es sich neigt, was es am meisten liebt und übt, kurz, wohin sein eigentliches Leben und Streben geht. [...]. Man sieht jetzt, wohin ich will. Ich will die Uebung und den Gebrauch der französischen Sprache in Teutschland abgeschafft wissen.'

19. The quoted concepts can be found in all of Arndt's works after 1804/06, and with a special density in the quoted article 'Über deutsche Art und das Welschtum bei uns'.

20. See Arndt, *Deutsche Art*, 34: 'Bei den meisten wird dieses Mischmasch des Verschiedenen, in den jahren eingetrichtert, wo sie die erszten einfältigen Bilder des Lebens auffassen und aus sich entwickeln sollen, eine schwächliche und flache Charakterlosigkeit erzeugen.'

21. See *Ibidem* 142, 138, 130.

22. Translation: 'Also I swore hot bloody hate, and deep anger without remorse to the Frenchmen and the French agression which harms our German land'. Ernst Moritz Arndt, *Des deutschen Knaben Robert Schwur*, in Arndt, *Werke Part I Gedichte*, W. Steffens (ed.), 128.

23. Arndt, *Deutsche Art*, 139: 'Darum laßt uns die Franzosen nur recht frisch hassen, laßt uns unsre Franzosen, die Entehrer und Verwüster unserer Kraft und unschuld, nur noch frischer hassen, wo wir fühlen, daß sie uns unsre Tugend und Stärke verweichlichen und entnerven! Als Deutsche, als Volk, bedürfen wir dieses Gegensatzes, und unsere Väter waren ein viel besseres Volk, als wir jetzt sind, als der Gegensatz und Widerwille gegen die Welschen am lebendigsten war.'

24. Ernst Moritz Arndt, *Über Sitte, Mode und Kleidertracht. Ein Wort aus unserer Zeit*, Frankfurt/M. 1814, 12: 'Wir Deutschen bleiben elende Knechte, wenn wir die fremde Art, Sitte und Sprache nicht aus unseren Gränzen vertilgen und auch unser Volk, unsere Art und unsere Sitte nicht aus dem Stolz erfassen, den wir verdienen.'

25. See on this point the useful, but very incomplete and not very precise dissertation of Chang Tien-Lin, *Die Auseinandersetzung E. M. Arndts mit Frankreich*. Inaugural-Dissertation, Tübingen 1940.

26. 'Weil der Nationalgeist fehlt, ist ein Volk von 30 Millionen der Spott Europens geworden'. Ernst Moritz Arndt, *Reisen durch einen Teil Teutschlands, Ungarns, Italiens und Frankreichs in den Jahren 1789 und 1799 (3rd part)*, Leipzig 1804, 204.

27. Ernst Moritz Arndt, *Der Rhein. Deutschlands Strom, aber nicht Deutschlands Grenze*, Leipzig 1813, new ed. München 1921, 7-8: 'Bald ward auch das neugemachte Königreich Holland vernichtet, Holland hieß eine Anspülung der französischen Ströme und war in eine französische Landschaft verwandelt.'

28. See on the concept of semi-orality (combining written texts and oral performances in different ways, theatre, readings, etc.) which has been created in Germany especially by Fritz Nies. See for example his article '"Zeit-Zeichen". Gattungsbildung in der Revolutionsperiode und ihre Konsequenzen für die Literatur- und Geschichtswissenschaft', *Francia* 8 (1980) 257-275; and his book *Bahn und Bett und Blütenduft. Eine Reise durch die Welt der Leserbilder*, Darmstadt 1991, esp. 77, 81, 113-114; and the whole subject Hans-Jürgen Lüsebrink, 'Semi-Oralität. Zur literaturwissenschaftlichen Tragweite einer provokativen Kategorie' in *Offene Gefüge. Festschrift für Fritz Nies zum 60. Geburtstag*, Henning Krauß ed., with Louis Van Delft, Gert Kaiser and Edward Reichel, Tübingen 1994, 152.

29. See on this point Hans-Jürgen Lüsebrink, '"L'appel au peuple, l'apostrophe aux rois" – zur Rhetorik öffentlicher Rede im Frankreich der Spätaufklärung.' Akten des Potsdamer Kolloquiums 1993. Hans Erich Bödeker, Etienne François eds., *Aufklärung/ Lumières und Politik*, Leipzig 1995.

30. Ernst Moritz Arndt, *Aufruf an die Deutschen zum gemeinschaftlichen Kampfe gegen die Franzosen. Endliches Schicksal Napoleons, vorhergesagt im Jahre 1806 von A. von Kotzebue. Die Stimme in der Wüste an ächte Deutsche*, Berlin und Halle 1813, 11: 'zum Ersten: Bleibt Eurem Charakter auch in jedem Verhältnisse getreu! Seyd gerecht gegen Freund und Feind! [...]. Zum Zweiten: Tausendfältige Beweise habt ihr, daß Eures Feindes Werk Lug und Trug ist. Lasset Euch daher nicht wankemüthig machen durch seine scheinheiligen und gleißnerischen Vorspiegelungen, wenn er von seinen Absichten; durch seine unverschämten Prahlereien, wenn er von seinen Thaten spricht.'

CHAPTER *10*

1. Lewis Carroll, *Through the Looking-Glass and What Alice Found There*, in *The Annotated Alice*, Harmondsworth 1972, 265. For corrections and inspiration, I thank Daan den Hengst, David Rijser, Frans Slits, Chris Heesakkers, Machteld Bolkestein, Johan Heilbron and Eric Moormann.

2. To give just one example from L. Dussler, *Raphael. A Critical Catalogue of his Pictures, Wall-Paintings and Tapestries*, London 1971: 'Neither this theory [Vasari's], which indicates a complete misunderstanding of the theme, nor an interpretation based on the writings of St. Bonaventura, put forward by Gutman, requires refutation' (73). And Schlosser's thorough investigation of the programme of themes in the Stanza della Segnatura and its predecessors leaves no doubt as to their nature: they are representations of the four Faculties (theology, philosophy, jurisprudence and medicine, replaced here by poetry), subdivisions which were traditional in the organization of libraries' (70).

3. See E.H. Gombrich, 'Raphael's *Stanza della Segnatura* and the Nature of its Symbolism' in *Symbolic Images*, London 1972, 85-101.

4. V. Golzio, *Raffaello nei documenti, nelle testimonianze dei contemporanei e nella letteratura artistica del suo seculo*, Rome 1936, 203.

5. For the older literature see Dussler, *Raphael*, 69-79; H. von Einem, *Das Programm der Stanza della Segnatura im Vatikan*, Opladen 1971; J. Shearman, 'The Vatican Stanze: Functions and Decorations', *Proceedings of the Britisch Academy in Rome* 57 (1971) 3-58; H. Pfeiffer, *Zur Ikonographie von Raffaels Disputa. Egidio da Viterbo und die christlich-platonische Konzeption der Stanza della Segnatura* (Miscellanea Historiae Pontificiae 37) Rome 1975; J. Wood, 'Cannibalized Prints and Early Art History.

Vasari, Bellori and Fréart de Chambray on Raphael', *Journal of the Warburg and Courtauld Institutes* 51 (1988) 210-220.

6. H.B. Gutman, 'Medieval content of Raphael's "School of Athens"', *Journal of the History of Ideas* 2 (1941) 420-429 and 'Zur Ikonologie der Fresken Raffaels in der Stanza della Segnatura', *Zeitschrift für Kunstgeschichte* 21 (1958) 29-39; C.G. Stridbeck, *Raphael Studies. A Puzzling Passage in Vasari's "Vite"*, Stockholm 1960; M. Winner, 'Il giudizio di Vasari sulle prime tre Stanze di Raffaello in Vaticano', in *Raffaello in Vaticano*, Catalogue Rome 1984, who is more positive about Vasari than usual, but does not accept Vasari's identification of the Evangelists and his chronology, see especially 186-187. I published some of the ideas elaborated in this article in B. Kempers, 'Staatssymboliek in Raffaels Stanza della Segnatura', *Incontri*, 2 (1986/87) 3-48, 'Antiek fundament voor een christelijk monument: theologisch humanisme in Rafael's "School van Athene", in H. van Dijk and E.R. Smits (eds.), *Dwergen op schouders van Reuzen. Studies over de receptie van de Oudheid in de Middeleeuwen*, Groningen 1990, 83-107 and *Painting, Power and Patronage. The Rise of the Professional Artist in Renaissance Italy*, London 1992, 244-259. For a recent overview and a detailed iconographic analysis see in particular Winner, 'Il Giudizio di Vasari' and 'Progetti e esecuzione nella Stanza della Segnatura', *Raffaello nell'Appartemento di Giulio II e Leone X*, Milan 1993, 247-291.

7. J. Burckhardt, *Die Cultur der Renaissance in Italien*, Basel 1860. Burckhardt's statement on Raphael is remarkable because it is close to what Johan Huizinga wrote about Jan van Eyck. In this way, Huizinga aspired both to emulate Burckhardt, and to criticize him at the same time. For both authors see F. Haskell, *History and its Images. Art and the Interpretation of the Past*, London 1993, 331-345, 350-351 and 433-495.

8. The denial of revelation as a source of truth is, for instance, expressed by J.G. Fichte, *Versuch einer Critik aller Offenbarung*, 1793; Kant was a major philosopher to stress *Vernunft* as the source of wisdom; in France Diderot and d'Alembert contributed to this shift in emphasis. At a later stage ethics was given a place of its own. For changes in disciplinary classifications, see E. Zilsel, 'The Genesis of the Concept of Scientific Progress', *Journal of the History of Ideas* 6 (1945) 325-349; E.J. Dijksterhuis, *De mechanisering van het wereldbeeld*, Amsterdam 1950; P.O. Kristeller, 'The Modern System of the Arts. A Study in the History of Aesthetics', *Journal of the History of Ideas* 12 (1951) 496-527; and R. Darnton, *The Great Cat Massacre and other Episodes in French History*, New York 1984, 191-214 ('Philosophers Trim the Tree of Knowledge').

9. A. Comte, *Cours de philosophie positive*, 6 vols. Paris 1838, second edition 1864. He constructed three stages: *état théologique* (subdivided in the age of *polythéïsme* and *monothéïsme*), *état métaphysique* and the stage of the *sciences positives*, which Comte considered philosophical and positivist or scientific. See also J. Heilbron, *Het ontstaan van de sociologie*, Amsterdam 1990, 207, 217 and 246-252.

10. See Heilbron, *Het ontstaan van de Sociologie*, 63-4, 70-4, 103 and 115-124.

11. See Th. S. Kuhn, *The Structure of Scientific Revolutions*, Chicago/London 1970.

12. I omit the vast literature on Academies, see for instance Zilsel, 'Genesis', *Journal of the History of Ideas* (1945) 348.

13. *Idée de la perfection de la peinture* by, as the title page states ROLAND FREART SIEVR DE CHAMBRAY, is republished, with an introduction by A. F. Blunt, Farnborough 1968.

14. See also G. Vasari, *Vite de' più eccellenti pittori, architettori e scultori*, ed. G. Milanesi, 9 vols. Florence 1878-1885; on Raimondi, VI 490, and below.

15. On page 104 he states 'Ie ne veux pas m'amuser icy dauantage à faire vne glose continüe iusqu'à la fin de cette longue et tres-importune rapsodie de Vasari..', but on 115 he still is falsifying 'nostre Historien pictoresque Vasari, qui, sans discretion et sans esprit, et contre toute apparence d'aucune possibilité, a tellement confondu l'ordre des temps et des choses...'. However Fréart notes on 116 the risk 'de me rendre trop ennuyeux dans ma critique, et de m'ennuyer aussi moymesme à vne lecture si rapsodieuse.'

16. Forgetting for a moment the rules of proper decorum he tried to discredit Vasari using words like 'fantastiquer', 'ignorance' (93), 'ses ridicules admirations', 'espece de disgrace à Raphael', 'exaggerations extrauagantes', 'l'extrauagance de son Idée (100), 'sottes loüanges' (102), 'impertinens flateurs',

'vision fantastique', 'ridicule admiration', 'l'application chymerique' (115) and 'ces resueries qui sont vn vray labyrinte, d'où il est extremement difficile de sortir' (106).

17. Fréart, *Idée de la perfection*, 107-8. Cf. in opposition Wood, 'Cannibalized Prints', *Journal of the Warburg and Courtauld Institutes* (1988) 218-9, concluding that Fréart is correct in his criticism of Vasari.

18. See, among others, Blunt in his introduction to Fréart, *Idée de la perfection de la peinture.*

19. G.P. Bellori, *Descrizzione delle imagini dipinte da Raffaello d'Urbino nelle Camere del Palazzo Apostolico Vaticano*, Rome 1695.

20. Bellori, *Descrizzione delle imagine dipinte*, 4-6. It is worth mentioning that Bellori quotes the last word of *Giustizia*'s inscription as *tribuens*, not *tribuit*, which would correspond to Justinian's statement more closely; as the inscriptions were very difficult to read in the eighteenth century small mistakes during restoration work are not to be excluded. The variant *tribuens* would change my argument a little, see below.

21. For this engraving of 1523 see also Wood, 'Cannibalized Prints', *Journal of the Warburg and Courtauld Institutes* (1988) 215-216, with additional references. On this engraving, the book and the tablet have Greek texts, alluding to the Gospel of Saint Luke.

22. Bellori, *Descrizzione delle imagini dipinte*, 15-17.

23. See also Winner, 'Il giudizio di Vasari', *Raffaello*, 180-182. These drawings, among them the left and right-hand group of the *'Disputa'*, belong to his 'ricordi e scritti fatti infin da giovanetto'. For Vasari's iconographic analysis it is important to note that during his first visit he was very young, and may have made small mistakes. Yet as a painter, it is unlikely that he completely confused the two frescoes.

24. Vasari, *Vite*, VII 13.

25. See also Wood, 'Cannibalized Prints', *Journal of the Warburg and Courtauld Institutes* (1988) 211.

26. This section does not refer to all the material that I need, and only gives an outline for a new hypothesis which will be published separately. The function of the Stanza della Segnatura has been the subject of much debate. Shearman's hyphesis that it housed Julius' new *bibliotheca secreta* has been generally accepted. Von Einem in his *Programm der Stanza* does not accept this function. See Shearman, 'Vatican Stanze' with most of the older literature, and C.L. Frommel 'Il Palazzo Vaticano sotto Giulio II e Leone X. Struttura e funzione' in the catalogue *Raffaello in Vaticano* (1984) 118-135. Unfortunately there are no handbooks, letters or diaries from that period informing us on the etiquette in the semi-public part of the papal palace. For some later parallels, see P. Waddy, *Seventeenth-Century Roman Palaces. Use and the Art of the Plan*, New York 1990, 3-13.

27. Parmenio, presentation copy to Julius in Biblioteca Apostolica Vaticana Vat. lat. 3702.

28. P.O. Kristeller, *Studies in Renaissance Thought and Letters* II, Rome 1985, 68, 171.

29. See also Shearman, 'Vatican Stanze', notes 88 and 89.

30. See for instance Von Einem, *Programm der Stanza della Segnatura*, 20-22 and also Pfeiffer *Raffaels Disputa*, 153-170.

31. This translation might suggest a way of causal thinking in the context of modern science; it is important to stress that the domain of knowledge in the context of Raphael's 'School of Athens' is not restricted to natural philosophy.

32. In particular Lucretius, *De rerum natura* I 62-79, where *humana vita* is linked to religion and the realm of heaven, III 1072 ('...quam bene si videat, iam rebus quisque relictis naturam primum studeat cognoscere rerum...'), a passage in which the study of the nature of things is not restricted to the natural sciences, V 1161-1163 ('Nunc quae causa deum per magna numina gentis pervulgarit et ararum compleverit urbis suscipiendaque curarit solemnia sacra...') and V 1185 ('...nec poterant quibus id fieret cognoscere causis'), discovering by which causes all that came about refers to the array of heaven, and includes divinity, religion and ritual.

33. Most notably in his *Metaphysica*, known in Rome mainly through its Latin translations, Aristotle coined the concept *theologia* as one of three branches of theoretical philosophy, the other two are mathematics and physics, see *Metaphysica* 1026a, 'Immobilia vero omnes quidem cause sempiterne et maxime ee; hee namque cause manifestis divine sunt. Quare tres erunt philosophie theorice: mathematica, physica, theologia (non enim manifestum quia si alicubi divinum existit, in tali natura

existit)'; repeated in 1064b, 3, in some editions. See *Aristoteles Latinus* XXV 2 *Metaphysica*. Translatio anonyma sive 'media', ed. G. Vuillemin-Diem, Leiden 1976. This provides another argument against the identification of *causarum cognitio* with philosophy distinct in all respects being from theology. Such a conceptualization would have been alien to Plato and Aristotle who were studied with an ever increasing philologic attention. From late Antiquity to the High Renaissance the science of things divine or sacred science was considered to be the queen of all sciences. In early Greek usage the word referred to the content of myths. Augustine continues to consider philosophy and theology as to a large extent overlapping fields of interest, and Thomas Aquinas stresses their close connection. A clear cut distinction between philosophy and theology as specialized disciplines is foreign to the pre-Protestant Christian Neo-Platonism in Rome at the age of Julius II.

34. For Bonaventura see Gutman, 'Medieval content', *Journal of the History of Ideas* (1941) 425, 428, and 'Zur Ikonologie'; I think that Gutman overstates his thesis about the overwhelming influence of Bonaventura; his analysis of the inscriptions, 29. See also Pfeiffer *Raffaels Disputa*, 153-170, who refers to Thomas Aquinas as well. With Dante, Petrarch and others, they added meaning to classical and biblical concepts. For that reason they are portayed, but none of them is *the* source of the pictorial programme.

35. *Institutiones* 1.1 which opens with *De iustitia et iure*, its first sentence being 'Iustitia est constans et perpetua voluntas ius suum cuique tribuens. 1. Iuris prudentia est divinarum atque humanarum rerum notitia, iusti atque injusti scientia'. The meaning of this is clarified in section 3: 'Iuris praecepta sunt haec: honeste vivere, alterum non laedere, suum cuique tribuere', which is linked to two kinds of study: public law and private law, which consists of *ius naturale, ius gentium* and *ius civile*. See also *Digesta* 1.1.10, where the *iuris praecepta* are defined before *iuris prudentia*, while in 1.1 slightly different formulations are given.

36. Cicero, *De finibus bonorum et malorum*, V XXIII 65; Cicero links *institia* to other virtues, such as *fortitudo, temperantia* and *prudentia* (67), repeating the definition in other words '...iustitia in suo cuique tribuendo'. See also *De officiis* I, which in turn, has close parallels to Plato's *Republica* and his *Protagoras* where classifications of virtues are discussed. Cicero connects *iustitia*, the first of four aspects of *honestas* or the *honestum*, to *temperantia* (or *moderatio*, or *modestia*), *fortitudo* and *prudentia*, that implies knowing the past and the future (or *cognitio*, or *scientia*, or *sapientia*, or *ratio*). See also the influential definitions in *De inventione* II 160-162, of *prudentia, providentia, religio, pietas, cultus, ius, lex, fortitudo, temperantia* and related abstractions, in particular: 'Iustitia est habitus animi communi utilitate conservata suum cuique tribuens dignitatem'. Cicero's concepts, subsequently christianized, are relevant for the female personifications on the so-called 'Jurisprudence wall', yet neither *De officiis*, nor *De finibus* provides a clear cut fourfold classification that fits the personifications perfectly. Ambrosius coined the concept of four *virtutes cardinales* – *temperantia, fortitudo, sapientia* and *iustitia*, on which the others depend. This conceptualization was further elaborated by Thomas Aquinas. Augustus personified *iustitia, virtus, pietas* and *clementia* which were depicted on his *clupeus aureus* – golden shield.

37. See *Digesta* 1.1.1, 1.1.2, 1.7.45 (on divine and human law, the first concerning *res sacrae et religiosae*) and 1.8.6-10; knowledge of both the divine and the human is time and again declared to be crucial for justice, the law and its science. In an interpolation of Justinian (*Institutiones* 1.2.11), it is said that a divine providence always remains firm and immovable. *De conceptione digestorum* stresses God's authority, heavenly majesty and the Trinity as crucial to the world order; hence laws, constitutions and justice imply *res divinae et humanae*, and the study of both. With regard to the issue of identifications, I think the ruler to the left is more likely to be Caesar Augustus (*Princeps, Consul, Pater Patriae* and *Pontifex Maximus*) than Justinian who was not a major figure in the writings of Julius' advisors.

38. Cicero, *De legibus* I, VIII 24, where he stated that only man has any knowledge of God: 'itaque ex tot generibus nullum est animal praeter hominem, quod habeat notitiam aliquam dei'.

39. Tertullian and Augustine discuss *flatus* and related words and assigned them a Christian meaning. In a discussion of the Delphic oracles, Cicero used *afflatus* or *adflatus*, by the divine, as a means to foresee the future, see *De divinatione* II, LVII 117. See also *divino afflatus* for the Pythian priestess (I, XIX

38) and the same for the Erythraean sibyl (I, XVIII 34). Discussing great men he stated '...sine aliquo afflatu divino umquam fuit', see *De natura deorum* II, LXVI 167. Both Virgil and Cicero have been Christianized in the verbal and pictorial context of the Stanza della Segnatura. Cicero also used *numen* with some frequency as well as *harmonia*. For example, *Republica* I 16 and II 69, have a meaning that is relevant for the 'School of Athens' and the Stanza as a whole.

40. See J. O'Malley, *Rome and the Renaissance. Studies in Culture and Religion*, London 1981 (V) 292, 'sibyllae ducentis scientia prius, deinde numinis afflantis sapientia institui nos oportere significavit.'

41. See for example, L.L.E. Schlüter, *Niet alleen. Een kunsthistorisch-ethische plaatsbepaling van tuin en huis in het* Convivium religiosum *van Erasmus*, Amsterdam 1995.

42. If Bellori's transcription as 'tribuens' is correct, the happy few would have to meditate on similar things, yet in a somewhat simpler way: "knowledge of causes is inspired by divinity due to insight in the divinity, the law giving everyone his due".

43. Such as the magic square (SATOR/AREPO/TENET/OPERA/ROTAS). Augustine's reading of the prophecies of the Erythraean Sibyl (the initial letters of the verses formed 'Jesus Christ, the Son of God, the Saviour', *De civitate Dei* XVII, XVIII) and the inscriptions of the sibyls in the Sassetti Chapel in Santa Trinità at Florence.

44. The female personification is usually identified as Astronomy or the Aristotelian *Primo Moto; primum movens* or *causa* (with or without a specification) seems more correct to me.

45. See, among other publications, Kristeller, *Studies in Renaissance Thought*, further references on 586.

46. See in particular J. d'Amico, *Humanism in Papal Rome: Humanists and Churchmen on the Eve of the Reformation*, Baltimore 1983 and O'Malley *Rome and the Renaissance*; also *Giles of Viterbo on Church and Reform. A Study in Renaissance Thought*, Leiden 1968 and *Praise and Blame in Renaissance Rome. Rhetoric, Doctine and Reform in the Sacred Orators of the Papal Court, ca. 1450-1521*, Durham 1979. Their work is integrated in the view of Ch. S. Stinger, *The Renaissance in Rome*, Bloomington 1985, however with the exception of Raphael's iconography in the Stanza della Segnatura, 196-202. The trend in thinking may be coined theological, Biblical or Roman humanism, though none of these terms is entirely satisfactory.

47. There are remarkable, and I think convincing, parallels with earlier images, for instance medieval manuscripts, panel paintings (Francesco Traini, 'Triumph of Saint Thomas Aquinas', Santa Caterina in Pisa and Benozzo Gozzoli's 'Triumph of Thomas Aquinas' in the Louvre), frescoes (Carafa Chapel in Rome), mosaics and sculpture (the floor of Siena Cathedral shows Socrates, its façade Plato, Aristotle and the Evangelists). Their joint appearance, with Paul as well, is by no means exceptional. An interesting parallel is also the medal with on the *recto* a portrait of Cardinal Domenico Grimani, a friend of Julius II, and on the *verso* two personifications. To the left stands THEOLOGIA, stretching her left hand to the right one of PHILOSOPHIA, who is sitting and has a lower position, while above the hand of God touches the right hand of the woman who personifies theology (National Gallery Washington, Kress Collection). The frontispiece of G. Reisch, *Margarita philosophica*, 1503 shows *Philosophia* and the seven *artes* in a way that differs from Raphael, yet unites Aristotle and Seneca with the four Church Fathers in the margin. There was a dominant iconographic tradition, connecting the classical and biblical world.

48. Some of these identifications have been proposed in Kempers, 'Staatssymboliek', *Incontri*, (1986/87) 3-48; 'Antiek fundament voor een christelijk monument' in Van Dijk and Smits (eds.), *Dwergen op schouders van Reuzen*; and *Painting, Power and Patronage. The Rise of the Professional Artist in Renaissance Italy*, London 1992.

49. Known as *Libri quattuor sententiae* and *In quattuor libros sententiarum*, Rome 1504, published by Silver, and *Paulus Cortesius In Sententias*, Basel 1513, republished in the same town in 1540. See d'Amico, *Humanism in Papal Rome*, 148-168. The Paris edition by Badius (1513) contains the text *Pauli Cortesii Protonotarii...In quattuor libros sententiarum argutae romanoque eloquio disputationes.* The text was in the eighteenth century included in Cortesi's *Opera Omnia*.

50. Biblioteca Apostolica Vaticana Vat. lat. 1125; its miniatures contain references to Julius Ceasar and Augustus, as those in J.M. Nagonius, Vat. Lat. 1682 fol. 8v-9r. The printed edition of Vigerio was

published in Fano 1507 and Paris 1517 by both Badius and Koberger, together with the *Controversia de excellentia Dominicae Passionis*, its *editio princeps* being Silver in Rome 1512.

51. See O'Malley, *Rome and the Renaissance*, I, II, III, IV and V.
52. Biblioteca Apostolica Vaticana Vat. lat. 6325. See O'Malley, *Giles of Viterbo*, and Pfeiffer, *Raffaels Disputa*, who links the work of Giles of Viterbo to Raphael's iconography, and might have met more criticism than he deserved. Cf. Pfeiffer in *Raffaello a Roma* 1986, 50-51, and, in particular, Pfeiffer, *Raffaels Disputa*, 173-206, drawing close parallels between Egidio's phrases and Raphael's inscriptions.
53. Biblioteca Angelica 502.
54. Volume dedicated to Julius II, adorned with his coat-of-arms and other insignia in Biblioteca Apostolica Vaticana
55. Adriano Castellesi, *De vera philosophia ex quattuor doctoribus ecclesiae*, Bologna 1507 – published by A. de Benedictis and in 1514 by Mazochi in Rome – has a similar orientation on the Latin Doctors of the Church, but is more critical about the merits of pagan philosophy and the role of human reason. This cardinal, who was not a favourite of Julius II, returned to a defence of faith, but in a Ciceronian style; the liberal arts must be judged by their agreement with divine revelation. See d'Amico *Humanism in Papal Rome*, 169-188.
56. Similar views were also presented in France, for example in the publications of Jacques Lefèvre d'Etaples. He published on logic, mathematics, Aristotle, Saint Paul, the Gospels and other parts of the Bible. His aim was to provide accurate and elegant translations on the basis of reliable texts; he wanted to present Aristotle's natural philosophy in accordance with Christian doctrine. More critical, especially in his later works, was Guillaume Budé. He prepared an edition of the *Corpus iuris civilis* in 1508, when his *Annotationes in Pandectas* were published (Paris Badius 1508). In his annotations and commentary to the first twenty-four books of the *Digesta*, Budé quotes the Ciceronian definition of philosophy from *De oratore* Liber I: to know all things, human and divine, and links this to Ulpian's definition of jurisprudence which is likewise a quest for all embracing knowledge. Budé criticizes Accursius and prefers to refer directly to the classical tradition to provide a harmony among all scholarly pursuits and its practical adaptations. For this synthesis he likes to use concepts such as *encyclopedia* and *philotheoria*. His commentary on the Justinian definition of Justice (24) contains references to Cicero, Plato, Aristotle, Lactantius and Augustine, and to painted images of *iustitia*. A Paris edition (J. Petit 1508) of sections from the *Corpus* depicts an emperor in front of three bishops and four princes – alluding to the German Emperor – as well as the text 'AVGVSTVS'. This image occurs in several French editions of Justinian's *Corpus*. This imagery is another argument against identifying the ruler to the viewer's left on the 'Jurisprudance wall' as Justinian, who is given much less emphasis in contemporary ideas in Rome than Augustus, the legitimate founder of both imperial and papal authority. Attempts to provide a synthesis between Greek knowledge and Christian faith become a matter of debate in the 1520s and 1530s, witness Erasmus, *Dialogvs cvi titvlvs Ciceronianvs siue de optimo dicendi genere* (Basel 1528, published by Froben) and Budé, *De transitu Hellenismi ad Christianismum*, Paris 1535. This work dealt, again, with the relation between the pagan and the Christian that developed from Hellenist culture, but acquired ideas, concepts and a history of its own. Philosophy should aim at *cognitio Dei*, but Hellenism on its own runs the risk of misunderstanding the truth, and would bring only *philomoriae* or *pseudosophiae*.

Chapter 11

1. E. de Jongh, 'Seventeenth-century Dutch painting: multi-faceted research', in N.C.F. van Sas and E. Witte (ed.), *Historical research in the Low Countries*, Den Haag 1992, 35-46.
2. J.N. van Wessem, 'Jan Steen (1626-1679), *Het oestereetstertje*', *Openbaar Kunstbezit* 1 (1957) 7a-7b; 'Wij moeten wel bedenken dat een schilderstuk als kunstwerk nooit belangrijk is om het wát, maar alleen om het hoe'.

3. 'Men moet de Schilderijen niet oordeelen na de beeltenissen [figuren] die daar in staen/ maer na de konst in de selvige/ en na de aardige beduidingen'.
4. Svetlana Alpers, *The art of describing. Dutch art in the seventeenth century*, Chicago 1983.
5. Alpers, *Idem*, 103-109.
6. Cf. Peter Hecht, *De Hollandse fijnschilders*, Rijksmuseum Amsterdam 1989; Jan-Baptist Bedaux, *The reality of symbols. Studies in the iconology of Netherlandish art 1400-1800*, The Hague 1990; Eric-Jan Sluijter, 'Didactic and disguised meaning? Several seventeenth-century texts on painting and the iconological approach to Northern Dutch paintings of this period', in David Freedberg & Jan de Vries (ed.), *Art in history, history in art. Studies in seventeenth-century culture*, Santa Monica Ca. 1991, 175-207.
7. Sluijter, *Idem*, 184-187.
8. Cf. Lyckle de Vries, *Wybrand de Geest. 'De Friessche Adelaar'. Portretschilder in Leeuwarden 1592-c.1661*, Leeuwarden 1982, 20-23. Portraits were discussed at length only by Gerard Lairesse in *Het groot schilderboek II*, Amsterdam 1707, 5-42.
9. Cf. E. de Jongh, 'Die 'Sprachlichkeit' der niederländischen Malerei im 17. Jahrhundert', in Sabine Schulze (ed.), *Leselust. Niederländische Malerei von Rembrandt bis Vermeer*, Schirn Kunsthalle Frankfort 1993, 23-33.
10. S. F. Witstein, 'Aandacht voor de Aenleidinge' in *Tijdschrift voor Nederlandse taal- en letterkunde* 88 (1972) 81-106; E.K. Grootes, 'Vondels Aenleidinge ter Nederduitsche dichtkunste (1650)' in *Weerwerk. Opstellen aangeboden aan prof. dr. Garmt Stuiveling ter gelegenheid van zijn afscheid als hoogleraar aan de Universiteit van Amsterdam*, Assen 1973, 81-95 en 253-258. Grootes points out that Vondel has left various aspects aside. Cf. J. van den Vondel, *Aenleidinge ter Nederduitsche dichtkunste,* Utrecht 1977.
11. Cesare Ripa, *Iconologia, of uytbeeldingen des verstands...,* translated by D.P. Pers, Amsterdam 1644. A reprint of 1971 includes an interesting introduction by Jochen Becker, Utrecht 1971.
12. The idea that many seventeenth century paintings are multivalent on purpose has been advocated by Jan Bialostocki, *The message af images. Studies in the history of art*, Vienna 1988, 166-180; and Jochen Becker, 'Der Blick auf den Betrachter: Mehrdeutigkeit als Gestaltungsprinzip niederlandischer Kunst des 17. Jahrhundert' in *L'art et les révolutions*. Section 7, XXVIIe Congrès Internationale de l'Histoire de l'art, Straszburg 1992, 77-92.
13. Cat. exhibition *Johannes Vermeer*, National Gallery of Art, Washington and Mauritshuis, The Hague 1995-1996, 196-199.
14. Otto Vaenius, *Amorum emblemata*, Antwerpen 1608, 2-3.
15. E. de Jongh, *Kwesties van betekenis. Thema en motief in de Nederlandse schilderkunst van de zeventiende eeuw*, Leiden 1995, 91, 130, 240, 242 and 277 note 42.
16. See footnotes 40 and 46.
17. Cf. Jean H. Hagstrum, *The sister arts. The tradition of literary pictorialism and English poetry from Dryden to Gray,* Chicago etc. 1974.
18. Cf. Maria A. Schenkeveld, *Dutch literature in the age of Rembrandt. Themes and ideas*, Amsterdam 1991, 115-135.
19. Hagstrum, *The Sister Arts*, and *Oxford English Dictionary*.
20. De Jongh, *Kwesties van betekenis*, 185.
21. Joost van den Vondel, *Het Pascha* (1612), in *De werken* I, Amsterdam 1927, 164 ('een levende schoon-verwighe schilderije').
22. Idem, *Joseph in Dothan* (1640) in *De werken* IV, Amsterdam 1930, 74 ('gelijck wy in 't sluiten van dit werck, ten naesten by, met woorden des schilders verwen, teickeningen, en hartstoghten, pooghden na te volgen'). Cf. Schenkeveld, *Dutch Literature*, 120-121.
23. Joost van den Vondel, *De werken* IV, 590 ('Hy is gewoon zijn Poëzy/Te huwen aan uw schildery').
24. F. de Quevedo y Villegas, *Seven wonderlijcke ghesichten. In welcke alle de gebreken deser eeuwe, onder alle staten van menschen, vermaecklijck en oock stichtelijck, werden bestraft; ende als in een schilderye*

naecktelijck vertoont ..., Leeuwarden 1641; L.R. Pol, *Romanbeschouwing in voorredes. Een onderzoek naar het denken over de roman in Nederland tussen 1600 en 1755*, Utrecht 1987, 24.

25. Horatius, *De arte poetica*, vs. 333--334. Cf. De Jongh, *Kwesties van betekenis*, 100, 258, note 35.

26. Rensselaer W. Lee, *Ut pictura poesis. The humanistic theory of painting*, New York 1967, 3-9.

27. *Ibidem* 3; Hagstrum, *The Sister Arts*, 10, 29.

28. Cf. Allan Ellenius, *De arte pingendi. Latin art literature in seventeenth-century Sweden and its international background*, Uppsala, 1960, 72-96. K. Porteman, 'Geschreven met de linkerhand? Letteren tegenover schilderkunst in de Gouden Eeuw', in Marijke Spies (ed.), *Historische letterkunde, Facetten van vakbeoefening*, Groningen 1984, 93-113 esp. 106.

29. Sir Joshua Reynolds, *Discourses on art*, edited by Robert R. Wark, New Haven 1975, 130.

30. Cf. Peter Hecht, 'The paragone debate: ten illustrations and a comment', *Simiolus* 14 (1984) 125-136.

31. Irma A. Richter, *Paragone. A comparison of the arts by Leonardo da Vinci*, London 1949.

32. Philips Angel, *Lof der schilder-konst*, Leiden 1642, 27.

33. Porteman, 'Geschreven met de linkerhand?', Spies (ed.), *Historische letterkunde*; also Porteman, *Inleiding tot de Nederlandse emblemataliteratuur*, Groningen 1977.

34. J.A. Emmens, 'Apelles en Apollo. Nederlandse gedichten op schilderijen in de 17de eeuw', *Kunsthistorische opstellen* I, Amsterdam 1981, 5-60.

35. Roger H. Marijnissen, *Bruegel. Het volledig oeuvre*, Antwerpen 1988, 133-144. See also Mark Meadow, 'On the structure of knowledge in Bruegel's Netherlandish proverbs', *Volkskundig Bulletin* 18 (1992) 141-169.

36. See catalogue exhibition *Le siècle de Rembrandt. Tableaux hollandais des collections publiques françaises*, Musée du Petit Palais, Paris 1970-1971, 45-46.

37. Cf. Gerdien Wuestman discussing an etching from 1606 with the same theme, after David Vinckboons by Hessel Gerritsz (?), in Ger Luijten et al. (ed.), *Dawn of the Golden Age. Northern Netherlandish art 1580 - 1620*, Rijksmuseum, Amsterdam 1993-1994, 614-615.

38. See Longman's *Dictionary of English Idioms*, s.v. 'Possession'. Wuestman, in Luijten et al. (ed.), *Dawn of the Golden Age*, gives a somewhat different explanation of this proverb on the etching attributed to Hessel Gerritsz.

39. Walter L. Strauss and Marjon van der Meulen, *The Rembrandt Documents*, New York 1979, 387 ('Een pitoor nae 't leven, van Rembrant').

40. De Jongh, *Kwesties van betekenis*, 248, note 54. Gary Schwartz, *Rembrandt, zijn leven, zijn schilderijen*, Maarssen 1984, 206; H. Perry Chapman, *Rembrandt's Self-portraits. A study in seventeenth-century identity*, Princeton NJ 1990, 48. Cf. Lyckle de Vries, 'Tronies and other single figured Netherlandish paintings'g in H. Blasse-Hegeman et al.(ed.), *Nederlandse portretten. Bijdragen over de portretkunst in de Nederlanden uit de zestiende, zeventiende en achttiende eeuw, Leids Kunsthistorisch Jaarboek* 8 (1989), Den Haag 1990, 185-202; and E. de Jongh, 'De mate van ikheid in Rembrandts zelfportretten', *Kunstschrift* 35 (1992) nr. 6, 13-23.

41. *Woordenboek der Nederlandsche Taal* 12 kol. 2027.

42. E. de Jongh, 'Jan Steen, so near and yet so far', in *Jan Steen, painter and storyteller*, exhibition catalogue National Gallery of Art, Washington, and Rijksmuseum Amsterdam 1996-1997, 45-49

43. *Ibidem* 48-49

44. See E. de Jongh et al., *Faces of the Golden Age. Seventeenth-Century Dutch Portraits*, exhibition catalogue The Yamaguchi Prefectural Museum of Art, Yamaguchi 1994, English Supplement, 48-49.

45. Ripa, *Iconologia, of uytbeeldingen des verstands*, 316-317, 484, 470.

46. Ben Broos, *Meesterwerken in het Mauritshuis*, Den Haag 1987, 185-189.

47. Alpers, *The art of describing*, 187.

48. Ben Broos et al., *Hollandse meesters uit Amerika*, exhibition catalogue Mauritshuis, Den Haag 1990-1991, 291-294.

49. A difference of opinion exists on how the text should be transcribed. Seymour Slive, *Frans Hals* I, Londen 1970, 93, reads 'naers' instead of 'naeis': 'Who recognizes my arse from the rear'. Also in

Broos et al., *Hollandse meesters*, 293. Cf. E. de Jongh, 'Woord en Beeld. De salon van de gezusters Kunst', *Kunstschrift* 38 (1994) nr. 5, 6-12.

50. 'Die mij beschouwd, die wiste graag/ En wie ik zij, en wat ik draag:/ Maar vriend, ik ben als die mij ziet;/ want nogh ken ik mijn zelven niet.'

51. E. de Jongh et al., *Still-life in the age of Rembrandt*, exhibition catalogue Auckland City Art Gallery, Auckland 1982, 198-203.

52. A catalogue of Sotheby, New York 19 mei 1995, attributed this work to the French artist Simon Renard de Saint-André, who was deeply influenced by Dutch *vanitas* painters.

53. See *Nederlandse 17de eeuwse schilderijen uit Boedapest*, exhibition catalogue Centraal Museum, Utrecht 1987, 84-85; and *De wereld binnen handbereik. Nederlandse kunst- en rariteitenverzamelingen*, 1585-1735, exhibition catalogue Amsterdams Historisch Museum, Amsterdam 1992, 20.

54. De Jongh et al., *Still-life in the age of Rembrandt*, 192-197.

55. The poem in Brisé's painting runs as follows:
'De doot stelt hoogh en laagh gelyck:/En 'tmiddelbaar en Arm en Ryk./Het sterven is't gemeene lot,/ De Boek Geleertheit en Marot/Zyn even schoon en wys in 't Graf/De Delvers Graaf en Bissopsstaf/ De Zackpyp, ende Tulbantskroon/Staan al int uiterst even schoon/Laat woelen al wat woelen wil/ Soo staat het al ten lesten stil.'
There are some small differences compared to Vondel's text and orthography; Joost van den Vondel, *De werken* IX, Amsterdam 1939, 293.

56. Zie Lydia De Pauw-De Veen, *De beqrippen 'schilder', 'schilderij' en 'schilderen' in de zeventiende eeuw*, Brussel 1969, 141-142.

57. See note 55.

CHAPTER *12*

1. Earlier versions of this text were delivered in the form of lectures at Stanford and Cornell Universities in 1990 and 1992, respectively. In this regard I would like to thank Keith M. Baker (Stanford) and Nan E. Karwan Cutting (Cornell), as well as their students, for their valuable suggestions, which I have taken into account as far as possible. The present text was rendered into English with the sensitive and competent assistance of Deborah Cohen, Sabine Koerner-Bourne and Michael Wagner.

2. For a general overview of this subject, see Jeanne Duportal, *Etude sur les livres à figures édités en France de 1601 à 1660*, Geneva 1992, and Jean-Marc Chatelain, *Livres d'emblèmes et de devises: une anthologie, 1531-1735*, Paris 1993. The question of whether such allegories were broadly comprehensible or elitist puzzles is discussed in Peter Johannes Schneemann, *Geschichte als Vorbild: Die Modelle der französischen Historienmalerei 1747-1789*, Berlin 1993, 66-93; see also Antoine de Baecque, 'The Allegorical Image of France, 1750-1800: A Political Crisis of Representation', *Representations* 47 (1993) 111-43.

3. The publishing house Aux amateurs des Livres has brought out a selection of reprints: *Les Recueils d'emblèmes et les traités de physiognomie de la Bibliothèque interuniversitaire de Lille*, 11 vols., Paris 1989.

4. These details as well as those in subsequent interpretations may be verified by consulting the comprehensive texts that accompany the emblem books and explain their illustrations; in this connection see Cesare Ripa, *Iconologie où les principales choses qui peuvent tomber dans la pensée touchant les vices sont représentées*, trans. from the Italian by Jean Baudoin, 2 vols., Paris 1643, vol. I 99-101.

5. *Ibidem* I 54, 58.

6. Some references in Maurice Agulhon's *Marianne au combat: L'imagerie et la symbolique républicaines de 1789 à 1880*, Paris 1979; also Lynn Hunt, *Politics, Culture, and Class in the French Revolution*, Berkeley 1984, 52-86; and Valérie Chansard, 'Les rapports du discours de la symbolique dans les vignettes révolutionnaires' in Michel Vovelle (ed.), *Les Images de la Révolution française*, Paris 1989, 317-22.

7. More on this in Klaus Herding and Rolf Reichardt, *Die Bildpublizistik der Französischen Revolution*, Frankfurt 1989, 151-53.

8. Jean Adhémar, 'L'enseignement par l'image', *Gazette des Beaux-Arts* 97 (1981) 53-60, and 98 (1981) 49-60.

9. The best overview of this body of sources to date – apart from the musical and iconographical aspects – is Jean Hébrard, 'Les catéchismes de la première Révolution', in Lise Andriès (ed.), *Colporter la Révolution*, Montreuil 1989, 53–73; and idem, 'La Révolution expliquée aux enfants: les catéchismes de l'an II', in Marie-Françoise Lévy (ed.), *L'Enfant, la famille et la Révolution française*, Paris 1989, 171-92 and 461-63.

10. *La Société des Jacobins: Recueil de documents pour l'histoire du club des Jacobins de Paris*, ed. Alphonse Aulard, 6 vols., Paris 1889–97, III 263.

11. Jacques-Marie Boyer-Brun, *Histoire des caricatures de la révolte des François*, 2 vols., Paris 1792, I 9–10.

12. More on the popular use of pictures for didactic purposes during the French Revolution in Herding and Reichardt, *Die Bildpublizistik der Französischen Revolution*, 15-20.

13. This allegory illustrates the chapter 'Cinquième Entretien. L'Egalité' by Chemin-Dupontès fils, *L'Ami des jeunes patriotes, ou Catéchisme républicain dédié aux jeunes Martyrs de la Liberté*, Paris 1793-1794, 30-33.

14. For want of more recent work on this topic, André Blum's classic series of essays, 'L'estampe satirique et la caricature en France au XVIIIᵉ siècle', remains a standard work, in *Gazette des Beaux-Arts* 52/i (1910) 379-92, 52/ii (1910) 69-87, 108-20, 243-54, 275-92, and 52/iii (1910) 449-67. Furthermore, a whole series of examples is contained in the *Handbuch politisch-sozialer Grundbegriffe in Frankreich 1680-1820*, ed. by Rolf Reichardt and Hans-Jürgen Lüsebrink, 18 issues to date (Munich 1985-95).

15. For more details, see Antoine de Baecque, *La Caricature révolutionnaire*, Paris 1988; and Herding and Reichardt, *Die Bildpublizistik der Französischen Revolution*.

16. On the significance of this 'pictorial battle' for the conceptual development of class-consciousness, see Herding and Reichardt, *Die Bildpublizistik der Französischen Revolution*, 103-12.

17. The model for this drawing was a caricature directed against the Jesuit Gabriel Malagrida dating from 1758, Bibliothèque Nationale Paris, Dép. des Est., Coll. Hennin, nr. 8891.

18. This print is interpreted in greater detail by Antoine de Baecque in 'Iscariotte, géant aristocrate ou l'image-monstre de la Revolution' in *Annales Historiques de la Révolution Française* 64 (1993) 322-32.

19. Jean-Louis Desprez' *Chimère* (1777-84) did in fact provide the pictorial idea but whereas Desprez portrayed a monster of the African desert, the anonymous revolutionary draughtsman politicised the image to the extent that it became a vehicle for drastic social criticism.

20. Commentary on a frontispiece that portrays the *aristocratie* as a many-headed dragon in *Étrennes à la vérité, ou Almanach des Aristocrates* (1790) 1.

21. Yves-Marie Bercé, *Croquants et nu-pieds: soulèvements paysans en France du 16ᵉ au 19ᵉ siècles*, Paris 1974.

22. See, among others, the fundamental methodological critique of the history of concepts by Dieter Busse, *Historische Semantik: Analyse eines Programms*, Stuttgart 1987.

23. In what follows this term is understood as referring to the particular vocabulary that defines a key concept within a specific context or series of similar contexts (paradigms), differentiates meaning (syntagms) and defines by the juxtaposition of opposites (antonyms). For an illustration of this, refer to the empirical case studies mentioned in the following footnote.

24. Hans-Jürgen Lüsebrink and Rolf Reichardt, 'La *Bastille* dans l'imaginaire social de la France à la fin du XVIIIᵉ siècle, 1774-1799', *Revue d'Histoire Moderne et Contemporaine* 30 (1983) 196-234; R. Reichardt, 'Der *Honnête Homme* zwischen höfischer und bürgerlicher Gesellschaft: Seriell-begriffsgeschichtliche Untersuchungen von *Honnêteté*-Traktaten des 17. und 18. Jahrhunderts' *Archiv für Kulturgeschichte* 69 (1987) 341-70.

25. In this article, the terms 'key concepts' and 'key words' refer to words that are especially rich in meaning and which have played an outstanding role in the collective consciousness of, as well as in the creation of the (pictorial) symbols common to, particular historical language groups. In my understanding, a socio-cultural history of concepts should combine the sociological tenets of Berger/ Luckmann and Lewis, Wittgenstein's theory of linguistic communication and Foucault's approach to a semantic of historical discourse. On this, see my introduction to the *Handbuch politisch-sozialer Grundbegriffe*, vol 1/2, 60-84; Busse in D. Busse, Fritz Hermann, Wolfgang Teubert (eds.), *Historische Semantik; Begriffsgeschichte und Diskursgeschichte: Methodefragen und Forschungsergebnisse der historischen Semantik,* Opladen 1994.

26. In Alain R. Girard and Claude Quétel, *L'Histoire de France racontée par le jeu de l'oie*, Paris 1982, 85-98, the game is reproduced but no critical commentary is provided.

27. Compare for example with Nyon le Jeune's *Catéchisme de la Constitution Française*, Paris 1791, especially 7-10, 15-16 and 26.

28. The following interpretation is based on my annotated reprint of the game but contains a large number of modifications and additions; see R. Reichardt, *Das Revolutionsspiel von 1791: Ein Beispiel für die Medienpolitik und Selbstdarstellung der Französischen Revolution,* Frankfurt 1989.

29. See M. A. Katritzky, 'Italian Comedians in Renaissance Prints', *Print Quarterly* 4 (1987) 236-54, especially 249.

30. On the following see Henri-René d'Allemagne, *Le noble jeu de l'oie en France de 1640 à 1950,* Paris 1950, as well as Girard and Quétel. More recently, three articles of James A. Leith have rediscovered the pedagogical and political funtions of these games: 'Pedagogy through Games: the *Jeu de l'Oie* during the French Revolution and the Empire' in *Proceedings of the Consortium on Revolutionary Europe 1992* (1993) 166-199; 'La pédagogie à travers les jeux: le Jeu de l'Oie pendant la Révolution française et l'Empire' in Josiane Boulad-Ayoub (ed.), *Former un nouveau peuple? Pouvoir, Éducation, Révolution,* Québec/Paris 1996, 159-186; 'Clio and the Goose: the Jeu de l'Oie as Historical Evidence' in Carolyn W. White (ed.), *Essays in European History, Selected from the Annual Meeting of the Southern Historical Association,* Lanham / London 1996, Vol. III 225-261.

31. The popular *Précis historique de la Révolution française* by Jean-Paul Rabaut Saint-Etienne (Strasbourg, 1791/92), promoted itself on the fly-leaf with the following announcement: 'jeu national à la porté de tout le monde, et propre à faire connoître à toutes les classes de la société les avantages et les bienfaits de la révolution et de la constitution. Ce jeu, principalement destiné à instruire les habitants des campagnes, se vend, par paquets de 20 exemplaires, à raison de 5 livres, et de 6 livres francs de port.' Incidentally, Rabaut Saint-Etienne's almanac propagated the same view of history as our game.

32. More details in Herding and Reichardt, *Die Bildpublizistik der Französischen Revolution,* 20-24; see also Claudette Hould, 'La gravure en Révolution' in C. Hould (ed.), *L'Image de la Révolution française,* Québec 1989, 63-94.

33. The second print bears the same title: *Jeu de la Révolution Française,* Anonymous, coloured etching, 1791, 35 x 50.5 cm, Bibliothèque Nationale Paris, Dép. des Estampes, Coll. Hennin, no. 11050.

34. See Fig. 11 as well as the following copies or variants: two identical copies attributed to M. Smith Publishers in London (presumably pirated) and Treuttel Publishers in Strasbourg, respectively (both in the Bibliothèque Nationale Paris, Dept. des Estampes, Coll. de Vinck, nos. 4292 and 4293); a simplified copy without accompanying text, entitled *Poule de Henri IV* (illus. in Girard and Quétel, 92); and a German translation including all accompanying texts, entitled *Nationalspiel, oder das Huhn Heinrich des Vierten, in den Topf gethan im Jahr 1792,* coloured etching with printed letters, printed in Strasbourg by Treuttel, 1792, Musée Historique Strasbourg.

35. See the chronological list in Reichardt, *Revolutionsspiel,* 8-9.

36. Quoted in Marcel Roux et al., *Graveurs du dix-huitième siècle,* 15 vols. to date, Paris 1931-77, II 158.

37. On this point see Marcel Reinhard, *La Légende de Henri IV,* Paris 1936.

38. Clarence D. Brenner, 'Henri IV on the French Stage in the Eighteenth Century', *Publications of the Modern Language Association* 46 (1931) 540-53; Anne Boès, *La Lanterne magique de l'histoire: Essai*

sur le théâtre historique en France de 1750 à 1789, Paris 1982; Michèle Root-Bernstein, *Boulevard Theatre and Revolution in Eighteenth-Century Paris*, Oxford 1982.

39. See among others, Louis-Laurent Prault, *L'Esprit de Henri IV, ou Anecdotes les plus intéressantes, traits sublimes, reparties ingénieuses, & quelques lettres de ce Prince*, Amsterdam 1790.
40. See the description in Prault, 109; on the historical authenticity of this scene refer to Reinhard, 103.
41. Prault, 74, embellishes Henry's words: 'si Dieu me fait la grace de vivre dix-huit mois ou deux ans, je veux qu'il n'y ait pas un Paysan dans mon Royaume qui ne mette le Dimanche une poule dans son pot.' According to Reinhard, 58-59, the words 'le Dimanche' were not in the original statement but added posthumously.
42. Charles Collé, *La Partie de chasse de Henri IV*, Paris 1760/64. Originally banned due to its implicit criticism of despotism, the play was extremely successful and in autumn 1791 was staged again in Paris; see also the review in the newspaper *Révolutions de Paris* 114 (10.-17. Sept. 1791) 493, and 115 (17-24. Sept. 1791) 520-21.
43. See Charles Tillon, *Le Laboureur et la République: Michel Gérard, député paysan sous la Révolution française*, Paris 1983.
44. Paris 1792; in some of the many editions of this almanac every one of the 12 'entretiens' on the Constitution is illustrated with an etching showing Père Gérard in the company of his peasants.
45. Examples include Abbé Athanase Auger, *Catéchisme du citoyen français, composé de l'esprit et de la lettre de la nouvelle Constitution*, Paris 1791; Comte de Mirabeau, *Catéchisme de la Constitution, à l'usage des habitans de la campgane*, 1791.
46. See, among others, the anonymous text *La Constitution Française en chansons, à l'usage des honnêtes gens*, Paris 1792; as well as Marchant, *La Constitution en vaudevilles*, Paris 1792. See also Herbert Schneider, 'The sung constitutions of 1792: An essay on propaganda in the Revolutionary song', in Malcolm Boyd (ed.), *Music and the French Revolution*, Cambridge 1992, 236-75.
47. Book I, Chapter 1. Chapters 3 and 4 are entitled 'Du droit du plus fort' and 'De l'esclavage', respectively.
48. By not showing Voltaire himself but rather his mortal remains at the ceremonial pantheonisation on 11 July 1791, this miniature - modelled on a contemporary illustrated broadsheet - establishes another link between the Enlightenment and the Revolution.
49. They are holding the manifesto for Louis XVI with which they protested against the Constitution on the 10 September 1791: 'Lettre de Monsieur et de M. le comte d'Artois au roi leur frère', printed in *Gazette nationale ou le Moniteur* no. 266, 23 Sept. 1791.
50. By connecting this Paradise with the Apotheosis of the great Men (field 81), which stands under the sign of the Pantheon, the game replaces the Christian notion of Resurrection with a secular 'Ascension' as decreed by Parliament in an act of political canonization.
51. Playing off Henry IV against Louis XVI in both texts and pictures was a common journalistic practice at that time, as the following three prints (among others) testify: anonymous etching without title concerning the accession to power, 1775, Bibliothèque Nationale Paris, Cabinet des Estampes, Coll. de Vinck, no. 458; the plan of a monument to Henry IV and Louis XVI, coloured aquatint by François Janinet after a painting by Charles Varenne, 1790, Bibliothèque Nationale Paris, Cabinet des Estampes, Coll. de Vinck, no. 460; and the caricature *Ventre Saint Gris ou est Mon fils?...*, anonymous, coloured etching, 1792, Bibliothèque Nationale Paris, Cabinet des Estampes, Coll. de Vinck, no. 4002; see the illustrations in Reichardt, *Revolutionsspiel*, 14-16.
52. On the iconography of this symbol, see R. Reichardt, 'Prints: Images of the Bastille', in Robert Darnton and Daniel Roche (eds.), *Revolution in Print: The Press in France 1775-1800*, Berkeley 1989, 223-51; *Die 'Bastille': Symbolik und Mythos in der Revolutionsgraphik*, Mainz 1989.
53. Ibid., as well as Hans-Jürgen Lüsebrink and Rolf Reichardt, *Die 'Bastille': Zur Symbolgeschichte von Herrschaft und Freiheit*, Frankfurt 1990, 128-35.
54. *Ibidem* 25-28.
55. *Ibidem* 123-28.

56. This result corresponds exactly with the lexical and semantic text analysis of the anti-Bastille pamphlets; see Lüsebrink and Reichardt, 'La Bastille dans l'imaginaire social', *Revue d'Histoire Moderne et Contemporaine* (1983) 198-214.

57. For the significance of this symbol in the field of Revolutionary graphics, see Renée Néher-Bernheim, 'Les Tables de la Loi dans l'iconographie de la Révolution' in Mireille Hadas-Lebel and Evelyne Oliel-Grausz (eds.), *Les juifs et la Révolution française: Histoire et mentalités*, Louvain/Paris 1992, 29-52.

58. The great significance of this iconography for the political culture of France in the 19th century is sketched in my article 'Der Bilderkampf zwischen Königtum und Republik' in *Französische Presse und Pressekarikaturen 1789-1992*, Mainz 1992, 80-93.

59. See Lüsebrink and Reichardt, *Die 'Bastille'*, 222-58; R. Reichardt, Die Stiftung von Frankreichs nationaler Identität durch die Selbstmystifizierung der Französischen Revolution am Beispiel der *Bastille*, in Helmut Berding (ed.), *Mythos und Nation*, Frankfurt 1996.

60. Steven L. Kaplan, *Adieu 89*, Paris 1993, 307, 331, 335, 441; Raymonde Monnier and Michel Vovelle, *Les Colloques du Bicentenaire*, Paris 1991.

61. In a general sense, the game was predetermined to have an essentially didactic character by virtue of the fact that it belongs to the genre of educational games.

62. Herding and Reichardt, *Die Bildpublizistik der Französischen Revolution*, 33-50.

63. Lüsebrink and Reichardt, *Die Bastille*, 190-202 and 228-58.

CHAPTER 13

1. Zie *Resolutien van de Heeren Staaten van Holland en Westvriesland, 1595*, 580.

2. See A.J. Gelderblom, *In Hollands Tuin*, Gouda 1995; Simon Schama, *The Embarrassment of Riches. An Interpretation of Dutch Culture in the Golden Age*, London 1987, 69-71; P.J. Van Winter, 'De Hollandse Tuin', *Nederlands Kunsthistorisch Jaarboek* 8 (1957) 29-121.

3. See Martin van Gelderen, *The political thought of the Dutch Revolt, 1555-1590*, Cambridge 1992; and Martin van Gelderen (ed.), *The Dutch Revolt*, Cambridge Texts in the History of Political Thought, Cambridge 1993.

4. Michael Ermarth, 'The transformation of hermeneutics: 19th century ancients and 20th century moderns', *The Monist* 64 (1981) 177.

5. Roy J. Howard, *Three faces of hermeneutics*, Berkely Ca., 1982, 9; cf. Dietrich Bohler, 'Philosophische hermeneutik und hermeneutische Methode', in Manfred Fuhrmann, Hans Robert Jauss, Wolfgang Pannenberg (eds.), *Text und Applikation*, München 1982, 497.

6. David Couzens Hoy, *The critical circle; Literature, history and philosophical hermeneutics*, Berkely Ca. 1978, 11.

7. Richard Bernstein, *Beyond Objectivism and Relativism. Science, Hermeneutics, and Praxis*, Philadelphia 1983, 145.

8. Donald R. Kelley, 'Horizons of Intellectual History: Retrospect, Circumspect, Prospect', *Journal of the History of Ideas* (1987) 143. Other recent reflections on these developments include John Toews, 'Intellectual History after the Linguistic Turn: The autonomy of Meaning and the Irreducibility of Exprience', *American historical Review* 92 (1987) 879-907; John H. Zammito, 'Are We Being Theoretical Yet? The New historicism, the New Philosophy of history, and "Practicing historians"', *Journal of Modern History* 65 (1993) 783-814.

9. See Reinhart Koselleck and Hans-Georg Gadamer, *Hermeneutik und Historik*, Sitzungsberichte der Heidelberger Akademie (1987) Bericht 1, Heidelberg 1987; Melvin Richter, 'Reconstructing the History of Political Languages: Pocock, Skinner, and the *Geschichtliche Grundbegriffe*' in *History and Theory* (1990) 44-5 and Melvin Richter, *The History of Political and Social Concepts. A Critical Introduction* Oxford 1995, 35.

10. Richter, *The History of Political and Social Concepts*, 35.
11. See Reinhart Koselleck's contribution to this volume, 'Social History and *Begriffsgeschichte*'. The following notes, however, refer to Koselleck's original text 'Begriffsgeschichte und Sozialgeschichte' in Reinhart Koselleck, *Historische Semantik und Begriffsgeschichte*, Stuttgart 1978, 19-36.
12. *Ibidem*; Reinhart Koselleck, 'Linguistic Change and the history of Events', *Journal of modern History* 61 (1989) 649. For what follows see also Reinhart Koselleck, 'Begriffsgeschichte und Sozialgeschichte', *Ibidem*.
13. Page 26 in this volume.
14. Melvin Richter, 'Conceptual History (*Begriffsgeschichte*) and Political Theory', *Political Theory* 14 (1986) 610. See also Richter, *The History of Political and Social Concepts*, 10.
15. Koselleck, 'Begriffsgeschichte und Sozialgeschichte', in *Historische Semantik und Begriffsgeschichte*, 28-30.
16. Gadamer, *Truth and Method*, New York 1975, 269.
17. See Koselleck, 'Begriffsgeschichte und Sozialgeschichte', in *Historische Semantik und Begriffsgeschichte*, 29; Richter, *Reconstructing the History of Political Languages*, 41.
18. Quentin Skinner, 'Meaning and the understanding of speech acts', in James Tully (ed.), *Meaning & Context. Quentin Skinner and his Critics*, Oxford 1988, 29.
19. See Quentin Skinner, 'Motives, intentions and the Interpretation of Texts', and Quentin Skinner 'Social meaning' and the explanation of social action' both in Tully, *Meaning and Context*, where it is argued that there is a 'sharp line' to be drawn between the motives of an actor to do action X and the intentions the author has in doing act X. Contextual factors can show the reasons, the motives for performing act X. They do not, however, unveil the 'point' of act X.
20. Quentin Skinner, 'A Reply to my Critics', in Tully, *Meaning and Context*, 232.
21. J.G.A. Pocock, 'Introduction: The state of the art', in J.G.A. Pocock, *Virtue, commerce and history*, Cambridge 1985, 5.
22. Pocock, *Virtue, Commerce and History*, 8.
23. Quentin Skinner, *The foundations of modern political thought. Volume 1: The Renaissance*, Cambridge 1978, xiii.
24. Pocock, *Virtue, Commerce and History*, 28.
25. See Erasmus, *Praise of Folly*, Harmondsworth 1971, 152.
26. Koselleck, *Linguistic Change and the History of Events*, 652.
27. *Ibidem* 653. See Herodotus, *History* 3.72.
28. *Ibidem* 655.
29. *Ibidem*, 652.
30. Page 7.
31. Hans-Georg Gadamer, *Truth and Method*, New York 1975, 426. See also Koselleck contribution to this volume.
32. Bödeker, 'Practising Begriffsgeschichte', unpublished paper delivered at NIAS (1995) 6.
33. See Rolf Reichardt, 'Zur Geschichte politisch-sozialer Begriffe in Frankreich zwischen Absolutismus und Restauration. Vorstellung eines Forschungsvorhabens', *Zeitschrift für Literaturwissenschaft und Linguistik* 47 (1982) 49-74 and Rolf Reichardt, 'Einleitung' in Rolf Reichardt and Eberhard Schmitt (eds.) *Handbuch politisch-sozialer Grundbegriffe in Frankreich 1680-1820*, München 1985, 82-5.
34. Bödeker, 'Practising Begriffsgeschichte', 2.
35. See James Farr, 'Understanding conceptual change politically' in Terence Ball, James Farr, Russell L. Hanson (eds.), *Political innovation and conceptual change*, Ideas in Context 11, Cambridge 1989, 24-49 and Terence Ball's contribution to this volume, 'Conceptual History and the History of Political Thought'.
36. Ball, 'Conceptual History and the History of Political Thought', in this volume.
37. *Ibidem*.
38. Skinner, *A Reply to my Critics*, 283.

39. See James Farr, *Understanding conceptual change politically*, 38; and the contributions of Terence Ball and Iain Hampsher-Monk to this volume.

40. According to Pocock, *Virtue, Commerce and History*, 9, 'it is a large part of our historian's practice to learn to read and recognize the diverse idioms of political discourse as they were available in the culture and at the time he is studying: to identify them as they appear in the linguistic texture of any one text and to know what they would ordinarily have enabled that text's author to propound or 'say'.

41. See Skinner, *Meaning and Context, passim.*

42. See L. van den Branden, *Het streven naar verheerlijking, zuivering en opbouw van het Nederlands in de 16e eeuw*, Gent 1956, and for Coornhert Arie-Jan Gelderblom, "Nieuwe stof in Neerlandsch'. Een karakteristiek van Coornherts proza' in H. Bonger, J.R.H. Hoogervorst, M.E.H.N. Mout, I. Schöffer, J.J. Woltjer, *Dirck Volckertszoon Coornhert. Dwars maar Recht*, Zutphen 1989, 98-114.

43. See Ger Luijten, Ariane van Suchtelen, Reinier Baarsen, Wouter Kloek, Martijn Schapelhouman (eds.), *Dawn of the Golden Age. Northern Netherlandish Art, 1580-1620*, Amsterdam/Zwolle 1993, and Ilja M. Veldman, 'Coornhert en de prentkunst' in Bonger et. al. (eds.), *Dwars maar Recht*, 115-143.

44. See Johan Huizinga, *Dutch Civilization in the Seventeenth Century*, London 1968; E.H. Kossmann, 'De Nederlandse zeventiende eeuwse-schilderkunst bij de historici', in Frank Grijzenhout and Henk van Veen (eds.), *De Gouden Eeuw in perspectief. Het beeld van de Nederlandse zeventiende-eeuwse schilderkunst in later tijd*, Heerlen 1992, 280-298.

45. See Ad van der Woude, 'The volume and value of paintings in Holland at the time of the Dutch Republic', in Jan de Vries and David Freedberg (eds.), *Art in History. History in Art: Studies in seventeenth-century Dutch culture*, Santa Monica Ca. 1991, 285-329.

46. See Eddy de Jongh, 'Realisme en schijnrealisme in de Hollandse schilderkunst van de zeventiende eeuw' in *Rembrandt en zijn tijd*, Brussels 1971, 143-194; Eddy de Jongh et. al, *Tot lering en vermaak: betekenissen van Hollandse generevoorstellingen uit de zeventiende eeuw*, Amsterdam 1976; E. de Jongh, 'Some notes on intepretation', in Freedberg and De Vries (eds.) *Art in History*, 119-136; E. de Jongh, 'De iconologische benadering van de zeventiende-eeuwse Nederlandse schilderkunst', in Grijzenhout and Van Veen (eds.), *De Gouden Eeuw in perspectief,* 299-329, the essays in E. de Jongh, *Kwesties van betekenis. Thema en motief in de Nederlandse schilderkunst van de zeventiende eeuw*, Leiden 1995, and E. de Jongh's contribution to this volume, 'Painted Words in Dutch Art of the Seventeenth Century'. For an extremely useful collection of the main contributions to the debate see Wayne Franits (ed.), *Looking at Seventeenth-Century Dutch Art. Realism Reconsidered*, Cambridge 1997.

47. De Jongh, 'Painted words', in this volume.

48. Eric J. Sluijter, 'Didactic and disguised meanings? Several Seventeenth-century texts on painting and the iconological approach to northern Dutch paintings of this period' in Freedberg and De Vries (eds.), *Art in History,* 175.

49. Simon Schama, *The embarassment of riches: An Interpretation of Dutch culture in the Golden Age*, New York 1987.

50. Svetlana Alpers, *The Art of Describing. Dutch Art in the Seventeenth Century*, London 1989, 229.

51. See David Freedberg, 'Science, Commerce, and Art: Neglected topics at the junction of History and Art History' in Freedberg and De Vries (eds.), *Art in History: History in Art*, 377-406.

52. Alpers, *The Art of Describing*, 103.

53. See De Jongh in his contribution 'Painted Words in Dutch Art'.

54. For Huizinga's reflections on history see Jo Tollebeek's essay on 'Huizinga: vernieuwer binnen een cultuurtraditie', in *De Toga van Fruin. Denken over geschiedenis in Nederland sinds 1860*, Amsterdam 1990, 197-257, W.E. Krul, *Historicus tegen de tijd. Opstellen over leven & werk van J. Huizinga*, Groningen 1990, and W.E. Krul, 'Huizinga's definitie van de geschiedenis', the concluding section in Krul's new edition of Huizinga's main articles on historiography, Johan Huizinga, *De taak der cultuurgeschiedenis*, W.E. Krul ed., Groningen 1995, 241-339.

55. As Jo Tollebeek labels Huizinga's enterprise. See J. Tollebeek, *De Toga van Fruin*, 212.

56. For Huizinga's view on the interrelationship between art and history see in particular Francis Haskell, 'Huizinga and the "Flemish Renaissance"' in Francis Haskell, *History and its Images. Art and the Interpretation of the Past*, New Haven 1993, 431-495; Bram Kempers, 'De verleiding van het beeld. Het visuele als blijvende bron in het werk van Huizinga', *Tijdschrift voor Geschiedenis*, 106 (1993) 515-534; Frank van Vree, 'Beeld en verhaal - de historicus als kunstenaar' in P.W.M. de Meijer e.a., *Verhaal en relaas*, Muiderberg 1988, 19-35; cd. note 54.

57. Johan Huizinga, 'Het esthetische bestanddeel van geschiedkundige voorstellingen' in Huizinga, *De taak der cultuurgeschiedenis*, 27.

58. See Haskell, *History and its Images*, 488: 'what turns his [Huizinga's] achievement into a landmark in historical method is the explicitness with which he raises fundamental questions concerning the validity of his approach'.

59. As quoted in Haskell, *History and its Images*, 490.

60. Freedberg, *Science, Commerce and Art*, 414-5.

61. F.R. Ankersmit, 'Statements, Texts and Pictures' in Frank Ankersmit and Hans Kellner (eds.), *A new Philosophy of History*, London 1995, 219.

62. Ernst H Gombrich, *Meditations on a Hobby Horse*, London 1963; Nelson Goodman, *Languages of Art*, Indiana 1985.

63. See Kempers, 'De verleiding van het beeld', *Tijdschrift voor Geschiedenis* (1993) 45.

64. As quoted in Haskell, *History and its Images*, 492.

65. See Rolf Reichardt's contribution to this volume and Quentin Skinner, 'Ambrogio Lorenzetti: The Artist as Political Philosopher', *Proceedings of the British Academy* (1986) 1-56.

66. Plato, *Cratylus*, 408. See Donald Kelly, *Horizons of Intellectual History*, 152.

Index of Names

Index of Subjects

Absolutism 84, 194
agency 5, 49, 50, 83, 91, 92, 104, 231
allegory 181
Ancient Constitution 42, 228
ancients and moderns 140-141
Annales School 17, 24, 104
architecture, as cultural space 140, 141
aristocracy 45, 112, 116, 215, 221, 223-225
aristocrat as traitor 195, 196, 197, 198, 213, 224, 225
arithmetic 152, 157, 164
artes liberales 135, 151, 152, 157
astrology 143-145

Begriffsgeschichte 1-8, 13, 22-26, 28, 30, 31, 33-35, 37, 38, 47-49, 51-63, 75, 77, 78, 89-91, 96-101, 105, 115, 228, 229, 230-233, 223, 238
broadsheet 194, 196

citizen(ry) 198, 216
classicism 140
commonwealth 71, 227
constitution 1, 24, 27, 42, 45, 48, 49, 57, 58, 61, 77, 115, 120, 121, 204, 208, 210, 211, 219, 223, 228
convention 43, 46, 92
cosmopolitanism 125
cosmopolite 7, 106, 107, 110, 111
court 20, 109, 140, 143, 152, 153, 158, 160, 164
crisis 16
cultural history 7, 20, 89, 103-105, 114, 135, 237
cultural transfer see transfer
culture 3, 8, 14, 20, 23, 76, 80, 104, 105, 108-110, 112, 113, 116, 117, 121, 123-126, 142, 143, 151, 157, 168, 173, 174, 227, 235-237

diachrony 2, 4, 5, 30-32, 34, 35, 39, 40, 42, 46, 48, 49, 51, 53, 62, 230

dictionary 8, 13, 20, 52, 88, 117, 118, 233
discourse 1-3, 5, 7, 46, 48, 49, 51, 53, 61, 62, 64, 75, 77-83, 91, 98, 100, 101, 116, 117, 120, 122-128, 140, 173, 229, 231, 232

emblem 6-8, 98-100, 140, 142, 172, 176, 186, 235
empiricism 235
Enlightenment 1, 18, 20, 21, 23, 33, 104, 110, 112, 117, 121, 126, 221
equality 45, 55, 82, 106, 189, 192
ethnicity 82, 122-124

fatherland 22, 106-108, 110, 111, 114, 118, 124, 210, 214, 215
feudal society 20, 42, 116
foreign 70, 108, 109, 112, 116, 117, 121-125, 164
form and content 167, 170
French Revolution 7, 38, 48, 61, 111-113, 116, 117, 119, 124-127, 191-225
French Republic 192

game 8, 175, 191-225, 234
genre 5, 7, 8, 29, 44, 46, 47, 77, 93, 95, 100, 127, 169, 170, 175, 179, 235
geometry 145, 152, 157
Golden Age 143, 235, 238
grammar 40, 46, 125, 152, 158, 162-164

harmony 157, 158, 160, 163, 164, 175, 234, 236
hermeneutics 9, 14, 24, 89, 90, 155, 228-230, 237, 238
Herrschaft 1-2
historicism 16, 39, 52, 90, 228
historiography 2, 13, 17, 20, 38, 47, 52, 61, 83, 91, 95, 104, 140, 230
history 1-9, 13-21, 23-35, 37-40, 42-44, 46-55, 57-64, 67, 73, 75-78, 81-84, 86-101, 103-106, 109, 110, 113-115, 117, 131, 135, 140, 141, 144, 152, 154, 155, 164, 170, 175, 185, 189, 227-238

Sattelzeit 2-4, 14, 15, 18, 19, 21, 22, 90, 91, 93, 113

semantic field 2, 7, 8, 56, 106, 109, 111, 114, 117, 118, 128, 225, 234

semantics 5, 21, 34, 35, 47, 54, 55, 59, 60, 61, 62, 63, 64, 91, 103, 105, 107, 111-115, 120, 122, 123, 124, 126, 127, 152, 170, 220-223, 232, 233

semasiology 2, 6, 52, 58, 92, 95, 97, 232

social history 4, 5, 7, 14, 16, 17, 23-28, 30-32, 34, 35, 47, 49, 51, 52, 54, 59, 61-63, 89, 91, 103-106, 109, 110, 113, 114, 117, 229, 230, 232

sources 18, 19, 21, 24, 28, 29, 31-33, 38, 53, 59, 103, 131, 144, 152, 155, 228, 233, 234, 237

speech act 4-6, 42-46, 62, 105, 231, 234

stained glass windows 227

Stanza della Segnatura, Vatican 7, 131, 135, 140, 143-145, 150, 151, 155, 157, 165

stratification 16, 110, 113, 114

studia humanitatis 152

symbol 63, 94, 163

synchrony 2, 4, 5, 30, 31, 32, 34, 35, 39, 40, 42, 46, 48, 51, 62

text and image 7-9, see also words and images

theology 14, 20, 26, 33, 108, 131, 140, 143-145, 151-154, 156, 158, 160, 162-164

toleration 84, 106, 110, 209, 215, 225

transfer, cultural 4, 7, 47, 52, 110, 115-117, 121, 125-128

trivium 152

urbanisation 20

vanitas 168, 178, 185, 188, 235

Volk 118, 121, 128

words and images 7, 8, 100, 135, 151, 152, 155, 157, 170, 234-238